Maclean's Companion to Canadian Arts and Culture

Maclean's Companion to Canadian Arts and Culture

Tom Henighan

RAINCOAST BOOKS

Vancouver

First published in 2000 by

Raincoast Books
8680 Cambie Street
Vancouver, B.C.
V6P 6M9
(604) 323 • 7100

www.raincoast.com

1 2 3 4 5 6 7 8 9 10

CANADIAN CATALOGUING IN PUBLICATION DATA

Henighan, Tom.
Maclean's companion to Canadian arts and culture

ISBN 1-55192-298-3

1. Arts, Canadian—20th century—History and criticism. 2. Arts, Canadian—20th century—Handbooks, manuals, etc. I. Title.
NX513.A1H447 2000 700'.971'0904 C99-911320-8

Cover design: Leslie Smith
Interior design: Jeremy Drought, Last Impression Publishing Service, Calgary, Alberta

Printed and bound in Canada

Table of Contents

Dedication · ix

Preface · xi

1 · Theatre · 1

2 · Music · 41

3 · Visual Arts · 79

DEDICATION

For Jim Comiskey in Los Angeles,
Tom Lucey in Frankfurt,
David Peat in Pari, Italy
and Bob Maclean in Athens ...
this glimpse of Canadian culture.

Preface

What this book is about and how to use it

THIS book is exactly what the title suggests: a companion to Canadian arts and culture. Ordinary Canadians who have no connection with the arts, Canadian students, new immigrants, foreign visitors, the world in fact, should not be ignorant of what this country has accomplished in the serious and popular arts. Everybody—or almost everybody—has at least heard of Margaret Atwood, Glenn Gould, Tom Thomson and Céline Dion. But consider the following names, chosen almost at random: Edward Johnson, Grant Strate, Jean Gascon, Félix Leclerc, Ozias Leduc, Bill Reid, Étienne Gaboury and Tomson Highway—how many Canadians have even the slightest idea of their singular achievements? One of my intentions here is to bring such names (and there are hundreds, no doubt thousands more) into Canadian consciousness. We should be familiar with the creative spirits of our culture; but we should also have a national perspective on our institutions. Our country is vast and, for better or worse, determinedly regional; it is not easy to travel everywhere in Canada and difficult sometimes to penetrate the local scene. Where do we find our great artistic and cultural institutions? In what ways do they serve their communities? What can they offer the visitor? What needs improving and changing?

This book should serve the reader in several ways. First, by providing an overview of Canadian achievements in each major field of artistic endeavour. Each chapter provides a snapshot of our arts and entertainment history from the perspective of the early 21st century. In my lead essays I attempt to give a glimpse of the whole scene and to suggest, in the few paragraphs available to me, what the trends are and what policies and interests underlie our arts production. But the book offers more than an overview; it contains a generous helping of specifics about Canadian culture. There are names and dates, addresses and telephone numbers, lists of awards, information about orchestras and recordings, galleries and publishing companies,

notes on festivals and special events, suggestions for reading, viewing and listening—in short, a plethora of information that should give the busy reader almost all he or she needs to know in order to enhance present and future pleasures in the pursuit of entertainment and culture in Canada.

This book has its origins in another book of mine, *Ideas of North*, published by Raincoast Books in 1997, a book that was welcomed by many as the first comprehensive guide to Canadian arts and culture ever. In *Ideas* I wished to inform above all, thus the useful lists (revised and expanded here). At the same time, following on my earlier book, *The Presumption of Culture* (Raincoast Books, 1996), there were many cultural issues I badly wanted to address. *Ideas of North* therefore became both a guide and something of a polemic.

Maclean's Companion to Canadian Arts and Culture has been constructed differently and is quite different in tone. Although, as previously, I have sought to be "personal, provocative and lively," I have climbed on no soapboxes and attempted no passionate pleas for changes of attitude, or of government policy, on the key cultural issues I continue to address. Since writing my first two books I have had many useful conversations with Canadian artists, administrators, presenters and publishers, and some of what I have learned is included in this guide. In the *Maclean's* tradition, however, I have attempted to function as a reporter, to offer, as objectively and accurately as I can, a mirror to the rich, complex and exciting culture that Canadians have created and will carry with them into the new millennium.

When I began to work on *Ideas of North* I already had a healthy respect for the compilers of reference works dealing with Canadian issues or with other cultural facts, but after completing that volume and after tackling the whole thing afresh in the present text, my respect has increased a thousandfold. To gather information is a painstaking task. No one thanks you for getting a hundred things right but they will curse you if you make one mistake—and mistakes are inevitable. Which leads me to the question that many readers may be asking: "Why do we need this book at all? Isn't everything out there on the World Wide Web?" In fact, rich as the Internet is in information on arts and culture (see, for a start, the Web sites we have listed in our bibliography), it contains little in the way of interpretation and intellectual perspective. And even its factual contents are, thanks to the very nature of the medium, diverse and scattered. In order to assemble even half the information contained in the present volume, the dutiful Web-surfer would have to spend the better part of a month with mouse in hand and printer on the go. Here, as elsewhere, those wonderful portable information instruments that we call books still have their place.

In putting together this book I have had help from various sources. I would like to thank Susan Globensky, a nonpareil student assistant if there ever was one, for her research and general support, and Myfanwy Parry for some important last-minute assistance. Also Monique Trottier at the Raincoast end of things for much useful probing, checking and compiling of data. Some of my friends and acquaintances in the arts were very helpful. I must mention Burf Kay, Robert Powell, Florence Hayes, Jim Comiskey, Larry McDonald, Lee Harris, Megan Williams, Dennis Purcell, Richard Taylor and Susan Hanson-Broten. Special mention must be given to Brian Scrivener, Raincoast's former managing editor, who has been such a delight to work with throughout, and to Michael Benedict of *Maclean's*, who set the parameters of this book with fine precision and gave sensible and shrewd advice and criticism from the start. Derek Fairbridge, my patient editor at Raincoast, helped sharpen this manuscript with many creative suggestions. Finally, the notion of a guide to Canadian culture did not originate with the present writer; it came from the former president and publisher of Raincoast Books, Mark Stanton, and we all owe him thanks for encouraging us to make the idea a reality.

1
Theatre

PROFESSIONAL theatre, despite its relatively short history in Canada, chronic funding difficulties and increasing pressure from other entertainment sources, has become one of our national artistic miracles. Every kind of theatre flourishes here. A few companies present great works of the past, often in new and striking productions—one naturally thinks of the Stratford and Shaw Festivals, or the Soulpepper Company in Toronto. Some theatres take pride in developing new Canadian works, as do Theatre Passe Muraille, Toronto, Théâtre d'aujourd'hui, Montréal, and Alberta Theatre Projects' playRites series. Canada also has a number of venues that pay special attention to minority life and the politics of exclusion (for example, Buddies in Bad Times and Native Earth Performing Arts, both in Toronto), while Québec in particular has nourished a striking theatre of improvisation, mime and acrobatics, typified by such companies as Carbone-14 and Théâtre ex machina. We do not lack for children's drama either, as witness the Green Thumb Theatre of Vancouver, Carrousel, based in Montréal, and the Young People's Theatre, Toronto. And despite the apparent downfall of theatre impresario Garth Drabinsky's personal empire, Canadians continue to be offered Broadway musical revivals or Lloyd Webber-like extravaganzas with spectacular special effects and rather bland content. Finally, in recent years we have witnessed the growth of the fringe festivals, which now form a coast-to-coast network of innovation, madness and delight, luring theatre-goers by the thousands to enjoy this definitively postmodern theatrical experience.

Yet the above categories, insofar as they suggest rigorous boundaries, are deceptive. Those who program theatre in Canada

Andrew Oxenham

Theatre Passe Muraille in Toronto has been home to some exciting experimental works for stage.

1

today must be fast on their feet, for they face conditions that undermine stability, factors that may necessitate scuttling the most ardent personal wishlist, crises that defy the determination to mount a consistent season. One can imagine some melancholy soliloquies on the part of many an artistic director: "How can I present this on the stage space available to me, with the personnel I can enlist?" "How can I reach the audience I hope is out there?" "What is going to bring them to my production?" "How am I going to pay for all this?"

Some compromises have been deemed necessary for survival, for example the production of *Camelot* at Stratford, the ubiquity of *Dracula, Anne of Green Gables* or their equivalents, the substitution of what are considered crowd pleasers for substantial drama. And survival, if not everything, is already a huge achievement for almost any contemporary company. Readers who consult our theatre listings should keep in mind that these companies we mention, although among the most stable in the country, have in some cases come near the brink more than once, and may do so again. Meanwhile, hundreds of others—whatever brief celebrity they may achieve— function in a kind of twilight zone in which their demise is almost a foregone conclusion.

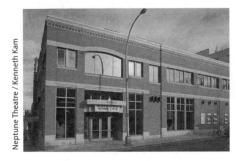

Neptune Theatre / Kenneth Kam

Diversity makes it difficult to generalize about the evolution of our contemporary theatre companies, but despite differences a pattern emerges that gives us a sense of common experiences, problems and directions. Working in a favourable climate created by federal funding, almost all of our professional companies were established in the 1960s or 1970s. Many, like the Neptune Theatre in Halifax and Theatre Aquarius, which began inauspiciously in Ottawa, went through an early phase where survival was

Extended construction and remodelling of the Neptune Theatre was completed in 1999.

very much in question. Those that avoided going under had a strong vision of what they wanted to accomplish and stuck to it—or else modified their vision in the light of the audience that offered itself. Companies like Theatre Passe Muraille in Toronto or Centaur Theatre in Montréal, troupes that managed to combine fiscal responsibility with either a strong vision or a sure adaptability to their audiences, did well, although few of them would have made it at all without federal and/or provincial funding. Most of our theatre groups worked quickly to acquire suitable performing spaces or,

like the Citadel Theatre in Edmonton, built facilities that entrenched them strongly in the community. Education and touring were not on all agendas. These became most important in provinces with relatively small and scattered populations such as Manitoba and Saskatchewan. Such is the pattern of survival and growth in the past; but what of the present and future?

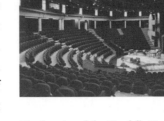

The interior of the Citadel's Maclab Theatre in Edmonton.

Recession, government cutbacks, and increased competition for the audience's dollars—from the mid-1980s to the end of the 1990s, the theatre community has had to make some huge adjustments to the new reality of tight budgets, rapid media development, shifting demographics and unpredictable audiences. Theatres have failed everywhere in the past, but the sheer number of closures in Canada during the mid-1990s was alarming and has included such well-known venues as the Bastion Theatre in Victoria; Tamanhous Theatre in Vancouver; Theatre 3 in Edmonton; Stage West in Regina; Theatre Plus in Toronto and the Penguin Theatre in Ottawa.

A predictable result of this crisis was that nervous presenters began to look for ways both to save money and to ensure packed theatres. Budget-cutting moves resulted in an unprecedented number of open-ended runs, one-person and small-cast shows and co-productions of many plays (sometimes by several companies), as well as mergers, cooperative exchanges among companies (including sharing of performing space), the renting out of company space for other purposes, new attempts at television and film sales and the creation of dinner theatre and "staged murder" formats.

To draw crowds, mainstream companies turned increasingly to controversial shows: nudity on stage became more common, sensational issues replaced old-fashioned domestic dramas, local appeal became a factor. On the other hand, crowd pleasers such as *The Sound of Music* were mounted without apology, and in theatre, as in the other arts, "community responsibility" became the shibboleth of the 1990s. Gimmicky advertising, contests and prizes; appeals to special interests, to children, university students and seniors—theatre in North America has never been terribly elitist but elitism definitely became a dirty word. The idea was to be inclusive and hip all at once, to make the theatre "a fun place to be." The big shift, however, was in programming. Encouraged, or perhaps seduced, by the success of the splashy big-budget, special-effects musical, artistic directors have often become overzealous in

3

their attempts to "find the right formula," meaning the correct combination of lightweight entertainment, designed to fill seats, and challenging theatre, designed to sustain quality. With all these pressures in view, with the temptation to compromise seemingly irresistible, it is to the credit of Canadian theatre companies that they continued to produce new and significant drama through the 1990s. Our country is too geographically extended and has too many conflicting regional and historical allegiances to create a "national theatre," yet we are recognized around the world as a source of important drama and as a place where theatrical art flourishes.

This achievement is all the more remarkable when one reflects on our somewhat chequered theatrical past. For hundreds of years theatre was all but banned in Québec, while English Canada was thoroughly colonized by American and British theatrical interests. Our unique, lively, occasionally inhibited and still rather invisible theatrical tradition is replete with surprising and curious facts. For example, after the fall of French Québec, it was the English garrison that reintroduced the plays of Molière into the province: they had been banned by the famous 18th-century bishop Jean-Baptiste Saint-Vallier, successor to François de Laval and rival of Governor Frontenac. In the 1850s, Harriet Beecher Stowe's *Uncle Tom's Cabin* was the most popular production of one of Toronto's first professional theatres, the Royal Lyceum, yet a few years later, in Victoria, B.C., when another play was presented, a race riot ensued when black members of the audience refused to obey the seating restrictions.

The Dominion Drama Festival (1932–39, 1947–69) was clearly an important stimulus to the growth of theatre expertise across the country, yet when government patronage fell short the festival was financed by a liquor company, a fact that caused some controversy, while up until 1965 the adjudicators of the final entries were all non-Canadian. The festival, despite its positive contributions, is now viewed with some embarrassment as the last gasp of a discredited colonialism.

Some writers see the Second World War as a watershed in the history of Canadian drama. A more plausible turning point might be the advent of the Royal Commission on National Development in the Arts, Letters and Sciences, the renowned Massey-Lévesque Commission of 1951, which resulted in the creation of the Canada Council in 1957 and gave a tremendous impetus to the development of all the arts across the whole country. With the founding in 1953 of the Stratford Festival—which was to become, among other things, a wonderful training ground for native theatrical talent—Canadian professional theatre began to come of age. By the mid-1970s, the climate had changed. Controversy erupted in 1975 when Robin Phillips, who was British, became artistic director at Strat-ford—this kind of furor was something new

in Canada. The 1960s and 1970s saw an evolution from touchy nationalism to national self-confidence. It was a peak period of theatre development and of construction of facilities. Government largess, spurring vital growth, may have encouraged complacency. In fact, box office receipts seldom covered more than half of theatre production expenses. Also, grants came with strings attached: in 1971, the Canada Council suggested that a 50 percent subsidy should mean 50 percent Canadian content.

Michel Tremblay, the playwright who made joual *respectable.*

Yet the new national energy in theatre was nothing if not diverse: it fostered the work of directors such as Paul Thompson and Bill Glassco, of actors such as William Hutt and Christopher Plummer, and of playwrights such as George F. Walker, David Fennario and Michel Tremblay. In Toronto, companies such as Tarragon Theatre were second to none in literary sophistication, while at Theatre Passe Muraille and elsewhere, populism and collective methods prevailed. In the West, the Manitoba Theatre Centre brought to life the notion of regional theatre, while the CODCO group demolished stereotypes about Newfoundlanders to the delight of urban audiences across Canada. Everywhere, theatre became a vehicle for self- or group-awareness, a celebration of new or recovered values, a challenge to old complacencies. What's more, Canadians began to enjoy seeing themselves on stage, a sure sign that the bad old colonized days were ending.

In Québec, where the Catholic Church had suppressed theatre for so long, it helped bring it back to prominence thanks to the creation of the Compagnons de Saint-Laurent, a didactic Christian theatre group of the 1930s that was a catalyst and training ground for many Québec theatre people, the noted director Jean Gascon among them. The enduring appeal of the so-called "burlesques," which began in the 1920s, and of the "*Fridolinades*" (vaudeville revues) of Gratien Gélinas, which ran from 1938 to 1946, had also helped keep the theatrical spirit alive in Québec, and with the advent of radio a new market for actors, directors and writers appeared. Funding from the federal government and Québec government sources amid the Quiet Revolution of

5

the 1960s ensured that theatre would be one of the touchstones of the new Québec. The work of important playwrights such as Jacques Ferron, Antonine Maillet, Marie-Claire Blais and Claude Gavreau began to appear and reflected the changing francophone society, but Québec companies also established links with European sources, while French-language theatre outside Québec began to explore the complexities of living within a linguistic and cultural tradition ignored or scorned by the majority.

Why did our theatre mature so quickly from such unpromising beginnings? There are many reasons. Thanks to our English and French founding cultures we had strong lines of connection with theatrical centres in Britain and Europe. Later, we were fortunately able to attract very gifted talent from a diversity of countries. We benefited greatly from CBC Radio's early commitment to serious drama, which laid the foundation for much that happened in the post-war period. The success of the Stratford and Shaw Festival theatres meant that a whole generation of theatre people could be trained on home soil. And the steady funding of theatre by the Canada Council ensured continuity and the development of new talent. Today, Canadian theatre is renowned for the willingness of our troupes to create infrastructures for play development. Before they are mounted, most Canadian plays go through a rigorous series of workshops, readings, try-outs and revisions, often at great expense to the company. This is one of the essential things that Canada Council funding helps pay for. Today, individual Canadian playwrights are turning out an astonishing variety of work and are getting performances just about everywhere. The sophisticated and dazzling theatrical works of Robert Lepage have been seen in London and Tokyo; *The Rez Sisters* by Tomson Highway reached the Edinburgh Festival; the plays of George F. Walker have been translated and performed around the world. Judith Thompson, Michel Tremblay and Brad Fraser, among others, are wellknown beyond

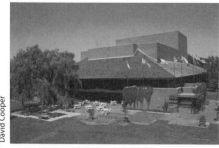

David Cooper

The Shaw Festival's Festival Theatre.

our borders. And in quite another vein, a recent Canadian "entertainment," *2 Pianos 4 Hands*, originated at the Tarragon Theatre in Toronto and performed by Ted Dykstra and Richard Greenblatt, has achieved not only a six-month run on Broadway, but is scheduled for a 45-week American tour, after which it goes to London's West End.

As we move into the 21st century we can identify two extremes of theatrical

presentation that have had a large impact on the Canadian scene in general. Both of these gained prominence for a variety of reasons, but chief among them may be the cutbacks in public funding that destabilized budgets and the appearance of new technologies that changed audience habits and perhaps undermined the notion of the old-fashioned mainstream theatre season. These two extreme forms are the big-budget productions, many of them musicals, and the fringe festivals.

The former began, predictably, in 1985, almost as soon as the economic downturn started to make producers nervous. *Cats* was the first big England-derived show to tour Canada, followed by *Les Misérables*. Soon after, Garth Drabinsky produced *The Phantom of the Opera* in Toronto at the refurbished Pantages Theatre. *Miss Saigon* followed in the new Princess of Wales Theatre built for just such presentations by promoters Ed and David Mirvish. That year one could also drop in on *Crazy for You*, an American musical, at the Royal Alexandra next door. Drabinsky came back in 1993 with *Kiss of the Spider Woman*, which went on to New York, where it garnered no fewer than seven Tony Awards. Continuing his triumphal march, Drabinsky took over the North York Performing Arts Centre, where his new production of *Showboat* opened before bouncing along to Broadway in 1994. In Vancouver, the Ford Centre for the Performing Arts also opened with *Showboat*, and the provincial government cheerfully funded excursions by schoolchildren from all over the province to get a taste of this masterpiece of American popular theatre.

Such events caused middlebrows to cheer, and Drabinsky and others argued that the productions were all really good for Canadian culture. Weren't Canadians at last showing the Americans how to do it? Didn't such blockbuster shows, coming as they did in such bad times, offer unparalleled opportunities for Canadian theatre talent to stay employed? Drabinsky even argued that his shows justified government support of "serious" theatre. After all, without the Canada Council there would have been no theatre in Canada and therefore no "pool of talent" for him to draw upon! Many disagreed with these assumptions, suggesting that the big productions were superficial, dramatically obvious and musically vapid, and that they contributed nothing to Canadian culture except another powerful jolt of American (or British) values.

The existence of such productions seemed to give the lie to those who argue that untrammelled "free enterprise" is a guarantor of quality (unless one means technical production quality). If one reverses Drabinsky's argument, it might be suggested that such productions actually drain away part of the audience—not to mention the talent—from the community theatres and compel the public to think of drama in

terms of showmanship and urban glitz, rather than in terms of clashes of ideas or of powerful confrontations of individuals or groups in a particular setting. However, it now seems clear that the arrival of the big-budget shows has not meant the demise of small-scale Canadian theatre or musicals. This is fortunate for Canada, because the American-style musicals, although they touch something universal in their projection of inflated wish fantasies and the horror of barely averted nightmare, merely use these elements to manipulate audiences, which they calculatingly drown in a wash of sentiment, sound and spectacle.

During 1998, however, Garth Drabinsky himself took centre stage in an amazing drama when his theatrical and financial empire collapsed amid charges of "serious irregularities" in accounting. He was promptly ousted as chief executive and chairperson of Livent Inc. by the company's American owners, and, according to the *Toronto Star*, his departure was "greeted largely with silence by the theatre community." In the end, perhaps the biggest influence of the Drabinsky productions on Canadian theatre was to alert "serious" and highbrow Canadian theatres to the existence of a large audience hungry for sheer entertainment and spectacle, one that might turn out for *West Side Story* or *Dream a Little Dream*, and stay away in droves from some "promising" playwright's dreary take on life in North Bay or Lachine. Drabinsky, for all his extravagances, had seemed to contact a new and much wider Canadian theatre audience, one that hungered for staged fairy tales, and pseudo-Broadway panache. Drabinsky's partial conquest of New York on New York's own terms also impressed Canadians and helped further destroy any lingering inferiority complexes connected with marketing Canadian productions.

Drabinsky is gone but that other great and popular fashion of the 1980s and 1990s, fringe theatre, seems healthier than ever. Its route to popularity has been very different, for it has found its strength in dealing out many a shock and challenge to enthusiastic audiences who love its diversity and its often frenetic energy. Unlike the big musicals, which are products of the few aimed at the well-off middle class, the fringe shows are creations of the not-so-few aimed in all directions at once. Fringe theatre has some claim to be called "primal theatre." It can involve a collective, ritualistic, initiatory experience, and in its iconoclastic, sometimes obscene earthiness evokes distant memories of the Dionysiac rituals that are at the root of all theatrical experience.

It was in 1982 that Brian Paisley, then associated with the Chinook Theatre, first borrowed the fringe idea from Edinburgh and introduced it to Edmonton. Other cities followed, a fringe circuit emerged, and it became possible for actors to play a whole summer season, moving from one venue to the next across the country. The

astonishing thing is that hundreds of thousands of people attend fringe every year in Canada, experiencing a theatre of surprises that ranges from the absurdly inept to the sophisticated and arcane. Fringe creates a theatre supermarket for either the fanatic or the casual theatre-goer. Its existence has demonstrated to cities such as Winnipeg, Edmonton, Victoria and Vancouver that festival culture does not necessarily mean big names and expensive facilities.

As the new century dawns, Canadian theatre, although vital and sometimes challenging, is going through radical changes and its future shape is not yet clear. New plays are being written, much less self-consciously Canadian in content than was the case in the 1960s and 1970s, although the best of the older ones are being revived with great success. Among the latter one might mention John Gray's *Billy Bishop Goes to War*, John Murrell's *Waiting for the Parade*, Michael Ondaatje's *The Collected Works of Billy the Kid*, James Reaney's *Donnelly Trilogy* and various works by George F. Walker and Michel Tremblay. The cultural and linguistic barrier between English Canada and Québec remains, and Québec theatre has taken its own direction and made its own statement on that great world stage. Without exception, theatres are attempting to match repertory with facilities, and to adapt to the changes in audience demands created by the new leisure and by the unparalleled individual command of cultural resources promoted by new technologies. Government funding can no longer be relied upon as a guarantor of survival, but many companies that owe their existence to that funding are finding new ways to survive.

Above all, the Canadian theatre of today possesses talent in abundance, at all levels and in all regions, while the public's demand for good drama, although changing its focus, has not slackened. These are perhaps the best indicators of a bright future for many forms of theatre art in Canada.

Major Theatre Companies in Canada (and a sampling of smaller troupes)

FOR information about multi-purpose facilities such as the National Arts Centre, see Major Canadian Performance Centres, listed in the Cultural Spaces & Showplaces section.

ALBERTA

Alberta Theatre Projects (ATP), Calgary: Founded in 1972, its present home is the 465-seat Martha Cohen Theatre, which opened in 1985. This company—middle-of-the-road and regional to a fault—began with a focus on theatre for young audiences (funded federally and by provincial educational sources) but it evolved quickly into a reliable showcase for Prairie drama and mainstream Canadian premieres. Notable presentations include Sharon Pollock's *Chatauqua Spelt Energy* (1979) and John Murrell's *Waiting for the Parade* (1980). The resident company gives approximately 220 performances a year and ATP umbrellas playRites, one of the most important annual festivals of new Canadian works. Among playRites' many successes is Brad Fraser's landmark *Unidentified Human Remains and the True Nature of Love* (1989). This hit played worldwide and was filmed by Denys Arcand in 1994. During the 1998–99 season, ATP moved to a repertory system, rotating works in a fashion that seemed well-designed to meet the needs of today's audiences. Nonetheless, by the end of 1999 the company was facing a severe financial crisis. Following six straight years of balanced budgets ATP found itself approximately $500,000 in the red. This may have been due partially to its shift to the repertory system— which reportedly caused some confusion among subscribers—but whatever the reason no one was expecting this solid theatrical enterprise to do anything but bounce back.

D. Michael Dobbin, producing director, has headed artistic operations for the past 17 years. **220 – 9th Ave. SE, Calgary, AB, T2G 5C4.** Phone: **(403) 294•7475**; Fax: **(403) 294•7493;** Internet: **http://www.atplive.com**

Lunch Box Theatre, Calgary: This niche company presents one-act plays or one-hour segments of longer plays for lunchtime audiences. It was founded in 1975 by Bartley and Margaret Bard and Betty Gibb, and since 1988 has been developing new Canadian plays as part of its mandate. Its performances are keyed to reach new audiences and as many as 3,000 students a year from Calgary and surrounding areas attend. The Bards continue through 1999 as artistic directors. **229, 205 – 5th Ave. SW, Calgary, AB, T2P 2V7**. Phone: **(403) 265 • 4292**; Fax: **(403) 264 • 5461**.

Northern Light Theatre, Edmonton. Like Calgary's Lunch Box Theatre, Northern Light began in 1975. Northern Light is a non-profit theatre group with a keen sense of cutting-edge drama and a cosmopolitan vision (in 1994–95 it sponsored a week-long reading of new Québec plays). Northern Light naturally draws heavily upon the amazing base of theatre talent in the Edmonton area. D. D. Kugler is the current artistic director. **11516 – 103rd St., Edmonton, AB, T5G 2H9**. Phone: **(780) 471 • 1586**; Fax: **(780) 471 • 6264**.

One Yellow Rabbit, Calgary: Wild and energetic theatre and the annual festival known as "High Performance Rodeo" keep this

Jason Stang

The One Yellow Rabbit ensemble is renowned for its "High Performance Rodeo," a festival of new and experimental theatre that has become a highlight of the Calgary theatre scene.

15-year-old company where the action is. Current co-artistic directors are Blake Brooker and Michael Green. **21, 225 – 8th Ave. SE, Calgary, AB, T2G 0K8**. Phone: **(403) 264•3224**; Fax: **(403) 264•3230**; Internet: **http://www.oyr.org**

Theatre Calgary: Founded in 1968, the company moved to its present location, the 750-seat Max Bell Theatre, in 1985. During the late 1970s and early 1980s, under artistic director Rick McNair, Theatre Calgary produced many Canadian premieres, including works by Sharon Pollock, W.O. Mitchell, Robert Kroetsch, John Murrell and others. Like its shadow twin, Alberta Theatre Projects, it found angst in Alberta and made it entertaining. As it has expanded to a multimillion-dollar operation, this company has frequently encountered

financial problems despite generous support from the Canada Council and a large reservoir of corporate donors in its own backyard. In recent years it has decided to focus on "classic plays from the Canadian and international repertoire"—in practice, this has meant very solid but also conservative programming. Ian Prinsloo is the current artistic director. **220 – 9th Ave. SE, Calgary, AB, T2G 5C4**. Phone: **(403) 294•7447**.

Citadel Theatre, Edmonton: Founded in 1965 by Edmonton lawyer and real-estate magnate Joe Schoctor, the Citadel Theatre has been almost a microcosm of the successes and failures in the wider sphere of the Canadian theatre world. Where Calgary's two main theatres plodded forward toward competence and even brilliance, the Citadel was all splash

and dash. Two American artistic directors (John Hulbert and Robert Glenn, 1965 – 68) concentrated on American and European drama and were controversial and only partially successful financially. They were succeeded by the Irishman Sean Mulcahy (1968 – 72), who made a strong commitment to programming international classics (Sean O'Casey, Henrik Ibsen, Arthur Schnitzler), but it was John Neville, coming from a distinguished career in England, who brought Citadel to national prominence by ambitious and astute programming and casting. Neville also presided over the company during the building program that resulted in the construction of the present theatre structure, one of the gems of contemporary Canadian architecture. This complex includes the 685-seat Shoctor Theatre, a studio space seating about 250, and the 240-seat Zeidler Hall, used for children's productions. Facilities added in 1984 included the Maclab Theatre, a 700-seat thrust stage, and the 150-seat open-air Tucker Amphitheatre. The post-Neville years (1978 – present) have been less happy ones for the theatre, marked by artistic uncertainties, as well as wild and unsuccessful attempts to "do" popular Canadian themes (*The Apprenticeship of Duddy Kravitz*, 1983 – 84, a flop) and to please popular taste (*Pieces of Eight*, a musical adaptation of *Treasure Island*, a huge flop). Imported productions began to multiply in the late 1980s, while the theatre, in common with many Canadian artistic institutions, experienced a financial crisis in the early 1990s. Under Robin Phillips, who was artistic director from 1990 to 1995, the company found a firmer artistic and financial base. In 1999, Edmonton-born Bob Baker, who had helped save the Canadian Stage Company (and other theatres) from financial collapse, returned to the Citadel as artistic director. **9828 – 101A Ave., Edmonton**, AB, T5J 3C6. Phone: **(780) 426•4811**.

BRITISH COLUMBIA

The Arts Club Theatre, Vancouver: Founded in 1958, this company began in the manner of a little theatre, with light comedies and thrillers. It has grown into a three-theatre organization, with two spaces, including the 450-seat Granville Island Stage, in addition to its original building on Seymour Street. Growth is mainly due to Bill Millerd, artistic director and impresario since 1972. Musicals, cabarets and revues are a specialty, but there have been many mountings of established Canadian plays, some contemporary classics and even a few premieres of Canadian work. The Millerd policy of giving the public what it wants and doing it with some flair has meant good box office receipts and an enviable stability for this company over the years. Jon Stettner is the current general manager. **1585 Johnston St., Vancouver**, BC, V6H 3R9. Phone: **(604) 687•5315** (admin.); **(604) 687•1644** (box office).

Belfry Theatre, Victoria: Founded in 1974, this company produces plays from the international repertory, with a strong emphasis on Canadian work, most recently that of George F. Walker (*Problem Child* and *Featuring Loretta* from the *Suburban Motel* sextet). Roy Surette is the artistic director. **1291 Gladstone Ave., Victoria**, BC, V8T 1G5. Phone: **(250) 385•6815**.

Carousel Theatre Company, Vancouver: A mainstream theatre company with an attached theatre school. Productions are mounted at the Waterfront Theatre on Granville Island. The troupe puts a strong emphasis on children's theatre. It has performed across Canada and at international children's festivals. Elizabeth Ball is the artistic director. **1411 Cartwright St., Vancouver**, BC, V6H 3R7. Phone: **(604) 669•3410**; Fax: **(604) 669•3817**.

Green Thumb Theatre for Young People, Vancouver: Founded in 1975 in Vancouver by Dennis Foon and Jane Howard Baker, this theatre's commitment to original scripts and its sure sense of the wide range of material (both traditional myths and stories and contemporary "problem" dramas) that interests young theatre-goers has resulted in years of successful and inventive productions, in foreign tours, in prizes (Chalmers Award, 1985, for Colin Thomas's *One Thousand Cranes*), and in continuing financial and artistic stability. The theatre presents 600 performances annually. Patrick McDonald is the current artistic director. **1885 Venables St., Vancouver, BC, V5L 2H6.** Phone: **(604) 254•4055.**

Playwright's Theatre Centre, Vancouver: Founded in 1970 by Douglas Bankson and Sheila Neville, this organization became an important theatrical clearinghouse for scripts, first from British Columbia, then, starting in 1972, from all over the country. Under Pamela Hawthorn it actually began to develop scripts, concentrating on women writers; it also encouraged the adaptation of existing plays and the creation of new work for television. No one died of excitement reading Hawthorn-mentored scripts, but bringing along new writers is always a useful service. The company continues to specialize in readings, seminars and the workshopping of new plays. Linda Gorrie is the current administrator. **Suite 201, 1398 Cartwright St., Vancouver, BC, V6H 3R8.** Phone: **(604) 685•6228;** Fax: **(604) 685•7451.**

Theatre One, Nanaimo: This company began in 1984 as a kind of Shakespeare West group, devoted to producing the works of the Bard. In 1995 it became a year-round regional theatre and in 1998 took its present name. It produces an appealing blend of local-derived and other Canadian-authored plays, and showcases star talent from across the country, employing both professionals and student trainees in theatre arts. The artistic producer is David Mann. Theatre location: **150 Commercial St.;** Administration: **PO Box 626, Nanaimo, BC, V9R 5L9.** Phone: **(250) 754•7587;** Fax: **(250) 754•9908.**

Touchstone Theatre, Vancouver: This theatre specializes in new Canadian work, by both local and national playwrights. The current artistic director is Katrina Dunn. **399 W 5th Ave., 2nd Floor, Vancouver, BC, V5Y 1J6.** Phone: **(604) 709•9973;** Fax: **(604) 709•9943.**

Vancouver Playhouse Theatre Company: This company was founded in 1963 to present new Canadian works but quickly transformed into a company offering what it discerns as "the finest in classic and contemporary theatre, drawn from the Canadian and international repertoire." The first artistic director was Michael Johnston. A string of gifted people followed, including Malcom Black, Joy Coghill, Paxton Whitehead, Christopher Newton and Walter Learning, whose five-year tenure was the longest. Glynis Leyshon is the current artistic director. The Playhouse is the largest theatre company in British Columbia and has been very successful in mixing somewhat challenging pieces with crowd pleasers to create a nicely varied fare. It runs its six-play mainstage season in the 647-seat Vancouver Playhouse, located next to the Queen Elizabeth Theatre. **160 W 1st Ave., Vancouver, BC, V5Y 1A4.** Phone: **(604) 872•6622** (admin.); **(604) 873•3311** (box office); Fax: **(604) 873•3714.**

MANITOBA

Le Cercle Molière, Winnipeg: This French-language theatre was founded in 1925. Through its annual community and youth festival it keeps the spirit of French-language theatre alive in the West. The current artistic director is Roland Mahé. **340, boul. Provencher,**

Winnipeg, MB, R2H 0G7. Phone: (204) 233•8053; Fax: (204) 233•2373; Internet: http://home.ican. net/~cmoliere/

Manitoba Theatre Centre (MTC), Winnipeg: This company was formed in 1958 from the nucleus of amateur and semi-professional groups. John Hirsch and Tom Hendry, its founders, were its dominant artistic shapers through the mid-1960s. The repertory was mainstream contemporary and classic modern (J. M. Synge, John Osborne, Bertolt Brecht, Samuel Beckett), although some Canadian plays were premiered. However, the latter proved not to be a strong point of the MTC over the years. Nevertheless, many early productions were successful and excellent actors were drawn from local sources and from the Stratford Festival. The "vaulting ambition" to create a genuine community-based theatre, with strong touring and educational adjuncts throughout Manitoba, did not work out consistently over the years. The 800-seat Dominion Theatre served the company until 1968; the new mainstage on Market Avenue, with 785 seats, was completed in time for the 1970–71 season. Problems ensued: there were conflicts between the board and several artistic directors during the 1970s; the theatre school closed. During the 1980s and early 1990s, under Richard Ouzounian and Rick McNair, some of the ties with the broader community and amateur theatre groups were restored: the theatre school was reopened and the company's touring productions attempted to draw in local performers. The founding of the Winnipeg Fringe Festival in 1988 brought the world to Manitoba and established first-year attendance records for a fringe. Steven Schipper is the MTC's current artistic director. **174 Market Ave., Winnipeg, MB, R3B 0P8**. Phone: (204) 942•6537; Internet: **http://www.mtc.mb.ca**

Manitoba Theatre for Young People (MTYP), Winnipeg: This company performs for 80,000 young people and their families annually through an eight-play subscription series. It also runs a theatre school for young talent, with a current enrolment of 600. The company's 1995–96 budget was $800,000. The current artistic director is Leslee Silverman. The MTYP moved into a new facility in August 1999: **The CanWest Global Performing Arts Centre, 2 Forks Market Rd., Winnipeg, MB, R3C 4X1**. Phone: **(204) 947•0394**.

Prairie Theatre Exchange (PTE), Winnipeg: Founded in 1972 as the Manitoba Theatre Workshop, this dynamic organization has been active in maintaining a theatre school, puppet theatre, drama festivals, television productions and children's theatre. In addition, PTE began, in the early 1980s, production of new Canadian drama with strong regional and populist roots, including George Ryga's *The Ecstasy of Rita Joe* (1981). Allen MacInnis is the current artistic director. **389 Portage Ave., Floor 3, Unit Y 300, Portage Place, Winnipeg, MB, R3B 3H6**. Phone: **(204) 942•5483** (box office); **(204) 942•7291** (admin.).

NEW BRUNSWICK

Theatre New Brunswick, Fredericton: In 1964, the 1,000-seat Beaverbrook Playhouse (later modified with a slight reduction in seating capacity) was opened but not until Walter Learning became artistic director in 1968 did Theatre New Brunswick begin to function as a professional company. The following year the company established itself as a provincial touring group, and it has remained strong in this respect. Its early productions were predictable mainstream modern British and American plays. This repertory was eventually expanded to include work by local writers, notably the sad but trenchant work of Alden Nowlan. In the mid-1980s, under artistic director Janet Black, the emphasis shifted to Canadian premieres and

new international works, produced on a second stage. Walter Learning returned as artistic director in 1995 and departed in 1999. The new artistic director, David Sherren, took over the company at a time when it had gone $600,000 into the red, but he was optimistic, suggesting that a stronger management structure and a change of programming would resolve the problem. In 1998, Theatre New Brunswick received close to a half-million dollars in grants from public and private sources, designed to enable it to "restructure its finances" and to broaden its community outreach. **PO Box 566, 686 Queen St., Fredericton, NB, E3B 5A6.** Phone: **(506) 458 • 8344**.

NEWFOUNDLAND

The vitality of Newfoundland theatre is hardly conveyed by listing current companies. The Mummer's Troupe (1972 – 82), organized by Chris Brookes, developed exciting collectives. The stage version of CODCO (1973 – 79) evolved into the Wonderful Grand Band Company and broke into CBC Television from 1986 to 1988 with *S&M Comic Book*. *The Best of CODCO* toured the country and CBC ran a show, *CODCO*, from 1988 to 1993, which formed the basis of the recent, much-admired CBC Television show *This Hour Has 22 Minutes*.

Theatre Newfoundland and Labrador, Corner Brook: Founded in 1979 in Stephenville by Maxim Mazumdar, this company has from the beginning presented a mainstream repertory of classic and modern plays, including some Canadian works. The former artistic director was Edmund McLean, who also instituted a provincial touring program. **PO Box 655, 35 West St., Corner Brook, NF, A2H 6G1.** Phone: **(709) 639 • 7238**.

Rising Tide Theatre, St. John's: The company was founded in 1978. It evolved from the Mummer's Troupe and later moved into a 1,100-seat facility in the Arts and Culture Centre. The current emphasis is on new Canadian work, but some international plays are featured. It runs a summer festival and organizes a historical pageant in Trinity Bright. The current artistic director is Donna Butt. **PO Box 7371, St. John's, NF, A1E 3Y5.** Phone: **(709) 738 • 3256**; Fax: **(709) 738 • 0909**.

Shakespeare By The Sea, St. John's: This summer festival began in 1993. It showcases the talents of Newfoundland actors in Shakespeare and related drama, mainly atop the spectacular cliffs of St. John's Logy Bay. In 1996, productions expanded to a second venue in downtown St. John's. The artistic director is Jennifer Deon-Kirkland. **67 Fagan Dr., St. John's, NF, A1A 3N2.** Phone: **(709) 576 • 0980**; Fax: **(709) 579 • 4429**.

NOVA SCOTIA

Atlantic Theatre Festival, Wolfville: This annual summer festival theatre was launched in 1996 with strong private-sector investment and an operating budget of about $1.5 million. Heavily aimed at tourists, the festival at first featured two or three traditional masterpieces in new productions, with a strong emphasis on Shakespeare, Restoration and 18th-century comedy. The aim seemed to be to create a kind of Stratford East, but by 1998 it appeared that the classics were not drawing the crowds. The company budget (which had fattened to $2.2 million) was cut and the emphasis was threatened to be redirected toward more snappy modern fare such as *Night of the Iguana* and *The Miracle Worker*. At this point an emergency fundraising campaign, with notable support from Christopher Plummer, collected $750,000. Michael Bawtree left the company and was replaced by new artistic director Jerry Étienne. Under Étienne, the summer 1999 program budget was cut by $1 million, and the company reduced from 20 actors to 14. The

program, which included Henrik Ibsen's *Hedda Gabler*, a Georges Feydeau farce and W. Somerset Maugham's *The Constant Wife*, was a success and there were high hopes for a balanced budget and a small surplus by the end of 1999. **356 Main St., Wolfville, NS, B0P 1X0**. Phone: **1 (800) 337 • 6661** (box office); **(902) 542 • 4242**; Internet: **http://www.atf.ns.ca**

Mermaid Theatre, Windsor: This company developed touring productions for young Nova Scotia audiences, using puppets and live actors to present works inspired by Micmac stories and more contemporary children's novels and fairy tales. Later tours included cross-Canada and international appearances in England and the United States. A youth theatre program designed to teach adolescents theatrical self-expression is now in place. Evelyn Garbary, Sara Lee Lewis, the managing director, and Tom Miller founded the theatre. Jim Morrow is the current artistic director. **PO Box 2697, 132 Gerrish St., Windsor, NS, B0N 2T0**. Phone: **(902) 798 • 5841; (902) 798 • 2697** (box office); Fax: **(902) 798 • 3311**; Internet: **http:// www3.ns. sympatico.ca/onstage/mermaid**

Neptune Theatre, Halifax: Founded in 1963, with Leon Major as the first artistic director, Neptune began as a repertory theatre

Geri Nolan-Hilfiker

The Mermaid Theatre of Nova Scotia performs "The Shaman and the Bagpipe," part of an adaptation of Noah and the Woolly Mammoth, *by Howard Norman.*

attempting to balance classic plays with new Canadian works. The first production was George Bernard Shaw's *Major Barbara* starring Mavor Moore. Heinar Piller and Robert Sherrin followed Major as artistic director, and there were many successes, including works by Robert Bolt, James Reaney, Michel Tremblay, Harold Pinter and David Freeman. Winter-season repertory had to be abandoned in 1971 due to the limitations of the facility. On several occasions, the company ran up a large debt, part of which was paid off by the province in 1966. Following the ambitious but not altogether successful tenure of John Wood in 1977, Neptune hired John Neville, who brought both budgetary responsibility and excitement onstage, both as actor and artistic director. During the tenure of Richard Ouzounian, which began in 1986, there were many world premieres, but further economic problems, combined with unpredictable performance standards, led to his replacement after two years. Recent repertory has reinstated the original mixture of traditional classics and established Canadian plays. The six-production mainstage format has been re-established. Three plays are produced in the studio series and some lighter summer productions have been aimed, not altogether successfully, at the tourist market. Extended theatre construction and remodelling was finally completed in 1999. Linda Moore, who has been at the helm 10 years, will be the artistic director up until the end of the 1999 – 2000 season. **1593 Argyle St., Halifax, NS, B3J 2B2**. Phone: **(902) 429 • 7300** (admin.); **(902) 429 • 7070** (box office); Fax: **(902) 429 • 1211**; Internet: **http://neptune. ns.sympatico.ca**

ONTARIO

Blyth Festival, Blyth: Founded in 1975 by Keith Roulston, James Roy and Anne Chislett, this summer festival was designed to appeal to the local community, to capture local history

and values and to draw tourists to the area. At first, productions leaned toward collectives such as *The Farm Show* but no loyal audience emerged and the group veered toward more commercial fare, such as light comedies and thrillers. Katherine Kaszas was artistic director from 1984 to 1991, Janet Amos from 1979 to 1984, the latter returning in 1994 to attempt to rescue the festival from near collapse after several years of financial trauma. Fortunately, Blyth has survived through the 1990s and has continued to attract 35,000 to 40,000 visitors annually to its satirical, generally light and very topical new productions. Anne Chislett is the current artistic director. **107 Queen St. N, Blyth, ON, N0M 1H0**. Phone: **(519) 523 • 9300**; Fax: **(519) 523 • 9804**.

Buddies in Bad Times, **Toronto**: A self-described "queer" theatre company, founded in 1979, this troupe is committed to the development and production of radical new Canadian work. Now housed in the renovated old building of the defunct Toronto Workshop Productions, Buddies is a lively place with many new Canadian productions, readings, cabarets, festivals and work in view by Brad Fraser, Timothy Findley and Ann-Marie MacDonald, among many others. Sarah Stanley is the current artistic director. **12 Alexander St., Toronto, ON, M4Y 1B4**. Phone: **(416) 975 • 8555**; Fax: **(416) 975 • 9293**; Internet: **http://www.buddies.web.net**

Canadian Stage Company (CSC), **Toronto**: This company resulted from the 1988 merger of the Toronto Free Theatre and CentreStage companies. Co-artistic directors were Guy Sprung and Bill Glassco. CSC's large budget, its four stages and its ready access to the lucrative Toronto market as well as to some of the best theatrical talent in Canada gave it a potentially commanding position among national theatre companies. Despite these advantages, near disaster followed in the wake of artistic

differences, declining grants and shifting audience tastes. In 1990, Bob Baker took over as artistic director and managed to reduce CSC's $3-million debt to a mere $700,000, thus assuring its survival into the late 1990s. Baker also moved away from the theatre's implicit commitment to new Canadian work and put some lively mainstream plays—as well as a few bombs—on the mainstage of the St. Lawrence Centre. Baker resigned in 1998 to return to Edmonton. Martin Bragg is the new artistic producer. **26 Berkeley St., Toronto, ON, M5A 2W3**. Phone: **(416) 368 • 3110**; **(416) 367 • 8243** (box office); Fax: **(416) 367 • 1768**.

Factory Theatre (formerly Factory Theatre Lab), **Toronto**: Founded in 1970 by Ken Gass and Frank Trotz, this company soon achieved a strong profile among alternative theatres in

Factory Theatre

Since the 1970s, Factory Theatre has been one of the best showcases for alternative stage performances in Toronto.

Maclean's Companion to Canadian Arts and Culture

Toronto. It helped develop the important Canadian playwright George F. Walker, among others. Gass departed amid controversy in 1977 (when he produced *Winter Offensive*, a play about Adolf Eichmann and his family in Auschwitz) and was replaced by Bob White. In 1987, Jackie Maxwell became artistic director and she was followed by Katherine Kaszas. From the first, this company has been notable for its development of new scripts and for its inventive and non-traditional productions such as George F. Walker's *Theatre of the Film Noir* (1981). During its history it has produced over 500 plays for mainstage and many more in workshop. Since 1984 the company has played in the 230-seat auditorium at its Bathurst Street location. The company suffered major financial woes in the mid-1990s. Ken Gass is once again artistic director. **125 Bathurst St., Toronto, ON, M5V 2R2**. Phone: **(416) 504•9971** (box office); **(416) 504•4473** (admin.); Fax: **(416) 504•4060**; Internet: **http://www.factory theatre.ca**

Grand Theatre, **London**: The Grand Theatre building was built in 1901 by Ambrose Small (the Ontario financier who mysteriously disappeared and supposedly haunts the Grand) and was restored in 1977–78. Theatre London, a transformed amateur group, made itself over into the Grand Theatre Company in 1983 and hired Robin Phillips as director to stir up some action—which he did, turning staid London on its ear, creating some brilliant productions, such as Shakespeare's *Timon of Athens*. However, he also reputedly ran up a million-dollar debt during his spectacular nine-play season. Following Phillips's departure and after a few years in the doldrums Martha Henry became artistic director (1988–95). Michael Shamata, who took over in 1995, is currently the artistic director. Steven Dietz's adaptation of the Bram Stoker novel *Dracula* and Stephen Sondheim's *A Little Night Music* are among his most successful recent productions. The 1999–

2000 season featured Oliver Goldsmith's *She Stoops to Conquer* and *Travels with My Aunt*, based on the Graham Greene novel. **471 Richmond St., London, ON, N6A 3E4**. Phone: **(519) 672•8800**; Fax: **(519) 672•2620**; Internet: **http://www.grandtheatre.com**

The Great Canadian Theatre Company (GCTC), Ottawa: Founded in 1975, this group was launched by Robin Mathews and other local academics as part of a fermenting Marxist-tinged Canadian nationalism. Despite its narrow focus, which was criticized by many and resulted in too many productions that were both politically shrill and theatrically naïve, the company has shown a dogged survival instinct and has even generated support from the relatively conservative and politically allergic Ottawa public. While the nationalist-leftist commitment endured through the 1980s and resulted in a string of left-wing, populist and collective endeavours (for example, *Sandinista!*), the evolution has been toward mainstream yet committed theatre. The company's recent artistic directors (Steven Bush, Arthur Milner and Micheline Chevrier— the latter scheduled to depart after the 1999–2000 season) have followed this line. The theatre's broader community connection has been especially evident in its active workshop and children's programming. GCTC, which moved into its present 218-seat theatre in 1982, has survived financially on a tenuous balance of government grants, private support and subscriptions. Lorne Purdy will take over following Chevrier. **910 Gladstone Ave., Ottawa, ON, K1R 6Y4**. Phone: **(613) 236•5196**; Internet: **http://www.gctc.ca**

Magnus Theatre Company Northwest, Thunder Bay: Founded in 1972, the company's first artistic director was Burton Lancaster, who concentrated on establishing the group with children's theatre and mainstream commercial fare. Under Tibor Feheregyhazi (1978–82) the

18

company solidified. A theatre school was created under the next artistic director, Brian Richmond (1982 – 87). Mario Crudo, who took over in 1992, broadened the repertory to include more Canadian plays, including works by Morris Panych and Carol Shields. Some touring has ensued and a theatre-in-schools program is in place. Crudo remains artistic director. Theatre location: **639 McLaughlin St.**; Administration: **Central School Building, 10 Algoma St. S, Thunder Bay, ON, P7B 3A7**. Phone: **(807) 345 • 8033** (admin.); **(807) 345 • 5552** (box office); Internet: **http://www. norlink.net/~magnus**

Native Earth Performing Arts, Toronto: Founded in 1982, this company scored a great success with Tomson Highway's *The Rez Sisters* (1986), which won both the Dora and Chalmers Awards for Best New Play and went on the Edinburgh Festival of 1988. Three years later the same writer's *Dry Lips Oughta Move to Kapuskasing* was an even bigger triumph, winning a second Chalmers and four Dora Awards. Not only has this company brilliantly succeeded in producing work that reflects the Native Canadian experience, it also organizes an annual festival, provides professional workshops and classes and generally serves as a resource for Native theatre. The company is handled by an artistic directorate consisting of Daniel David Moses, Sandra Laronde, Jani Lauzen and Alejandro Ronceria. **503 – 720 Bathurst St., Toronto, ON, M5S 2R4**. Phone: **(416) 531 • 1402**; Fax: **(416) 531 • 6377**.

Necessary Angel, Toronto: This well-established, award-winning company has been creating important drama for more than two decades. Outstanding productions include Michael Ondaatje's *Coming Through Slaughter*, John Krizanc's *Tamara* and Timothy Findley's *Not Wanted on the Voyage*. The acting company is especially well regarded and includes, among other notables, Tamara Bernier, Megan Follows and John Gilbert. The very successful new playwright Jason Sherman is another asset. Richard Rose is founding artistic director and has directed most of the productions during the company's history. **201 – 490 Adelaide St. W, Toronto, ON, M5V 1T2**. Phone: **(416) 703 • 0406**; Fax: **(416) 504 • 8702**; Internet: **http://www.interlog.com/~nangel/**

Nightwood Theatre, Toronto: Among this feminist theatre company's notable productions of recent years was Diana Braithwaite's *Wonder Quartet* (1992). The current artistic director is Lisa Palmer and the producer is Leslie Lester. **9 Saint Nicholas St., Toronto, ON, M4Y 1W5**. Phone: **(416) 944 • 1740**; Fax: **(416) 944 • 1739**; Internet: **http://www.toronto.com/E/V/TORON/0013/ 42/80/**

Second City, Toronto: Second City came to Toronto in 1973. To the disappointment of many, it closed after a short run, but soon afterward Andrew Alexander convinced the owners of the restaurant in the Old Firehall Theatre on Lombard Street to take a chance on a show called *Hello Duli*. Ever since, Second City has been synonymous with world-class comic talent. Names like Dan Aykroyd, John Candy, Gilda Radner, Eugene Levy, Rosemary Radcliffe, Joe Flaherty, Rick Moranis, Andrea Martin and Martin Short have become familiar to television and film fans who never visited the original venue. Since 1997, performances have been at the new and more spacious location in the heart of Toronto's theatre district. The company is owned by Roy Lister, Len Stuart and Andrew Alexander, who is also the executive producer. Lyn Okkerse is the producer and Cynthia Buchanan is the artistic director. **56 Blue Jays Way, Toronto, ON, M5V 2G3**. Phone: **(416) 343 • 0011** (box office); **(416) 343 • 0033** (admin.); Fax: **(416) 343 • 0034**; Internet: **http://www.secondcity.com**

Shaw Festival, Niagara-on-the-Lake: Founded in 1962 by Brian Doherty, this festival theatre established itself from 1967 to 1977 under Paxton Whitehead. It has since become the second-largest repertory theatre in North America. In 1973, the 860-seat theatre designed by Ronald Thom was opened by Queen Elizabeth II (there are currently three stages). During the 1980s, Christopher Newton extended (and perhaps over-extended) the company's activities, but the overall movement was clearly forward, with a broadening of the repertory to include European comedies (Derek Goldby's production of *Cyrano de Bergerac* starring Heath Lamberts was a highlight). Under Newton, the festival sustained its high standard for sets and costume design, implemented lunchtime theatre and provided excellent training for young Canadian theatre professionals. The attempt during 1984 – 87 to extend the Shaw productions into Toronto was financially unsustainable, but it was a laudable attempt to expand and enrich "festival" theatre with urban input. Less eminent than Stratford, less exciting than collective and experimental companies such as Theatre Passe Muraille or Factory Theatre, the Shaw Festival has weathered several crises to become an indispensable institution, and it is clearly one of a handful of must-see theatre attractions in Canada at this time. Christopher Newton is the current artistic director. **PO Box 774, Niagara-on-the-Lake, ON, L0S 1J0**. Phone: **1 (800) 511 • 7429**; Internet: **http://www. shawfest. sympatico.ca**

Soulpepper Theatre Company, Toronto: With funding from both private and public sources, this company took shape in 1998, founded mostly by former Stratford performers, several of whom were mentored by Robin Phillips. Their aim has been to create a troupe that would play the classical theatre repertory. Phillips himself got involved and worked with the company on some early productions. Plays like Friedrich Schiller's *Don Carlos* and Molière's *The Misanthrope* headlined their first season at the du Maurier Theatre at Harbourfront. An ambitious program has followed, including presentations of Ferenc Molnar's *The Play's the Thing* and Samuel Beckett's *Endgame*. Soulpepper is an actor-driven company whose four artistic directors include Albert Schulz, Nancy Palk, Diego Metamoros and Diana Leblanc. **228 King St. E, Toronto, ON, M5A 1T1**. Phone: **(416) 203 • 6264; (416) 973 • 4000** (box office).

Stratford Festival, Stratford: Canada's most famous company began as a tent theatre in 1953 with the celebrated Tyrone Guthrie directing and Alec Guinness acting in a six-week Shakespeare season. From there it has grown to a huge plant (three theatres, including the 2,276-seat Festival Theatre with its striking neo-Elizabethan design), a large administrative staff, 100 actors and innumerable sets and costumes. In 1994, there were no fewer than 497 performances through the 27-week season. The roll of Stratford's artistic directors reads like a who's who of Canadian theatre and includes Michael Langham (1956 – 67), Jean Gascon (1968 – 74), Robin Phillips (1975 – 80), John Hirsch (1981 – 85) and John Neville (1985 – 89). The current artistic director is Richard Monette. Notable foreign tours have taken place, but above all Stratford has been an extraordinary training ground for Canadian acting talent, including Will Hutt, Tony van Bridge, Martha Henry, Kate Reid, Colm Feore and Christopher Plummer. It is a measure of the severity of the crisis that struck Canadian artistic institutions in the early 1990s that even a central pillar such as Stratford was affected. As a result, John Neville put *Cabaret* and *My Fair Lady* on the mainstage ("*Et tu, Brute?*") and although the deficit declined, the rescue of high art by commercial glitz worried the thoughtful and pleased few bardolators. The festival, which has never really made money, continues to

thrive artistically. In 1997, Stratford's 45th season, it unveiled a newly renovated Festival Theatre (a $13-million facelift), more cotton-candy fare in *Camelot*, and a new production of *Oedipus Rex*. During 1999, alongside *The Tempest* and *Midsummer Night's Dream* one could find *West Side Story*, a new *Dracula* and an adaptation of *Pride and Prejudice* made pertinent by the Jane Austen film vogue. Given the financial realities of theatre in Canada in the 1990s, the company's shift of focus was probably inevitable. To fulfill the role of shrine and yet to stay in touch with living theatre is not easy and Stratford remains an exciting project and a must-see attraction for all visitors to Canada. **PO Box 520, Stratford, ON, N5A 6V2**. Phone: **1 (800) 567 • 1600**; Internet: **http://www.culturenet.ca/stratford**

Sudbury Theatre Centre: Founded in 1971, this company's first artistic director was Tony Lloyd, who set the company on its feet by programming a standard mainstream repertory. A new theatre with a 292-seat capacity opened in 1982. Local subscribers and support from Inco Nickel Company have helped keep this company afloat. It has expanded to include a youth theatre, dinner theatre productions and a touring unit that serves schools, mostly in northern Ontario. **170 Shaughnessy, PO Box 641, Stn. B, Sudbury, ON, P3E 4P8**. Phone: **(705) 674 • 8381**.

Tarragon Theatre, Toronto. Founded in 1971 by Bill Glassco and Jane Gordon, Tarragon developed to present a host of significant new Canadian plays, including works by Sharon Pollock, Joanna Glass, George F. Walker, Judith Thompson, David French and many others. Also, many of Michel Tremblay's works have been presented by Tarragon in English. Located in a converted factory in northwest Toronto, the 210-seat theatre has been renovated more than once and since 1983 has been served by a small-space adjunct, The Extra Space. In 1974, the

theatre began a playwright-in-residence program and in 1982 the Six Playwrights Unit, an extended workshop for promising writers, was instituted, while actors have been served by the Maggie Bassett Studio training program since 1980. In the mid-1970s, more translations of classic foreign plays were commissioned. Urjo Kareda succeeded Bill Glassco as artistic director in 1982 and is known for his unusual openness to the work of unknown writers and his ability to develop scripts. Recent productions have included *The Designated Mourner* by Wallace Shawn and *New World* by John Murrell. **30 Bridgman Ave., Toronto, ON, M5R 1X3**. Phone: **(416) 536 • 5018** (admin.); **(416) 531 • 1827** (box office); Fax: **(416) 533 • 6372**; Internet: **http://www.interlog.com/~tarragon**

Theatre Aquarius, Hamilton: This company originated in Ottawa in 1970 and first performed at the National Arts Centre. Peter Mandia, the founder, together with his co-artistic director Nanci Rossov, soon turned to producing new Canadian plays (in 1972 there were five). However, Ottawa audiences seemed uninterested and the group moved to the Hamilton Place Complex in 1973, occupying a very small 325-seat theatre. This new space hampered the company's development, though the subscription audiences were solid. Through the 1970s and 1980s, Aquarius staged main-stream productions from New York, Toronto and London, but there were also a few Canadian premieres. A new theatre complex was opened in the downtown area in 1990 and Aquarius has worked toward programming that balances classic modern plays and audience pleasers like *The Sound of Music* with its *Stage Write* series of new and experimental Canadian drama. Under Max Reimer, artistic director since 1995, a total debt reduction of $1.8 million has put this company on a less precarious financial footing. **190 King William St., Hamilton, ON, L8R 1A8**. Phone: **1 (800) 465 • 7529**; Fax: **(905)**

522•7865; Internet: **http://www.theatre aquarius.org**

Theatre Passe Muraille, Toronto: Founded in 1968 by Jim Garrard out of Rochdale College, an experimental facility with a thoroughly 1960s ambience, this company was unhampered from the beginning by theatre architecture, theme or traditional notions of what constitutes dramatic art. Martin Kinch and Paul Thompson followed Garrard and initiated exciting collective creations such as *Doukhobors*, Carol Bolt's *Buffalo Jump* and *The Farm Show*. Controversies have been frequent, to wit, Rochelle Owens' *Futz* and *I Love You, Baby Blue*, the latter a Metro *dolce vita*. In 1979, the Thompson-Linda Griffiths creation *Maggie and Pierre* ran at the company's new space on Ryerson Avenue and reached off-Broadway and film. This company has not elicited the most sophisticated scripts in the world, but things have seldom been dull on stage. Layne Coleman is the current artistic director. **16 Ryerson Ave., Toronto**, ON, M5T 2P3. Phone: (416) 504•7529; Fax: (416) 504•8980; Internet: **http://www.passemuraille.on.ca**

Young People's Theatre, Toronto: Founded in 1966 by Susan Rubes, this company has been one of Canada's most successful theatre organizations of any kind. From the beginning the group received international recognition, and it has proved a solid training ground for young Canadian theatre professionals. Rubes and her 1980 successor, Peter Moss, employed major directorial and acting talent (Paul Thompson, John Hirsch, Robin Phillips, Eli Wallach, Eric Donkin) to enliven the presentations. The theatre's present space on Front Street seats 468. There is an adjunct space of 175 seats for smaller productions, and since 1983 the company has had a theatre school and playwrights-in-residence. The practice of mounting plays on controversial issues, while not forgetting the classics or the necessity of being entertaining, together with its quality productions, have made the company outstanding. Pierre Tetrault is the current artistic director. **165 Front St. E, Toronto, ON, M5A 3Z4**. Phone: (416) 862•2222; Fax: (416) 363•5136; Internet: **http://www.toronto. com/ypt**

PRINCE EDWARD ISLAND

Theatre Prince Edward Island, Charlottetown: A small company with a budget of under $100,000, Theatre PEI performs Canadian, classical and contemporary works. It also serves as a resource organization for theatre development in the province. The current artistic director is Robert Maclean. **PO Box 1573, Charlottetown, PE, C1A 7N3**. Phone: (902) 566•0321.

QUÉBEC

Carbone-14, Montréal: This company began as Les Enfants du Paradis in 1975. In 1980, it moved into its first permanent space and took its current name. The group is renowned for improvisation, mime and collective work. It has consciously forged links to such enduring theatrical styles as commedia dell'arte, music hall and acrobatics. Its early performances were most often in streets, parks and nightclubs— it was truly a *theatre passe muraille*. This tradition of energy and physical challenge has survived the company's transition into a permanent space and its acceptance by the establishment, both inside and outside Québec. Perhaps its most acclaimed production is *Le dortoir* (*The Dormitory*), which was also made into a film. Like many Québec companies, Carbone-14 features strong imagery, multimedia spectacle and sheer physicality, and this has influenced not only innovative theatrical creators like Robert Lepage, but dance companies and English-language theatre

groups with a flair for the offbeat. Gilles Maheu is the current artistic director. **1345, av. Lalonde, Montréal, QC, H2L 5A9**. Phone: **(514) 521•4198**.

Centaur Theatre, Montréal: Founded in 1969 as a non-profit corporation, the English-language Centaur is now located in the Old Stock Exchange Complex, which opened in 1975 and has two performing stages of 255 and 440 seats. These facilities underwent a $2.1-million facelift between 1995 and 1999. The season runs from October to June and features international drama as well as classic fare. Throughout most of its history, the theatre was guided by artistic director Maurice Podbrey, who originally hailed from South Africa. Centaur achieved especial success with the plays of the South African Athole Fugard, and among its 40 or 50 Canadian productions are the works of David Fennario, whose *Balconville* was premiered by this company in 1979, and Rick Salutin's *Les canadiens*, which originated there in 1977. Centaur has an enviable record of financial stability. **453, rue Saint-François-Xavier, Montréal, QC, H2Y 2T1**. Phone: **(514) 288•3161**; Fax: **(514) 288•8575**.

La compagnie Jean Duceppe, Montréal: Founded in 1973 by actor Jean Duceppe, this company has had a history of box office success achieved through its generally meticulous productions of comedies from Québec and elsewhere, contemporary British and American plays (Broadway hits and classics in French translation), and similarly well-chosen if unexperimental fare. It performs in the 900-seat Port Royal Theatre in the Place des Arts. The current artistic director is Michel Dumont. **1400, rue Saint-Urbain, Montréal, QC, H2X 2M5**. Phone: **(514) 842•8194**; Internet: **http://www.montrealmedia.qc.ca/duceppe**

Playwright's Workshop, Montréal: This company goes all the way back to 1963 when the Western Québec Division of the Dominion Drama Festival decided to create a group that specialized in the creation and shaping of new plays for performance. We take workshops for granted these days, but this company pioneered the idea in Canada. Bob White, Per Brask and Brian Richmond were important figures in the early development of the Playwright's Workshop and in the 1980s Rina Fraticelli, Michael Springate, Peter Smith and Svetlana Zylin extended its activities further. In the years to follow there was expansion of translation work, many new production techniques and the creation of various avenues of exchange among existing theatrical groups. Paula Danckert has been the artistic director since 1998. Location: **4324, boul. Saint-Laurent, 2nd Floor, Montréal, QC, H2W 1Z3**. Administration: **PO Box 604, Postal Station Place d'Armes, Montréal, QC, H2Y 3H8**. Phone: **(514) 843•3685**; Fax: **(514) 843•9384**.

Théâtre d'aujourd'hui, Montréal: This company focuses on creating and producing original Québecois theatrical work. Toward the end of the 1990s the troupe was moving toward improving its facilities as well as its outreach to the community at large. René Richard Cyr is the current artistic director. **3900, rue Saint-Denis, Montréal, QC, H2W 2M2**. Phone: **(514) 282•3900** (information and reservations); Internet: **http://www.emphase.com/tda**

Théâtre de quat'sous, Montréal: In recent years this theatre has specialized in staging translations of both American and English-Canadian plays. It has presented David Mamet's *Cryptogram* and virtually everything by the American writer Cynthia Lou Johnson. It has also introduced to Québec plays by anglophone Canadians Judith Thompson and Brad Fraser. Pierre Bernard is the current artistic director. **100, av. des Pins E, Montréal, QC, H2W 1N7**. Phone: **(514) 845•7277**.

Théâtre de l'île, Hull: This long-established French-language company produces new works by Québec writers as well as classic works such as the prize-winning André Rousseau adaptation of Edmund Rostand's *Cyrano de Bergerac*. Gilles Provost, founder and still artistic director, has a eye for the offbeat and effective, for example, Antonine Maillet's translation of Willy Russell's *Shirley Valentine*, and lesser-known but interesting works of Michel Tremblay. **1, rue Wellington, Hull, QC, J8X 2H3**. Phone: **(819) 595 • 7455**.

Théâtre du nouveau monde, Montréal: Eloi de Grandmont, Guy Hoffmann, George Groulx, Jean-Louis Roux and Jean Gascon founded this company in 1951. It has become the main serious establishment theatre in Québec, going through frequent shifts of focus, constantly trying out new endeavours but always finding ways to present powerful drama of many kinds and from many sources to its French-speaking audiences. Théâtre du nouveau monde's repertory has varied enormously over the years. Many distinguished Québec plays originated here—works by Claude Gavreau, Denise Boucher, Roch Carrier and Jacques Ferron. However, presentations have often included Molière classics (*Le malade imaginaire*, *L'école des femmes*) translations and adaptations of modern classics (by George Bernard Shaw, Bertolt Brecht, Tennessee Williams), and contemporary plays from all parts of the world. Théâtre du nouveau monde has never been static: a theatre school was opened in 1952; an English-language branch, which failed, in 1954; a summer theatre in 1963. Later a lunch theatre, Théâtre-Midi, was created, and lectures and newsletters were instituted in order to broaden the contacts of the company with the wider artistic community. Thanks to this intrinsic dynamism and confidence the company has toured successfully almost everywhere, carrying its Molière to Paris and London and visiting Moscow and New York with successful productions. In the mid-1980s a financial crisis forced the theatre to sell its plant and to assume tenancy in its own building, but a newly renovated theatre was opened in 1997. Lorraine Pintal is the current artistic director. **84, rue Sainte-Catherine O, Montréal, QC, H4C 2S7**. Phone: **(514) 866 • 8668**.

Théâtre du rideau vert, Montréal: Founded in 1948 by the actress Yvette Brind'amour, this company failed to survive an early attempt to expand its repertoire, closed, and then reopened in 1956. The next few years, with a strong emphasis on European French-language writers, saw both surprising failures (George Bernanos's *Dialogues des Carmelites*) and surprising successes (Henri Montherlant's *Reine morte*). The real contribution of this company, though, derives from its commitment to Canadian French-language playwrights such as Antonine Maillet, Michel Tremblay, Marie-Claire Blais, Marcel Dubé and Jean Barbeau, a commitment that began in the early 1960s. In 1965, the company took productions of Françoise Loranger and Shakespeare (in French translation) to Moscow and Paris. One might see this company's development as a barometer of the rising interest in Québec of native French-language drama, which has never precluded an acute awareness of what is happening in the international sphere. Typically the company has not felt compelled to take much note of parallel developments in English Canada. The current artistic director is Guillermo de Andrea. Antonine Maillet is the writer-administrator. **4664, rue Saint-Denis, Montréal, QC, H2J 2L3**. Phone: **(514) 844 • 179**3 (box office); **(514) 844 • 0267** (admin.); Internet: **http://scoopnet.ca/rideauvert/index.html**

Théâtre du trident, Québec City: This company began in 1970 and has never wavered in its policy of presenting an intelligent blend of Québecois and classic European and

American works. This is a regional theatre in the sense that its roots are very much in the local community, but its outstanding productions of the most important Québecois playwrights and its intelligent attention to the great works of the modern stage, together with its attentions to youth theatre, have carried its reputation everywhere in Canada. Roland Lepage, versatile teacher, playwright and the first French-Canadian winner of a Chalmers Award, was the company's artistic director for many years. Marie-Thérese Fortin is the current artistic director. **269, boul. René-Lévesque E, Québec City, QC, G1R 2B3**. Phone: **(418) 643•5873**; **(418) 643•8131**; Fax: **(418) 646•5451**.

Théâtre ex machina, Québec City: Robert Lepage, Canada's reigning theatrical genius, is the artistic force behind this company. His work is as likely to be found on the boards in Japan or England as in Québec or Ontario. His film *Nô*, shot in a couple of weeks with this company, was screened at the opening gala for the 1998 Montréal Film Festival. *Geometry of Miracles*, another Lepage marathon of theatrical wonders, intrigued audiences at the 1998 du Maurier World Stage Festival in Toronto. **103, rue Dalhousie, Québec City, QC, G1K 4B9**. Phone: **(418) 692•5323**; Fax: **(418) 692•2390**.

Théâtre le carrousel, Montréal: This long-flourishing children's theatre company was founded by Suzanne Lebeau and Gervais Gaudreault in 1975. It has toured nationally and internationally and has given more than 3,000 performances to a total audience of some 500,000 children and adults. **2017, rue Parthenais, Montréal, QC, H2K 3T1**. Phone: **(514) 529•6309**; Fax: **(514) 529•6952**.

SASKATCHEWAN

Globe Theatre, Regina: The company began modestly in 1966 but now features a mainstage season of six plays, performed in the 400-seat Globe Theatre, plus two annual satellite productions. The artistic director is Ruth Smillie. **1801 Scarth St., Regina, SK, S4P 2C9**. Phone: **(306) 525•6400**.

Persephone Theatre, Saskatoon: Founded in 1974, with Brian Richmond as first artistic director, the company has presented many seasons of repertory carefully balanced between classics, contemporary hits and Canadian premieres, with an overriding emphasis on regional talent. It found permanent space in 1983 in the former Westgate Alliance Church. A youth theatre was created in 1982. **2802 Rusholme Rd., Saskatoon, SK, S7L 0H2**. Phone: **(306) 384•2126** (admin.); **(306) 384•7727** (box office); Fax: **(306) 382•9144**.

25th Street Theatre, Saskatoon: An inventive and durable, mainly collective and populist theatre group, founded in 1971 by Andras Tahn and others. Actors Layne Coleman and Linda Griffiths originated with this company, which has been responsible for many Canadian premieres and currently produces the Saskatoon Fringe Festival, as well as an annual Women's Arts Festival. The artistic director is Sharon Baker. **616 – 10th St. E, Saskatoon, SK, S7H 0G9**. Phone: **(306) 664•2239**; Fax: **(306) 653•7701**; Internet: **http://interspin.com/25thstreet**

YUKON TERRITORY

Nakai Theatre Ensemble, Whitehorse: This company is devoted to producing work reflective of the Northern experience. It serves as a resource centre for playwrights, actors, producers and directors in the area. Nakai took Cristina Pekanik's *Cloudberry* to the 1997 San Francisco Fringe Festival. Michael Clark is the artistic director. **PO Box 5381, Whitehorse, YT, Y1A 4Z2**. Phone: **(867) 667•2646**.

Major Figures in the Recent History of Canadian Theatre

Hume Cronyn (1911 –): This gifted actor, director and writer, despite other international triumphs, kept his Canadian connections alive. He was born in London, Ontario, and some of his early work was with the Montréal Repertory Theatre. In the mid-1930s he began to make a name for himself on Broadway with major parts in plays such as *Three Men on a Horse* and *High Tor*. Alfred Hitchcock aficionados recall his performances in the master's *Shadow of a Doubt* and *Lifeboat*; he also wrote screenplays for two Hitchcock movies. Cronyn was nominated for an Academy Award for Best Supporting Actor for his performance in *The Seventh Cross* (1944). He appeared onstage and on the screen in partnership with his wife, Jessica Tandy, notably in Samuel Beckett's *Happy Days* (1972) and Ron Howard's *Cocoon* (1985). Cronyn, who played Shylock and Richard III at the Stratford Festival, was the first Canadian to be given the American National Medal of Arts. He has also been awarded the Order of Canada.

Jean Gascon (1921 – 88): Gascon was a distinguished and pioneering Québec theatre personality who bridged the bicultural gap and made his presence felt in English Canada. Born in Montréal, he trained in France, returning in 1951 to help found Montréal's Théâtre de nouveau monde. Gascon later became the first director of the National Theatre School of Canada and was artistic director of the Stratford Festival from 1968 to 1974. He was later head of theatre at the National Arts Centre in Ottawa. His many honours include the Molson Prize for lifetime artistic achievement.

Gratien Gélinas (1909 – 99): As playwright, actor, producer and director he was probably more responsible than anyone else for the rebirth of theatre in Québec. In 1937, Gélinas created the character Fridolin, whose radio antics and adventures summed up something quintessential about francophone Montréal. This character Gélinas developed further in subsequent annual theatrical revues, many semi-improvised and dubbed "Fridolinades," which between 1938 and 1946 provided an artful kind of vaudeville/revue medium for Québec theatre. In 1948, he created Tit-Coq, the lovable bastard, and this character became almost a Canadian folk hero. Gélinas himself later appeared at the Stratford Festival as an actor, founded a theatre company and created another important character, Bousile, a cynical servant to an opportunist Québec family. Gélinas served as chairperson of the Canadian Film Development Corporation from 1969 to 1978 and in 1986 was co-president of Groupe de travail sur le statut de l'artiste, a federal advisory group, working on behalf of artists.

William Glassco (1935 –): As artistic director of Tarragon Theatre in Toronto from 1971 to 1982, Bill Glassco was perhaps the central figure in the Toronto theatre of his era. He premiered many notable Canadian plays, including James Reaney's *The Donnellys Trilogy*, and works by David Freeman and David French, while promoting the work of Michel Tremblay in English Canada. In 1985, Glassco became director of the Canadian Stage Company (formerly called CentreStage), where he supervised many notable productions, and in 1988 he premiered George F. Walker's *Nothing Sacred*. At the end of the 1990s, Glassco was doing mostly freelance directing and by

preference working on more classic plays rather than new Canadian productions.

Martha Henry (1938 –): One of Canada's greatest actresses, a consummate director and winner of numerous awards, Henry was born in the United States, trained at Canada's National Theatre School, and made her Stratford Festival debut in 1962 as Miranda in *The Tempest.* She has since performed most of the major Shakespearean female roles at Stratford. Henry won a Genie in 1980 for her performance in the television series *The Newcomers,* and in 1984 for her performance in the film version of Timothy Findley's *The Wars.* She served as artistic director at London, Ontario's Grand Theatre from 1988 to 1995. At Stratford she excelled as Mary Tyrone in the 1994 – 95 production of *Long Day's Journey into Night.* In 1989, she received the Toronto Drama Bench Award for an Outstanding Contribution to Canadian Theatre. In 1990, she was made a companion in the Order of Canada, and in 1996, she was honoured with a Governor General's Performing Arts Awards.

John Hirsch (1930 – 89): This eminent artistic director, teacher and administrator saw the Stratford Festival through some of its worst days and was respected around the world. Born in Hungary, he came to Canada in 1947 and attended the University of Manitoba. He was involved in the founding of the Manitoba Theatre Centre. From 1967 to 1969 he was co-director of the Stratford Festival, and from 1974 to 1978 he headed television drama for the CBC. He returned to Stratford between 1981 and 1985. He also did productions for the National Arts Centre, the Shaw Festival and Toronto Arts Productions. Hirsch taught theatre at Yale University and the University of California. He won honours in the United States as well as Canada, notably the New York Drama Critics' Award for his translation and production of the Yiddish classic, *The Dybbuk.*

William Hutt (1920 –): Hutt, one of Canada's greatest actors, sums up in his career the best of Stratford's elegant and flexible tradition. Born in Toronto, he attended Trinity College and played at Hart House as an apprentice actor. Hutt moved into professional theatre in 1948 and went to Stratford in 1953, where he became a superstar and mainstay, performing innumerable major roles, including Hamlet, Macbeth, King Lear (in three different productions), Prospero, Falstaff, Titus Andronicus, Brutus, Timon of Athens and Richard II. In 1975, he undertook and brought off triumphantly the role of Lady Bracken in Oscar Wilde's *The Importance of Being Ernest.* He has toured extensively with the Stratford Company and has struck up a notable acting partnership with Martha Henry, most recently in the much-praised 1994 – 95 Stratford production of Eugene O'Neill's *Long Day's Journey into Night.* In 1992, Hutt was among those who received the first Governor General's Performing Arts Awards.

Robert Lepage (1957 –): Québec's new star, Lepage is already in demand around the world for his daring and imaginative theatre conceptions, which promise to influence all future theatre. Born in Québec City, Lepage enrolled in the local Conservatoire d'art dramatique at age 17, and joined that city's (now defunct) Théâtre Repère in 1982. He was co-writer and director of *La trilogie des dragons* in 1985 and of *Le polygraphe* in 1988. His one-man show, *Needles and Opium* (1991), extended his reputation. He has since worked around the world, in particular in Japan and England, and has recently directed the feature films *Nô,* *Le polygraphe* (from his own play) and *Le confessionnal,* which was shown at Cannes in 1995 and won a Genie as Best Picture. He is the founder and impresario of Théâtre ex machina in Québec City, which produced Lepage's thought-provoking theatre piece, *The Seven Streams of the River Ota.*

Mavor Moore (1919 –): James Mavor Moore, a pioneer of Canadian theatre as writer, actor, producer and director, was one of the Toronto elite who shaped so much of the artistic life of English Canada in the 1940s and 1950s. Moore was active and prominent both in CBC Radio and later in television. In the 1940s, he was connected with the New Play Society in Toronto, which was a milestone on the road to professional theatre in Canada. Moore as writer worked on the annual review *Spring Thaw* (beginning in 1948) and wrote the libretto for Harry Somers' *Riel*, the best Canadian opera. He chaired the Canada Council from 1979 to 1983, wrote his autobiography as well as regular columns for *The Globe and Mail*, and taught at York University. In 1996, he became the chairman of the first ever British Columbia Arts Council. Moore has won three Peabody Awards, was honoured with the Order of Canada in 1973 and with the prestigious Molson Prize in 1986.

John Neville (1925 –): Neville has given yeoman service to several of our major theatres both as actor and artistic director. Born in England, he began his career there and came to Canada in 1972. He was artistic director of Edmonton's Citadel Theatre from 1973 to 1978 and of Halifax's Neptune Theatre from 1978 to 1983. As an actor, his Stratford Festival debut was in *Love's Labour's Lost* in 1983. Neville was the artistic director of the Stratford Festival from 1985 to 1989 and helped restore the financial stability and artistic stature of the festival, although he also introduced several popular entertainment vehicles such as *My Fair Lady* to the Stratford stage.

Robin Phillips (1942 –): Phillips was born in England and did all his early training there, working in provincial theatre and on television. He was artistic director of the Stratford Festival from 1975 to 1980, an appointment that was attacked by Canadian ultranationalists. Yet Phillips's contribution to Canadian theatre has been outstanding. He supervised 35 productions at Stratford and created the Young Company there, and returned later as a very successful stage director (*The School for Scandal, Cymbeline*). He also worked in films (*The Wars*, 1981), and, after various stints abroad, launched Edmonton's Citadel Theatre's 25th season in 1989 with *The Crucible* and *A Midsummer Night's Dream*. He was artistic director at Citadel from 1990 to 1995, and in recent years he has worked in musical theatre. Phillips is an outstanding example of a foreign artist whose talent carried him beyond the reach of ultranationalist criticism. His continuing activity here has helped push Canadian theatre into a more cosmopolitan phase.

Christopher Plummer (1929 –): A distinguished performer at the Stratford Festival and a popular and versatile film actor, Plummer was born in Toronto, the great-grandson of Canadian prime minister Sir John Abbott. He began his career with the Montréal Repertory Theatre and made his professional debut in 1948 with Ottawa's Stage Society, performing more than 100 roles with its successor, the Canadian Repertory Theatre. American success followed and included starring roles in such plays as *J. B.* (1958), *The Resistible Rise of Arturo Ui* (1963) and *The Royal Hunt of the Sun* (1965), culminating with a Tony for his performance in the musical *Cyrano* (1973). Plummer performed impressively in England at Stratford and in London at the National Theatre, and at Canada's Stratford as Hamlet, Macbeth and Mark Antony, among other major roles. One of his best film roles was Sherlock Holmes in *Murder by Decree* (1969), for which he won a Genie, and as a psychotic criminal in *The Silent Partner* (1978), the best of the Canadian tax-shelter movies. But his most lucrative and famous film role, if one of his least convincing, was the irascible/lovable senior Von Trapp in *The Sound of Music* (1965). Plummer was made a Companion of the Order of Canada in 1968.

Kate Reid (1930 – 93): An English-born actress of huge range and accomplishment, Reid conquered audiences on both sides of the border, but remained active in Canada until her death. She grew up in Toronto, where she studied and performed as a young actor, then went on to roles in London, England, returning to Stratford in Canada in 1959. Reid was a most versatile actor and played many Shakespeare heroines, Clytemnestra, Big Momma in *Cat on a Hot Tin Roof*, and an infinite variety of other challenging roles. Playwrights of the calibre of Tennessee Williams, Arthur Miller and Edward Albee wrote for her and she received many major awards, including ACTRA and Dora Awards in 1980 and 1981, the Earle Grey Award in 1988, as well as the Order of Canada in 1974.

Paul Thompson (1940 –): As a distinguished director, teacher and administrator, Thompson represents as well as anyone the feisty spirit of Canadian alternative theatre. From 1971 to 1982 he was artistic director of Toronto's Theatre Passe Muraille and brought fresh energy to the Canadian scene, introducing nationally significant themes and collective creations. Some of his notable productions include *The Farm Show* (1972), *1837: The Farmers' Revolt* (1973), *Far As the Eye Can See* (1977) and *Maggie and Pierre* (1980). Thompson was director/general of the National Theatre School (NTS) in Montréal from 1987 to 1991, and he continued his innovations, setting up a director's program for both French and English theatre trainees. Later he directed new Canadian and Native Canadian plays at Centaur Theatre, Alberta Theatre Projects, the Blyth Festival, Native Earth Performing Arts in Toronto and the De-ba-jeh-mu-jig company on Manitoulin Island in Lake Huron.

Jessie Awards

THESE awards are named for professional theatre pioneer Jessie Richardson. They honour excellence in and raise awareness of professional theatre in Vancouver. The Jessies were established in 1983 by the Vancouver Professional Theatre Alliance, but prior to 1991 records are incomplete. Awards are presented in June for productions in the preceding year.

Outstanding Production of a Play or Musical

1998: small theatre – *Brilliant!* (The Electric Theatre Company); large theatre – *The Overcoat* (Vancouver Playhouse)
1997: small theatre – *The Anger in Ernest and Ernestine* (Arts Club Theatre); large theatre – *The Imaginary Invalid* (Arts Club Theatre)
1996: *The Orphan Muses* (Touchstone)
1995: *Oleanna* (Vancouver Playhouse/Belfry Theatre)

1994: *Lilies* (Arts Club, Pink Ink, Touchstone)
1993: *The Number 14* (Touchstone/Axis Mime)
1992: no award
1991: *The Road to Mecca* (Arts Club)

Outstanding Direction of a Play or Musical

1998: small theatre – Liesl Lafferty & Chris McGregor, *House*; large theatre – Wendy Gorling & Morris Panych, *The Overcoat*
1997: small theatre – Michael Schaldemose, *Kvetch*; large theatre – Morris Panych, *The Imaginary Invalid*
1996: Stephane Kirkland, *The Orphan Muses*
1995: Peter Hinton, *Scary Stories*
1994: Sandhano Schultze & Roy Surette, *Lilies*
1993: no award
1992: no award
1991: play – Jane Heyman, *The Road to Mecca*; musical – Larry Lillo, *Herringbone*

Sidney Risk Award for Outstanding Original Script

1998: Jenn Griffin, *Drinking with Persephone*
1997: Colin Heath, *For Art's Sake*
1996: Dorothy Dittrich, *When We Were Singing*
1995: Michael MacLennan, *Beat the Sunset*
1994: Linda Carson, *Dying to Be Thin*
1993: Katherine Schlemmer, *Iceberg Lettuce*
1992: Gordon Armstrong, *A Map of the Senses*

Outstanding Performance, Lead Actress

1998: small theatre – Sarah Rodgers, *The Two Character Play*; large theatre – Doris Chillcott, *Happy Days*
1997: small theatre – Paulina Gillis, *The Anger in Ernest and Ernestine*; large theatre – Nora McLellan, *Who's Afraid of Virginia Woolf?*
1996: Kelli Fox, *Keely and Du*
1995: Nicola Cavendish, *Four Dogs and a Bone*

1994: Tamsin Kelsey, *A Doll's House*
1993: no award
1992: no award
1991: Joy Coghill, *The Road to Mecca*

Outstanding Performance, Lead Actor

1998: small theatre – Mike Stack, *Alphonse*; large theatre – David Storch, *Picasso at the Lapin Agile*
1997: small theatre – Peter Anderson, *The Anger in Ernest and Ernestine*; large theatre – Tom McBeath, *Who's Afraid of Virginia Woolf?*
1996: Alan Williams, *Vigil*
1995: Shawn Macdonald, *Beat the Sunset*
1994: Allan Morgan, *Lilies*
1993: no award
1992: no award
1991: Jay Brazeau, *Other People's Money*

Outstanding Performance, Supporting Actress

1998: small theatre – Susan McFarlen, *Menopositive! The Musical*; large theatre – Nicole Robert, *The Game of Love and Chance*
1997: small theatre – Beatrice Zeilinger, *Patagonia*; large theatre – Lynda Boyd, *Poor Super Man*
1996: Patti Allan, *Three Tall Women*
1995: Leslie Jones, *Escape from Happiness*
1994: Nora McLellan, *Road*

Outstanding Performance, Supporting Actor

1998: small theatre – Hiro Kanagawa, *A View From the Bridge*; large theatre – Allan Zinyk, *Picasso at the Lapin Agile*

1997: small theatre – Shawn Macdonald, *The Pintauro Café*; large theatre – Alex Ferguson, *Sex in Heaven*
1996: David Lovgren, *Keely and Du*
1995: Allan Morgan, *Coyote Ugly*
1994: John Moffatt, *Lilies*

Outstanding Ensemble Cast

1998: *The Overcoat* and *Mojo*
1997: *The Pintauro Café* and *The Imaginary Invalid*
1996: *When We Were Singing*
1995: *Mom's the Word*
1994: *Road*
1993: *Beggars in the House of Plenty, The Number 14* and *All Grown Up*
1992: *Love and Anger*

Sam Payne Award for Outstanding Newcomer

1998: Peter Scoular
1997: Matthew Smith
1996: Kirsten Williamson

1995: Kirsten Robek
1994: Laura Sadiq
1993: Vincent Gale
1992: Columpa Bobb
1991: Nancy Bryant

Career Achievement Award

1998: Dennis Foon
1997: Micki Maunsell
1996: Bill Millerd
1995: Robert Clothier, Shirley Broderick
1994: John Brockington
1993: Larry Lillo
1992: Barney O'Sullivan
1991: Dennis Tupman

Patron of the Arts Service Award

1998: WaaZuBee Cafe and Subeez Cafe
1997: VanCity Credit Union
1996: Don Atkins
1995: Kenn Walker

Source: Vancouver Professional Theatre Alliance

Dora Awards

THE Dora Awards are named after Dora Mavor Moore, a teacher and director who helped establish professional theatre in Canada in the 1930s and 1940s. Administered by the Toronto Theatre Alliance, the *Doras* were first awarded in 1980. They honour excellence in professional theatre in Toronto and are presented annually for productions in the preceding year. The following list is only a partial one; listed are *Dora* winners through the 1990s.

1997–1998 SEASON

General Theatre Division

• Outstanding Production of a Play: *Patience*, Tarragon Theatre

• Outstanding Production of a Musical: *Oedipus Rex* with *Symphony of Psalms*, Canadian Opera Company
• Outstanding New Play: *Problem Child*, by George F. Walker

- Outstanding New Musical: *C'était un p'tit Bonheur,* by Guy Mignault and Felix Leclerc
- Outstanding Direction of a Musical: Francois Girard, *Oedipus Rex* with *Symphony of Psalms*
- Outstanding Direction of a Play: Ian Prinsloo, *Patience*
- Outstanding Performance by a Female in a Musical – Principal Role: Rebecca Caine, *The Cunning Little Vixen,* Judith Forst, *Oedipus Rex* with *Symphony of Psalms,* Julian Molnar, *The House of Martin Guerre*
- Outstanding Performance by a Male in a Musical – Principal Role: Roger Honeywell, *The House of Martin Guerre*
- Outstanding Performance by a Female in a Play – Principal Role: Kristen Thomson, *Problem Child*
- Outstanding Performance by a Male in a Play – Principal Role: Eric Peterson, *The Designated Mourner*
- Outstanding Performance in a Featured Role – Play or Musical: Sarah Orenstein, *Patience*

Independent Theatre Division

- Outstanding Production: *Valley Song,* New Globe Theatre
- Outstanding New Play or Musical: *Kicked,* by Michael Healey
- Outstanding Direction: Seanna McKenna, *Valley Song*
- Outstanding Performance by a Male: Les Carlson, *Valley Song*
- Outstanding Performance by a Female: Yanna McIntosh, *Valley Song*

1996–1997 SEASON

Large Theatre Division

- Outstanding New Play or Musical: *Ragtime,* by Lynn Ahrens, Stephen Flaherty, Terrence McNally
- Outstanding Production of a Play: *The Three Lives of Lucie Cabrol,* Harbourfront Centre, Théâtre de complicité
- Outstanding Production of a Musical: *Ragtime,* Livent Inc.
- Outstanding Direction: Frank Galati, *Ragtime*
- Outstanding Performance by a Male in a Play: John Dolan, *Oliver Twist; or The Street Boy's Progress*
- Outstanding Performance by a Female in a Play: Lilo Baur, *The Three Lives of Lucie Cabrol*
- Outstanding Performance by a Male in a Musical: Brian Stokes Mitchell, *Ragtime*
- Outstanding Performance by a Female in a Musical: Audra McDonald, *Ragtime*

Mid-Size Theatre Division

- Outstanding New Play, Musical or Revue: *Still The Night,* by Theresa Tova
- Outstanding Production of a Play: *The Soldier Dreams,* Canadian Stage Company, da camera
- Outstanding Production of a Musical or Revue: *Still The Night,* Tapestry Music Theatre, Theatre Passe Muraille, Tova Entertainment
- Outstanding Direction: Daniel Brooks, Daniel MacIvor, *The Soldier Dreams*
- Outstanding Performance by a Female in a Play: Frances Hyland, *2000*
- Outstanding Performance by a Male in a Play: Steve Cumyn, *Angels in America: Parts I & II*

- Outstanding Performance by a Female in a Musical or Revue: Liza Balkan, *Still The Night*
- Outstanding Performance by a Male in a Musical or Revue: Mark Christmann, *The Martha Stewart Projects*

Small Theatre Division

- Outstanding New Play or Musical: *Harlem Duet* by Djanet Sears
- Outstanding Production: *Harlem Duet*, Nightwood Theatre
- Outstanding Direction: Djanet Sears, *Harlem Duet*
- Outstanding Performance by a Female: Alison Sealy Smith, *Harlem Duet*
- Outstanding Performance by a Male: Randy Hughson, *Possible Worlds*

1995 – 1996 SEASON

Large Theatre Division

- Outstanding New Play or Musical: *The Glorious 12th* by Raymond Storey
- Outstanding Production of a Musical: *A Little Night Music*, Canadian Stage Company, Grand Theatre, London
- Outstanding Production of a Play: *The Seven Streams of the River Ota*, Harbourfront Centre, Ex Machina
- Outstanding Direction: Robert Lepage, *The Seven Streams of the River Ota*
- Outstanding Performance by a Female in a Play: Nicola Cavendish, *Later Life*
- Outstanding Performance by a Male in a Play: Heath Lamberts, *One For The Pot*
- Outstanding Performance by a Female in a Musical: Mary Ellen Mahoney, *A Little Night Music*
- Outstanding Performance by a Male in a Musical: Dan R.Chameroy, *Beauty and the Beast*

Mid-Size Theatre Division

- Outstanding New Play or Musical: *High Life,* by Lee MacDougall
- Outstanding Production of a Play: *2 Pianos, 4 Hands*, Tarragon Theatre, Talking Fingers Productions
- Outstanding Production of a Musical or Revue: *The Barber of Seville*, Theatre Columbus
- Outstanding Direction: Richard Rose, *Seven Lears*
- Outstanding Performance by a Female in a Musical or Revue: Paulina Gillis, *The Barber of Seville*
- Outstanding Performance by a Male in a Musical or Revue: Jay Turvey, *Falsettos*
- Outstanding Performance by a Female in a Play: Karen Robinson, *Riot*
- Outstanding Performance by a Male in a Play: Brent Carver, *High Life*

Small Theatre Division

- Outstanding New Play: *Only Drunks and Children Tell The Truth*, by Drew Hayden Taylor
- Outstanding Production: *The Cold War*, VideoCabaret
- Outstanding Direction: *The Cold War*, Michael Hollingsworth
- Outstanding Performance by a Male: Bryan James, *Stockholm(e)*
- Outstanding Performance by a Female: Allegra Fulton, *Frida K*

1994 – 1995 SEASON

Large Theatre Division

- Outstanding New Play or Musical: *Molly Wood*, by John Wimbs, Christopher Richards
- Outstanding Production of a Play: *Molly Wood*, Lovers & Madmen
- Outstanding Production of a Musical: *Tommy*, David & Ed Mirvish, Concert Productions Int., Pace Theatrical Group, Dodger Productions
- Outstanding Direction: Des McAnuff, *Tommy*
- Outstanding Performance by a Male in a Play: Nigel Shawn Williams, *Six Degrees of Separation*
- Outstanding Performance by a Female in a Play: Fiona Reid, *Six Degrees of Separation*
- Outstanding Performance by a Male in a Musical: Tyley Ross, *Tommy*
- Outstanding Performance by a Female in a Musical: Kathy Michael McGlynn, *Into The Woods*

Mid-Size Theatre Division

- Outstanding New Play or Musical: *Poor Super Man*, by Brad Fraser
- Outstanding Production of a Play: *Poor Super Man*, Canadian Stage Company, Manitoba Theatre Centre
- Outstanding Production of a Musical or Revue: *Assassins*, Eclectic Theatre, Grassy Knoll Productions
- Outstanding Direction: Derek Goldby, *Poor Super Man*
- Outstanding Performance by a Female in a Play: Nancy Beatty, *The Faraway Nearby*
- Outstanding Performance by a Male in a Play: Chris Peterson, *Poor Super Man*
- Outstanding Performance by a Female in a Musical or Revue: Paulina Gillis, *Assassins*
- Outstanding Performance by a Male in a Musical or Revue: Richard McMillan, *Assassins*

Small Theatre Division

- Outstanding New Play: *Lebensborn*, by Sabina Fella
- Outstanding Production: *Oedipus*, *Die in Debt*, Nightwood Theatre
- Outstanding Direction: Josephine Le Grice, *The Conquest of the South Pole*
- Outstanding Performance by a Female: Martha Ross, *The Attic, The Pearls,* and *3 Fine Girls*
- Outstanding Performance by a Male: David Jansen, *The Conquest of the South Pole*

1993 – 1994 SEASON

Large Theatre Division

- Outstanding New Play or Musical: *The House of Martin Guerre*, by Leslie Arden
- Outstanding Production of a Play: *Homeward Bound*, Canadian Stage Company
- Outstanding Production of a Musical: *Crazy For You*, David & Ed Mirvish, Roger Horchow and Elizabeth Williams
- Outstanding Direction: Mike Ockrent, *Crazy For You*
- Outstanding Performance by a Female in a Play: Brenda Robins, *Dancing at Lughnasa*
- Outstanding Performance by a Male in a Play: Tom McCamus, *Abundance*
- Outstanding Performance by a Female in a Musical: Louise Pitre, *Piaf*
- Outstanding Performance by a Male in a Musical: Kevin Gray, *Miss Saigon*

Mid-Size Theatre Division

- Outstanding New Play or Musical: *Come Good Rain*, by George Bwanika Seremba

- Outstanding Production of a Play or Musical: *Death and the Maiden*, Canadian Stage Company and Manitoba Theatre Centre
- Outstanding Direction: Ken McDougall, *Never Swim Alone*
- Outstanding Performance by a Male in a Play or Musical: Robert Haley, *Death and the Maiden*
- Outstanding Performance by a Female in a Play or Musical: Patricia Collins, *White Biting Dog*

Small Theatre Division

- Outstanding New Play: *The Death of the King*, adapted and translated by Soheil Parsa and Peter Farbridge
- Outstanding Production: *The Last Supper*, DNA Theatre in association with Platform 9 and Theatre Passe Muraille
- Outstanding Direction: Hillar Liitoja, *The Last Supper*
- Outstanding Performance by a Male, Ken McDougall, *The Last Supper*
- Outstanding Performance by a Female: Karen Hines, *Oh, Baby!*

1992 – 1993 SEASON

Large Theatre Division

- Outstanding New Play or Musical: *Kiss of the Spiderwoman – The Musical*, by Terrence McNally, John Kander and Fred Ebb
- Outstanding Production of a Musical: *Kiss of the Spiderwoman – The Musical*, Livent Inc.
- Outstanding Production of a Play: *Whale*, Young People's Theatre
- Outstanding Direction: Harold Prince, *Kiss of the Spiderwoman – The Musical*
- Outstanding Performance by a Female in a Play: Fiona Reid, *Fallen Angels*

- Outstanding Performance by a Male in a Play: Hardee Lineham, *Richard III*
- Outstanding Performance by a Female in a Musical: Kate Hennig, *Ratbag*
- Outstanding Performance by a Male in a Musical: Brent Carver, *Kiss of the Spiderwoman – The Musical*

Mid-Size Theatre Division

- Outstanding New Play or Musical: *Bob's Kingdom*, by Neil Munro
- Outstanding Production of a Musical: *Forever Plaid*, Follows Latimer Productions Inc.
- Outstanding Production of a Play: *The Stone Angel*, Theatre Passe Muraille
- Outstanding Direction: Maureen White, *The Stone Angel*
- Outstanding Performance by a Female in a Play: Anne Anglin, *The Stone Angel*
- Outstanding Performance by a Male in a Play: Richard McMillan, *The Stone Angel*
- Outstanding Performance by a Male in a Musical: Neil Bartram, Paul Castree, John Devorski, Brian Hill, *Forever Plaid*
- Outstanding Performance by a Female in a Musical: Shari Saunders, *Nigredo Hotel*

Small Theatre Division

- Outstanding New Play: *The Great War*, by Michael Hollingsworth
- Outstanding Production: *The Life and Times of Mackenzie King*, produced by VideoCabaret
- Outstanding Direction: Daniel Brooks, Daniel MacIvor, *The Lorca Play*; Jan Komarek, *Dance of the Blue Harlequins*
- Outstanding Performance by a Female: The Company (Valerie Buhagiar, Caroline Gillis, Paulette Phillips, Ali Riley, Nadia Ross, Maria Vacratsis, Tracy Wright), *The Lorca Play*

- Outstanding Performance by a Male: Guillermo Verdecchia, *Fronteras americanas*

1991–1992 SEASON

Drama/Comedy Division

- Outstanding New Play: *Escape From Happiness*, by George F. Walker
- Outstanding Production: *Three Sisters*, produced by Equity Showcase Theatre, The Banff Centre for the Arts
- Outstanding Direction: Neil Munro, *Hamlet*
- Outstanding Performance by a Female in a Leading Role: Nicola Cavendish, *Shirley Valentine*
- Outstanding Performance by a Male in a Leading Role: Rod Beattie, *The Wingfield Trilogy*
- Outstanding Performance by a Female in a Featured Role: Donna Goodhand, *A Woman's Comedy*
- Outstanding Performance by a Male in a Featured Role: Robert Haley, *Singer*

Revue/Musical Division

- Outstanding New Revue or Musical: *Shopping Off to Buffalo* and *Ontario: Yours To Recover*, by Christopher Earle, Kathryn Greenwood, Nick Johne, Jenny Parsons, Ed Sahely, Judith Scott, Brian Smith
- Outstanding Production: *Closer Than Ever*, produced by Jeffrey Latimer in association with Laurence Follows and Closer Than Ever Partners
- Outstanding Direction: Jennifer Stein, *Knights of the Endless Day*
- Outstanding Music Direction: David Warrack, *Closer Than Ever*
- Outstanding Performance by a Female: Norma Dell'Agnese, *God Almighty's Second-Class Saloon: A Brecht Weill Cabaret*

- Outstanding Performance by a Male: Richard Greenblatt, *God Almighty's Second-Class Saloon: A Brecht Weill Cabaret*

1990–1991 SEASON

Drama/Comedy Division

- Outstanding New Play: *Lilies*, by Michel Marc Bouchard, translated by Linda Gaboriau
- Outstanding Production: *Lilies*, produced by Theatre Passe Muraille
- Outstanding Direction: Richard Monette, *Saint Joan*
- Outstanding Performance by a Male in a Leading Role: Jim Mezon, *Burn This*
- Outstanding Performance by a Female in a Leading Role: Seana McKenna, *Saint Joan*
- Outstanding Performance by a Male in a Featured Role: Stephen Ouimette, *7 Stories*
- Outstanding Performance by a Female in a Featured Role: Nancy Beatty, *7 Stories*

Revue/Musical Division

- Outstanding New Revue or Musical: *That Scatterbrain Bookie*, by Joey Miller
- Outstanding Production: *Hush*, produced by Theatre Passe Muraille
- Outstanding Direction: Peter Moss, *That Scatterbrain Bookie*
- Outstanding Musical Direction: Allen Cole, *Hush*
- Outstanding Choreography: William Orlowski, *That Scatterbrain Bookie*
- Outstanding Performance by a Female: Maria Vacratsis, *2nd Nature*
- Outstanding Performance by a Male: Gordon Pinsent, *Anne of Green Gables*

1989 – 1990 SEASON

Drama/Comedy Division

- Outstanding New Play: *Love and Anger*, by George F. Walker
- Outstanding Production: *Love and Anger*, produced by Factory Theatre
- Outstanding Direction: JoAnn McIntyre, *The Collected Works of Billy the Kid*
- Outstanding Performance by a Female in a Leading Role: Nancy Beatty, *Love and Anger*
- Outstanding Performance by a Male in a Leading Role: Stuart Hughes, *The Collected Works of Billy the Kid*
- Outstanding Performance by a Female in a Featured Role: Patricia Collins, *The Europeans*
- Outstanding Performance by a Male in a Featured Role: Julian Richings, *Coming Through Slaughter*

Revue/Musical Division

- Outstanding New Revue or Musical: *Rigoletto*, by Michael Hollingsworth, Don Horsburgh, Deanne Taylor
- Outstanding Production: *The Phantom Of The Opera*, produced by Livent Inc., Tina VanderHeyden, Really Useful Theatre Company Canada
- Outstanding Direction: Harold Prince, *The Phantom Of The Opera*
- Outstanding Musical Direction: Don Horsburgh, *Rigoletto*
- Outstanding Choreography: Juan Carlos Copes, *A Rose For Mr. Tango*
- Outstanding Performance by a Female: Charlotte Moore, *The Rocky Horror Show*
- Outstanding Performance by a Male: Colin Wilkinson, *The Phantom Of The Opera*

Floyd S. Chalmers Canadian Play Awards

FIRST awarded in 1973, the Floyd S. Chalmers Canadian Play Awards are given to Canadian plays produced in Metropolitan Toronto by any professional Canadian theatre company. These awards are funded by an endowment from the Chalmers family, held in trust by the Ontario Arts Council Foundation. To be eligible, the play must have been open to the general public and must have had at least 10 performances in Metropolitan Toronto. In 1983, plays for children became eligible for separate awards. The jury is made up of members of the Canadian Theatre Critics Association and the Toronto theatre community. The award is worth $40,000, with four winners receiving $10,000 each.

1999
- Michel Marc Bouchard, *The Orphan Muses*
- Leah Cherniak, Oliver Dennis, Maggie Huculak, Robert Morgan, Martha Ross, Michael Simpson, *The Betrayal*
- Jason Sherman, *Patience*
- George F. Walker, *The End of Civilization*

1998
- George F. Walker, *Problem Child*
- Djanet Sears, *Harlem Duet*
- Carole Frechette, *The Four Lives of Marie*
- David Rubinoff, *Stuck*

1997

- Don Druick, *Where is Kabuki?*
- Ted Dykstra & Richard Greenbolt, *2 Pianos, 4 Hands*
- Daniel MacIvor & Daniel Brooks, *Here Lies Henry*
- Guillermo Verdecchia & Marcus Youssef, *A Line in the Sand*

1996

- Timothy Findley, *The Stillborn Lover*
- Brad Fraser, *Poor Super Man*
- Andrew Moodie, *Riot*
- John Murrell, *The Faraway Nearby*

1995

- Robert Lepage, *Needles and Opium*
- Geoff Kavanagh, *Ditch*
- Ken Garnhum, *Pants on Fire*
- Diane Cave & Nadia Ross, *The Alistair Trilogy*

1994

- Michael Hollingsworth, *The Life and Times of Mackenzie King*
- Hillar Liitoja, *The Last Supper*
- Alisa Palmer, *A Play About The Mothers of Plaza do Mayo*
- Guillermo Verdecchia, *Fronteras americanas*

1993

- Normand Chaurette & Linda Gaboriau (Trans.), *The Queens*
- Joan MacLeod, *The Hope Slide*
- Jason Sherman, *The League of Nathans*
- George F. Walker, *Escape from Happiness*

1992

- Michel Marc Bouchard & Linda Gaboriau (Trans.), *Lilies*
- Daniel Brooks & Guillermo Verdecchia, *The Noam Chomsky Lectures*
- Daniel MacIvor, *House*
- John Mighton, *A Short History of Night*

1991

- Marie Brassard & Robert Lepage, *Polygraphe*
- Brad Fraser, *Unidentified Human Remains and the True Nature of Love*
- Judith Thompson, *Lion in the Streets*
- Michel Tremblay, *La maison suspendue*

1990

- Sally Clark, *Moo*
- Tomson Highway, *Dry Lips Oughta Move to Kapuskasing*
- John Krizanc, *The Half of It*
- George F. Walker, *Love and Anger*

1989

- Paul Ledoux & David Young, *Fire*
- Ann-Marie MacDonald, *Goodnight Desdemona, Good Morning Juliet*
- Michel Tremblay, *Le vrai monde?*
- George F. Walker, *Nothing Sacred*

1988

- Tom Wood, *B Movie, The Play*
- Robert Fothergill, *Detaining Mr. Trotsky*
- Judith Thompson, *I Am Yours*
- Ralph Burdman, *Tête-à-Tête*

1987

- John Murrell, *Farther West*
- Linda Griffiths, *Jessica*
- Don Hannah, *The Wedding Script*
- Tomson Highway, *The Rez Sisters*

1986

- Michel Tremblay, *Albertine, in Five Times*
- Michael Hollingsworth, *History of the Village of Small Huts: New France*
- Michael Mercer, *Goodnight Disgrace*
- Allan Stratton, *Papers*

1985

- George F. Walker, *Criminals in Love*
- David French, *Salt Water Moon*
- John Krizanc, *Prague*
- Sharon Pollock, *Doc*

1984
- Sherman Snukal, *Talking Dirty*
- Claude Meunier, *Brew*
- Jean-Pierre Plante, Francine Ruel, Louis Sala, Michel Coté, Marcel Gauthier, Marc Messier, Betty Lambert, *Jennie's Story*
- Margaret Hollingsworth, *Ever Loving*

1983
- Anne Chislett, *Quiet in the Land*
- John & Joe Lazarus, *Dreaming and Duelling*
- Tom Walmsley, *White Boys*

1982
- Allan Stratton, *Rexy!*
- Charles Tidler, *Straight Ahead/Blind Dancers*
- George F. Walker, *Theatre of the Film Noir*

1981
- Erika Ritter, *Automatic Pilot*
- Neil Munro, *F C U*
- George Luscombe, Mac Reynolds, Larry Cox, *Mac Paps*
- John Craig, George Luscombe, *Ain't Lookin'*

1980
- David Fennario, *Balconville*
- David French, *Jitters*
- John Gray, *Billy Bishop*
- Antonine Maillet, *La Sagouine*
- John Murrell, *Waiting for the Parade*

1979
- Roland Lepage, *Le temps d'une vie*

1978
- Rick Salutin, *Les canadiens*

1977
- W. O. Mitchell, *Back to Beulah*
- Larry Fineburg, *Eve*

1976
- John Herbert, *Fortune and Men's Eyes*

1975
- James Reaney, *Saint Nicholas Hotel*

1974
- David French, *Of the Fields, Lately*

1973
- David Freeman, *Creeps*

Children's Play Awards

1999
- David S. Craig & Robert Morgan, *Dib and Dob and the Journey Home*
- Robert Morgan, *The General*

1998
- Ronnie Burkett, *Old Friends*
- Robert Priest, *Minibugs & Microchips*

1997
- David S. Craig, *Napalm the Magnificent*
- Ron Reed, *Book of the Dragon*

1996
- Anne Chislett, *Flippin' In*
- Rex Deverell, *Belonging*

1995
- Joan MacLeod, *Little Sister*
- Dennis Foon, *The Short Tree and The Bird That Could Not Sing*

1994
- Maristella Roca, *Pinocchio*
- Kathleen McDonnell, *Loon Boy*
- Edward Roy, *A Secret Life*

1993
- Michael Miller, *Birds of a Feather*
- Shirley Barrie, *Carrying the Calf*
- Paula Wing, *Naomi's Road*

1992
- Drew Hayden Taylor, *Toronto at Dreamer's Rock*
- Maristella Roca, *The Servant of Two Masters*
- Colin Thomas, *Flesh and Blood*

1991
- Martha Brooks, *Andrew's Tree*
- Colin Thomas, *Two Weeks Twice A Year*

1990
- The Great Unwashed Fish Collective, *i.d.*
- Jim Betts, *The Groundworld Adventure*
- Shirley Barrie, *Straight Stitching*

1989
- Carol Bolt, *Ice Time*
- Marvin Ishmael, *Forever Free*

1988
- Beverley Cooper & Banuta Rubess, *Thin Ice*
- Frank Etherington, *The Snake Lady*
- Robert Morgan, *Not As Hard as it Seems*

1987
- Dennis Foon, *Skin*

- Robert Morgan & David Craig, *Morgan's Journey*

1986
- Suzanne Lebeau, *Little Victories/Les petits pouvoirs*
- Duncan McGregor, *Running the Gauntlet*
- John Lazarus, *Not So Dumb*
- Paul Shilton & Jim Biros, *The Fabulous Farming Show*

1985
- Colin Thomas, *One Thousand Cranes*
- Robert Bellefeuille & Isabel Cauchy, *Les nez*

1984
- Jim Betts, *Mystery of the Oak Island Treasure*
- Anne Dansereau, *Une histoire a dormir debout*
- Joel Greenberg, *The Nuclear Power Show*

1983
- Marcel Sabourin, *Pleurer pour rire*

Source: Ontario Arts Council

The Governor General's Awards for Drama

FOR a complete list of recipients of the *Governor General's Literary Awards*, including awards for drama, see page 180.

2
Music

THE music scene in Canada is rich and various. Whatever the taste of the listener, there is much of quality to hear in concert and on the radio; rock videos play continuously on television; classical music, too, is televised; while festivals, ranging from the modest to the spectacular, featuring jazz, folk, popular and classical music are presented from coast to coast. At the same time, CDs that feature Canadian artists and music continue to appear, both from the multinational labels and from smaller Canadian companies. Canadian name talent in popular and classical music has probably never been more prominent on the world scene, while the depth and range of music making across the country is solid and impressive.

In recent decades Canada has been a particularly striking, and perhaps unexpected, source of popular music. Since the 1950s, when Ottawa singer Paul Anka broke into the American market, this country has produced one major talent after another. Gordon Lightfoot, Joni Mitchell, Neil Young, The Band, Bryan Adams and k.d. lang have all had their moments atop the charts and have enjoyed successful concert tours. Yet when (in 1999) *The Globe and Mail* offered a "diva comparison" using four world-class acts, namely Céline Dion, Sarah McLachlan, Shania Twain and Alanis Morissette, all of them Canadian, it was clear that we had entered an even richer era for homegrown pop talent.

Given its incredibly varied output of pop music and the existence of marketing instruments and media of unparalleled potency, the nearby American presence might be expected to affect Canada in a daunting way. In fact, Canadian artists and promoters have often used the American structures to reach audiences unthinkable in a merely national context, while others have established a Canadian identity by playing against the system. Which strategy is preferable? That depends upon whether one puts the emphasis on success and the financial benefits that flow from it, or on the content of the art and its power to express something specifically Canadian. Shania Twain, who grew up in Timmins, Ontario, lives mostly in the United States and Europe and records

From bubble-gum teenage princess to international mega-star angry woman, the story of Alanis Morissette's incredible worldwide success is already legend.

Singer, songwriter and mastermind behind the Lilith Fair summer music festival, Sarah McLachlan has found an international audience with her honest, heartfelt songs.

Maclean's / Phil Snel

Crystal Heald

Shania Twain has become an international pop music phenomenon, reaching listeners beyond just country music audiences.

CBC Television

in Nashville. She sings with a twang, benefits from big production values and in her traversal of the good old country themes seldom betrays much more than 10 seconds worth of Canadian identity. The Tragically Hip, from Kingston, Ontario, on the other hand, express a great deal of Canadian consciousness in their very popular albums, but are hardly known in the United States. Luckily, there are no rules about these things; Canadian artists still have sufficient freedom to follow whatever path suits them. On the other hand, we should not delude ourselves into thinking that success in the American market—when it is achieved by taking on an American identity— is necessarily a gain for Canadian culture.

In fact, Canadian musicians might be forgiven for seeing the above situation as a potentially creative one, framed not so much in terms of "should I sell out?" (which is loading the question), but rather as "how do I want to develop my talent? What audiences do I want to reach?" The profitable side of the double option is made possible by the Canadian Radio-television and Telecommunications Commission's famous (or, to some, infamous) 1970 decree legislating Canadian content for commercial radio stations, a decree requiring that at least 30 percent of music each station broadcasts weekly must have our national stamp on it. The formula states that of the music, artists, production and lyrics, two out of four categories must be Canadian. (In 1998, the quota was raised to 35 percent and other conditions were added.) Some argue that, despite the awkward parameters, this was one of the most successful government interventions in culture ever achieved in Canada, simply because it created a strong home music market and eventually made the pop artist's choice—whether to go or stay—far less egregious. For the first time Canadian recording companies were able to survive (although they still only account for about 10 percent of total record sales), and artists could remain in Canada and build up their careers, with a reasonable expectation that success in the international market would follow. This has been the path of Anne Murray, The Guess Who, Bryan Adams, the Crash Test Dummies, k.d. lang, Céline Dion, Sarah McLachlan, Alanis Morissette and many others. At the same time, even if huge international stardom does not materialize, Canadians are now able to sell sufficiently within our own borders to mount sizable careers.

Once Canadian talent emerged, and Canadian content had been established as a positive musical value and not as a mere cultural necessity, other milestones were achieved. The creation of the MuchMusic television empire, for example, which over the years has tapped into the increasingly rich and diverse Canadian scene, has helped to give our musicians a global profile.

Despite these benefits, there has been much criticism of the "content regulation" system and suggestions that new technologies will eventually make it impossible to enforce. As much or more could be achieved, it is suggested, by a "shelf space" system that reserves a certain proportion of the total broadcasting time for Canadian content—which would be highly subsidized—without restricting individual broadcasters to quotas. Under such a system, some stations might have 100 percent Canadian music content, others only five or 10 percent. This would not matter so long as Canadian music occupied a specified number of hours of *total* weekly broadcast time. At the same time, the definition of Canadian content would be broadened and would be based not on ownership and location but on other factors, such as whether the interpreters, audience, setting and values expressed were Canadian.

For classical musicians and organizations (whose appeal is to less than five percent of the listening public), the situation is clearly quite different. One of the big issues for them in recent years has been contention over the salaries of Canadian orchestra players, who are paid much less than their American counterparts. Cutbacks in grants and in some cases a shrinking list of subscribers has worked against higher compensation for these musicians. As a result, player strikes by the Montréal and Toronto symphonies and, in the case of the National Arts Centre Orchestra, long-drawn-out and embittered contract negotiations have bedevilled their recent seasons, and although the Vancouver Symphony Orchestra has avoided such disruptions, its musicians receive lower salaries than any of the other three. As a result of such problems, some distinguished desk players in Canadian symphony orchestras, touring—trombone player Peter Sullivan and horn player John Zirbel from the Montréal Symphony, among others—have been lured south. More significantly, there have been interrupted seasons, threatened shut-downs and settlements that have in some cases inflated organizational debts to alarming levels.

Such conditions have naturally limited touring, while potentially lucrative recording contracts have proved very hard to get. Yet for Canadian orchestras, touring—especially foreign touring—is an important quality test. Success at Carnegie Hall or Lincoln Center, kudos in London, Berlin or Vienna are not only satisfying in themselves but are likely to make public funding sources at home more generous. The Montréal Symphony annually visits Carnegie Hall, and although the Toronto Symphony's 1999 European tour was cancelled due to lack of sponsorship, the National Arts Centre Orchestra still has plans for an extensive North American tour in 2000.

As for recording, it is true that Canadian classical music ensembles, with the notable exceptions of the Montréal Symphony and Tafelmusik Baroque Orchestra, have had some difficulty getting contracts with the international recording giants, yet several once-famous American orchestras have had similar problems! Here the competition of lower-priced but excellent European ensembles, which are making many recordings for budget labels such as Naxos, has proved daunting. Yet thanks to companies such as CBC Records, Analekta Records of Montréal and to the efforts of individual entrepreneurs in Canada, Canadian classical music *is* appearing regularly on CD.

Most Canadian classical music presenters would probably argue that the key issues of today have little to do with the needs of nationalistic self-expression. Our symphony orchestras, opera companies and other ensembles face almost exactly the same problems as their American counterparts. The chief of these seem to be, first, staying solvent in the face of huge expenses and, second, attracting new audiences and keeping them, without either vulgarizing programs or giving up completely on new music.

In recent years, Canadian organizations have energetically sought private-sector sponsors for individual performances. They have learned that corporations have little fear of putting funds into traditional classical music, as opposed to the perceived risk to the company image in supporting, for example, a controversial play. Cutbacks in Canada Council funding, and the present obsession with avoiding elitism at all costs, have led the presenters of the classics to strive after a balance between perceived quality and demographic outreach.

Pop music, jazz and significant non-musical talent are being imported into the concert halls. In the early 1990s, the Canadian Opera Company commissioned an opera libretto from famed novelist Robertson Davies. More recently, film directors such as Atom Egoyan and theatre stars such as Robert Lepage and Christopher Plummer have also been called upon to work in opera. Anything to dress up old productions and to sell new ones to a younger generation that likes its culture chic. Programs that include traditional opera, baroque, all-Beethoven subscription series and evenings with Mahler or Shostakovich are also maintained, not only because they too can draw audiences if they are wellmarketed, but because the whole mission of classical music, its unique stamp of quality, would be lost without them.

In recent years, following the example of theatre, film and popular music, the presenters of classical music have learned how well the festival concept works to overcome seemingly impossible marketing limitations. The Winnipeg Symphony with

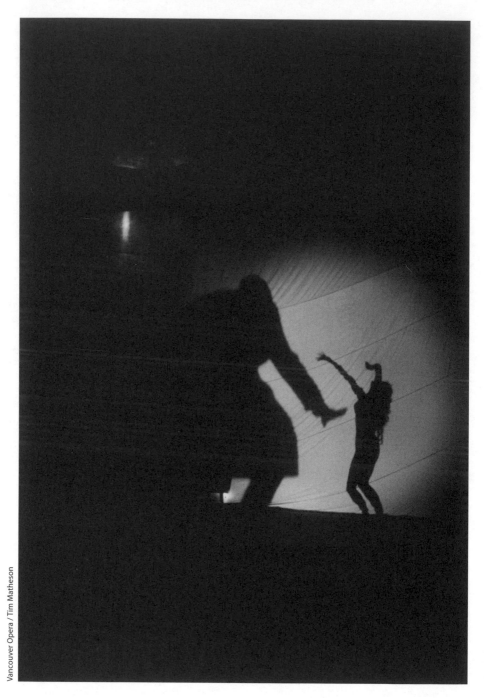

Atom Egoyan brought his cinematic flare to the opera house for his production of Richard Strauss's Salome.

Bramwell Tovey presiding over its New Music Festival has achieved the symphonic equivalent of a fringe-theatre soiree, and has seen attendance records go through the roof. And similar gatherings of the classical clan have worked quite well in various settings: at the Lanaudière Summer Festival in Québec, the Toronto New Music Festival, the Ottawa Chamber Music and Strings of the Future Festivals, the Festival of the Sound at Parry, Ontario, and the Scotia Festival of Music in Halifax, among others.

For classical music organizations, the bottom line contains a single word: "survival." It appears that the 1980 – 90s funding crisis in the arts that finished off the Hamilton Philharmonic and brought a few other, of our major classical music ensembles close to bankruptcy may have sounded a useful alarm bell, awakening the complacent and decreeing that, if our symphony orchestras and opera companies wished to achieve permanent financial stability, public-sector funding could not be the only answer. The Vancouver Symphony was rescued from oblivion by a striking effort on the part of local politicians and businessmen. But the shock of its near collapse in 1988, similar to the Toronto Symphony's recent brush with disaster, suggested the necessity not only to balance the books but to market more imaginatively what is, after all, a minority taste. The $900,000 debt of Symphony Nova Scotia was cut in a single year by a Herculean effort launched by management in cooperation with the orchestra and interim conductor Raffi Armenian; it could not have been accomplished by government bailout alone. Leslie Dunner, who took over the orchestra thereafter, made sure to mesh his programs with popular taste, as did Vancouver's resident conductor Clyde Mitchell.

Both the Montréal Symphony and the National Arts Centre orchestras survived rather severe player strikes in the late 1990s and continue under dynamic conductors, Charles Dutoit and Pinchas Zukerman. But a closer look at the foundations of these organizations reveals some shaky underpinnings: in Montréal, dwindling subscribers and mounting debt; in Ottawa, almost total dependency on government

As music director of the National Arts Centre Orchestra in Ottawa, Pinchas Zukerman is both a magnetic conductor and a stunning solo violinist.

funding and a management structure at the National Arts Centre that—at least until the appointment of Peter Herrndorf as CEO in 1999—seemed in almost total disarray (see chapter eight).

Of the three major Canadian opera companies, the Opéra de Montréal has in recent years seemed the most financially secure, although probably at the price of innovation and stage excitement. The Canadian Opera Company, with good artistic leadership, excellent marketing strategies and the prospect at last of a new performing centre, seemed nonetheless a little nervous about dwindling government support, while Vancouver was a virtual disaster area, although the arrival of James Wright, the new general director, may bode well for the beginning of the new millennium.

The lesson that might be drawn from two decades of shocks and change in our classical music scene is that no funding sources can be relied upon absolutely. Government cutbacks have displayed the unreliability of public-sector funding, and proposed government legislation has threatened to undermine the lucrative game of tobacco company sponsorship, parleyed into big success in Winnipeg. There is no substitute for building a grassroots audience.

We are told by the demographics experts that we can expect more positive commitment to classical music, opera and the other "high" arts just because our population is aging. It is not only the "Three Tenors" who have made opera popular, these experts say, it is the fact that the baby-boomers have reached an age where they can begin to enjoy the more rarefied atmosphere of the opera stage and the concert hall. But the experience of today's younger generation has been shaped by popular music. They find the deepest expression of their emotional life in hard rock, country, Celtic folk and even in rap. Are we to believe that at fortysomething they will start preferring Beethoven and Mozart, Verdi and Strauss to the familiar forms they have grown up with?

CD companies are already having to deal with changes of taste only partially related to demographics. Young people are buying fewer CDs because they can download music from the Web. Older women are buying more because some of the best popular artists of the day are women who produce songs that speak to them directly. Unless we change the way we educate young people about "serious" culture, or find new ways to improve access to it for those with no inner drive to seek it out, the growth of an audience for classical music in this country is far from assured. Certainly, it will not come about by magic, or through demographic changes alone.

One good sign is that music by Canadian composers of classical music is becoming better known. The work of an older generation, including Healey Willan, Godfrey

Ridout and others, has been rediscovered on CD and in the concert hall. Some of the music of Jean Coulthard, Violet Archer, Harry Somers, R. Murray Schafer, Pierre Mercure, Murray Adaskin, Claude Vivier and others who came into prominence in the 1950s and 1960s is regularly programmed. Also, a new generation of talented composers including Patrick Cardy, Gary Kulesha, Randolph Peters and Glenn Buhr, among many others, has benefited not only from the composer-in-residence programs of some of our major orchestras, but from CBC commissions and broadcasts. One of the cultural factors that may be making it easier for open-minded audiences to get in touch with contemporary Canadian classical music is the notable decline of the influence of dodecaphonic or 12-tone music since the 1950s. Neo-romanticism has affected the work of Canadian composers as it has their American counterparts, and this has meant the return of melody and a welcome relief from sounds that, for some decades, associated new classical music with shrieks, squeals, howls and groans—a whole battery of neurasthenic noise-making.

Canada has given birth to astonishingly talented popular musicians and to indisputably great classical instrumentalists and singers, such as Glenn Gould and Jon Vickers. Meanwhile, the pool of Canadian talent of the present day—a host of up-and-coming popular artists—and already established classical talents such as Marc-André Hamelin, Angela Hewitt, Jon Kimura-Parker, Valerie Tryon, James Ehnes, Ben Heppner, Catherine Robbin and Richard Margison, suggests real vitality in our traditions. The success of our smaller instrumental groups—classical and borderline jazz—such as the Orford String Quartet, the Tafelmusik Baroque Orchestra, the Canadian Brass and Nexus, shows that the problems of our large musical organizations have much to do with the expenses of numbers.

Columbia Artists Management Inc./ Lisa Kohler

Many radio stations maintain substantial classical programming and have broadcasters with great expertise in presenting it: Shelagh Rogers and many others at the CBC, Mark Antonelli at CKUA

He may not yet be as wellknown as the "Three Tenors," but Ben Heppner's strong tenor voice is just as captivating.

in Edmonton, Peter Keigh and Adriane Markow at CJRT in Toronto, to name a few. Yet, unless we create firm economic and, in some cases, firmer artistic foundations for our important orchestras and opera companies, and begin producing some great conductors (they are scarce enough in the world today, to be sure, and Canada has some promising talent in that sphere) our classical-music scene will remain unbalanced. It will be tilted in favour of native-born soloists, but without the solidifying power of tradition, the rootedness, the day-to-day development and interaction that a large world-famous classical ensemble can bring to a community's music making.

Many other aspects of Canadian music are flourishing and deserve more attention than I can give here. Such special niches as gospel and even rap, which is eagerly consumed although only marginally produced in Canada, constitute interesting byways. And the whole range of folk styles, including bluegrass, Celtic and especially Cape Breton, have developed in fascinating ways in this country.

In general, jazz is also healthy, and is arguably becoming more central to the Canadian scene than it has been in the past. Despite the fact that jazz in Canada, like our native imitations of Broadway musicals, manifests itself very much as "borrowed

Maclean's / Phill Snel

This country has produced a number of jazz greats—among them, Kenny Wheeler, Paul Bley, Gil Evans and Maynard Ferguson—but Oscar Peterson is the towering figure on the Canadian jazz landscape.

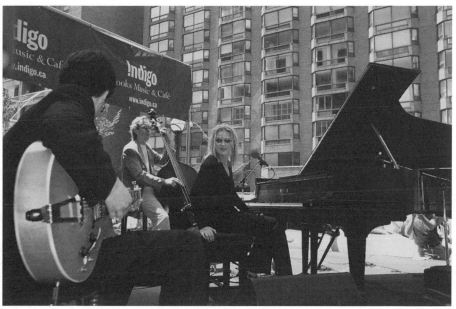

Maclean's / Phill Snel

Singing with a smooth, smoky voice reminiscent of jazz vocalists from the 1940s and 1950s, Diana Krall performs with her combo on Toronto's Bay Street.

culture," many would argue for the existence of strong and individual native traditions in certain areas. From almost day one, American jazz musicians have visited Canada (Jelly Roll Morton was in Vancouver in 1920) but the strong fertilization occurred only after the second World War, and names like those of Bert Niosi, Trump Davidson and Johnny Holmes loom large as influences from that period. The most readily recognizable jazz names in Canada today include our indisputable native great Oscar Peterson, as well as flutist Moe Koffman, guitarists Lenny Breau, Ed Bickert and Sonny Greenwich, trombonist Rob McConnell, composer and bandleader Phil Nimmons, vibraphonist Pete Appleyard, and new stars such as singer-pianist Diana Krall, clarinet virtuoso Francois Houle and saxophonist Jean Derome, among others. Maynard Ferguson, Kenny Wheeler, Paul Bley and Gil Evans are outstanding among the small number of Canadian-born jazz musicians who have established themselves south of the border. In truth, Canadian jazz musicians have necessarily faced south, but have done so in a way that has fostered the growth of local talent. Our numerous jazz festivals, including the 10-day Festival international de jazz in Montréal, which has occasionally attracted as many as half-a-million people, testify to a strong interest in the form. Other festivals take place annually in Toronto, Ottawa, Guelph, Edmonton,

Vancouver and Calgary, and several of these cities have excellent jazz venues in nightclubs, taverns and the like. The CBC and various local stations, some of them university-based, deliver a variety of well-informed and lively jazz programs, though the air-time of these shows is only a fraction of that devoted to popular and classical music, while only three or four Canadian companies record jazz.

Several organizations created over the past few decades have contributed much to the development of Canadian music. These include the Canadian League of Composers, founded in 1951, and the Canadian Music Council, which goes back to the mid-1940s. The latter has served Canadian musicians by preserving scores, providing access to contests, publishing books and magazines on music in Canada and occasionally giving prizes in the field of classical music. It was also responsible for the creation of the Canadian Music Centre in 1959. This is a professional but non-governmental information agency designed to promote and preserve Canadian music of all kinds. Although the first office was in Toronto, the CMC later created branches across the country. It has served as both a repository of information and a connecting link among composers, publishers, performing organizations and record companies. Another group, the Association of Canadian Orchestras, founded in 1972, has served to promote the interests of its members through meetings, workshops and seminars designed to keep them in touch with current developments. It has also lobbied the Canada Council Music and Opera Section and the Heritage Ministry on behalf of its constituents.

Despite some uncertainties created by shocks associated with the erosion of public funding, as well as the pressure of new technologies and of demographic changes, the Canadian music scene is healthy, and in some areas, powerfully creative. Most forms of popular music are flourishing. As for traditional classical music, a new thrust of education, better marketing, more long-term involvement of the private sector and more subtle and resilient government policies will assure its growth and health for many decades into the new millennium.

Major Canadian Orchestras
(and selected smaller ensembles)

ALBERTA

Calgary Philharmonic Orchestra (CPO): The CPO was created (through an amalgamation of two existing orchestras) as an amateur/part-time professional ensemble in the mid-1950s, after which it went through several decades of growing pains under various conductors, none of whom had the necessary stature or length of tenure to transform it into an ensemble worthy of the audience that rapidly emerged in booming oil-rich Calgary. José Iturbi, the noted pianist, and Franz-Paul Decker were among those who laboured to build the orchestra. With the move of Mario Bernardi west in 1983 and the opening of the 1,800-seat Jack Singer Concert Hall in 1985, a period of growth and stability ensued. The orchestra, a full-size ensemble capable of playing Mahler and Strauss, gave Bernardi a chance to expand his own repertory on a regular basis. The Bernardi reign, however, ended uncertainly. In common with other major Canadian orchestras, the CPO suffered greatly from government cutbacks and from its own failure to build an audience to match its artistic ambitions, so that by 1993 it was over $1.6 million in debt. Nonetheless, the CPO has dealt vigorously with its financial woes; thanks to the expertise of marketing director Graeme Menzies, subscriptions soared in 1994 to 12,300, while the "Mozart on the Mountain" concept in 1995 attracted 13,000 to a concert on Mount Allan, near Calgary. Leonard Stone, the orchestra's executive director, working with Menzies, reduced the near-fatal 1993 debt to a mere $900,000. Hans Graf, an Austrian, took over as music director in 1995; Mario Bernardi became conductor laureate and important new blood was injected

shortly afterward with the arrival of Rolf Bertsch (assistant conductor), while the ubiquitous Bramwell Tovey, hopscotching his way toward Vancouver, was made principal guest conductor. As the decade ended, the CPO offered the kind of catch-all season programming, often corporate-sponsored, that has become common among symphony orchestras across North America: mainstream classics, baroque, young people's concerts and pop concerts featuring rock groups, such as the New Mammas and Pappas, that sometimes shook up the staid Philharmonic subscribers. "Name personalities" materialized on stage, along with some excellent guest soloists, as the orchestra sought to broaden its subscription base. **205 – 8th Ave. SE, Calgary, AB, T2G 0K9.** Phone: **(403) 571•0270**; Internet: **http://www.htn.com/cpo/**

Edmonton Symphony Orchestra (ESO): This orchestra's origins date back to the 1920s, but the original ensemble folded in 1932. Its successor, created in 1941, had to endure the usual several decades of uncertainties while orchestra and audience grew up together. A turning point was the appointment of the English-born Brian Priestman in 1964. He began the main series concerts, created offshoot performing groups and established a national talent contest for young performers. His successor, Lawrence Leonard, was a great stabilizing force. In 1973, it was decided to use the model of Ottawa's National Arts Centre Orchestra and to restrict the ensemble to "classical" size (i.e., about 50 players). Unlike the Calgary Symphony, the ESO has toured considerably in western Canada, and has frequently wooed its audiences with blatantly

"pop" fare, once even commissioning a work from Rod McKuen. In 1999, the orchestra began a more imaginative and substantial outreach with its Resound Festival of Contemporary Music, which includes a "Canadian Concerto Competition." Financially, the ESO has been well managed. By the end of 1998, it had achieved its fifth consecutive year of debt-free operation. Uri Mayer, resident conductor from 1984 to 1995, was succeeded by Grzegorz Nowak. The orchestra's subscription base is presently about 11,600 people, and it gives approximately 100 performances a season, most of them in the Francis Winspear Centre for Music, located in downtown Edmonton. **9720 – 102nd Ave. NW**, **Edmonton**, **AB**, **T5J 4B2**. Phone: **(780) 428 • 1108** (admin.); **(780) 428 • 1414** or **1 (800) 563 • 5081** (box office); Fax: **(780) 425 • 0167**; Internet: **http://www.edmontonsymphony.ab.ca**

BRITISH COLUMBIA

CBC Vancouver Orchestra: Established in 1938 and led for many years by John Avison, this ensemble plays primarily Canadian and 20th-century music for small orchestra, supplementing this with similarly scaled works from earlier periods. The latter came more to the fore in 1979 with the arrival of John Eliot Gardner as leader. In 1982, Gardner was replaced by Mario Bernardi, who continues to lead the group. Over the past decade, the orchestra has performed some 92 different works by 57 Canadian composers and has made 15 CDs for CBC Records.

Vancouver Symphony Orchestra (VSO): Although there had been symphonic ensembles in Vancouver since the late 19th century, it was not until 1930 that the modern Vancouver Symphony Society was formed under Allard de Ridder, who stayed with the orchestra for 11 years. De Ridder lured eminent guest conductors including Sir Thomas Beecham,

and succeeded in getting performances on the CBC. During the late 1940s, the orchestra expanded its program and its debt, ushering in a period of relative instability, one which ended when Irwin Hoffman became music director in 1952. Hoffmann, an American, built the orchestra, premiered works by Canadian composers and established new links with the community. The English-born Meredith Davies, whose tenure ran from 1964 to 1970, continued to build the orchestra and presided over a considerable number of local premieres of large-scale and important 20th-century works. The long reign of music director Kazuyoshi Akiyama, which stretched from 1972 to 1984, saw the orchestra come to real maturity. During his term the quality of guest artists increased further, the subscription list swelled (in 1979 – 80 it was the largest in North America), premieres of Canadian music occurred, CBC recordings were issued, a quarterly magazine was launched, and serious touring began, including a trip to Japan in 1974. With Akiyama's departure and cutbacks in federal grants, the VSO entered a rocky phase. Despite Akiyama's hard work there was no sign of commercial (non-CBC) recording contracts. The appointment of conductor Rudolph Barshai from Moscow in 1985 didn't help. By that time the orchestra was doing some 190 concerts per year, and expensive tours, rising costs, internal dissension and static patronage and subscriptions thrust the VSO into the million-dollar deficit club. Finally the unthinkable happened. In 1988, the orchestra had to shut down for five months in order to regroup and deal with its $2.3-million debt. Intelligent private intervention resulted in a community contribution of $400,000, a onetime federal government bailout grant of $500,000 was received, and the orchestra was able to continue. Shortly afterward, Sergiu Commisiona became music director and began the process of rebuilding the orchestra. In 1995, Clyde Mitchell, an unabashed popularizer,

became resident conductor, collaborating with Commisiona. Thanks to this new infusion of talent, more concerts featuring collaborations with pop stars, new corporate sponsors and aggressive marketing strategies, the orchestra ran four consecutive years in the black and a debt-paying plan was put in place. A proposed merger of VSO musicians with those of the Vancouver Opera, however, met with resistance from both players and public and had to be cancelled. At the end of the decade, with the worst of the crisis over, Bramwell Tovey received a five-year appointment as music director, replacing Commisiona. Tovey's personable podium manner, clever programming and competent conducting seemed to promise a new stability in Vancouver, although the orchestra's relatively low salary scale is a source of potential trouble down the road. Andrey Boreyko, as the new principal guest conductor, should reinforce Tovey creatively. The VSO performs approximately 130 concerts annually, most of them downtown in the Orpheum Theatre, although the ensemble also regularly concertizes in Greater Vancouver and other areas of the province. **601 Smithe St., Vancouver, BC, V6B 5G1.** Phone: **(604) 684•9100; (604) 976•3434** (for information on concerts); Fax: **(604) 684•9264**; Internet: **http://www.culturenet.ca/vso**

MANITOBA

The Winnipeg Symphony (WSO): The WSO played its first concert in 1948, although the orchestra had many predecessors dating back to the late 19th century. Victor Feldbrill, who took over as music director in 1958 and served for 10 years, put the orchestra on the map in Canada. During his reign the WSO gave a great many Canadian premieres. In 1968, the orchestra moved to its present home in the Manitoba Centennial Concert Hall. Piero Gamba was another significant force during his nine-year term, which began in 1971. The

Paul Martens

Vancouver Symphony Orchestra music director Bramwell Tovey offers a personable podium manner and clever programming ideas.

dynamic Italian created an impressive program (utilizing also the Philharmonic Choir, which became officially linked with the orchestra), yet when Gamba resigned in 1980 the orchestra had fallen $900,000 in debt, making Winnipeg a fast starter in the "we can outspend you" orchestra sweepstakes. During the 1980s, the orchestra developed further under Kazuhiro Koizumi, a competent Japanese maestro, and Simon Streatfeild, a versatile and sometimes brilliant conductor, but financially things hardly improved. The appointment of Bramwell Tovey as artistic director in 1989 was a turning point. Tovey, along with composer Glenn Buhr and others, including WSO executive director Max Tapper, who resigned in 1996, launched the New Music Festival in 1992. It started rather tentatively but soon became one of the big surprises in the arts scene of the 1990s—the symphonic equivalent of the theatrical "fringe festivals." In 1999, 13,900 people attended, and the $400,000-plus budget was funded by the du Maurier cigarette company. The festival has brought international renown to the orchestra.

Every January, Winnipeg is now the place to be for those eager to hear a variety of fascinating, well-played new music and, thanks largely to du Maurier, the prices were made affordable for almost any music lover. However, Health Minister Allan Rock's 1998 announcement of reforms to the Tobacco Act signalled du Maurier's exit and the festival's near demise. Luckily, two local corporations stepped in as sponsors, something of a miracle given the demands on the city's corporate generosity exerted by the Pan American games and other events on Winnipeg's calendar. In 2000, Tovey moved to Vancouver and Joseph Silverstein, former Boston Symphony concertmaster, was appointed as interim maestro through the 2001 – 2002 season. In 1997, Rosemary Thomson was appointed first conductor-in-residence, a position designed to give experience to promising Canadian podium talent. It will be interesting to see if, with these changes, Winnipeg can continue to generate musical excitement to match that of the Tovey era. **101 – 555 Main St., Winnipeg, MB, R3B 1C3.** Phone: **(204) 949 • 3999; (204) 949 • 3950** (general office); Internet: **http://www.wso.mb.ca**

NOVA SCOTIA

Symphony Nova Scotia, Halifax: This ensemble began in 1968 as the Atlantic Symphony Orchestra, which itself was an amalgam of local orchestras; as the Atlantic Symphony it became the first truly regional orchestra in Canada. In 1983, it took on its current name and attempted, without success, to stabilize finances and focus its artistic commitments. Based in Halifax, the symphony was led by Klaro Mizerit, Victor Yampolsky and, notably, by the late and lamented Austrian Georg Tintner. Like most Canadian orchestras it was staffed to a considerable degree by American players, and also employed musicians from other parts of Canada. This was certainly

a necessity, but it probably did little to ground the ensemble in the community. The orchestra was given perhaps more than its fair share of CBC Radio time—no doubt to emphasize the network's commitment to regional arts broadcasting; certainly not for artistic reasons. Through the 1970s and most of the 1980s the Canada Council provided generous support (about one third of the budget), but when this began to be cut back, the orchestra's debt neared the $1-million mark. Raffi Armenian, appointed as interim director during 1995 – 96, brought in a season of warhorses, appeals were made to regional pride and a dynamic management pitched in with ideas. By season's end, the debt had been reduced to only $325,000—an astonishing feat. Leslie Dunner, an American who came from the Detroit Symphony, took over as permanent conductor in 1997, and established rapport with the community through an unashamed embracing of cross-over concerts with Cape Breton fiddlers, Acadian singers, jazz combos, etc., although Beethoven, Mozart and other classics continue to be heard in the orchestra's Halifax Metro Centre venue. **Suite 301, 5657 Spring Garden, PO Box 218, Halifax, NS, B3J 3R4.** Phone: **1 (800) 874 • 1669; (902) 421 • 1300;** Internet: **http://sns.ns.sympatico.ca**

ONTARIO

Kitchener-Waterloo Symphony: This orchestra was created to accompany the Kitchener-Waterloo Choir, which had existed since the 1920s. The symphony was launched in 1944 by three of its members. Glenn Kruspe, one of the founders, served as principal conductor until 1960. He was succeeded by Frederick Pohl, who saw the orchestra through its next decade. In 1971, Raffi Armenian took over and began to program music by Canadian composers and to engage the leading Canadian soloists of the day for both the orchestral season and opera-in-concert productions. Under

Armenian, a shrewd programmer, this organization managed to avoid the huge financial overruns of most Canadian symphony orchestras. The current principal conductor is Chosei Komatsu. The orchestra performs in the Centre-in-the-Square, an excellent hall, and currently draws about 90,000 music lovers annually. **101 Queen St. N, Kitchener, ON, N2H 6P7**. Phone: **(519) 745 • 4711**; Internet: **http://www.kwsymphony.on.ca**

National Arts Centre Orchestra (NACO), Ottawa: Created in 1969 in the wake of centennial celebrations, this small orchestra (with a core of about 45 players) has had a relatively short but lively and contentious history. Was it a mistake to give the orchestra a name without a real place identity? Was it wrongheaded to limit its size, thus excluding from its concerts most of the popular 19th- and 20th-century symphonic repertory? Would it have been better to import a world-class conductor to take the orchestra through its formative years? Mario Bernardi returned to Canada in 1968 to be principal conductor and it must be said that he achieved some notable artistic success, especially in the operatic repertory that ran during the festival seasons beginning in 1971. He also helped make the NACO an exemplary interpreter of works from the Haydn-Mozart classical period, and though unloved during his tenure and unlamented at departure, he has returned occasionally to receive receptions from orchestra and audiences that were far more than nostalgic. Franco Mannino, an odd and intriguing musical personality, led the NACO from 1982 to 1986; Gabriel Chmura (shabbily treated by management) from 1986 to 1990 and the very competent Trevor Pinnock from 1991 to 1996. The NACO was generally considered to be in the doldrums during the 1990s; one of the problems was repetitive programming that excluded almost all the interesting 20th-century works for small orchestra; another was

lack of a truly magnetic podium star. The latter problem was finally solved by the appointment of Pinchas Zukerman as music director in 1998. Zukerman walked into an unfortunate situation, however, one compounded by a major and quite bitter musicians' strike that seemed to threaten the orchestra's very existence, and by various NACO institutional disasters, some of them self-generated (see chapter eight). With these issues on the way to resolution, and with Zukerman's determination to concentrate on music making, the NACO has found its footing again. As the only orchestra in Canada to be totally government-funded, however, it continues to have special problems. Its $7-million budget makes it a vulnerable target of those who object to "taxpayers' money" being used to fund elite culture. Yet thanks to its generally good reception abroad and its excellent standards of ensemble playing, the NACO has always had—and continues to inspire—loyal support from most classical music fans in Ottawa and across the country. **PO Box 1534, Stn. B, Ottawa, ON, K1P 5W1**. Phone: **(613) 947 • 7000**; Internet: **http://www.nac-cna.ca**

National Youth Orchestra of Canada (NYO), Toronto: Established in 1960, this group consists of approximately 100 of the finest young Canadian soloists (aged 14 – 24). They are chosen annually, trained under an experienced conductor specially selected for the purpose, and afterward perform concerts nationwide. This kind of training represents an incomparable opportunity for the participants to broaden and deepen their musical and personal experiences and to develop as specifically Canadian musicians. The idea has its origins in Leopold Stokowski's All-American Youth Orchestra in 1940 but was directly activated in Canada by Walter Susskind, a conductor of Eastern European origins who led the National Youth Group through its early years. A number of talented Canadian conductors have led the NYO; Georg Tintner

and Kazuyoshi Akiyama in particular established exciting synergies with the young players. The orchestra, which by the 1990s had trained more than 2,000 young Canadian musicians, is funded by Heritage Canada, by the Canada Council and by the individual provinces, with some private contributions. Although financial shortfall threatened its demise in the mid-1990s—due mainly to the federal government's oversights in relation to arts-training funding—it has survived and continues to give delightful concerts and to fill one out of every three chairs in Canada's symphony orchestras with its graduates. **1032 Bathurst St., Toronto, ON, M5R 3G7**. Phone: **(416) 532•4470**; Fax: **(416) 532•6879**; Internet: **http://www.nyoc.org**

Orchestra London (OL): Founded in 1949, and first directed by Martin Boundy, this orchestra has grown steadily in artistic ambition and reach, thanks to the work of community-minded administrators, gifted musicians and conductors such as Uri Mayer and Victor Feldbrill. When the OL became a fully professional group in 1975, it had a core of about 26 full-time musicians but, generally, its ranks are filled out by freelance local professionals. The venue is most often London's Centennial Hall. Brian Jackson is the present principal conductor and, beginning in 1999, Simon Streatfeild will serve as artistic advisor and occasional conductor. The orchestra's annual budget is about $2 million; it has often performed on CBC Radio and has made a few CDs. **520 Wellington St., London, ON, N6A 3R1**. Phone: **(517) 679•8778**; Fax: **(517) 679•8914**.

Ottawa Symphony Orchestra (OSO): The first symphonic ensemble in the city goes back to the beginning of the 20th century. The present group was founded in 1965, but for years it was stuck at the level of a pleasantly competent amateurism. Essentially a pick-up ensemble,

the OSO seemed destined to play second fiddle to the virtuoso orchestra at The National Arts Centre. Over the years, however, things have changed. Under its current conductor, David Currie, it has given very creditable, even wonderful, performances of romantic and modern symphonic works, including the Mahler Second and Fifth, the Shostakovich Fifth and Tenth and Carl Orff's *Carmina Burana*. Both established soloists, such as pianist Angela Hewitt, and up-and-coming artists have performed with the orchestra. New music by Canadian composers has also been programmed in the OSO's five yearly concerts. With some sponsorship by Ottawa's high-tech industry, and some CBC broadcasts under its belt, the orchestra seems to have become a permanent fixture of the Canadian musical scene. **501 – 1390 Prince of Wales Dr., Ottawa, ON, K2C 3N6**. Phone: **(613) 224•4982**.

Tafelmusik Baroque Orchestra, Toronto: Tafelmusik was founded in 1978 by Canadian musicians Kenneth Solway and Susan Graves, both baroque specialists. It expanded from an ensemble of four and moved into original instruments, later hiring Jeanne Lamon, an American, who joined the group in 1981 and transformed it into a first-rate small orchestra. The ensemble was the first North American baroque orchestra to be invited to tour Europe. It has gained a lucrative exclusive recording contract with Sony Records—which imported Bruno Weil as leader for several recordings, not a wise move. The contract was dropped in 1997. Tafelmusik now records with Analekta and CBC Records. The group has an annual budget of over $2 million and 2,000 loyal subscribers and is one of the real ornaments of the Canadian music scene. **427 Bloor St. W, Toronto, ON, M5S 1X7**. Phone: **(416) 964•9562**; Fax: **(416) 964•2782**; Internet: **http://www.tafelmusik.org**

The Toronto Symphony (TSO): Founded in 1906 in the wake of other more tentatively established ensembles and at first linked to the Toronto Mendelssohn Choir, the orchestra has survived several name changes, a host of crises and shifts of artistic emphasis, years of prosperity and years of uncertainty, only to emerge in the mid-1990s not as the indisputably world-class institution it ought to be, but as an "essential Canadian orchestra" still trembling on the verge of complete success. The orchestra began under Frank Welsman in Massey Hall and, after a few years, attracted famous figures, including soloists of the calibre of Fritz Kreisler and Sergei Rachmaninoff, but the enterprise crashed in 1918 and did not resume until 1922. Under Luigi von Kunits the revamped orchestra gave Canada its first broadcasts of serious music (from the Robert Simpson Department Store in 1929–30). Ernest MacMillan became conductor after von Kunits's death in 1931; his "Christmas Box" concerts were famous and reportedly much fun. Anticipating many current efforts to woo audiences with novelties, he once conducted Alexander Mosolov's *The Iron Foundry* using a monkey wrench in place of a baton. The 1940s were a very successful decade for the orchestra but the early 1950s saw it capitulating to McCarthyist pressure to drop a few "suspected Reds" in its ranks, a debacle in which MacMillan played an ignoble role. Walter Susskind replaced Sir Ernest (as he was by then) in 1955 and although the music making continued on a high plane, the financial situation deteriorated until the arrival of the youthful Seiji Ozawa in 1965. Karl Ancerl succeeded him (summer concerts at Ontario Place began during his regime) and in 1975, following an interim, Andrew Davis, also youthful at the time of his appointment, took over. Davis and anglophile Toronto were a comfortable match, and he was a steady influence, using his appointment to perfect his craft (his career since has blossomed). He

came close to putting the orchestra in the international mainstream, leading the TSO on tours (as Ozawa had done) and producing a few amiable recordings. In 1982, the orchestra moved to Roy Thomson Hall, notorious for its dreadful deadfall sonics, but chic and central enough to rival any similar facility around the world. Dire days lay ahead, however. The financial squeeze of the late 1980s and early 1990s, combined with unpopular appointments and internal dissension, brought the ensemble close to bankruptcy. During the reign of conductor Guenther Herbig (1989–94) costs soared, subscriptions slipped, the orchestra debt multiplied to an alarming $3.7 million. Pay cuts were initiated and crisis management ensued. Herbig, an orchestra-builder but not a dynamic maestro, failed to attract a single recording contract. Management, therefore, turned to an available whiz kid, the then 37-year-old Jukka-Pekka Saraste, who arrived from Finland in 1994 to take over as music director. Under Saraste things looked up: the reviews were good, the players were animated and hopeful, subscriptions went up slightly and box office receipts were much improved. Moreover, a key visit to Carnegie Hall came off well, and an ambitious European tour was set to take place in February-March of 2000, while a three-year recording contract with Finlandia Records began to produce some excellent results. Unfortunately, 1999 saw some serious setbacks. The European tour, which would have been the TSO's first in eight years, had to be cancelled because of the withdrawal of promised private-sector sponsorships. Furthermore, a musician's strike (aimed at obtaining restoration of wages lost in previous salary cuts) began in September 1999. As Charles Dutoit had done in the 1998 strike in Montréal, Saraste sided with the players—but it was clear that the Finnish maestro would not have comparable leverage with the province. Premier Mike Harris was unlikely to see the TSO as an integral part of the second phase of his common-sense

revolution. Certainly, the strike will be settled—as of this writing the board and the musicians' union are negotiating again after a breakdown in talks—but any substantial contract will have serious financial repercussions for the orchestra. Meanwhile, there has been talk of finding a replacement for Saraste. (Apparently, a well-known leader with more "professional maturity" is being sought.) Saraste's conducting, for all its precision and panache, has been rather short of revelatory status; and the strike and the cancelled tour, although hardly his fault, may precipitate his departure. The TSO, however, may have some trouble finding a really impressive replacement. In sum, this orchestra, which has reached a certain degree of eminence, has not quite fulfilled its recent promise of achieving an even higher performance level, a greater focus of repertory, and a more defined presence on the world scene. Toronto deserves not merely a good but a great orchestra. Subscribers, fans and all Canadian classical music buffs are hoping that in a few years it will have one. **212 King St. W, Suite 550, Toronto, ON, M5H 1K5.** Phone: **(416) 598•0422; (416) 593•7769** (development dept.); Internet: **http://www.tso.on.ca**

The Toronto Mendelssohn Choir: This choir was founded in 1894 by Augustus Vogt and appeared in Massey Hall as early as 1895. Over the decades many famous leaders have served the group, including Sir Ernest MacMillan, Walter Susskind and Elmer Iseler, who amalgamated his Festival Singers of Canada with this group in 1968. After a glorious career, Maestro Iseler died in 1998, and Noel Edison was appointed as interim conductor. The choir has built up a generous repertory, has performed widely abroad and has premiered many Canadian works. **60 Simcoe St., Toronto, ON, M5J 2H5.** Phone: **(416) 598•0422**; Fax: **(416) 598•2992**; Internet: **http://www.tm choir.org**

QUÉBEC

Orchestre symphonique de Montréal/ Montréal Symphony Orchestra (MSO): Founded in 1934, with predecessors that date back to the 19th century, the MSO is, at the beginning of the 21st century, beyond question Canada's most distinguished symphonic ensemble. The 1934 orchestra arose out of the desire to create a francophone group to set against the reigning English Montréal Orchestra, and when Wilfrid Pelletier came from New York to become its first artistic director, the enterprise was well launched. Désiré Defauw took over from Pelletier and continued to lead the orchestra until 1952, although he was an early entry in the "absent leader" stakes which have bedevilled most major orchestras in the world since. During this period, however, the MSO attracted very distinguished guest conductors (Sir Thomas Beecham, Leonard Bernstein, George Szell, Bruno Walter) and, because of an accident that kept him in Montréal, benefited from the personal advice of Otto Klemperer. By the time Igor Markevitch took over in 1958, the MSO had seen more of the great conducting talent than any other Canadian orchestra, and when illness forced his departure the ensemble had the incredible luck (or wisdom) to latch onto the young Zubin Mehta. The Bombay-born Parsee, then in the first stages of his brilliant career, was chief conductor of the MSO from 1961 to 1967. (The orchestra's move to the Grande Salle of the Place des Arts took place in 1963.) Mehta's successor, Franz-Paul Decker, although something less than riveting, was a skilled, well-prepared performer, but Rafael Frübeck de Burgos was a disappointment and departed amid dissension, leaving the orchestra in some uncertainty. Once again, however, luck or good judgement on the part of the excellent administrator Pierre Beique (1939–70), who remained as special advisor and consultant through the 1970s, resulted in a fortunate

acquisition, and the Swiss Charles Dutoit was engaged, beginning in the 1978–79 season. From the time of Markevitch the orchestra has begun to commission and play numerous Canadian works; under Mehta, successful tours had been undertaken. Under Dutoit the MSO became ruler of the classical-record charts. Over 75 recordings have been made for Decca/London, resulting in no fewer than 40 national and international awards, an astounding achievement. All the more shocking that the MSO's exclusive Decca/London contract was suspended in 1998. It was a bad omen; 1998 also saw a three-week players' strike, which Dutoit supported, and which resulted in a solid rise in the musicians' salaries. In addition, two admired MSO principals defected to American orchestras. The strike was one factor in speeding the departure of the orchestra's managing director; it also produced some close confabulations between the maestro and Québec Premier Lucien Bouchard on the future of the MSO in the province. Dutoit achieved what some considered a near miracle when he helped engineer financial guarantees from the province that seemed to offset the dangerous $5.5-million orchestra debt. Bouchard, no doubt accurately, sees the orchestra as one of the indispensable gems in the province's artistic crown. At this writing, too, another Decca/London recording contract is rumoured to be in the offing. The MSO is still suffering the typical symphonic financial blues: touring, which has carried the orchestra to Hollywood, New York, Europe and Asia, is neither cheap nor necessarily lucrative—this is not the rock circuit. Also, MSO subscriptions have dropped by approximately 5,000 over the last decade (attributed to the now shopworn Place des Arts and the exit from Montréal of many anglophone supporters of the MSO). Despite these problems it now appears that the MSO has achieved in Québec something of the status of an untouchable institution. No Canadian should complain about this, since the MSO is arguably—and despite the recent crisis—the best symphonic ensemble in the country. **260, boul. de Maisonneuve O, 2nd Floor, Montréal, QC, H2X 2J4**. Phone: **(514) 842•3402**; Fax: **(514) 842•0728**; Internet: **http://www.osm.ca**

Orchestre Symphonique de Québec, Québec City: This orchestra, founded in 1902 and still in operation, has had the longest continuous run of any Canadian orchestra, but the going has not always been easy. Joseph Vezina was the first chief conductor, followed by Robert Talbot in 1924. In the 1930s, a splinter orchestra confused the situation, but in 1942, the present full-size symphonic ensemble was created. Wilfrid Pelletier and Françoys Bernier were important artistic influences in the 1950s and 1960s, the latter giving the orchestra a provincial reach, which eventually led to world-famous soloists appearing with the group. Pierre Dervaux took over in 1968 and presided until 1975, and was responsible for some notable concerts. James De Preist, a black American, became artistic director in 1976—the Québec organization deserves much credit for the social implications of this (black conductors at the time were hardly visible in the United States and none had been appointed artistic director of a major orchestra). Simon Streatfeild replaced De Preist in 1983 and Pascal Verrot succeeded him in 1991. However, some Canadian nationalists objected when the orchestra board decided in 1998 to go outside the Canadian talent pool and appoint Yoav Talmi, an only marginally known Israeli conductor, as Verrot's successor. (There are some very fine young Canadian conductors on the scene, both in and out of Québec.) **130, Grande-Allée O, Québec, QC, G1R 2G7**. Phone: **(418) 643•5598**.

McGill Chamber Orchestra, Montréal: This ensemble is a string orchestra of some 15 core players, founded by composer/conductor

Alexander Brott in 1945. It has toured widely, attracted notable soloists and commissioned some important Canadian compositions.

800, boul. René-Lévesque O, Suite 450, Montréal, Québec, H3D 1X9. Phone: **(514) 871•1224.**

Major Canadian Opera Companies

Canadian Opera Company (COC), Toronto: Founded in the 1940s as an offshoot of the Royal Conservatory of Music Opera School, this company had developed into an excellent operatic ensemble by the mid-1950s. Several key figures, including conductors Nicholas Goldschmidt and Ernesto Barbini, stage director Herman Geiger-Torel and general director Lofti Mansouri (who later went to San Francisco), made outstanding contributions during those early decades. By the late 1960s, the company was already well established and was fostering many of Canada's notable singers, including Patricia Rideout, Jan Rubes, Teresa Stratas and Jon Vickers. The Ensemble Studio Program, founded in 1980, continues the tradition of polishing the vocal and stage techniques of young singers. Indeed, the COC has made a point of developing Canadian artists rather than attempting to compete with the great international houses for the services of operatic superstars. Over the years the company has also commissioned notable compositions, for example, *Louis Riel* by Harry Somers, probably the best opera composed by a Canadian. Other commissions include Somers's *Mario and the Magician*, based on the story by Thomas Mann; Randolph Peters's *Nosferatu*, Gary Kulesha's *Red Emma* and *The Golden Ass* also composed by Peters, with a libretto by Robertson Davies. The COC has performed across the country, including at Expo '67 in Montréal, and although funding limitations have restricted this activity in recent years, it made notable appearances in New York and Edinburgh in 1994, presenting a critically

acclaimed double bill of Arnold Schoenberg's *Erwartung* and Béla Bartók's *Bluebeard's Castle*, both directed by Robert Lepage. A notable production of Richard Strauss's *Salome* directed by Atom Egoyan was presented in 1996–97 and Egoyan's own opera, *Elsewhereless*, with music by Vancouver composer Rodney Sharman, was premiered in 1998. The COC, along with other arts groups, has had to put up with the inadequacies of the Hummingbird Centre as a performance space, but at last, in 1998, plans were announced for a new $113-million facility at Queen Street West and University Avenue. Richard Bradshaw is chief conductor and general director of the COC, with a five-year contract renewed in 1998. A shrewd choice of repertory, high-quality singing and production, careful budgeting, and well-targeted marketing account for the continued success of this company, although the daunting job of financing opera was not made any easier in the 1990s by the increasingly uncertain nature of public funding for the arts at all three levels of government. **227 Front St. E, Toronto, ON, M5A 1E8.** Phone: **(416) 363•6671**; Fax: **(416) 363•5584**; Internet: **http://www.coc.ca**

Opera Atelier, Toronto: Founded in 1986, Opera Atelier is a prize-winning ensemble that specializes in authentic performances of baroque opera. Not as well known as it should be in Canada outside the Metro area, but internationally respected, the group is treasured by the same Toronto music lovers who support Tafelmusik Baroque Orchestra

(with which Atelier often collaborates). Opera Atelier has taken productions to France and Japan. In 1997, it received the Lieutenant Governor of Ontario's Award for the Arts. As with most opera companies the deficit is a problem, but it has been controlled, even though the company budget had soared to nearly $2 million by 1998. Atelier has achieved some success in attracting corporate support, even going outside Canada to do so; 50 percent of its budget is from box office receipts. Atelier presently produces two operas a year. Founders Marshall Pynkowski and Janette Zingg, a husband-and-wife team, are co-artistic directors. **87 Avenue Rd., Toronto, ON, M5R 3R9**. Phone: **(416) 925 • 3767**.

Opéra de Montréal (OdM): Founded in 1980 as a revival of the Opéra du Québec, which had folded after four seasons in Montréal, this company was created with the support of the Parti Québecois government and under the guidance of notable singers Joseph Rouleau and Robert Savoie. OdM's first artistic director was Jean-Paul Jeannotte, who organized an adjunct chamber company to tour the province and established the rule that, whenever possible, Québec artists would be given priority in the company's productions. In 1984, the Atelier lyrique de l'opéra de Montréal was opened, a training program for young singers, which resembled the Ensemble Studio created by the Canadian Opera Company four years earlier. Mainstream programming and successful productions failed to prevent the company from drifting once more toward insolvency, but before the worst could happen Bernard Uzan, a Franco-Tunisian stage director, was lured from the Tulsa Opera Company in Oklahoma and hired as general director. In the same year (1988) he became artistic director as well, and therein lies a tale. For while Uzan is widely respected as a manager who has used every trick in the book in a successful effort to keep the company afloat through hard times, he is less well regarded as an artistic presenter. Critics suggest that under his regime there have been too many routine stagings of overly familiar operas, that he has hired too many second-rate American singers and that production values in general have been mediocre at best. However, some productions (Richard Strauss's *Der Rosenkavalier* in 1991 and Leos Janácek's *Jenufa* come to mind) have been impressive across the board, and during the 1998–99 season the company presented two very interesting, if traditional, 20th-century American operas: Gian-Carlo Menotti's *The Consul* and Carlisle Floyd's *Susannah*. Also, some outstanding Canadian singers, such as Richard Margison and, very late in her career, Maureen Forrester, have made first appearances in Montréal under Uzan, while others, notably lyric soprano Lyne Fortin, have been developed under his regime. Uzan was rehired at the end of the 1997–98 season. The ensemble presents approximately seven productions a year and gives a total of about 40 performances. The Montréal Symphony Orchestra performs in the pit. **260, boul. de Maisonneuve O, Montréal, QC, H2X 2J4**. Phone: **(514) 985 • 2222**; **(514) 985 • 2258** (information); Internet: **http://www.operademontreal.qc.ca**

Vancouver Opera Company (VOC): Founded in 1959, this company developed steadily, beginning with a focus on the most popular repertory. During its first two decades the VOC mounted approximately four or five operas a year and gave some 25 performances annually. In the late 1970s, there were collaborative arrangements and a shared season with the Seattle Opera. By the early 1990s, expenditures had topped the $3-million mark, with ticket sales recovering about the total budget outlay and attendance figures often reaching 90 percent of capacity. While the VOC has always focused on the most popular repertory, it has occasionally presented works that are less commonly performed, for example, Leos

Janácek's *The House of the Dead*, Francis Poulenc's *Dialogues of the Carmelites* and Carlisle Floyd's *Susannah*. The VOC's casting policy over the years has differed from that of both the Canadian Opera Company and of the Opéra de Montréal. Unlike its eastern counterparts, Vancouver has not hesitated to import big international stars, including Placido Domingo, Joan Sutherland and Marilyn Horne, and the VOC Orchestra has accompanied Luciano Pavarotti in concert. As in Toronto and Montréal, however, there have been extensive training programs for young Canadian singers and artists of the calibre of Brett Polegato and Li-Ping Zhang have made their debuts on VOC's main stage. At first closely bound up with the Vancouver Symphony (as the COC in Toronto had been with the TSO), the VOC gradually developed its own orchestra, and Anthony Guadagno was appointed principal conductor in 1977. The quality of this company rose steadily through the 1980s and 1990s, and by 1993 it was boasting of its greatest attendance ever and trading advertising slogans with the Vancouver Canucks hockey team. Nothing is certain in the world of opera, however, and by the end of the 1990s the situation was far from rosy. Financial woes abounded: the annual budget had climbed to over $6 million and the accumulated deficit to nearly $1 million as a result of a particularly extravagant 1996–97 season. (Astoundingly, this deficit was virtually eliminated in 1998 at a single blow by some generous corporate donors.) Years of uncertain repertory choices, loss of benefactor support and the resignations of key board members, however, caused strains. Mainstage presentations were reduced to four, and an attempt was made to improve the market for opera locally by taking some productions into the community. Since 1991, Robert Hallam had been general director, with the sweeping powers of a European "intendant." He had launched an ill-fated attempt to merge the orchestra with that of the Vancouver Symphony and had been blamed for the departure of the popular music director David Agler. Although he was clearly not responsible for all the company's woes, he took much of the heat. When Hallam was replaced in 1999, many breathed a sigh of relief and looked forward to a happier era under the newly appointed general director James Wright, formerly of Opera Carolina. **500 – 845 Cambie St., Vancouver, BC, V4B 4Z9**. Phone: **(604) 682 • 2871**; **(604) 683 • 0222** (box office); Internet: **http://www.vanopera.bc.ca**

Top 20 Bestselling Canadian Songs
of All Time

IT is particularly difficult to ascertain all-time bestselling songs either written or sung by Canadians in Canada. The following alphabetical list is by no means scientific, but does serve as a departure point. Most of these singles can be found on the *Great Canadian Recordings* list.

Bryan Adams: "Everything I Do" (from *Robin Hood: Prince of Thieves Soundtrack*; "Everything I Do" is one of the top 10 all-time bestselling singles in North America).

Paul Anka: "Diana" (the Ottawa whiz kid's hit from the 1950s is one of the top 10 all-time worldwide bestselling singles, with sales in excess of nine million copies; it is only one of more than 400 Anka songs on record).

Beau Dommage: "La complainte du phoque en Alaska" (in the 1970s this group scored two platinum albums—100,000 or more copies sold—with *Beau Dommage* and *Où est passée la noce*).

Céline Dion: "Because You Loved Me" from *Falling Into You* and "Think Twice" from *The Colour of My Love* were among her mega-hits. The album *Let's Talk About Love* sold 22 million copies. In early 1997, Dion recorded the theme song for the blockbuster movie *Titanic*. "My Heart Will Go On," which won the Academy Award for Best Original Song, was about as successful as the film itself.

The Four Lads: "Standing on the Corner" (this 1950s rock and roll harmony group had a dozen U.S. and Canadian Top 40 hit records).

The Guess Who. "American Woman" (The Guess Who was Canada's first true internationally successful rock band and had another multimillion-selling hit single with "These Eyes").

Hagood Hardy: "The Homecoming" (probably the quintessential 1970s instrumental elevator ditty; it has sold more than 300,000 copies).

Dan Hill: "Sometimes When We Touch" (since Hill released this saccharine song in the late 1970s, it has sold more than four million copies).

Andy Kim: "Sugar, Sugar" (this bubble-gum rock hit of the late 1960s, as sung by the group The Archies, and written by Kim, sold more than eight million copies; Kim also scored big with "Rock Me Gently," which has sold more than three million copies).

Guy Lombardo and his Royal Canadians: "Auld Lang Syne" (Guy Lombardo and his band, according to *The Canadian Encyclopedia*, have sold approximately 300 million records worldwide, undoubtedly making him the all-time Canadian recording leader).

Don Messer and his Islanders: "The Good Old Days" (the godfather of Down East old-time music with more than 30 albums to his credit; definitely not Ashley MacIsaac).

Alanis Morissette: "You Oughta Know" (from *Jagged Little Pill*, which has sold more than 16 million copies worldwide; what is it about singers from Ottawa?).

Anne Murray: "Snowbird" (this multimillion-selling 1970 single propelled Murray to instant fame).

Michel Pagliaro: "J'entends frapper" (Pagliaro was the first Canadian to earn gold singles—more than 50,000 sold—in both French and English).

Rush: "New World Man" (since the mid-1970s this hard-rock band with a penchant for mega-decibel cosmic mythology and science fantasy has sold 15 million albums).

Hank Snow: "I'm Movin On" (this 1950s hit is one of the most popular country and western songs of the century; by 1985 it had been played one million times on radio stations in North America).

Shania Twain: "The Woman In Me" (Twain's album of the same name is the biggest-selling country album ever [more than 10 million copies], anywhere, by a female artist).

Ian Tyson: "Four Strong Winds" (in their heyday in the 1960s, Ian and Sylvia Tyson were one of the most popular folk acts in Canada, and had a significant following south of the border, too).

Gilles Vigneault: "Mon pays" (practically a national anthem in Québec; anglophone Canadians may remember the same tune in Patsy Gallant's atrocious disco hit, "From New York to L.A.").

Neil Young: "Heart of Gold" (over the years this longtime rocker's numerous albums have sold in the millions).

The Great Canadian Recordings

THESE are my personal choices, and since I am still working on being omniscient, I may have left out a few things! If you are in search of any of these titles, I suggest you consult a well-informed dealer in recorded music.

As every music collector knows, dates for recordings are often very hard to establish and relatively meaningless. In the name of consistency I have not listed any dates, except for historical items and for the ones that are in the record titles. I have made no particular effort to list the CD version of everything (CDs often drop or add material from previously issued LPs).

Best Popular Albums

A
Bryan Adams: *Wake Up the Neighbours*, A&M 75021-5367-2.

Paul Anka: *Anka Gold (1961)*, 2-Sire 2704.

Jann Arden: *Happy?*, A&M 31454-0789-2.

B
The Band: *The Band*, Capital STAO-132.

Barenaked Ladies: *Gordon*, Warner CD 26956.

Beau Dommage: *Beau Dommage*, Capitol ST 70.034.

Ed Bickert: *Pure Desmond*, Columbia CBS ZK40806.

Blue Rodeo: *Lost Together*, Warner WEA 77633.

Lenny Breau: *Cabin Fever*, True North TMSD 0138.

Edith Butler: *Chanson d'Acadie*, Radio-Canada International RCI 390.

C
Robert Charlebois: *Robert Charlebois Volume 1*, Select SSP-24131; *Swing, Charlebois Swing*, Solution/Kébec-Disc SN 939.

Chilliwack: *Chilliwack*, Parrot PAS 71040.

Bruce Cockburn: *Circles in the Stream*, True North TN 30.

Leonard Cohen: *The Best of Leonard Cohen*, Columbia ES 90334.

Stompin' Tom Connors: *My Stompin' Grounds*, Boot 7103.

Cowboy Junkies: *The Trinity Sessions*, BMG 8568-2-R.

Crash Test Dummies: *The Ghosts That Haunt Me*, Arista ARCD 8677.

D

Céline Dion: *Céline Dion*, Columbia CK 52473.

F

Robert Farnon: *Music of Farnon*, Reference RR47CD.

Maynard Ferguson: *Birdland Dreamband*, Victrola VIK-LX-1070.

Sue Foley: *Ten Days in November*, Shananchie 8031.

David Foster: *Rechordings (1991)*, Warner CD 8229.

G

André Gagnon: *Greatest Hits*, Columbia PS 90159.

Robert Goulet: *Camelot*, Columbia KOL 5620.

The Guess Who: *Best of The Guess Who*, RCA LSPX 1004.

Gregory Hoskings and the Stick People: *Raids on the Unspeakable*, True North TNK-81.

J

Pauline Julien: *Suite québecoise*, Gamma GS 112.

K

Moe Koffman: *Best of Moe Koffman*, GRT 9230-1053.

Diana Krall: *Stepping Out*, Justin Time Just-50-2.

L

k.d. lang: *Ingenue*, Warner CD 26840.

Daniel Lanois: *For the Beauty of Winona*, Warner CDW-45030.

Félix Leclerc: *Félix Leclerc et sa guitare*, Epic LF 2001.

Claude Léveillée: *Léveillée à Paris*, Columbia PS 816; *Claude Léveillée à la Place des Arts*, Columbia FS 611.

Monique Leyrac: *Monique Leyrac en concert*, Columbia PS 644.

Gordon Lightfoot: *The Way I Feel*, United Artists UAS 6587.

Guy Lombardo: *The Sweetest Music This Side of Heaven: 1932 – 9*, Decca 74229.

M

Michaela Foster Marsh: *Fairy Tales and the Death of Innocence*, Kavanaugh, HD3078.

Kate and Anna McGarrigle: *Kate and Anna McGarrigle*, Warner BS 2862.

Ashley MacIsaac: *Hi How Are You*, PolyGram PGS 7960220012.

Loreena McKennitt: *The Visit*, Warner WEA 75151.

Catherine McKinnon: *Voice of an Angel*: Arc AS 628-666.

Sarah McLachlan: *Fumbling Towards Ecstasy*, Nettwerk W2-6321.

Murray McLauchlan: *Day to Day Dust*, True North TN 14.

Don Messer and his Islanders: *The Good Old Days*, MCA TVLP 79052.

Lyn Miles: *Chalk This One Up to the Moon*, Snowy River SRR-S30-CD.

Joni Mitchell: *Clouds*, Reprise RS 6341.

Alanis Morissette: *Jagged Little Pill*, Maverick Reprise CDW 45901.

Moxy Früvous: *Bargainville*, Warner WEA 93134.

Anne Murray: *A New Kind of Feeling (1978)*, Capitol SW 11849.

N

Nexus: *The Best of Nexus*, Nexus 10251.

P

Kenneth Patchen: *Kenneth Patchen Reads with Jazz in Canada*, Folkways FL9718.

Oscar Peterson: *The Jazz Soul of Oscar Peterson*, Verve 5331002 *Night Train*, Verve, 8217242.

R

The Rankin Family: *The Rankin Family*, Rankin RFCD-8901.

Robbie Robertson: *Storyville*, Geffen GESSD-24303.

Rush: *Permanent Waves*, Anthem ANR-1-1021.

Jane Siberry: *When I Was a Boy*, Warner WEA 26824.

S

Sloan: *Twice Removed*, Geffen DGCSD 24711.

Laura Smith: *Between the Earth and My Soul*, Cornermuse MCASD-1032.

Hank Snow: *The Best of Hank Snow*, RCA-LSP-3478.

Stringband: *Canadian Sunset*, Nick-1.

T

The Tragically Hip: *Road Apples*, MCA 10173.

Shania Twain: *The Woman in Me*, PolyGram, PGS 3145228862.

Ian and Sylvia Tyson: *The Evening Concerts*, Vanguard 78148.

V

Gilles Vigneault: *Mon pays*, Columbia PS 634.

Y

Neil Young: *After the Gold Rush*, Reprise 6383.

Best Classical Albums

A

Pierrette Alarie (soprano), **Gabriel Faure**: *Requiem*, Lamoureaux Orchestra, Jean Fournet (conductor), Epic LC 3044.

Pierrette Alarie (soprano) and **Léopold Simoneau** (tenor): *Mozart Arias and Duets*, CBC Montréal Orchestra, Jean-Marie Beaudet (conductor), Radio-Canada International RCI-147.

B

Donald Bell (bass-baritone), **Ralph Vaughan Williams**: *Serenade to Music*, New York Philharmonic, Leonard Bernstein (conductor), Columbia MS-7177.

Alexander Brott (conductor), **Pierre Mercure**: *Divertissement*, Montréal Chamber Orchestra, Radio-Canada International RCI-154.

Canadian Brass: *Canadian Brass in Paris*, Boot BMC 3003.

E

James Ehnes (violin), **Paganini**: *24 Caprices*, Telarc 80398.

Elmer Iseler Singers, Elmer Iseler (conductor): *Gloria: Sacred Choral Works*, CBC MVCD-1058.

F

Maureen Forrester (contralto), **Harry Somers**: *Five Songs for Dark Voice*, NAC Orchestra, Mario Bernardi (conductor), CBC 286.

G

Glenn Gould (piano), **J. S. Bach**: *The Goldberg Variations*, Columbia ML 5060; **J. S. Bach**: *Toccatas*, Columbia M-35144, M-35831; **J. S. Bach**: *Keyboard Concertos*, CBS MYK 38524; *The Solitude Trilogy*, CBC PSCD-2003-3.

H

Marc-André Hamelin (piano): *Marc-André Hamelin at Wigmore Hall*, Hyperion 66765; **Kaikhosru Shapurji Sorabji**: *Sonata Number 1 for Piano*, Altarus CD 9050. *Marc-André Hamelin Plays Liszt*, Hyperion (UK) 66874.

Moshe Hammer (violin), **Valerie Tryon** (piano), **William Beauvais** (guitar): *Dances and Romances for Violin*, CBC MVCD-1071.

Ben Heppner (tenor), **Carl Maria von Weber**: *Oberon*, Cologne Philharmonic Orchestra, James Conlon (conductor), EMI Classics CDCB 54739.

Angela Hewitt (piano): *J. S. Bach: The Well-Tempered Clavier, Books I and II*, Hyperion CDA67301/2; CDA67303/4.

Gwen Hoebig (violin), *The Lark Ascending*: Winnipeg Symphony Orchestra, Bramwell Tovey (conductor), CBC SMCD 5176.

J

Edward Johnson (tenor): *Great Voices of Canada, Volumes 1 and 2*, Analekta AN-7801 and AN-7802.

K

Norbert Kraft (guitar): *The Blue Guitar*, Chandos 8784.

Anton Kuerti (piano): *Complete Beethoven Piano Sonatas*, Aquitaine M35 90365-9. M4S 90361-74.

L

André Laplante (piano), **Sergei Rachmaninoff**: *Piano Concerto Number 3 in D Minor*, Alexander Lazarev (conductor), CBC-SM-352.

Hugh LeCaine (composer): *Dripsody*, Folkways FM 34360.

Louis Lortie (piano), **Maurice Ravel**: *Complete Piano Music*, Chandos 7004.

M

Richard Margison, *French and Italian Arias*, CBC Records 5158.

Lois Marshall (soprano), **Ludwig van Beethoven**: *Missa Solemnis*, NBC Symphony, **Arturo Toscanini** (conductor), Robert Shaw Chorale, RCA-LM-6013.

N

The Naxos Introduction to Canadian Music, Naxos 8.550171-2.

Zara Nelsova (cello), **Ernest Bloch**: *Schelomo*, Ernest Bloch, conductor, London-LS-138.

O

Orchestra symphonique de Montréal, **Charles Dutoit** (conductor), **Maurice Ravel**: *Daphnis and Chloé*, London 400055; *Carmina Burana*, London 455-290-2.

Orford String Quartet, Felix Mendelssohn: *Quartets 12 and 13*, London LCS-7079.

P

Wilfrid Pelletier (conductor/piano): *Homage: 100th Anniversary*, Les Disques Fonovox Vox 7817-2.

Puirt a Baroque: *Bach meets Cape Breton*, Marquis Classics ERAD 181.

Q

Gino Quilico (baritone), **Emmanuel Chabrier**: *Le roi malgré lui*, Radio France Symphony, Charles Dutoit (conductor), Erato 45792.

Louis Quilico (baritone), **Jules Massenet**: *Esclarmonde*, National Philharmonic Orchestra, Richard Boynyge (conductor), Decca 612.

R

Shauna Rolston (cello): *Elgar and Saint-Saens Cello Concertos*, Calgary Philharmonic Orchestra, Mario Bernardi (conductor), CBC SMCD5147.

S

R. Murray Schafer: *String Quartet Number 2, Waves*, Orford String Quartet, Melbourne SMLP-4038.

Léopold Simoneau (tenor): *Famous Opera Arias*, Vienna Symphony Orchestra, Bernhard Paumgartner (conductor), Epic LC-3262; **Mozart**: *Cosi Fan Tutte*, Philharmonia Orchestra, Herbert von Karajan (conductor), 3 Angel 3522.

Steven Staryk (violin), **Richard Strauss**: *Ein Heldenleben*, Sir Thomas Beecham (conductor), Seraphim 60041.

Teresa Stratas (soprano), **Alban Berg**: *Lulu*, Pierre Boulez (conductor), Deutsche Grammophon 2-DG 2711-024.

T

Tafelmusik Baroque Orchestra, Jeanne Lamon (conductor), **Luigi Boccherini**: *Concerto da Violon-cello, Sinfonie*, Deutsche Harmonia Mundi 7867; **Henry Purcell**: *Dido and Aeneas*, CBC SMCD5147.

Valerie Tryon (piano), **Frédéric Chopin**: *Scherzos and Ballades*, CBC MVCD 1092.

Ronald Turini (piano): *Beethoven, Scriabin, Liszt, Ravel*, RCA 211.

V

Richard Verreau (tenor): *Quelques grands airs*, Wilfrid Pelletier (conductor), RCA LSC-2458.

Jon Vickers (tenor), **Giuseppe Verdi**: *Otello*, Berlin Philharmonic, Herbert von Karajan (conductor), 3-Angel SX3809.

W

James Healey Willan: *Sacred Choral Pieces*, Vancouver Chamber Choir, Jon Washburn (conductor), Virgin Classics 45183.

Juno Awards

THE Juno Awards were established in 1974 to honour achievement in the Canadian recording industry. The name was chosen to honour Pierre Juneau, former head of the Canadian Radio-television and Telecommunications Commission (CRTC), which instituted Canadian-content requirements in Canada's broadcast industry. Record sales determine nominations for most Juno categories. However, the actual winners are chosen by a vote of members of the Canadian Academy of Recording Arts and Sciences. No awards were given in 1988. Following the 1987 awards, the Juno presentations were moved from the fall to the spring of 1989. The 1989 awards were for 1988 releases. The following list is only a partial one.

Album of the Year

1999: Céline Dion, *Let's Talk About Love*
1998: Sarah McLachlan, *Surfacing*
1997: The Tragically Hip, *Trouble at the Henhouse*
1996: Alanis Morissette, *Jagged Little Pill*
1995: Céline Dion, *Colour of My Love*
1994: Neil Young, *Harvest Moon*
1993: k.d. lang, *Ingenue*
1992: Tom Cochrane, *Mad Mad World*
1991: Céline Dion, *Unison*
1990: Alannah Myles, *Alannah Myles*
1989: Robbie Robertson, *Robbie Robertson*
1987: Kim Mitchell, *Shakin' Like A Human Being*
1986: Glass Tiger, *Thin Red Line*
1985: Bryan Adams, *Reckless*
1983/84: Bryan Adams, *Cuts Like a Knife*
1982: Loverboy, *Get Lucky*
1981: Loverboy, *Loverboy*

1980: Anne Murray, *Greatest Hits*
1979: Anne Murray, *New Kind of Feeling*

Bestselling Album

1978: Burton Cummings, *Dream of a Child*
1977: Dan Hill, *Fuse*
1976: André Gagnon, *Neiges*
1975: Bachman-Turner Overdrive, *Four Wheel Drive*
1974: Bachman-Turner Overdrive, *Not Fragile*

Single of the Year

1999: Barenaked Ladies, "One Week"
1998: Sarah McLachlan, "Building A Mystery"
1997: Alanis Morissette, "Ironic"
1996: Alanis Morissette, "You Oughta Know"

1995: Jann Arden, "Could I Be Your Girl"
1994: The Rankin Family, "Fare Thee Well Love"
1993: Céline Dion/Peabo Bryson, "Beauty and the Beast"
1992: Tom Cochrane, "Life Is a Highway"
1991: Colin James, "Just Came Back"
1990: Alannah Myles, "Black Velvet"
1989: Blue Rodeo, "Try"
1987: Glass Tiger, "Someday"
1986: Glass Tiger, "Don't Forget Me (When I'm Gone)"
1985: Corey Hart, "Never Surrender"
1983/84: The Parachute Club, "Rise Up"
1982: Payola$, "Eyes of a Stranger"
1981: Loverboy, "Turn Me Loose"
1980: Anne Murray, "Could I Have This Dance"
Martha & The Muffins, "Echo Beach"
1979: Anne Murray, "I Just Fall in Love Again"

Bestselling Single

1978: Nick Gilder, "Hot Child in the City"
1977: Patsy Gallant, "Sugar Daddy"
1976: Sweeney Todd, "Roxy Roller"
1975: Bachman-Turner Overdrive, "You Ain't Seen Nothing Yet"
1974: Terry Jacks, "Seasons in the Sun"

Entertainer of the Year

1996: Shania Twain
1995: The Tragically Hip
1994: The Rankin Family
1993: The Tragically Hip
1992: Bryan Adams
1991: The Tragically Hip
1990: The Jeff Healey Band
1989: Glass Tiger
1987: Bryan Adams

Group of the Year

1999: Barenaked Ladies
1998: Our Lady Peace
1997: The Tragically Hip
1996: Blue Rodeo
1995: The Tragically Hip
1994: The Rankin Family
1993: Barenaked Ladies
1992: Crash Test Dummies
1991: Blue Rodeo
1990: Blue Rodeo
1989: Blue Rodeo
1987: Red Rider
1986: Honeymoon Suite
1985: The Parachute Club
1983/84: Loverboy
1982: Loverboy
1981: Loverboy
1980: Prism
1979: Trooper
1978: Rush
1977: Rush
1976: Heart
1975: Bachman-Turner Overdrive
1974: Bachman-Turner Overdrive

Female Vocalist of the Year

1999: Céline Dion
1998: Sarah McLachlan
1997: Céline Dion
1996: Alanis Morisette
1995: Jann Arden
1994: Céline Dion
1993: Céline Dion
1992: Céline Dion
1991: Céline Dion
1990: Rita MacNeil
1989: k.d. lang
1987: Luba
1986: Luba
1985: Luba
1983/84: Carole Pope

1982: Carole Pope
1981: Anne Murray
1980: Anne Murray
1979: Anne Murray
1978: Anne Murray
1977: Patsy Gallant
1976: Patsy Gallant
1975: Joni Mitchell
1974: Anne Murray

Male Vocalist of the Year

1999: Jim Cuddy
1998: Paul Brandt
1997: Bryan Adams
1996: Colin James
1995: Neil Young
1994: Roch Voisine
1993: Leonard Cohen
1992: Tom Cochrane
1991: Colin James
1990: Kim Mitchell
1989: Robbie Robertson
1987: Bryan Adams
1986: Bryan Adams
1985: Bryan Adams
1983/84: Bryan Adams
1982: Bryan Adams
1981: Bruce Cockburn
1980: Bruce Cockburn
1979: Burton Cummings
1978: Gino Vannelli
1977: Dan Hill
1976: Burton Cummings
1975: Gino Vanelli
1974: Gordon Lightfoot

Country Group of the Year

1999: Leahy
1998: Farmer's Daughter
1997: The Rankin Family
1996: Prairie Oyster

1995: Prairie Oyster
1994: The Rankin Family
1993: Tracey Prescott & Lonesome Daddy
1992: Prairie Oyster
1991: Prairie Oyster
1990: The Family Brown
1989: The Family Brown
1987: Prairie Oyster
1986: Prairie Oyster
1985: The Family Brown
1983/84: Good Brothers
1982: Good Brothers
1981: Good Brothers
1980: Good Brothers
1979: Good Brothers
1978: Good Brothers
1977: Good Brothers
1976: Good Brothers
1975: Mercey Brothers
1974: Carlton Showband

Country Female Vocalist of the Year

1999: Shania Twain
1998: Shania Twain
1997: Shania Twain
1996: Shania Twain
1995: Michelle Wright
1994: Cassandra Vasik
1993: Michelle Wright
1992: Cassandra Vasik
1991: Rita MacNeil
1990: k.d. lang
1989: k.d. lang
1987: k.d. lang
1986: Anne Murray
1985: Anne Murray
1983/84: Anne Murray
1982: Anne Murray
1981: Anne Murray
1980: Anne Murray
1979: Anne Murray
1978: Carroll Baker
1977: Carroll Baker

1976: Carroll Baker
1975: Anne Murray
1974: Anne Murray

Country Male Vocalist of the Year

1999: Paul Brandt
1998: Paul Brandt
1997: Paul Brandt
1996: Charlie Major
1995: Charlie Major
1994: Charlie Major
1993: Gary Fjellgaard
1992: George Fox
1991: George Fox
1990: George Fox
1989: Murray McLauchlan
1987: Ian Tyson
1986: Murray McLauchlan
1985: Murray McLauchlan
1983/84: Murray McLauchlan
1982: Eddie Eastman
1981: Ronnie Hawkins
1980: Eddie Eastman
1979: Murray McLauchlan
1978: Ronnie Prophet
1977: Ronnie Prophet
1976: Murray McLauchlan
1975: Murray McLauchlan
1974: Stompin' Tom Connors

Instrumental Artist of the Year

1999: Natalie McMaster
1998: Leahy
1997: Ashley MacIsaac
1996: Liona Boyd
1995: André Gagnon
1994: Ofra Harnoy
1993: Ofra Harnoy
1992: Shadowy Men on a Shadowy Planet
1991: Ofra Harnoy
1990: Manteca

1989: David Foster
1987: David Foster
1986: David Foster
1985: The Canadian Brass
1983/84: Liona Boyd
1982: Liona Boyd
1981: Liona Boyd
1980: Frank Mills
1979: Frank Mills
1978: Liona Boyd
1977: André Gagnon
1976: Hagood Hardy
1975: Hagood Hardy

Best Classical Album (Solo or Chamber Ensemble)

1999: Angela Hewitt, Bach: *Well-Tempered Clavier – Book 1*
1998: Marc-André Hamelin: *Marc-André Hamelin Plays Liszt*
1997: Marc-André Hamelin, Scriabin: *The Complete Piano Sonatas*
1996: Marc-André Hamelin, Aikan: *Grande Sonate/Sonatine*
1995: Erica Goodman: *Erica Goodman Plays Canadian Harp Music*
1994: Louis Lortie, Beethoven: *Piano Sonatas, Op. 10, Nos. 1 – 3*
1993: Louis Lortie, Ludwig van Beethoven: *Piano Sonatas*
1992: Louis Lortie, Franz Liszt: *Années de pèlerinage*
1991: Orford String Quartet, R. Murray Schafer: *Five String Quartets*
1990: Louis Lortie: *20th-century Original Piano Transcriptions*
1989: Ofra Harnoy, Franz Schubert: *Arpeggione Sonata*
1987: The Orford String Quartet/Ofra Harnoy, Franz Schubert: *Quintetin C*
1986: James Campbell and Eric Robertson: *Stolen Gems*
1985: The Orford String Quartet, W. A. Mozart: *String Quartets*

Best Classical Album (Large Ensemble)

1999: Tafelmusik Baroque Orchestra, Jeanne Lamon (musical director), Handel: *Music For The Royal Fireworks*

1998: James Sommerville (horn), CBC Vancouver Orchestra, Mario Bernardi (conductor): *Mozart Horn Concertos*

1997: I Musici de Montréal: *Ginastera/ Villa-Lobos/Evangelista*

1996: Orchestra symphonique de Montréal, Shostakovich: *Symphonies 5 and 9*

1995: Tafelmusik Baroque Orchestra, Bach: *Brandenburg Concertos Nos. 1–6*

1994: Tafelmusik Baroque Orchestra, Handel: *concerti Grossi, Op. 3, Nos. 1–6*

1993: Tafelmusik Baroque Orchestra, George Frederick Handel: *Excerpts Floridante*

1992: Orchestre symphonique de Montréal, Charles Dutoit (conductor), Debussy: *Pelléas et Mélisande*

1991: Orchestre symphonique de Montréal, Charles Dutoit (conductor), Debussy: *Images; Nocturnes*

1990: Tafelmusik Baroque Orchestra, Luigi Boccherini: *Cello Concertos and Symphonies*

1989: Orchestre symphonique de Montréal, Charles Dutoit (conductor), Bartók: *Concerto for Orchestra and Music for Strings, Percussion and Celeste*

1987: Orchestre symphonique de Montréal, Charles Dutoit (conductor), Gustav Holst: *The Planets*

1986: Toronto Symphony Orchestra, Andrew Davis (conductor), Gustav Holst: *The Planets*

1985: Orchestre symphonique de Montréal, Charles Dutoit (conductor), Maurice Ravel: *Ma mère l'oye; Pavane pour une infante défunte; Valses nobles et sentimentales*

Best Classical Album (Vocal or Choral Performance)

1997: Choeur et Orchestra symphonique de Montréal, Charles Dutoit (conductor), Berlioz: *La damnation de Faust*

1996: Ben Heppner, Toronto Symphony Orchestra, Andrew Davis (conductor): *Ben Heppner Sings Richard Strauss*

1995: Choeur et Orchestra symphonique de Montréal, Charles Dutoit (conductor), Berlioz: *Les Troyens*

1994: Claudette Leblanc (soprano), Valerie Tryon (piano): *Debussy Songs*

Best Classical Recording

1983/84: Glenn Gould: Johannes Brahms, *Ballades Op. 10* and *Rhapsodies Op. 79*

1982: Glenn Gould, J. S. Bach: *The Goldberg Variations*

1981: Orchestre symphonique de Montréal, Charles Dutoit (conductor), Maurice Ravel: *Daphnis and Chloé*

1980: Arthur Ozolins: *Stravinsky Piano Music and Chopin Ballads*

1979: Judy Loman, R. Murray Schafer: *The Crown of Ariadne*

1978: Glenn Gould and Roxolana Roslak, Paul Hindemith: *Das Marienleben*

1977: Toronto Symphony Orchestra: *Three Borodin Symphonies*

1976: Anton Kuerti, Ludwig van Beethoven: *Piano Music, Volumes 1, 2 and 3*

Best Classical Composition

1999: Colin McPhee, *Concerto For Wind Orchestra*

1998: Malcolm Forsyth, *Electra Rising*

1997: Harry Somers, *Picasso Suite (1964)*

1996: Andrew P. MacDonald, *Concerto for Violin and Orchestra*

1995: Malcolm Forsyth, *Sketches from Natal*

1994: Chan Ka Nin, *Among Friends*

1993: R. Murray Schafer, *Concerto for Flute and Orchestra*

1992: Michael Conway Baker, *Concerto For Piano and Chamber Orchestra*

1991: R. Murray Schafer, *String Quartet No. 5 — "Rosalind"*

1990: Oskar Morawetz, *Concerto For Harp and Chamber Orchestra and Harp Concertos*

1989: Alexina Louie, *Songs of Paradise*

1987: Donal Steven, *Pages of Solitary Delights*

Best Jazz Album

1999: Metalwood, *Metalwood 2* (Best Contemporary Jazz Album)

1998: Metalwood, *Metalwood* (Best Contemporary Jazz Album)

1997: Joe Sealy, *Africville Suite*

1996: Neufeld-Occhipinti Jazz Orchestra, *NOJO*

1995: Jim Hillman and the Merlin Factor, *The Merlin Factor*

1994: Holy Cole Trio, *Don't Smoke in Bed*

1993: P. J. Perry, *My Ideal*

1992: Renée Rosnes, *For the Moment*; Brian Dickinson, *In Transition*; and Rob McConnell and The Boss Brass, *The Brass Is Back*

1991: Mike Murley, *Two Sides*

1990: Jon Ballantyne Trio, featuring Joe Henderson, *Skydance*

1989: The Hugh Fraser Quintet, *Looking Up*

1987: The Oscar Peterson Four, *If You Could See Me Now*

1986: Oliver Jones, *Lights of Burgundy*

1985: Don Thompson, *A Beautiful Friendship*

1983/84: Rob McConnell and The Boss Brass, *All In Good Time*

1982: Fraser MacPherson/Oliver Grannon: *I Didn't Know About You*

1981: The Brass Connection, *The Brass Connection*

1980: Rob McConnell and The Boss Brass, *Present Perfect*

Best Mainstream Jazz Album

1999: Kirk MacDonald, *The Atlantic Sessions*

1998: The Hugh Fraser Quintet, *In the Meantime*

1997: Renée Rosnes, *Ancestors*

1996: Ingrid Jensen, *Vernal Fields*

1995: Free Trade, *Free Trade*

1994: Dave Young/Phil Dwyer Quartet, *Fables and Dreams*

Hall of Fame Award

1999: Luc Plamondon

1998: David Foster

1997: Lenny Breau, Gil Evans, Maynard Ferguson, Moe Koffman, Rob McConnell

1996: David Clayton-Thomas, Denny Doherty, John Kay, Domenic Troiano, Zal Yanovsky, Ronnie Hawkins

1995: Buffy Sainte-Marie
1994: Rush
1993: Anne Murray
1992: Ian and Sylvia Tyson
1991: Leonard Cohen
1990: Maureen Forrester
1989: The Band
1987: The Guess Who
1986: Gordon Lightfoot
1985: Wilf Carter

1984: Crewcuts, Diamonds, Four Lads
1983: Glenn Gould
1982: Neil Young
1981: Joni Mitchell
1980: Paul Anka
1979: Hank Snow
1978: Guy Lombardo, Oscar Peterson

Source: Canadian Academy of Recording Arts and Sciences

Some Distinguished Canadian Composers and Musical Personalities

Serge Garant (1929 – 86): Born in Québec City, Garant was a composer, conductor, pianist, teacher and critic. He was a significant composer who used tape recorders, aleatory or chance methods and other advanced techniques in some of his compositions. Active in major professional organizations, he worked for the CBC and studied with Olivier Messiaen, Pierre Boulez and other eminent teachers. His grounding in music was excellent, and what he learned he shared with younger Québec composers. Garant's work is serious and complex, disciplined and sometimes noble in reach. He occupies an important place in both Canadian music and the musical history of Québec.

Edward Johnson (1878 – 1959): A talented Canadian tenor, Johnson was born in Guelph, Ontario, but made his reputation in Italy (as Edoardo di Giovanni) and later joined the Metropolitan Opera in New York, where for 13 years he was a leading singer. He became general manager of the Met in 1935 and served there until 1950. Johnson was an outstanding tenor whose recordings are now being released on CD, and he was manager of the Met during

what was probably one of its greatest eras. He played no small part in this achievement, introducing many new productions and establishing harmonious relations with many great singers, which, in some ways, made a marked contrast with the performance of Rudolf Bing, who succeeded him.

Calixa Lavallée (1842 – 91): Composer of the music to "O Canada!", Lavallée was a choirmaster and prolific composer who wrote piano music and operas as well as orchestral and other works. He fought in the American Civil War and at one point advocated political union between Canada and the United States! One of the most important Québec musical prizes is named after him.

Sir Ernest Alexander Campbell MacMillan (1893 – 1973): Born in Etobicoke, Ontario, this conductor of symphonic and choral music was one of the outstanding figures in Canadian music from the 1920s through the end of the Second World War. During the First World War, MacMillan was interned in Germany as an enemy alien. After the war, he returned to Toronto to become a church organist and

teacher and was an eloquent writer on musical subjects. Subsequently, he became a University of Toronto academic and conducted choral music, then was appointed conductor of the Toronto Mendelssohn Choir. Always in demand as a guest conductor, he was showered with honours toward the end of his life. Some of his recordings with the Toronto Symphony retain a great deal of historical interest.

Wilfrid Pelletier (1896 – 1982): A distinguished Canadian conductor who was known for his sensitive accompaniments to vocalists, Pelletier served many years at New York's Metropolitan Opera and eventually rose to the position of conductor of the French repertory. Many collectors still treasure his accompaniments to some of the great singers of the 1930s and 1940s. In Canada he was the founding director of the Conservatoire de musique du Québec. He was the first artistic director of the orchestra of the Société des concerts symphoniques de Montréal (1935 – 1940), artistic director of the Québec Symphonic Orchestra (1951 – 60), a founder of the Société de musique contemporaine du Québec (1966) and national chairperson of Jeunesses musicales du Canada (1962 – 69). The music hall of Montréal's Place des Arts was named after this distinguished Canadian musician.

Raymond Murray Schafer (1933 –): This composer, writer and educator was born in Sarnia, Ontario. A distinguished composer, Schafer is a man of scholarship and ideas and an innovator with concern for the soul, the senses and the environment. He is fascinated by non-Western music, philosophy and religion and in the early 1980s created the experimental experience called *Ra*, which saw participants at the Ontario Museum of Science spend the night in ritual meditation in order to celebrate, or rather enact, the rebirth of the sun. Schafer founded the World Soundscape Project out of his interest in the environment, no doubt recalling that in the early Sumerian story the gods destroy the Earth because it is too noisy. He is also an expert on the poetry of Ezra Pound. Schafer has written many notable compositions for all sizes of ensembles.

Harry Stewart Somers (1925 –): Born in Toronto, Somers studied piano and classical guitar but turned to composing after studying with Darius Milhaud in Paris. He is a founding member of the Canadian League of Composers. Like R. Murray Schafer, he became interested in Eastern philosophy and music. He may be the Canadian composer most performed outside Canada; certainly his opera *Louis Riel* lays claim to being the best Canadian work in that field. Somer's music is unfussy, strong in character and often rich and meditative.

John Jacob Weinzweig (1913 –): Born in Toronto, Weinzweig has exerted considerable influence on Canadian composers who are over 40. The first Canadian to follow the 12-tone compositional method, he began teaching at the Toronto Conservatory in 1939 and became composition professor at the University of Toronto in the mid-1950s. Weinzweig was a co-founder of the Canadian League of Composers (1951) and the Canadian Music Centre (1959). His ballet suite *Red Ear of Corn* (1959) is one of his best-known works.

James Healey Willan (1880 – 1968): Born in London, England, Healey Willan came to Canada in 1913. He was an organist and choirmaster of great distinction, as well as a fine composer in a conservative, rather sumptuous style. Recently some of his music has appeared on CD, and there is no doubt he will occupy a permanent place in Canada's musical history, probably as a composer as well as a teacher, conductor and organist.

Ten Canadian "Hits" From the Past

- "When You and I Were Young, Maggie" (James A. Butterfield, words by G.W. Johnson, 1866)
- "The Maple Leaf Forever" (Alexander Muir, 1867)
- "Alouette" (anonymous, probably 1870s)
- "O Canada" (music by Calixa Lavallée, French words by Sir Adolphe-Basile Routhier, 1880; most popular English version by Robert Stanley Weir, 1908)
- "Darktown Strutter's Ball" (Sheldon Brooks, 1915)
- "When My Baby Smiles at Me" (Billy Munro, lyricist uncertain, 1919)
- "Squid Jiggin' Ground" (Arthur Scammell, 1928)
- "Tumbling Tumbleweeds" (Bob Nolan, 1933 – 34)
- "I'll Never Smile Again" (Ruth Lowe, 1939)
- "Cool Water" (Bob Nolan, 1950)

3
Visual Arts

CANADA is a good place to enjoy the visual arts. In our large cities, public, private and municipal galleries abound, while artists' collectives or special spaces are common. And our contemporary art is not limited to gallery walls: it appears as street sculpture, in ad hoc photo exhibitions, as oil paintings or watercolours displayed in cafés and restaurants or as bright murals adorning small town garages or office buildings in the city. Canadians have never had better opportunities to see the great art of the past and present. European, Asian and African art, as well as the art of the Americas, are regularly featured in our public galleries. And this is not even to take into account the miracles of the World Wide Web, which many institutions have increasingly made use of in the conviction that a virtual experience of art is better than no experience at all.

If the public has never had it so good, the same is not quite true of the artists and exhibitors. For despite the positive factors just mentioned, the individual artist is still confronted with the myriad problems of getting a showing in a society where visual sensitivities are rarely fostered. Our city planners and engineers are mostly indifferent to aesthetic considerations. Our suburbs are uniformly bland, and our shopping-centre architecture—in the age of the mega-store—has too much of the impersonality of the warehouse. Our children grow up with television and computer imagery that is repetitive and brain-dulling, and since Canadian art education is minimal or non-existent, most of our citizens have no reference points from which to judge new visual creations.

At the same time, public funding of the arts has dwindled and a formidable list of barriers—including the expenditure of much time and money—lies between the making of an artwork and its display in a gallery. Exhibitors, who suffer from public indifference and government cutbacks, are no less harried. The cost of showing art is high and the rewards are not always great. In the brave new world of cultural egalitarianism and political correctness, the public galleries in particular have lost their status as elite institutions and have attempted—sometimes with great ingenuity,

at other times with ill success—to satisfy both the requirements of mass appeal on the one hand, and aesthetic coherence and curatorial scholarship on the other.

Despite imaginative attempts to woo the public, many citizens remain out of touch with the taste of the educated few, the professional artists and the "experts." The movement from representational to abstract art left many behind, and the next leap, which has carried us to the postmodern dissolving of boundaries, to conceptual art, video art, installations and performances, has meant an almost complete alienation of the general public from advanced tastes. This is a gap that can only be bridged by education—but what form such education should take, and how to finance it, are contentious matters.

Many Canadians remain hostile or indifferent to contemporary "happenings." They do not understand why postmodern, feminist, environmental or body art should be paid for by public funding. Architecture and photography, also subject to controversy, are seen at least to be anchored in reality: a building has a use, and photographs are pictures of something. But what to make of a conceptual piece such as Eric Cameron's *Camera Inserted in My Mouth* (1973 – 76), a 30-minute videotape of the artist's saliva flow, or Bill Vazan's creation of the same period, which consisted of drawing two large curved lines offshore from both the East and West Coasts of our nation's land mass to "put Canada in parenthesis." The National Gallery of Canada (NGC)'s well-known battles during the 1980s and 1990s on behalf of modern artists like Barnett Newman, Jana Sterbak and Mark Rothko are symptomatic of a cultural information gap that most curators of public galleries feel it incumbent upon themselves to bridge. In the case of *Voice of Fire*, Newman's $1.8-million giant abstraction, the NGC argued that it was fundamentally a religious or mystical painting. Jana Sterbak's so-called "flesh dress" sculpture, which disgusted some because it incorporated raw meat, was exonerated on the grounds that the artist wished to shock us into new perceptions. And when Mark Rothko's painting, *Number 16*, was acquired in 1993, at the same purchase price as the Newman, the gallery tried mightily to explain its importance to a public that saw such a work as merely "noise on canvas" or as arbitrary daubs of colour, and one produced by a dead American at that.

Clearly, there is a serious sensibility gap between contemporary art and the public, one that the media often delights in, but which most curators have been working hard to close. When, in 1999, a child visitor to the NGC accidentally smashed part of a contemporary installation valued at $35,000, the *Ottawa Citizen* in a brief editorial used the incident to poke fun at contemporary artists and critics. Another debunking of contemporary art, this time in the *Toronto Sun*, stirred Maxwell Anderson, then

director of the Art Gallery of Ontario (AGO), to respond that it was easier to ridicule new art than to say something useful about it. The *Sun* critic later hailed realist painter Ken Danby and condemned Canada's public galleries as having "effectively banned" him in favour of supposedly incomprehensible postmodern stuff. The message here was that curators were out of touch with the taste of the time and that if the artists producing "unpalatable" art were not publicly funded they would simply disappear.

Such "populist" reactions, although historically uninformed and oversimplified, nonetheless point to the vulnerability of the new art of today compared with the new art of the past. Controversies certainly greeted new 19th-century art. Impressionists like Auguste Renoir and Claude Monet were damned by academicians while post-impressionists and symbolist paintings were excoriated by good middle-class citizens who saw such work as incomprehensible, decadent or immoral. When the public encountered painting that seemed even more challenging, works such as Marcel Duchamp's *Nude Descending a Staircase* (in the infamous New York Armory Show of 1913), this public furor grew strident. Even so, there was still a sense in which such art could be perceived as part of a tradition—perverse it might be, but it was a composition in a frame. Postmodern art, by contrast, has broken all such boundaries to become indistinguishable from "reality." Or, as some would say, it has acquired alternative significations (e.g., art belongs to a tribal sacrality, it expresses a certain kind of politics or it exists to reveal such and such about society).

The mission of the public gallery was probably never simple, but in having to deal with such intangibles, it seems to have grown dauntingly complex. At the same time, one can be sympathetic to some of the responses of the baffled public and question the notion that art is without boundaries. It might be argued that exhibitions featuring junk from the attic, used fluorescent lights, cast-off condoms and the like, while valid for those who wish to promote them, bear the same relation to vital art that systematic self-flagellation or sitting on pillars does to a vital sanctity in religion.

Funding cuts, the mandate to reach a broader public, the seeming incomprehensibility of much contemporary art—these are the jagged rocks that the Canadian public galleries have had to circumnavigate to avoid disaster. In recent decades, the most popular way of resolving such incompatible realities has been to opt for the blockbuster show. These shows—although not uniformly successful—at their best can have sex appeal or soul appeal. They can be, as some galleries have found, incomparable instruments for wooing, dazzling and also for enlightening the mass-market audience. Although the phenomenon goes back at least as far as the vastly popular and much circulated *Treasures of Tutankhamen* show of 1976 – 77, the

first consistent Canadian blockbuster shows appeared in the 1980s, in particular at the Montréal Museum of Fine Arts (MMFA) under its then director, Pierre Théberge, sometimes known as "Mr. Blockbuster." The MMFA drew 517,000 visitors to its Pablo Picasso show of 1985, 436,419 to see its Leonardo da Vinci show of 1987, and 256,738 to *Monet at Giverny*, which ran in 1999. During 1994 – 95 nearly 600,000 people flocked to the Art Gallery of Ontario to see the Barnes exhibition, a small assortment of work by Renoir, Paul Cezanne, Henri Matisse and others on loan from a famous Philadelphia collection. Despite its miscellaneous character, this exhibition generated net revenues of $2.6 million for the gallery, and brought an estimated $71 million into the Canadian economy. In 1997, 340,000 visitors dropped in at the NGC to see the Renoir portraits with comparably stimulating effects on the gallery coffers and the local economy.

Part of the appeal of these exhibitions is that they flatter the taste (or prejudices) of a middle-class audience, most of whom are dubious about much of the art produced after Matisse. One might see the blockbuster frenzy as an outbreak of nostalgia on the part of a public fed up with too many postmodern "installations," artworks that it is asked to love, but can't. The flight to the great masters, especially the impressionists, has also led to more partnerships between the public galleries and private enterprise, which, for obvious reasons, loves safe and popular images. Sponsorships by Midland Walwyn, Chrysler Canada, Chubb Insurance, and others, have in some cases made profitability possible for the galleries, whose exhibition costs sometimes far exceed their box office receipts and gift shop sales receipts. In addition, such sponsorships have provided not only a corporate imprimatur, but also glitzy openings, extra publicity and a sense of occasion beyond the art itself.

On the negative side, the shows in question have sometimes been "renovation shows," exhibitions that, like the Barnes, become possible because a gallery somewhere else must clear its holdings during building remodellings. Such exhibitions, since they don't spring from a particular curatorial vision, are often rather unfocused. It is always a good thing when visitors supply their own expertise and take away their own impressions—a gallery is a place for personal encounters with art, not passive consumption—but shows that have been well conceived by knowledgeable art historians can be enlightening in themselves. The MMFA's symbolist retrospective of 1995, an intended blockbuster, was a failure on that count, since it only drew 112,269 visitors, but it was brilliantly presented and became, for some visitors, a real cultural and artistic revelation. The exhibition of Renoir portraits at the NGC, on the other hand, was both hugely popular *and* aesthetically delightful, not to mention revelatory of some new sides of Renoir's art. And while corporate Canada was clinking glasses

beside the Picassos at the NGC show of 1998, the small gallery at Carleton University in Ottawa was providing an even more revealing look at Picasso by documenting the artist's minotaur graphics series, with enlightening commentary about its genesis in Picasso's eroticism and inner violence.

Because of the increasing credibility gap between artists and public referred to above, the federal Art Bank's function as a purchasing agent, repository and distribution centre for contemporary Canadian art is surely more important than ever. Despite some nagging management problems, the Art Bank had been performing valuable service. However, in 1995, a hasty, ill-prepared move by the Canada Council to reform it initiated a crisis that required an Art Bank Transition Advisory Committee to resolve. A new manager, Luc Rombout, introduced some economies, including the renting of a new storage facility. In 1999, he was replaced by Victoria Henry, formerly of the Canadian Museum of Civilization. The Art Bank owns some 18,000 works of art, nearly 7,000 of which are rented for public display to government and private clients across Canada, generating over $1 million in revenue annually. Although it is not currently buying art, the bank hopes that its private-sector marketing program, now in the planning stage, will enable it to resume purchasing within a few years.

In October 1996, the bank unveiled a pioneering CD-ROM program containing images of its complete collection. This movement into new technology was matched by many galleries, which in the late 1990s established elaborate Web sites and started to become part of a worldwide "virtual museum," nothing less than the "museum without walls" predicted in another context by the famous French art critic André Malraux in his book *The Voices of Silence*.

Works in the Art Bank collection have almost always been well chosen. Comparisons with some similar European agencies are revealing. In 1992, the Art Bank's Dutch equivalent offered the public at no cost several warehouses full of "treasures"— 215,000 state-purchased works of dubious quality that aroused only mirth when they saw the light of day. Canada's Art Bank clearly represents a sensible way in which government can assist in the familiarization of the public with contemporary art.

Just as there is no single "right" way to present art to the public, so there is no single dominant Canadian tradition of visual art; the country is too large, too culturally diverse. Canadian artistic traditions were still being formed at a time when Western art was rapidly moving away from representation and toward abstraction. Yet from the beginning Canadians have been highly sensitive to the visual world around them. Diverse and often spectacular scenery awaited the first settlers whose European techniques and perspectives produced an imaginary Canada—"sublime" in the 18th-

With a style marked by expressionistic distortions of form, the Group of Seven—some of whom are pictured here at Algonquin Park in 1914—came to define Canadian visual arts in the early part of the 20th century. From left: Tom Thomson, F. H. Varley, A. Y. Jackson, Arthur Lismer, Marjorie Lismer and Esther Lismer.

century manner, yet often visually stilted. This imaginary world was hardly different from those of the other early European colonies. By comparison, the first Canadian portraits of our settlers and of our native peoples, fashioned by painters such as Paul Kane and William Berczy, often flash forth with an immediate and startling sense of specific truth.

The real breakthrough in painting the Canadian natural environment occurred with the appearance of Tom Thomson and the Group of Seven in the early part of the 20th century. Their style has become, for good and ill, the most popular—the classic Canadian style. Only the magic realists (Alex Colville, Mary and Christopher Pratt, Ken Danby) have achieved a comparable level of public acceptance. But how to convince the public that such realism represents only one path, and that J. W. Morrice, Jean Paul Lemieux, Paul-Émile Borduas, Jean-Paul Riopelle, the Toronto and Montréal internationalists and many of the postmoderns, such as Michael Snow, Jana Sterbak and Barbara Astman, are also part of an emerging Canadian tradition? This, in fact, might be seen as one of the central educational missions of Canada's public galleries.

Indeed, in recent years, Canadians have dutifully trooped through exhibitions that have begun to fill in our visual past: an Emily Carr retrospective has toured the country, as has a Group of Seven show, and we have had exhibitions of Borduas and Riopelle, among others, at the MMFA. In 1996, the AGO mounted its occasionally vulgarized but helpful *OH! Canada* show. In 1998, the various Montréal galleries in particular celebrated with great élan the 50th anniversary of the founding of Les Automatistes. A retrospective of Cornelius Krieghoff will be seen in Toronto during 1999 – 2000. And some of our public galleries, despite much criticism on this score, have addressed the issue of representing local art: the Edmonton, Winnipeg and Victoria galleries, as well as the Nova Scotia and Newfoundland galleries, should be commended in this regard. During 1999, the Vancouver Art Gallery featured "Weak Thought," a collection of new abstract art from that city, as well as the work of internationally known Vancouver-based artist Stan Douglas.

Emily Carr sought to capture in her paintings the beauty and mystery of the Canadian wilderness—particularly that of the B.C. coast.

B.C. Archives D-06009

Traditional Native art occupies a special place in our cultural history. In recent decades, contemporary Native artists, with their unique perspectives on nature and society, have established a strong presence on the scene and have found new ways of relating their creative efforts both to their own traditional art and to Euro-Canadian themes and aesthetics. Although souvenir Native art is still all too prevalent, many dealers now feature some of the best of the traditional and modern examples, while public galleries across the country have achieved important collections. The best-known schools of contemporary Native art include West Coast (associated with sculptor Bill Reid), Inuit (mostly sculpture and printmaking), the Woodlands School of Art (stemming from the success of the Ojibway painter Norval Morriseau), and an increasing number of Native artists (Alex Janvier and Jane Ash Poitras among them) who have chosen to work independently of First Nations traditions without necessarily disowning the issues and imagery arising from this heritage.

The case of the Haida artist Bill Reid is particularly interesting. Born in Victoria,

UBC Museum of Anthropology / Bill McLennan

Haida artist Bill Reid with his sculpture Raven and the First Men *(1981).*

B.C., in 1920, of a Haida mother and a Canadian-American father, he had little contact with First Nations culture until 1954, when he studied Haida art in both Toronto and at various British Columbia archaeological sites. Gradually he mastered the skills of the Haida carvers and jewellery makers. After study in England, Reid returned to Canada to produce (despite the onset of Parkinson's disease) some of his greatest works. Among his most famous works are *Raven and the First Men*, a creative extension of traditional Haida sculpture, and *The Spirit of Haida Gwaii*, completed before his

death in 1998 and now on display in the Vancouver International Airport. His whole life, though, might be taken as a representation of the struggle of Native artists to establish creative contact with their heritage.

When we turn to sculpture and to video we find another way of contemplating both the very beginnings and the most recent developments in our traditions of visual arts. The 17th and early 18th centuries saw the appearance in Québec of indigenous wood sculptors of great skill, all of them influenced by the great French schools. Ecclesiastical and some secular work, notably ships' figureheads, are among the treasures left by such sculptors as Noel Lévasseur and Francis Baillairgé, both of whom came out of families of notable artists and artisans. The dawn of the 19th century saw Louis Quévillon, another master of woodcarving, at work in Montréal, while there was an enormous output of ships' figureheads in both Québec and in southern Ontario. The era of monumental wood sculpture ended even before the death, in 1928, of the famous sculptor Louis Jobin, who worked in Québec City at the Church of Sainte-Anne-de-Beaupré and carved in both wood and ice for carnivals and church festivals.

The advent of plaster and bronze sculpture coincided with the growth of a realist aesthetic. Celebration of historical roots was the mode, whether in Québec, Ontario or the West. Artists such as Louise-Phillipe Hébert, who fashioned the statue of Maisonneuve, founder of Montréal, now at the Place d'Armes in that city, and Emmanuel Otto Hahn, noted for his romanticized Native subjects, and others produced images of individuals or types from our history. The First World War saw a proliferation of monuments, some of them in retrospect seeming like gigantic public nuisances. More sensual and appealing pieces soon appeared, for example, the works of Alfred Laliberté, but true modernism in sculpture reached Canada at a rather late date. When it did arrive, in the 1950s and after, it came with a vengeance, and all traditional boundaries seemed to be broken, while new materials and radically new conceptions of the relation of a sculpture to a site emerged.

The famous English modernist Henry Moore was a great influence on Canadian sculptors, and the Moore collection at the Art Gallery of Ontario stands even today as a challenge and a delight to both artists and public. But the smooth surfaces and relatively massive volumes of Moore's work seem far removed from many contemporary pieces. Abstractions in metal, welded steel or moulded plastic, these are often directly opposed to older humanistic conceptions of what sculpture should be. Fibreglass constructions, found objects, walk-in sites with video projections or slogans that create a new relationship between spectator and object—these are only

a few of the new developments.

Postmodern artists such as Michael Snow, Liz Magor, Jana Sterbak, Ian Carr-Harris and others have played with and challenged both the vision and the ideology of the casual spectator. Since sculpture is often commissioned as part of a new construction and gets into parks and city squares, it remains a highly visible art, open to controversy and feedback from a sometimes baffled but seldom indifferent public.

Video art, by contrast, has developed as an esoteric and rather self-contained medium, ironically so, in view of our television-saturated society. Its connection with marginal or revolutionary ideologies is much stronger than is the case with painting or sculpture, although exploration of the forms of visual narrative have also been favoured, especially among Québec artists.

A-Space, the first Canadian artist-run video centre, opened in Toronto in the 1970s. The Canada Council created its media-arts section in the 1980s, by which time the major galleries were committed to doing exhibitions of video art. Only in the past decade, however, have we seen the evolution of video techniques into the new universe of computer technology, multimedia and virtual reality. Such art occupies the reality predicted by Canada's media guru Marshall McLuhan: it treats technology as the main "extension of man" and celebrates a narcissistic and almost impersonal world, one in which human experience is almost completely divorced from natural processes and flesh-to-flesh encounters.

No informed spectator would question the work of video art's best practitioners, such as Vera Frenkel, but one has many memories of time spent in general galleries in which exhibits devoted to this kind of art are passed over, or actively scorned, even by well-intentioned visitors. Indeed, to walk from a room full of traditional paintings into a space where a solitary monitor flickers with incomprehensible and seemingly interminable black-and-white images is a disconcerting experience even for the tolerant. Perhaps the real future of such art is not in the galleries, or even in special spaces designed for it, but on the home telecomputer of the future, where artists can lure the browser into sampling a medium that is both the fulfillment and the antithesis of television itself.

Architecture at its best eradicates self-consciousness about "art" and marries aesthetic experience to the everyday; this is hardly possible with cutting-edge painting or sculpture. If the modern visual artist finds difficulty in making contact with believers among the public, the contem-porary architect carries a different burden: the challenge of achieving a clear vision of functional beauty in a creative process that has become expensive, dauntingly complex, highly politicized and techno-

logically fragmented.

Canadian architecture at the turn of the new century, like our buildings of the previous 300 years or so, can be understood as part of wider stylistic movements that originate elsewhere. Yet our new architecture is far from boring or anonymous. Not unlike Americans, we have emerged from the somewhat sterile international style of the post-war era. Since the mid-1960s, we have been moving toward a healthy diversity of approaches, some of them playful, others retrospective, symbolic or challenging—and this without the benefit of a great and dominating national presence like Frank Lloyd Wright to lend courage to our new creators. Structures such as Moshe Safdie's Library Square in Vancouver, Douglas Cardinal's Canadian Museum of Civilization in Hull, Étienne

Vancouver Public Library / Oi Lun Kwan

Moshe Safdie's Library Square in Vancouver is a modern Colosseum devoted to books, not to battling gladiators.

Gaboury's Precious Blood Church in St. Boniface, Manitoba, and Peter Rose's Bradley House in North Hatley, Québec—these and others have the power to intrigue, challenge, amuse, baffle and, in some cases, even to strike awe in the spectator.

With architecture, however, politics and politicians are never far away—witness Pierre Trudeau's intervention in the choice of a plan for the National Gallery of Canada in the 1980s. That intervention has been generally judged to be a creative one, although more controversy attended a similar Trudeau intervention in the case of the Canadian Embassy in Washington in the 1970s. In 1999, yet another furor erupted when a jury of architects entrusted with choosing the architectural firms and plans for the new Canadian Embassy in Berlin, scheduled to be opened in 2001, was overruled by the Department of Foreign Affairs and International Trade. Whether such reversals of juried competitions would, in the long run, corrupt the whole process of governmental decision-making in architecture, or whether political intervention must be accepted as part of architectural realpolitik, is a matter that will be strongly debated long after this particular issue has been put to rest.

Since its invention in the 19th century, photography has always been a challenge

and a creative irritant to traditional painting. Artists like Edgar Degas flirted with the medium but never plunged in fully. Art galleries moved from skepticism, through cautious interest, to genuine commitment, and collectors have followed suit. By the end of the 20th century, photographs by creative artists like Man Ray, Edward Steichen and Brassai could sell for prices that challenge some old masters.

Since the 1850s, the days of those remarkable pioneers William Notman, Alexander Henderson and Samuel McLaughlin, Canadian photography has flourished and moved steadily toward recognition as an art form in its own right. Until recently, the National Film Board, the National Gallery and the National Archives of Canada have been the chief collectors and exhibitors of material. Currently, there is arts funding for photographers and exhibitions in private galleries and artist-run centres, as well as recognition by major galleries. The establishment of Ottawa's Canadian Museum of Contemporary Photography in 1985 can be seen to coincide with a rich phase of Canadian photographic art in which boundaries between painting and photography and between photography and performance—indeed almost between the image of a past and fixed reality and a reality that is created in the moment—have dissolved. This expansion can be noted by comparing the work of traditionalists like the Yousuf Karsh, Donald Buchanan and Roloff Beny with that of Barbara Astman and Michel Brault—for both of the latter, photography has been a foundation for pursuing the image in other media, rather than an end in itself.

In Canada, at century's end, the visual arts are flourishing as part of the larger international scene: they have gained considerable recognition in that wider sphere, yet they continue to be, sometimes doggedly, but often inventively, Canadian. This translates very often into a concern with the means rather than with the substance of expression. It suggests a standing back, an objectivity, a strong awareness of community, some degree of satirical energy combined with a cautious and specifically applied optimism about human society, and also a sense of the rigorous boundaries set by nature. Such a tradition—humanistic and open to experience—is unlikely to lead to an impasse or to an exhaustion of artistic means. The Canadian visual art of the future, whether it veers toward radicalism, or continues along these cautious channels, has a strong foundation to build upon.

Major Public Galleries

THESE listings focus mostly on Canada's public art galleries. Anthropological museums, almost all of which contain notable art of various kinds, are listed separately in chapter eight. Those who want to explore the art scene in depth in any city will, of course, seek out private, municipal and university galleries and other art spaces, which often feature excellent collections and striking exhibitions.

ALBERTA

Edmonton Art Gallery (EAG): Specializes in western Canadian art. Also holds contemporary and historical Canadian and international paintings, sculpture, graphic art and photography. The Canadian collection includes several interesting 19th-century artists, such as Frederick Verner (*Turned Out of the Herd*) and Adolphe Vogt (*Approaching Storm*), not to mention the inevitable Cornelius Krieghoff. It has many excellent modern works. The building comprises 10 exhibition areas, classrooms, a small auditorium, a members' lounge and a gift shop. Vincent Varga, from the Windsor Gallery, took over as executive director in 1996. The EAG mounts exhibitions that travel the province, showing off some of its 4,000 or so pieces; in 1997, these reached nearly a million Albertans. In recent years the gallery has collaborated with the Glenbow Museum in presenting the Alberta biennial shows. Like most biennials these have drawn mixed reviews, but seem a worthy exercise nonetheless. **2 Sir Winston Churchill Sq., Edmonton, AB, T5J 2C1**. Phone: **(403) 422•6223**; Fax: **(403) 426•3105**. Admission fee for non-members; open daily. Internet: **http://www.eag.org/info.html**

Southern Alberta Art Gallery, Lethbridge: Located on the edge of an attractive city park, and housed in an extension of the old Lethbridge library, this public gallery is noted across Canada as one of the places where you can discover good contemporary work by up-and-coming Canadian artists. Joan Stebbins, the gallery director for the past decade, travels across Canada for about a month each year, visiting artists' studios in the larger cities. As a result, this provincial city with a population of about 60,000 is one of the best places to see the finest new work from Toronto, Montréal, Calgary and Vancouver. **601 Third Ave. S, Lethbridge, AB, T1J 0H4**. Phone: **(403) 327•8770**; Fax: **(403) 328•3913**. Admission fee for non-members; closed Mondays. Internet: **http://upanet.uleth.ca/~saag**

BRITISH COLUMBIA

The Vancouver Art Gallery: The old Vancouver courthouse was transformed into an art gallery in 1983. The feeling in and around the building is wonderful: elegant, urbane, somehow unhurried despite the streams of traffic on the surrounding thoroughfares. The central staircase and the glass-topped dome are notable, combining neo-classical solidity with elegance. The exhibitions have often been fascinating (Edvard Munch graphics, Toulouse-Lautrec prints and posters, a retrospective of Andy Warhol's work, Audubon engravings, masks from the Pacific Northwest, new abstract art from Vancouver), but a visit may leave you wondering: where's the permanent collection? Sure, there are notable Emily Carrs: see, for example, *Wood Interior*, which is haunting: where does that secret door lead to? Or look at *Zinoqua of the Cat Village*. There are a few

Frederick Varleys and some Jock Macdonald abstractions, but even allowing for temporary exhibitions, somebody seems to have cheated the court. Maybe the board of trustees should talk to some of the lumber barons or Pacific Rim magnates about expanding the collection. Even so, toward the end of the 1990s the gallery was running well and attracting nearly a million visitors a year. A current issue involves the redevelopment of Robson Square, which, if done well, could further enhance the gallery's virtues of location and ambiance. The gift shop is one of the best anywhere and the café is very good. **750 Hornby St., Vancouver, BC, V6Z 2H7.** Phone: **(604) 662•4700** (office); **(604) 662•4719** (recorded information); **(604) 662•4706** (gallery shop); Fax: **(604) 682•1086.** Admission fee; closed Mondays and Tuesdays in winter. Internet: **http://www.vanartgallery.bc.ca**

The Art Gallery of Greater Victoria: Oriental art is the focus, and there is a lot of it here, although no great spectacular masterpiece to make a visit obligatory. You can view Chinese pottery (Tang, Ming, Yuan), Japanese woodcuts (including Hokusai) and 17th-century Japanese paintings. There are also oriental figurines (check out the Bactrian camel), lacquered cases, grave ornaments and book covers. The permanent collection of European art is pretty thin, featuring mostly minor work (Jean-Baptiste Greuze, Jan Wynants, Walter Sickert, Georges Rouault), and there are some token earlier Canadian pieces (David Milne and Jock Macdonald), but the gallery has a laudable policy of exhibiting the work of local artists: these include Emily Carr, Sophie Deane-Drummond, the late Jack Shadbolt and sculptor Elza Mayhew. The collection is housed mostly in a 19th-century mansion with the Tolkienish name of Gyppeswick. It's appropriately shabby genteel, but occasionally livens up, when the exhibition is right. Anyone interested in Emily Carr—and everyone should be —must visit

the Emily Carr House (**207 Government St.**) and the Emily Carr Art Gallery (in the **Parliament Buildings at 1107 Wharf St.**), which displays Carr originals on a temporary basis. The AGGV gift shop is the usual higgledy-piggledy—just try and find a postcard of something from the gallery! **1040 Moss St., Victoria, BC, V8V 4P1.** Phone: **(250) 384•4101** (program/admin.); **(250) 384•1531** (current exhibitions); Fax: **(250) 361•3995.** Admission fee for non-members; open daily. Internet: **http://aggv.bc.ca**

MANITOBA

The Winnipeg Art Gallery: Founded in 1912, the gallery opened its current wonderful building in 1971. Its permanent collection of approximately 17,000 works is diverse and often intriguing. Besides the usual British dutifuls there is a decent sampling of modern Europeans, also Gothic and Renaissance panels, master prints and drawings, furniture and porcelain and a wonderful 16th-century Russian icon. Even though the gallery holds a compulsory Cornelius Krieghoff, it is George Agnew Reid's *The Story* that is reported to be its most popular picture. (It is an archetypal scene of country boys yarning together, though among anecdotal paintings here I prefer Manitoban W. Frank Lynn's *The Dakota Boat*.) The numerous modern Canadian works include a good representation of David Milne and of Manitoban Lionel LeMoine FitzGerald, a later member of the Group of Seven who spent nearly all of his life in Winnipeg. Also, Harold Town, Kenneth Lochhead, Alex Colville and Alfred Pellan. This gallery claims to have the largest collection of Inuit art in the Western world; it includes soapstone and serpentine as well as ivory and bone sculptures by artists from Baker Lake, Cape Dorset, Wakeham Bay, Pelly Bay and Port Harrison. In addition, there are Inuit prints by Cape Dorset artists Parr, Peter Pitseolak, Una, Lucy Qinnuayuak and

Baker Lake's Jessie Oonark. In 1999, the gallery landed an important exhibition of Dutch paintings that had been seen previously at the Art Gallery of Ontario and seemed to be working on a "second stop" arrangement with the AGO. Patricia Bovey took over as director in 1998. Gallery facilities include an auditorium, library, outdoor sculpture court, studios, a restaurant and gift shop. **300 Memorial Blvd., Winnipeg, MB, R3C 1V1**. Phone: **(204) 786•6641** or **(204) 775•7297** (24 hrs); Fax: **(204) 788•4998**. Admission fee; closed Mondays. Internet: **http://www.wag.mb.ca**

NEW BRUNSWICK

The Beaverbrook Art Gallery, Fredericton: Endowed by New Brunswick-born British press magnate Lord Beaverbrook, who gave the gallery as a gift to the province, this museum opened in 1959 and occupies a rather non-descript building on the banks of the Saint John River in downtown Fredericton. The collection is dominated by British and Canadian paintings from various periods. Visitors are confronted in the main lobby by Salvador Dali's *Santiago El Grande* (*grande* is right). In 1998, director Curtis Collins caused a minor sensation by hanging the painting *In My Father's House* by Canadian Attila Richard Lukacs near the Dali. Variously described as "Nazi skinhead art" and a bold homoerotic work that shows men in "full anal flaunt," the work was removed after some weeks of controversy. One thing is certain, Dali himself probably would not have been shocked, merely peeved at being upstaged by Lukacs. Visitors who get past the lobby will find pleasing landscapes and/or portraits by Thomas Gainsborough, John Constable, Joshua Reynolds, George Stubbs, William Hogarth and J.M.W. Turner. Among the moderns, look for Francis Bacon, Walter Sickert, William Orpen, and Stanley Spencer, as well as for a few Winston Churchills and a very characteristic Wyndham Lewis image called "The Mud

Clinic." The fun pieces, however, are probably the Graham Sutherland portraits and sketches. They are a little tentative artistically perhaps (the Frederick Varley portrait of Janet Beaverbrook is more definitive than any of them), but nonetheless fascinating in their perspectives on recent notables. Among those captured are Helena Rubenstein, an epitome of insecure, icy vulgarity; Lord Beaverbrook, looking like a hobbit; Churchill, pensive and baby-vulnerable; Somerset Maugham, whose face appears to be collapsing into itself; and the writer Edward Sackville-West, looking quizzical. There are also some fine pre-Raphaelite and Victorian academic paintings. Among the Canadians, you guessed it, Cornelius Krieghoff is notably represented. This artist's half-caricaturing mode can put one off, but you will probably want to stop before his *Merrymaking*, considered to be his finest painting and full of figures from a vanished world. There are also a few works by J. W. Morrice and Paul Kane. Twentieth-century Canadian art can be seen in works by the Group of Seven and Tom Thomson, as well as by Goodridge Roberts, Emily Carr, David Milne, Alfred Pellan, Alex Colville, Clarence Gagnon and Henri Masson. In addition, the gallery has a collection of Canadian and local New Brunswick art and sculpture, of 18th-century British porcelain and of 14th- to 19th-century European decorative arts. There is the usual ho-hum gift shop. **703 Queen St., PO Box 605, Fredericton, NB, E3B 5A6**. Phone: **(506) 458•8545** or **(506) 458•8546**; Fax: **(506) 459•7450**. Admission fee; closed Mondays. Internet:**http://www.beaverbrookartgallery .org**

NEWFOUNDLAND

Art Gallery of Newfoundland and Labrador, Memorial University, St. John's: The old university art gallery became the de facto provincial gallery in 1994. The permanent

collection is mainly contemporary Canadian art (from 1960 to the present), with an emphasis on work by the province's artists, including Christopher and Mary Pratt, Carl Barbour, Frank Lapointe, Gerald Squires and Steve Paine. Also folk art and crafts. Patricia Grattan is the current director. **Arts and Culture Centre, Memorial University of Newfoundland,** (at Prince Philip Drive and Allandale Road). **PO Box 4200, St. John's, NF, A1C 5S7**. Phone: **(709) 737 • 8210** (office); **(709) 737 • 8209** (recorded info.); Fax: **(709) 737 • 4569**. Free admission; closed Mondays. Internet: **http://www.mun.ca/agnl**

NOVA SCOTIA

Art Gallery of Nova Scotia, Halifax: The collection features traditional and contemporary Nova Scotian art as well as folk art. Temporary exhibitions, which are thematic, individual, related to specific media or sometimes geographical, change every six to 12 weeks. Travelling exhibitions serving the province are organized by the gallery. Bernard Riordan is the current director. **1723 Hollis St., PO Box 2262, Halifax, NS, B3J 3C8**. Phone: **(902) 424 • 7542** (admin.); **(902) 424 • 3002** (info.); Fax: **(902) 424 • 7359**. Closed Mondays; entrance fee. Internet: **http://www.agns.ednet.ns.ca**

ONTARIO

Art Gallery of Hamilton: A large modern building made of wood and stone with a functional, open-concept interior, the gallery is located in Hamilton's downtown core, adjacent to the Convention Centre and Hamilton Place. The permanent collection consists mainly of historical and contemporary Canadian works, plus a few minor European works, but there is much of interest. Blair Bruce's *The Phantom Hunter* has a Jack Londonish flair; Horatio Walker's *Ave Maria* is Millet from the

perspective of a 19th-century Canadian internationalist. I love Adrian Hebert's *Place St. Henri*, which is almost Chirico. Then there is Alex Colville's celebrated *Horse and Train*. Or think ugly: look for Reinhard Reitzenstein's welded steel and patina *Spike Virus*, Ed Zelenak's *Noah's Ark (Six Plane Curve)* or William Kurelek's garish and grisly *Is This the Nemesis?* The gallery is currently planning a near-$10-million renovation of its aging building that will include upgrading the interior and wrapping the exterior in gold-and-silver steel panels. Shirley Madill was appointed gallery director in 1999. **123 King St. W, Hamilton, ON, L8P 4S8**. Phone: **(905) 527 • 6610**; Fax: **(905) 577 • 6940**. Admission fee; closed on Mondays and Tuesdays. Internet: **http://www.culturenet.ca/agh**

Agnes Etherington Art Centre, Kingston: Founded in 1957, this gallery has an excellent collection of Canadian contemporary and historical paintings, as well as some fine old masters and the Justin and Elizabeth Land collection of African art. The gallery renovation, which has dispersed the collection for several years, is expected to be completed and the "New Agnes" opened by May 2000. This will definitely be a facility worth visiting. Among recent important bequests, the Agnes acquired (from Albert and Isabel Bader of Milwaukee) more than 120 works, preponderantly 17th-century Dutch paintings, mainly by pupils of Rembrandt. The pieces are valued at some $40 million. Once the new plant is completed and the more than 13,000 works in the permanent collection are rehoused there, the gallery will have new opportunities for mounting exhibitions and for community and visitor services. For information about interim services and access to the collection, and for details of the reopening and possible new hours and admission policies, contact the gallery directly. **University Avenue and Queen's Crescent, Queen's University, Kingston, ON, K7L 3N6**.

Phone: **(613) 533 • 2190**; Fax: **(613) 533 • 6765**.
Internet: **http://www.queensu.ca/ageth/html**

The McMichael Canadian Art Collection, Kleinburg: In 1965, Robert and Signe McMichael donated their Kleinburg property —it's set on a hilltop with a nice view of the Humber River Valley—and their art collection to the Province of Ontario. They have since had second thoughts and in 1996 decided to sue for breach of contract. The issue was the choice of new works for the gallery; the McMichaels objected to some recent acquisitions as being too "modernist" and thus out of character with the collection. A lower court agreed with their right to have a say, but in 1997 the Ontario Court of Appeal overturned the ruling, and when the couple asked the Supreme Court of Canada to hear the case, it declined. The couple's log-and-stone home Tapawingo (a First Nations word meaning "place of joy"—would they name it that now?), since their generous bequest, has been expanded into a two-level public building with 14 exhibition spaces. The permanent collection now includes more than 5,000 works, focusing on the Group of Seven and Tom Thomson, as well as Canadian aboriginal art. There is something eerie about this place; it is almost a national artist mausoleum. Six members of the Group of Seven—A.Y. Jackson (who lived at the McMichael for the last six years of his life), Frederick Varley, Frank Johnston, Lawren Harris, Arthur Lismer and A. J. Casson—are buried on the grounds; Tom Thomson's Rosedale Ravine shack was moved to the McMichael property and authentically refurnished. The gallery displays other Canadian works from the 19th and 20th centuries by J W Morrice, Emily Carr, David Milne, William Beatty, by the so-called Canadian Group of painters and by Québec artists like Maurice Cullen and Albert H. Robinson. Look especially for the superb Clarence Gagnon illustrations for Louis Hémon's novel *Maria Chapdelaine*. The

McMichael Canadian Art Collection

So much of Lawren Harris's work catches the essence of Canada's natural world—Snow *(c.1917) is no exception.*

McMichael also houses a large permanent collection of approximately 1,000 works by Inuit artists—traditional work from Baker Lake, early Cape Dorset drawings, and late Cape Dorset sculptures, as well as contemporary Inuit sculptures, including *Bust of a Woman* by John Tiktak of Rankin Inlet, and the Cape Dorset artist Pauta Saila's massive stone bear, which stands near the gallery's front entrance. In the Raven's Work Gallery, built in 1986, are housed the Northwest Coast material including wooden masks and carved objects from the Haida, Tsimshian and Tlinglit groups; paintings and prints in the Woodland style by artists like Norval Morrisseau, Carl Ray and Daphne Odjig; Iroquois steatite sculptures; and work by Alex Janvier, Canada's first modernist Native Canadian artist, as well as by Clifford Maracle (look for *Blue Indian Thinking*), Robert Houle, Carl Beam and Jane Ash Poitras. The library contains rare books, archival photographs, artist files, exhibition catalogues, periodicals, manuscripts and correspondence. There is a good gift shop. **10365 Islington Ave., Kleinburg, ON, L0J 1C0**. Phone: **(905) 893 • 1121**, Fax. **(905) 893 • 0692**. Admission fee for non-members; open daily during summer (May 1 – Oct. 31), closed Mondays during winter. Internet: **http://www.mc michael. on.ca**

The London Regional Art Gallery: The model of what such a gallery should be. Many

interesting paintings by noted London artists, including Paul Peel, F. M. Bell-Smith, Eve Bradshaw, Jack Chambers and Greg Curnoe, together with a good selection of other Canadian works (e.g., Frederick Varley, Jean-Paul Lemieux, Jack Bush, Christopher Pratt, Jean-Paul Riopelle), and including a varied collection of international pieces from Wassily Kandinsky to Andy Warhol: in total 2,532 works by 840 artists. **421 Ridout St. N, London, ON, N6A 5H4**. Phone: **(519) 672 • 4580**; Fax: **(519) 660 • 8397**. Admission free; closed Mondays.

Canadian Museum of Contemporary Photography, **Ottawa**: This gallery is oddly situated, tunnelled into the hillside between the Chateau Laurier and the Rideau Canal. It seems to have been made for hobbits, but despite having the feeling of a lair or burrow this is not exactly a cosy place, but rather clean-lined, efficient and up-to-date. People tend to forget about it because the National Gallery, which does many photography exhibits, is only a few blocks away, but it is well worth a visit. The rooms are large and brightly lit and the rotating exhibits are usually interesting enough to dissipate the notion that you have strayed into a reproduction of Hitler's bunker in Berlin. The information handouts are excellent and the gift shop is outstanding, with many interesting books and reproductions of historic and modern photography. **1 Rideau Canal, PO Box 465, Stn. A, Ottawa, ON, K1N 9N6**. Phone: **(613) 990 • 8257**. Open every day in summer until Sept. 6; from Sept. 7, closed Mondays and Tuesdays; free admission. Internet: **http:// cmcp.gallery.ca**

National Gallery of Canada, **Ottawa**: Airy interior spaces shaped by a stately pleasure dome that recapitulates the contours of the Parliamentary Library's domed roof in the distance, massive ramps, postcard glimpses of Parliament Hill—Canada's largest collection of art (more than 40,000 works) is housed in a

monumental building designed by noted architect Moshe Safdie (of Expo '67 fame). When the original design panel ended up deadlocked, Pierre Elliott Trudeau cast the deciding vote for the present structure. A wise choice. Since it opened in 1988, the NGC has been a dominant presence on Ottawa's Sussex Drive, with its great views and convenience to Byward Market restaurants, galleries, chic shops and bookstores. The colourful and astute Shirley Thomson, first director in the new building, saw the gallery through its early years. The well-respected Pierre Théberge, master of the blockbuster exhibition during his Montréal years, took over in 1998. The NGC's collection of European paintings is representative rather than deep or exciting (though there are van Eycks, Rembrandts, Gauguins and Picassos), but the Canadian collection is comprehensive: Cornelius Krieghoff's genre scenes; pioneer paintings of Native peoples by Paul Kane; minor but pleasing 19th-century landscapes and portraits; the quietly intriguing work of the turn-of-the-century master J. W. Morrice; the powerful oil sketches of Tom Thomson—not to mention a cornucopia of important work by the Group of Seven and a good representation of Canadian modern schools. Bored by the notion of chasing Canadian culture or of spotting excised fig leaves (the gallery got some publicity by ostentatiously removing one from a Lucas Cranach female nude)? Then spend some time with *The Virgin and Child* by Bernard van Orley, or with J. L. Jerome's *Camels at the Watering Place*. You can also relax in the pleasant interior courtyard or browse through the latest photography exhibition. The gallery's special exhibitions, whether in-house or on loan on such artists or themes as Degas, Emily Carr, William Morris, Egyptian-inspired kitsch and the Royal Family's (somewhat stilted) collection, have often been very imaginative and successful. In 1997, however, the NGC and chief curator Colin Bailey hit the jackpot with an exhibition of portraits by Renoir, a show that

was artistically revealing, and seen by 340,000 visitors. The economic impact was huge; reportedly it generated $33.2 million in goods and services in Ontario and Québec. The Picasso exhibition of 1998, costly and notably less popular, but underwritten to the tune of more than $500,000 by Midland Walwyn Corporation, had much to recommend it, while a large 1999 show revealing the indefatigable Honoré Daumier's all-encompassing world of 19th-century France (with Van Gogh's *Irises* as a come-on) offered treasures for the persistent. Likely to break all records, however, is the blockbuster show that will include Monet, Renoir and other impressionists, scheduled for the summer of 2000. The gallery also regularly features intriguing "installations" by contemporary Canadian artists; they're sometimes ingenious, often reminiscent of nightmare garage sales, fluorescent light displays and displaced welding shops, but shock and "re-seeing" are part of their value. Also, look for thematic exhibits from the gallery's collection of 15,000 photographs. With good refreshment facilities, an excellent auditorium for small concerts, a well-stocked gift shop (except for, alas, the usual dearth of gallery reproduction postcards) and good underground parking facilities, you have the makings of one of the more upbeat art-viewing experiences anywhere. **380 Sussex Dr., PO Box 427, Stn. A, Ottawa, ON, K1N 9N4**. Phone: **(613) 990 • 1985** May 1 to Oct. 10, every day; Oct. 11 to April 30, Wednesday to Sunday; admission free, except for special exhibits. Internet: **http://national.gallery.ca**

Art Gallery of Ontario (AGO), Toronto: The familiar narrow glass pyramid jutting above Chinatown seems to represent low-key chic in a particularly Toronto style. The AGO, founded in 1900, boasts a collection of 10,000 works. It is a central institution, but cool and unstuffy in ambiance. If I had to choose, this is the Canadian gallery I'd like to be locked inside

overnight. A huge collection, many famous Canadian paintings; European 15th to 20th century; British 18th to 20th century; Inuit prehistoric; the unique Henry Moore sculpture gallery, and "The Grange," a historically restored house-museum recreating Canada in the 1830s. I have a particular fondness for the early modern Europeans and Victorian British: Emil Nolde's *Picnic II* and *Sunset*; Raoul Dufy's *The Regatta* and *Harbour at Le Harve*; Jan Toorop's *After Work*; the Finn Edelfelt's *At Sea*; Claude Monet's *Charing Cross Bridge: Fog*; George Watts's *The Sower of the Systems* and James Tissot's glorious anecdote *The Sales Clerk* (notice the man leering through the window). At least half the collection consists of Canadian art, an *embarras des riches* rivalled only by the National Gallery. The AGO has provided several intriguing views of Canadian art, for example, its *The Mystic North* exhibition, retrospectives of Alex Colville and Lawren Harris and the much more controversial and possibly too gimmicky *OH! Canada* show of 1995. During 1995, the gallery hosted the lucrative Barnes touring collection, drawing nearly 600,000 visitors and a reported $2.6 million in net revenue. Much less popular, although the gallery tried to put a good face on it, was the 1998 Courtauld Collection Exhibition, hampered by rush planning , poor marketing and high admission prices. The Courtauld nonetheless drew 300,000 people, and marked a reasonably successful exit for director Maxwell Anderson, who, having served at the AGO since 1995, went on to the Whitney Museum in New York. New director Matthew Teitelbaum, who took over in 1998, inherited a gallery deficit of about $1.5 million and a debt of $5.5 million. Like Anderson an advocate of the high-tech presentation of art to a wide audience, Teitelbaum has also emphasized what he sees as the fundamental teaching mission of the AGO, including placing Canadian art in a broader international context. Toward the end of the 1990s, the gallery was anything but

sleepy and uncontroversial. There was a conflict between management and volunteers under Anderson; more trimming of staff under Teitelbaum; some spottily attended exhibitions; some complaints over the marketing of the "Art in the Age of Van Gogh" exhibition (with a mere five Van Goghs in sight, and only three of them imported for the exhibition, the title seemed to some to be rather misleading); while the introduction of a Thursday night "culture and cocktails" feature, complete with sexy themes and quickie tours of the collection, also raised a few eyebrows, although most took the event in the spirit in which it was intended. But why should one of the central arts institutions in Canada have to be dull? A good place to visit, with a pleasant ambiance all around. Typical of Canadian galleries, the gift shop could be more focal. Good restaurant and cafeteria. The street flags advertising special exhibitions have always been a great touch. **317 Dundas St. W, Toronto, ON, M5T 1G4**. Phone: **(416) 979•6648** (general info.); **(416) 979•6660** or **(416) 977•0414** (admin.); Fax: **(416) 979•6646**. Admission fee; closed Mondays. Internet: **http://www.ago.net**

Art Gallery of Windsor: Originally housed in a deteriorating brewery warehouse, the gallery was moved to a shopping centre and the brewery leased to the province for a gambling casino. The director responsible for the move, Vincent Varga, now in Edmonton, has suggested that this gambit involved a few good "post-modern paradoxes" and how right he is! The idea of shopping-centre art certainly conforms to the "let's get more contact with the public" philosophy of today's public galleries, but what does it do for the equally valid idea of an art gallery as a special place where one can escape from some of the vulgarities and inanities of mass culture? I'm only asking. A small collection of mostly Canadian art. **Devonshire Mall, 3100 Howard Ave., Windsor, ON, N8X 3Y8**. Phone: **(519) 969•4494**; Fax: **(519)**

969•3732. Free admission; closed Mondays. Internet: **http://www.mnsi.net/~agw/**

PRINCE EDWARD ISLAND

Confederation Centre Art Gallery and Museum, Charlottetown: This gallery, as part of its location and purpose, is exceedingly conscious of historical perspective and preservation. Its approximately 15,000 works are lodged inside the podium section of the centre's large cube-and-glass cradle structure that faces the Prince Edward Island Provincial Building. The notable Robert Harris collection, replete with images of the Canadian past, is a highlight, but there are graphics, decorative arts and porcelain from 1780 to 1880. (Be grateful that the *Anne of Green Gables* memorabilia are elsewhere.) Annual exhibitions are numerous and the gallery runs a gift shop and an art- rental service. **145 Richmond St., Charlotte-town, PE, C1A 1J1**. Phone: **(902) 628•1864** (general info.); **(902) 628•6111**; Fax: **(902) 566•4648**. Admission fee except for Canadian Museum Association members; open daily. Internet:**http://www.confederationcentre .com**

QUÉBEC

Musée d'art contemporain de Montréal: This is an exciting small gallery, opened in 1965. It has had some location and acquisition problems, but the collection, including many Québec modernists and in particular a fine range of Paul-Émile Borduas paintings acquired through Museums Canada, is stimulating. The temporary exhibitions (not always of Québec artists, for example, the Attila Richard Lukacs exhibition of 1994) are often outstanding. **185, rue Sainte-Catherine O, Montréal, QC, H2X 1Z8**. Phone; **(514) 847•6906**; Fax: **(514) 847•6916**. Free admission; closed Mondays. Internet: **http://Media.MACM.qc.ca**

The Musée d'art contemporain de Montréal is a small but exciting gallery. It houses many works by Québec modernists.

Musée des beaux arts de Montréal/Montréal Museum of Fine Arts: The origins of this museum date back to 1847, while its first permanent space opened in 1879, making this the oldest art museum in Canada. Appropriately, its representative collection spans nearly every period and many media—paintings, prints, drawing, sculptures, tapestries, jewellery, pottery, stained glass. The building is an odd amalgam, not much fun to navigate. The old neo-classical pile (from 1912) blends poorly with the 1979 Lebensold-designed adjunct across Sherbrooke Street; the tunnel connecting the two parts is banal where it might have been weird and wonderful. The visitor's experience tends to be fractured and a bit frustrating, although the staff are extremely friendly in both languages. The nice thing about this gallery is that you can forget about the Group of Seven (not that they aren't hanging around) and lose yourself, if you wish, in an old-fashioned room-by-room jog through art history. Here you will find Inuit art, works from Africa, the Far East, Greece and Rome, together with works of Western masters such as El Greco, Goya, Rubens, Pissarro, Rembrandt, Gainsborough, Constable, Corot, Courbet, Matisse, Manet, Renoir, Cézanne, Monet and Rodin. There are many 19th-century Canadian paintings, and Montréal's James Wilson Morrice is well represented. You can also explore significant modern work by Québecois artists such as Alfred Pellan, Jean-Paul Riopelle and Paul-Émile Borduas, whose famous *L'étoile noire* is here. Needless to say, the excitement of Les Automatistes' revolution had nothing to do with this good, grey museum. Nonetheless, this gallery has had some problematic special exhibitions, notoriously the Picasso garage sale of 1985. The symbolist retrospective of 1995 got mixed reviews and lost $2 million (thanks

partially to an antique-auto show running simultaneously), yet it was one of the most haunting exhibitions I've ever seen—brilliantly presented, hugely varied in outreach of image, and sensibly documented. Other excellent shows of the 1990s included *The Age of the Metropolis*, *The Time of the Nabis*, masterpieces from the Guggenheim, the sculpture of Michelangelo, *Monet at Giverny* (which drew 256,738 visitors) and the work of Magritte and Giacometti. If this list suggests that some excellent and inventive curating and exhibiting was functioning at the MMFA through that decade, it doesn't lie. Guy Cogeval is the current director. Café and restaurant; superb bookstore and a decent gift shop. **1379 or 1380, rue Sherbrooke St. O, Montréal, QC, H3G 2T9**. Phone: **(514) 285•2000** (info.); **(514) 285•1600**; Fax: **(514) 844•6042**. Admission fee except for Canadian Museum Association members, for temporary exhibitions; donations requested for entrance to the permanent collections; closed Mondays. Internet: **http://www.mmfa.qc.ca**

Musée McCord d'histoire canadienne/ McCord Museum of Canadian History, Montréal: This McGill University museum contains 80,000 objects that are separated into four collections. There is much ethnological material relating to the Prairies, eastern woodlands, the Arctic and the Northwest Coast, as well as Québec folk art, decorative arts, costumes and textiles. I list it here, however, because of the Notman Photographic Archives, which include approximately 700,000 prints and glass negatives from the beginnings of photography in Canada, creating a unique pictorial record. There's a library, gift shop and a documentation centre. **690, rue Sherbrooke St. O, Montréal, QC, H3A 1E9**. Phone: **(514) 398•7100**; Fax: **(514) 398•5045**. Admission fee except for Canadian Museum Association members; closed Mondays. Internet: **http://www.musee-mccord.qc.ca**

Musée du Québec, Québec City: A rich panorama of Québec art is visible here, from the earliest portraits and landscapes of Jean Berger, François Maleparte de Beaucourt, Paul Beaucourt, Joseph Legaré, Joseph and Théophile Hamel and Jean-Baptiste Roy-Audy through the classic works of Ozias Leduc, right up to Jean-Paul Lemieux, Alfred Pellan, Jean-Phillipe Dallaire and Jean-Paul Riopelle. The bookstore specializes in Québec art. **Parc des Champs-de-Bataille, 1, av. Wolfe–Montcalm, Québec City, QC, G1R 5H3**. Phone: **(418) 643•2150**; Fax: **(418) 646•3330**. Free admission; open every day. Internet: **http://www.mdq.org**

SASKATCHEWAN

Dunlop Art Gallery, Regina: The gallery, built in 1964, forms part of the Regina Public Library. In 1972, it was named after a well-known Regina librarian, and, it has been professionally curated since the early 1960s. The permanent collection includes Saskatchewan art, some minor European work and a special collection made up of works by self-taught artists: outsider art, folk art and "art brut" (not a perfume for macho men, but "unschooled" art, including "primitives," child art, art by mentally ill persons, etc.) **2311 – 12th Ave., PO Box 2311, Regina, SK, S4P 3Z5**. Phone: **(306) 777•6040**; Fax: **(306) 777•6221**. Free admission; open every day. Internet: **http://www.dunlopartgallery.org**

Top 10 Best-Attended Exhibitions

Art Gallery of Ontario

- *Treasures of Tutankhamen*, Nov. 1 to Dec. 31, 1979: 734,501
- *Barnes Exhibit*, Sept. 12, 1994 to Jan. 1, 1995: 597,127
- *Courtauld Exhibition*, June 10 to Sept. 20, 1998: 300,000
- *Vincent van Gogh*, Jan. 24 to March 22, 1981: 233,433
- *OH! Canada Project*, Feb. 16 to May 5, 1995: 125,000
- *Turner and the Sublime*, November 1, 1980 to Jan. 4, 1981: 99,179
- *Barbara Hepworth*, May 19 to Aug. 7, 1995: 87,433
- *Vatican Splendour*, Oct. 4 to Nov. 30, 1986: 82,540
- *Sketchbooks of Picasso*, July 29 to Oct. 2, 1988: 73,618
- *Michael Snow Project*, March 11 to June 5, 1994: 61,975

Source: Art Gallery of Ontario, Toronto

National Gallery of Canada

- *Renoir's Portraits*, June 26 to Sept. 14, 1997: 338,233
- *Picasso: Masterworks from the Museum of Modern Art*, April 2 to July 12, 1998: 253,170
- *Degas*, June 16 to Aug. 28, 1988: 253,001
- *Emily Carr*, June 28 to Sept. 3, 1990: 140,902
- *Karsh: Art of the Portrait*, June 28 to Sept. 4, 1989: 136,755
- *Egyptomania: Art Inspired by Ancient Egypt, 1730 – 1930*, June 16 to Sept. 18, 1994: 121,918
- *Corot*, June 20 to Sept. 22, 1996: 107,317
- *The Queen's Pictures: Old Masters from the Royal Collection*, June 23 to Sept. 10, 1991: 100,558
- *A Primal Spirit: Ten Contemporary Japanese Sculptors*, June 27 to Sept. 22, 1991: 100,339
- *The Group of Seven: Art for a Nation*, Oct. 13 to Dec. 31, 1995: 69,890

Note: This list is only of exhibitions mounted since the opening of the new building in 1988.

Source: National Gallery of Canada, Ottawa

Montréal Museum of Fine Arts

- *Pablo Picasso: Meeting in Montréal*, June 20 to Nov. 10, 1985: 517,000
- *Leonardo da Vinci, Engineer and Architect*, May 22 to Nov. 8, 1987: 436,419
- *Monet in Giverny: Masterpieces from the Musée Marmottan*, Jan. 28 to May 9, 1999: 256,738
- *Marc Chagall*, Oct. 28, 1988 to Feb. 27, 1989: 245,883
- *The 1920s: Age of the Metropolis*, June 20 to Nov. 17, 1991: 245,286
- *Salvador Dali*, April 27 to June 29, 1990: 192,963
- *Moving Beauty*, May 11 to Oct. 15, 1995: 184,352
- *Magritte*, June 20 to Oct. 27, 1996: 163,577
- *Miró in Montréal*, June 20 to Oct. 5, 1986: 160,598
- *William-Adolphe Bourguereau*, June 21 to Sept. 23, 1983: 151,489

Source: Montréal Museum of Fine Arts

Vancouver Art Gallery (Top 5)

- *Face to Face: Four Centuries of Portraits*, June 17 to Sept. 26, 1999: 102,775
- *The Group of Seven: Art for a Nation*, June 20 to Sept. 2, 1996: 101,888
- *Andy Warhol: Images*, June 22 to Oct. 1, 1995: 94,629
- *Down From the Shimmering Sky: Masks of the Northwest Coast*, June 4 to Oct. 12, 1998: 94,229
- *Matisse Illustrates*, June 26 to Oct.19, 1997: 93,500

Source: Vancouver Art Gallery

A Baker's Dozen of Significant Canadian Paintings

William Berczy (1744 – 1813), *The Woolsey Family* **(1808 – 09), National Gallery of Canada, Ottawa**: This family portrait with a large dog whose nose bisects the picture and a landscape seen through the window at left is understated, with gently flowing lines that never break the quiet repose or the classical serenity of these Wedgwood-like figures. An authentic masterpiece, unified, yet fascinating in every detail: eight figures, the dog, fireplace, mirror, parquet floor and distant water, harmonious browns and greens—a very satisfying picture.

Cornelius Krieghoff (1815 – 72), *Merrymaking* **(1860), Beaverbrook Art Gallery, Fredericton**: Considered one of Krieghoff's most impressive genre scenes; a multitude of figures in animated, diverse activity, the snow-draped inn dominated by a great evergreen tree; a diagonal line from top right to bottom left divides the frenetic human activity from the sombre, bleak repose of surrounding nature. Are we meant to feel the contrast between this transient, bubbling human life and the impersonal serenity that encloses it?

Paul Peel (1860 – 92), *A Venetian Bather* **(1889), National Gallery of Canada, Ottawa**: A beautiful female nude, a mere girl, posed before a mirror, hardly a novel concept, but what lovely curves, warm skin tones, what a piquant suggestion of face and hair! The image in the mirror invites more than contemplation, although the cute kitten defuses the sensuality with Victorian coyness. But why "Venetian," and where does she plan to bathe?

Ozias Leduc (1864 – 1955), *L'enfant au pain* **(about 1895), National Gallery of Canada, Ottawa**: One of the Canadian "old masters," Leduc lived long enough and practised well enough to influence a new generation of Québec artists. No wonder they respected him. A mystical communion seems to exist between the boy, the bread and bowl, and between the whole scene and the spectator, who must be reduced to awe by the absolute serenity of this scene. The boy plays his mouth organ; the silent music adds to the stillness of the eternal objects. We perceive the boy's shirt as the only note of vanity, mild enough, yet somehow very human, enough to banish drabness and to allow us to see this as a happy painting, one that speaks of the magic that can arise when

childhood, unspoiled, confident, dreaming, turns its inward gaze on simple objects ennobled by the painter's eye and hand.

James W. Morrice (1865 – 1924), *La citadelle de Québec* **(1897), Musée du Québec, Québec City:** Morrice's paintings have wonderful stillness, a simplification of forms and muted colours that draw us to look more closely at their details. A few faceless, huddled figures, a horse and wagon, the houses squeezed in behind, compressed, the bleak, grey citadel humped with snow—the cold is almost palpable. If it weren't for the touch of blue background in the sky and the daubs of colour in the stall to the right, this wouldn't be Québec City at the turn of the century but some half-deserted city of the mythical Hyperboreans.

A. Y. Jackson (1882 – 1974), *Edge of the Maple Wood* **(1910), National Gallery of Canada, Ottawa:** The land rises slightly, the foreground is mottled with stones and shadows, a snake fence joins earth and sky at right, two tree trunks form a kind of natural gate to the dishevelled, inviting farm buildings at the left. They, in turn, are almost lost in this tenuous, dreaming fall landscape, which evokes something quintessential of Canada.

Paul-Émile Borduas (1905 – 60), *L'étoile noire* **(1957), Musée des beaux-arts, Montréal:** Delicately yet strongly textured and sculpted on the canvas, an abstraction manifesting a symbolic reverberation that many non-figurative paintings lack, or demonstrate too intellectually. This work takes us at once to an archetypal universe of forms, a mysterious inner work that is like a Rorschach for some universal birth process in nature.

F. H. Varley (1881 – 1969), *Portrait of Margaret Fairley* **(1921), Art Gallery of Ontario, Toronto:** The sumptuous background drapings and richly coloured flowing dress only reinforce the strength of the face, which is sculpted and illuminated so as to focus the whole composition. We get an immediate sense of the subject's personality which, whatever the reality, is here seen as honest, strong and sensible, with a definite gift of insight in the beautiful and intelligent eyes. One of the best portraits by Canada's greatest portrait artist.

Lawren Harris (1885 – 1970), *Maligne Lake, Jasper Park* **(1924), National Gallery of Canada, Ottawa:** Is this what Margaret Atwood and Glenn Gould were trying to tell us about the North? Is this Canada? Do we live where two mirroring triangles meet, at the vanishing point of darkness? There is nothing human here except the shaping spirit of imagination. Despite the deceptive clarity of the images, the implicit geometry, we feel an uncertainty: what is mirroring what? Is the unsettled sky actually dissolving in the lake water? Has the lake water been aported into the sky? This is a world that can turn upside down in an instant and hoist the foreground rocks above us, like a guillotine.

Emily Carr (1871 – 1945), *Zinoqua of the Cat Village* **(1931), Vancouver Art Gallery:** In the mid-1990s a powerful Emily Carr retrospective toured some Canadian cities. Following the artist's development from work to work, one saw a gradual movement away from mere representation, or picturesqueness, and a summoning of the power to portray, through nature, some inner darkness and disturbing mystery felt at the heart of things. Carr endeavoured, it seems, to simplify her forms, although they did not become geometrical and the perspectives often carry the eye to a central darkness. This painting seems to embody a kind of terror. What mysterious place is this? The cats speak of the supernatural, of ancient sorceries. Is this a fantasy picture, the representation of a legend? Have the cats been transformed from human shape? No matter what the explanation, the overall mood is

sombre and haunting. It is not easy to forget this picture.

Alex Colville (1920 –), *Horse and Train* **(1954), Art Gallery of Hamilton**: You have seen reproductions of this—one too many, perhaps. Yet how brilliant this work is, and how strange. That is no real horse but a dark visitation that has climbed down out of a niche on some Greek pediment, a spectral horse from some monstrous dream of antiquity. Drawn inexorably toward the locomotive's Cyclopean eye by the unyielding steel rails that stand for what the Greeks called "necessity," or fate, the horse will smash the train to pieces and gallop on into the nothingness of smoke that drifts behind.

Harold Town (1924 – 90), *Monument to C. T. Currelly* **(1957), Vancouver Art Gallery**: Great art galleries and museums are—or used to be—modern urban versions of Tutankhamen's tomb: gloomy, vaulted chambers that could suddenly light up with unexpected treasures. There, Disney was not to be seen, nor anything plastic; and nothing condescended to the visitor. Harold Town's tribute to C. T. Currelly, a

former director of the Royal Ontario Museum, recalls that kind of experience: blocks of colour resembling stone, a complexity of action in the brain cells; imagination breaking loose from the formalities of the labyrinth. This collage invites us to wander into our own inner spaces, to treat reality as a palimpsest.

Michael Snow (1929 –), *Walking Woman* (choose one in a gallery near you): Where have all the walking women gone? How many people reading this can remember seeing themselves in those polished reflective figures at Expo '67? (There the art exhibition, by the way, no doubt reflecting a Saint Exupéry title, was called *Terre des hommes*.) The walking women appear in *Venus Simultaneous* (1962) and in myriad forms through the 1960s, some of them bringing to mind the Coca-Cola culture, which is now far too depressingly pervasive. But Snow was interested not in pop culture but in trompe l'oeil and magic, in the spaces between the obvious and the arcane. He is an anatomist of the spectator's puzzled process, and has found witty ways to jar us into remembering that seeing is an intellectual and cultural, not merely a physiological, act.

Top 17 Highest Prices Ever Paid for Canadian Paintings At Auction

- *Untitled* (1955), Jean-Paul Riopelle, May 5, 1989: $1,610,000
- *Lake Superior III* (no date), Lawren Harris, June 1, 1999: $960,000
- *Untitled* (1950), Jean-Paul Riopelle, November 30, 1989: $798,000
- *Untitled* (no date), Jean-Paul Riopelle, May 22, 1991: $700,000
- *L'Autriche* (1954 – 55), Jean-Paul Riopelle, June 29, 1989: $532,000
- *Bull Ring, Marseilles* (no date), James Wilson Morrice, May 26, 1995: $520,000
- *Portrait of Maungwudaus* (no date), Paul Kane, June 2, 1999: $475,000
- *Filets frontière* (1951), Jean-Paul Riopelle, June 30, 1988: $462,000
- *… et plus …* (1959), Jean-Paul Riopelle, November 30, 1989: $456,000

- *Mountains in Snow: The Rocky Mountain Paintings* (no date), Lawren Harris, November 18, 1986: $450,000
- *The Ice Harvest* (1913), Clarence Gagnon, November 28, 1989: $450,000
- *Before the Bath* (1892), Paul Peel, May 24, 1995: $445,000
- *Tryptique* (c. 1954), Jean-Paul Riopelle, May 11, 1994: $420,000

- *Early Canadian Homestead* (1859), Cornelius Krieghoff, November 16, 1994: $400,000
- *The Young Gleaner* (1888), Paul Peel, May 31, 1990: $380,000
- *Composition* (no date), Jean-Paul Riopelle, May 15, 1990: $380,000
- *Composition 1953*, Jean-Paul Riopelle, October 16, 1990: $375,000

Source: *Canadian Art Sales Index 1998 – 99*. Westbridge Publications Ltd., Vancouver, B.C.

Famous Canadian Art Movements

The Group of Seven

The members of what became the Group of Seven began to associate in Toronto between 1910 and 1913, although the movement was not officially founded until 1920, after their first exhibition at the Art Gallery of Toronto. The original Group, mostly commercial artists, included Franklin Carmichael, Lawren Harris, A.Y. Jackson, Franz Johnston, Arthur Lismer, J.E.H. Macdonald and F. H. Varley. Tom Thomson, one of the moving forces in this anti-academic and anti-traditional art, was never an official member. The Group was strongly influenced by European (and especially Scandinavian) symbolist landscape painters and by the post-impressionists. Although painting landscape was not their only strength, their characteristic subject was nature. Their style is marked by expressionistic distortions of form and by heavy, distinctly coloured surfaces. Through these means and others they sought to capture the visionary moment, the grandeur and alien power of the essential North. Although disliked by many academic critics and artists, the Group found many allies and supporters, and their triumph was swift and nearly complete. It is their original vision of Canadian landscape that has endured. As the individual work of some of these painters evolved, new directions appeared: Lawren Harris moved toward abstraction; Varley toward a softer, more Eastern mysticism. Later, the Group expanded and changed: A. J. Casson joined in 1926, replacing Franz Johnston. Edward Holgate joined in 1930 and L. L. FitzGerald in 1932. Emily Carr, one of the major Canadian landscape painters, though clearly having some affinities with the Group, was never invited to join. The Group disbanded in 1933; its influence, however, has been pervasive, and it was another decade before a more internationally tuned and "progressive" art emerged in Canada.

Les Automatistes

Les Automatistes were a Québec group of painters influenced by the work and ideas of Paul-Émile Borduas. They, as well as Borduas, were influenced by Marxism and psycho-analysis, and especially by the ideas of the French surrealist André Breton. Breton believed that creativity derived from a central hidden source in the human mind, one that linked the conscious and unconscious. This source could

tap unknown but very real forces in the universe and was the basis of all artistic creativity. In order to make contact with this source one had to cast off conventional ideas and the superficial programming effected by society. Thus, Les Automatistes became not only Canada's first important movement in abstract art but a powerful cultural force advocating individual creativity at the expense of the more repressive forces in Québec society. The first major Borduas exhibition (1942) led to the coalescing of the group, which included Jean-Paul Riopelle, Marcel Barbeau, Pierre Gauvreau, Fernand Leduc, Jean-Paul Mousseau and Roger Fauteaux. The Automatiste manifesto *Refus Global* appeared in 1948, and the group held a number of exhibitions, including their first in Montréal in 1946, one in New York the same year and one in Paris in 1947. The last group exhibition was held in Montréal in 1954. After Borduas and Riopelle

went to France, Fernand Leduc led the movement in the direction of the hard-edged abstraction of the so-called Plasticiens. Founded in 1954, the latter were led by Rodolphe de Repentigny (who painted under the pseudonym Jauran) and included Claude Tousignant, Guido Molinari, Rita Letendre, and Jean McEwen. This movement had sufficient coherence and creative energy to assure the triumph of abstractionism in the Montréal of the 1950s and 1960s, and in retrospect appears as the sophisticated international alternative to the Group of Seven's Canadian nationalism, which had spent its real force by the end of the Second World War.

The Painters Eleven

The continued dominance of the Group of Seven in English Canada, the lack of direct links to Paris and other factors, led to the tardiness

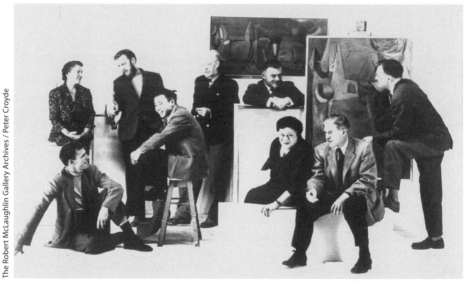

The Painters Eleven was an informal collective of Canadian abstract artists. From left: Tom Hodgson, Alexandra Luke, Harold Town, Kazuo Nakamura, Jock Macdonald, Walter Yarwood, Hortense Gordon, Jack Bush, Ray Mead. Two canvases by Oscar Cohen appear in the background; the other two, on which Town and Yarwood are resting, are by William Ronald. They are turned to the wall as a dig at Ronald, who had moved to New York.

of Toronto in entering the mainstream of modern international abstractionism. Jock Macdonald, Jack Bush, Harold Town and William Ronald were among those who eventually looked to New York and Paris for ways of developing beyond the pictorial landscape icons of the Group. The Painters Eleven began after Alexandra Luke organized the touring Canadian Abstract Exhibition in 1952 and William Ronald, in the following year, promoted an exhibition at Simpsons Department Store in Toronto. This was dubbed "Abstracts at Home,"—a sly way of suggesting that there was more than one way of seeing Canada in art—and included the work of Ronald, Luke, Jack Bush, Kazuo Nakamura, Oscar Cahen, Ray Mead and Tom Hodgson. The group later added to its ranks Hortense Gordon, Walter Yarwood, Harold Town and Jock Macdonald, and took the name Painters Eleven, which in itself suggests a more casual coming together than the ideological attunements of Les Automatistes. In 1957, they invited Clement Greenberg, a leading New York critic, to talk about art with them in person, yet apart from their commitment to abstractionism, the group had little in common. They first exhibited together in 1954 and dissolved in 1960, although their influence carried through the 1960s and 1970s, especially via the Isaacs Gallery artists, who embraced modernism and postmodernism in various forms and included Graham Coughtry, Joyce Wieland and Michael Snow.

The Atlantic Magic Realists

Alex Colville, born in Toronto in 1920, taught at Mount Allison University from 1946 to 1963 and created a significant body of representational painting, inspiring others by his example as a teacher. Along with Mary and Christopher Pratt, Colville developed a meticulous style that, by portraying specific objects or situations with a hyper-realistic clarity, or by producing disturbing juxtapositions, forced the viewer to read beyond the level of visual cliché. This alternative to abstraction and expressionistic exaggeration has become popular with the public because it leads directly from traditional representation, which it initially resembles but transcends by heightening or focalizing the subject in a specific way. Thus, while some of the naïve viewer's demands for "comprehensibility" seem to be met, the overall effect is to unseat the viewer's complacency by adding strangeness, alienating effects, or "magic" to the realism that seems on the surface to be predominant.

Some Notable Examples of Canadian Architecture

THIS list does not, of course, pretend to name "the greatest" Canadian architecture. It seeks to be representative and includes all kinds of buildings, in various styles, from across Canada. Almost all our urban areas have fascinating buildings in abundance, which the interested reader should seek out, and our largest cities have dozens of sites worth visiting. In the Ottawa area alone there are some 17 buildings designed by the famous architect Francis C. Sullivan, a longtime associate of Frank Lloyd Wright. Sullivan was born in Kingston, Ontario, in 1882, and worked in Ottawa until 1920, when he left to become part of the Wright circle until his death in 1929.

- Séminaire du Québec, Québec City, QC (architects unknown, 1663 and later)
- Province House, Halifax, NS (ascribed to John Merrick, 1811 – 1818)
- St. Joachim Church, Montmorency, QC (Thomas Baillairgé, 1816 – 29)
- Upper Canada Village, near Morrisburg, ON (various architects, mostly 1820s – 1840s)
- Christ Church Cathedral, Fredericton, NB (Frank Wills and William Butterfield, 1846 – 53)
- St. Lawrence Hall, Toronto, ON (William Thomas 1850; restored by Eric Ross Arthur, 1967)
- The Parliament Buildings, Ottawa, ON. East and West Blocks (Stent and Laver, 1859 – 65); Library (Fuller and Jones, 1859 – 77); Centre Block (Fuller, Jones and Baillairgé, 1859 – 66). The current buildings are largely the result of rebuilding and remodelling after the 1916 fire, accomplished, in the opinion of art historians, with much less panache than the originals.
- Banff Springs Hotel, Banff, AB (Bruce Price, 1888)
- Union Station, Toronto, ON (Ross and Macdonald, Hugh Jones and John Lyle, 1915 – 20)
- Marine Building, Vancouver, BC (McCarter and Nairn, 1929 – 30)
- Ernest Cormier House, Montréal, QC (Ernest Cormier, 1931)
- Garden Court Apartments, Toronto, ON (Page and Steele, 1939)
- Habitat, Montréal, QC (Safdie, David, Barrott, Boulva, 1967)
- Precious Blood Church, St. Boniface, MB (Étienne Gaboury, 1968)
- Winnipeg Art Gallery, MB (Gustavo de Roza and the Number 10 Architectural Group, 1971)
- CN Tower, Toronto, ON (John Andrews, International/Roger Du Toit, Webb, Zarafa, Housden Partnership, 1973 – 78)
- Citadel Theatre, Edmonton, AB (Diamond, Myers and Wilkin, 1976)
- Bradley House, North Hatley, QC (Peter Rose, 1977)
- Granville Island Redevelopment, Vancouver, BC (Hotson, Bakker and Ball, 1977)
- LaSalle Metro Station, Montréal, QC (Gillon-Larouche, 1978)
- Wandich House, Peterborough, ON (Jim Stasman, 1979)
- National Gallery of Canada, Ottawa, ON (Moshe Safdie, 1988)
- Museum of Civilization, Hull, QC (Douglas Cardinal, 1989)
- Richmond Hill Central Library, Toronto, ON (Diamond and Schmitt, 1993)
- Library Square, Vancouver, BC, (Moshe Safdie, Downs and Archambault, 1996)

4
Dance

DANCE in Canada flourishes across a wide spectrum of styles, social commitments and budgets. Although rooted in the three metropolitan centres of Montréal, Toronto and Vancouver, dance also survives, however tenuously, in smaller and less affluent areas. Why should this be so in an era when many critics are lamenting the decline of dance? It is certainly a tribute to the indomitable desire to create and communicate on the part of Canadian artists—as well as being the culmination of many years when expansion was taken for granted. Perhaps also the fractionalizing of audiences (the cable channel phenomenon) leads new dance companies to believe that they can find a niche, if only they are able to tune their aesthetics—and their politics—to the right wavelength. Or perhaps dancers find the urge to choreograph their own work and to control their own productions irresistible.

Critics seem to agree that nothing in recent decades has quite matched the excitement generated by the explosion of new dance in Canada in the 1970s. Yet audience interest remains high—especially when the magic word "festival" is invoked—and the paucity of dance superstars has been partially compensated for by the broadening base of styles and presentations, and by the emergence of choreographers and companies rooted in ethnic traditions that promise fresh developments in the future.

A convenient way of understanding the dance scene in Canada today is to keep in mind the four major stylistic or expressive worlds that it encompasses. These include traditional classical ballet, with its rigorously formal structures; contemporary dance, which is marked by a freewheeling movement that, thanks to Broadway and film, is familiar to audiences; modern dance, which stretches the boundaries of the art by radicalizing movement, costume, scenery, medium or theme; and finally, folk dance, which is really revival dancing, an imitation of traditional dances rooted in specific ethnic customs. These are far from airtight categories: one might also mention the so-called "modern ballet," which represents a lively offshoot from the more formal

classical style, while modern dance, which is as disciplined as ballet, encompasses many stylistic approaches. Nonetheless, such categories serve to frame audience expectations: a Christmas *Nutcracker* is one thing, a performance by Danny Grossman's company is another; while an evening spent with La La La Human Steps or Marie Chouinard will be—to say the least—something quite different from one devoted to Balkan, Irish or Scottish country dance.

As is the case with all the arts in Canada, dance has been marked in recent years by the attempts of its creators and presenters to make contact with, even to create, a new public. This is partially a natural process of exploration and growth, but it is also a response to social changes, including declining government funding. Companies sense that they must find a broader audience base for their art, that they must engage the public on the level of idea or ideology as well as through aesthetics. While an expert might describe dance as the ritualized movement of bodies in space, and suggest that in essence it has little to do with social interactions, many choreographers in Canada (and elsewhere) seek to emphasize the social and political relevance of the art. The rarefied atmosphere that often marked traditional ballet has disappeared or has been sublimated. Instead, companies boast of their commitments to social causes and emphasize their community responsibilities. Dance Arts Vancouver, for example, highlights itself as featuring "Excellence in Creation, Relevance to Society,"

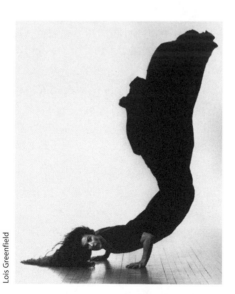

Lois Greenfield

Margie Gillis is one of Canada's outstanding performers of modern dance.

while Kaeja d'Dance, Toronto, has created several dance works with holocaust themes, while Margie Gillis of Montréal "puts her art at the service of AIDS education and research." Are these approaches out of line? One might argue that when truth is the object, there's no harm in relevance confounding beauty.

Some American critics, such as Terry Teachout, have lamented this overt politicizing and have suggested that it has worked to undermine the popularity of dance in the United States. Canadian critics Michael Crabb and Max Wyman, on the other hand, speak of a falling-off in the areas of talent, star quality and government funding, resulting in a scene that is still

dependent on the achievements of the golden era of dance creation in Canada during the 1960s and 1970s. These experts would probably agree that the situation is somewhat paradoxical. While Canadian dance may lack panache, it has broadened its base and strengthened its roots. If it has become too political, it has also demonstrated that it can reach out in new ways to embody the often inchoate fears, hopes and dreams of ordinary people.

Although events like the passing of Rudolf Nureyev and the retirement of Canada's prima ballerina Karen Kain may have deglamourized dance for the greater public, some exciting new dancers are visible on the Canadian scene. These include Joel Prouty and Jennifer Weisman of the Royal Winnipeg Ballet; Gail Skrela and Kerry Lynn Turner from Ballet British

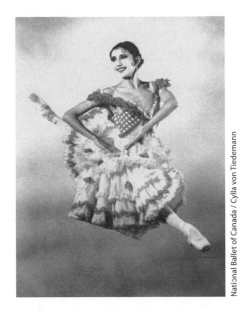

National Ballet of Canada / Cylla von Tiedemann

Principal dancer of the National Ballet of Canada, Chan Hon Goh—seen here performing Don Quixote—is one of the most talented young dancers in this country.

Columbia; Keir Knight from La La La Human Steps and Chan Hon Goh and Johan Persson from the National Ballet of Canada. At the same time, companies like Ballet North in Edmonton and the Tripp Dance Company in Calgary; In Motion and the Free Flow Company in southern Ontario and Springboard Dance in Vancouver, although not well known and possibly short of charisma, do fulfill a need in their respective communities. Such troupes commonly function with almost invisible budgets, and are composed of only a few dancer-choreographers, who must teach and give workshops as an integral part of their professional careers. Nevertheless, they demonstrate commitment to the art of dance, in which—as in other spheres—diversity is usually a sign of health.

Another good sign is the growth of dance companies in Canada with exotic, ethnic or folk roots, groups such as the Newton Moreas Dance Company of Toronto, which reaches back to the artistic director's Brazilian experience; the Kokoro Dance Theatre Society in Vancouver, which derives from the concept of *butoh* dance in Japan; or Roger Sinha's company, Sinha Danse of Montréal and Toronto, which is rooted in East Indian culture. Does one see in such creative companies the lineaments of a

Kokoro Dance / Laurence M. Svirchev

Vancouver's Kokoro Dance fuses Eastern and Western themes and techniques in its performances, such as "Dance of the Dead" featuring Barbara Bourget.

"world dance" to which Canada, with its strong multicultural commitments, might contribute?

One of the most popular categories of dance in Canada today is ethnic or folk dance. Festivals from coast to coast feature or promote this kind of dance. Some of these are based on specific ethnic traditions, for example, the Irish Festival on the Miramichi in New Brunswick or the Celtic Folk Roots Festival in Goderich, Ontario. Others, such as the Vancouver Folk Festival or the Newfoundland and Labrador Folk Festival have a broader focus. Such events ensure both the preservation of traditional dances and the creation of contemporary versions of dance rooted in specific cultures. Folk dance encompasses many styles and variants, including Scottish, Irish, German, Ukrainian, Balkan, Cajun, Québec square dance, contra and Morris dance—the list is extensive. What these have in common is the power to stir the non-professional to explore dance because of a sense of affiliation to a root culture.

Some decades ago, folk dancing in Canada seemed to be mired in nostalgic ritual, but as its practitioners forged more and more links to contemporary music and dance its popularity grew. Since the musical instruments associated with folk dancing— fiddle, guitar, banjo, accordion and so on—are much cultivated by amateurs, they help to make the dance rhythms and forms immediately accessible. The general popularity of commercial "folk music" and the huge international success of productions such as *Riverdance* have also helped to promote an interest in folk dance.

One of the most heartening aspects of this folk revival, however, has little to do with such commercial ventures. I refer to the valiant attempt of Canada's Native groups to reclaim their traditional dance arts after centuries of profanation and obliteration. Such dance goes beyond entertainment and connects with the most sacred rituals. Its revival is necessary if First Nations culture is to survive in the face of the disintegrating forces around them.

How does that most rarefied of traditional art forms, classical ballet, fit into this variegated scene? The National Ballet, with its 50 or so dancers and its $15-million budget, is seen as a cultural flagship. But, like the Royal Winnipeg Ballet (RWB), and

Les Grands Ballets Canadiens, it has had to sail in difficult waters following public funding cuts in the early 1990s.

To appeal to a wider audience, the RWB began with a combination of contemporary dance and classical ballet. The National Ballet established itself by mounting the full-evening story ballets and only later moved in the direction of contemporary dance. The National Ballet and Les Grand Ballets Canadiens have probably bridged these two worlds more successfully than the RWB, which may have had the misfortune to achieve iconic status even before it reached full artistic maturity. Despite being something of a Canadian phenomenon, and possessing stars of the magnitude of Evelyn Hart, the company has always had difficulty presenting itself in

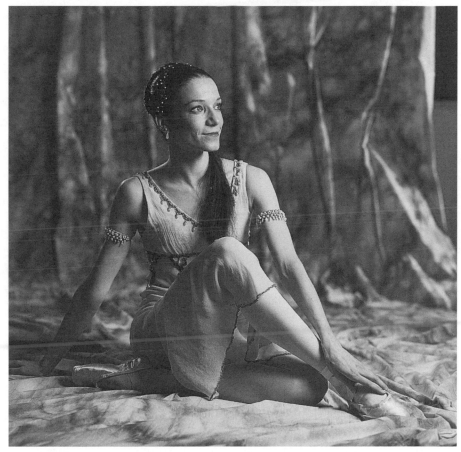

Maclean's / Brian Willer

A graceful and riveting performer, Evelyn Hart is one of the main reasons for the Royal Winnipeg Ballet's continuing popularity.

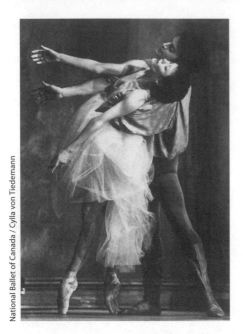

National Ballet of Canada / Cylla von Tiedemann

Karen Kain and Rex Harrington performing in the National Ballet of Canada's production of The Actress.

a clear focus. Yet few of even its most searching critics would consider an evening with the RWB a royal waste of time.

Today, when seemingly impossible demands are placed upon such large companies with central cultural missions, survival is the first miracle. One expects problems and controversies. Before the arrival of its current artistic director, André Lewis, the RWB went through too many rapid changes of direction, and its finances remain shaky. The National Ballet has lost star quality with the departure of Karen Kain and Frank Augustyn and has also had some severe budget shocks. Artistic director James Kudelka explained the 1999 release of 38-year-old principal dancer Kimberly Glasco by saying that her $100,000 salary was too high considering the small number of roles she had filled. The company spent approximately $1 million on its third-ever New York visit (the first to feature an all-Canadian program) and there it suffered poor box office, despite garnering considerable critical acclaim. The trip was deemed necessary, among other reasons, for the National Ballet to continue considering itself a company with international connections. Here we get a glimpse of the incompatibility between budgetary restriction and the requirement that our national cultural institutions represent Canada abroad. A general air of expectation for Canadian art is accompanied by a pulling back of government support for this very goal. Major cultural institutions such as the National Ballet have to live with the paradoxes inherent in this situation.

The dance section of the Canada Council remains a major source of support for most of the important companies. It has recently decided to rationalize its funding decisions by assigning weight to different aspects of a given troupe's achievements. While 65 percent goes to artistic merit, 10 percent goes to financial stability and 25 percent is allotted to the company's contribution to dance and to expanding audiences. Despite its scrupulous attempts at fairness, arts organizations outside the major urban

centres have often felt slighted by the council. It is difficult for dancers and choreographers who work outside Montréal, Toronto or Vancouver to keep in touch with the Canadian dance community. A musician on the Prairies has access to CDs, radio and Web radio from around the world, but dance must really be experienced live. A dance artist outside the three main centres must either travel or lose touch; there simply isn't enough company touring to let artists see each other's works. This is one reason why dance festivals are of such importance for a company's creative development.

In terms of regionalism and funding patterns, the case of the Alberta Ballet is particularly interesting. In 1998, the Canada Council grant to this company was substantially increased from $50,000 to $300,000. This, after several years of being rated by the council as a troupe of "poor relative artistic merit." Greg Epton, Alberta Ballet's executive director, suggested the poor rating had nothing to do with regional bias; rather, the council's criteria for judgement had been too vague. They may also have been too narrow: before 1991, the council would not even consider a company unless it performed ballet, contemporary or modern dance. With the increased blending of styles and the development of ethnic dance as a theatrical form, such rigorous categorization was less useful than before. The council has trouble justifying support for companies that are hard to classify, or for those that are floundering artistically or financially.

In its 15 years of existence, Calgary's Decidedly Jazz Danceworks (DJD) has never received any council funding, since it was judged as suffering from "lack of artistic merit." Yet its presentations seem to fit the category of urban folk style. They offer dance with strong roots in popular culture. Lacking council funding, DJD has become a shining example of how an arts organization can garner private-sector support—and luckily for the company, not all of this has come from cigarette companies. Successfully playing to popular

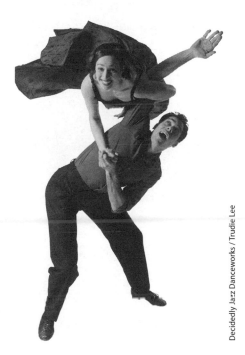

Decidedly Jazz Danceworks / Trudie Lee

Calgary's Decidedly Jazz Danceworks is Canada's only professional jazz dance company.

taste and expectations is one thing; converting the public to a new vision is another. A healthy arts scene will probably provide examples of both.

Private-sector support and community involvement in promoting dance are also notably visible in Vancouver. Here, a new dance centre designed by noted architect Arthur Erickson is slated for completion by July 2000. The eight-story multi-purpose structure will be located in the heart of Vancouver's downtown entertainment district. It will include not only performance space but rehearsal studios, production facilities and administrative offices for several companies, as well as an archival unit. The building will be named the Scotiabank Dance Centre (the bank is contributing $1 million to its construction) and will contain banking facilities as well as the dance components. Although funding from the City of Vancouver and other public sources is also involved, one wonders: is this the wave of the future in Canadian arts mega-projects?

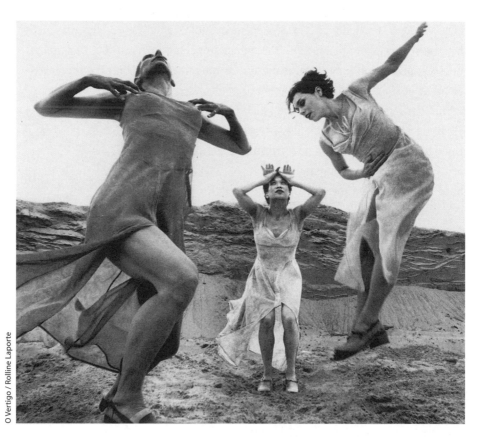

O Vertigo / Rolline Laporte

Montréal's O Vertigo Danse presents a variety of athletic and innovative preformances. Above are dancers Anne Barry, Chi Long and Marie-Claude Rodrigue in En Dedans.

Is dance in Canada heading for a new era of creativity and popularity? Perhaps. Many believe that with the emergence of a fresh generation of charismatic dancers and choreographers, more flexibility in government funding, new partnerships with the private sector, new ways of engaging the public, and a better balance between commitment to causes and a devotion to the miracles of bodies in motion, will come a new explosion of dance creativity in this country. After all, dance keeps its freshness better than some of the other traditional arts—opera, for example, which survives in Canada mostly as a museum culture. While the appearance of a new work afflicts most opera fans with acute anxiety, the promise of something different is likely to excite dance aficionados.

Intriguing new work can already be found at the Fringe Dance Festival held annually in Toronto, at Vancouver's Dance Alive! and at the Festival international de nouvelle danse, presented every two years in Montréal. It is at showcases like these that the catalysts for the next revolution in Canadian dance are likely to be found. Dance at the grassroots; dance with an increasing world focus; the survival of traditional classical ballet and a steady thirst for innovation; the breaking down of stereotypes both among dancers and choreographers and in the expectations of audiences—such fluidity and diversity bodes well for a Canadian dance scene that has scarcely 50 years of development behind it.

Major Canadian Dance Companies (and some other, smaller groups)

ALBERTA

Alberta Ballet Company, Edmonton: Formed as a professional group in 1966, this company was founded by Ruth Carse in the late 1950s. In 1990, after a merger with Calgary City Ballet, the company moved into the Nat Christie Centre where—under various artistic directors, including Brydon Paige—it settled down as a relatively small operation with a mainly traditional repertory. In recent years, more adventurous and contemporary work has been programmed, and the Canada Council seems to have noticed. It increased the company's grant by a whopping $250,000 for the 1998–99 season. The current artistic director is Mikko Nissinen. **1, 10645 – 63rd Ave., Edmonton, AB, T2S 0B8**. Phone: **(780) 428•6839**.

Ballet North, Edmonton: Founded in 1985, this small company puts most of its energies into workshops, demonstrations and touring. Paula Groulx is the artistic director. **12245 – 131st St., Edmonton, AB, T5L 1M8**. Phone: **(780) 455 • 8407**; Fax: **(780) 455 • 8406**.

Decidedly Jazz Danceworks, Calgary: This is Canada's only professional jazz dance company. Founded in 1984 by Vicki Adams Willis, Michelle Moss and Hannah Stilwell, and presently sporting a budget just short of $2 million, the troupe is noted for its ability to flourish on mostly private-sector financial support obtained from talk-radio station QR77, Canadian Pacific, du Maurier and others. (Provincial grants amount to only 10 percent of its budget, and the Canada Council, and a few critics, have judged the troupe's work to be artistically sub-par.) The company (which also runs a dance school) is, however, vastly popular in Calgary, thanks to its "feel-good," Broadway-style performances. Its Black and White Big Benefit Ball, which runs every November, is a highlight of the Calgary entertainment season. **1514 – 4th St. SW, Calgary, AB, T2R 0Y4**. Phone: **(403) 245•3533**; Fax: **(403) 245•3584**; Internet: **http://www.decidedlyjazz.com/index.htm**

BRITISH COLUMBIA

Ballet British Columbia, Vancouver: This company of about 15 dancers, resident at the Queen Elizabeth Theatre, has an operating budget of $2.1 million. It runs a 35-week season, tours the province and features an in-school program. It was founded in 1986, with Annette av Paul as artistic director, and was created as a successor to previous B.C. ballet companies that date back to the early 1970s. The company runs the *Dance Alive!* series held annually in Vancouver, one that features excellent companies from around the world. John Alleyne, the present artistic director, has followed the company's tradition of presenting contemporary works, including those of many distinguished Canadian choreographers, such as James Kudelka and Christopher House. **Suite 102, 1101 Broadway, Vancouver, BC, V6H 1G2**. Phone: **(604) 732 • 5003**; Fax: **(604) 732 • 4417**; Internet: **http://www.discovervancouver.com/balletbc**

Dance Arts, Vancouver: This company was founded by Jennifer Mascall, who moved from Toronto in the 1970s. Dance Arts is a New York-influenced improvisational and experimental

dance company with a strong sense of community responsibility. The group has toured widely, does shows and workshops for younger audiences and has performed many Canadian works. Judith Marcuse is the current artistic director. **402, 873 Beatty St., Vancouver, BC, V6B 2M6.** Phone: **(604) 606 • 6425**; Fax: **(604) 606 • 6432**; Internet: **http://www.dancearts.bc.ca**

Karen Jamieson Dance Company, Vancouver: This modern-dance group, which focuses on Canadian themes and music, sometimes collaborates with Native Canadian performers and does shows in anthropological museums and in Native communities throughout British Columbia. **707, 207 Hastings St., Vancouver, BC, V6B 1H7.** Phone: **(604) 685 • 5699**; Fax: **(604) 685 • 5772.**

Kokoro Dance Theatre Society, Vancouver: Founded in 1986, this small, experimental dance company is based on the Japanese *butoh* technique. (*Butoh* was created in the 1950s by Tatsumi Hijikata. He was seeking—via expressionism, Genet, de Sade and the Theatre of Cruelty—to explore human primordial impulses.) Flexible and leaning toward multidisciplinary works, this is a company that attempts to fuse Eastern and Western themes and techniques. Jay Hirabayashi and Barbara Bourget serve as chief choreographers and artistic directors, while Robert J. Rosen composes most of the music. **1201, 207 Hastings St., Vancouver, BC, V6B 1H7.** Phone: **(604) 662 • 7441**; Fax: **(604) 662 • 3886**; Internet: **http://www.shinnova.com/kokoro/index.htm**

MANITOBA

Contemporary Dancers Incorporated of Winnipeg: Canada's longest-surviving modern-dance group, this small company, founded by Rachel Browne in the 1960s,

became fully professional in 1971. The succession of artistic directors that followed Browne led to shifts in stylistics, which destabilized the company just when it had to gear up to face the financial uncertainties of the early 1990s. Under Tom Stroud, the current artistic director, the company has again gained focus. Its special emphasis on dance theatre includes a strong commitment to concise, expressive movement. **109 Pulford St., Winnipeg, MB, R3L 1X8.** Phone: **(204) 452 • 1239.**

Royal Winnipeg Ballet (RWB): Canada's longest-surviving dance company, the RWB originated in the late 1930s when Gweneth Lloyd and Betty Farrally, two English-immigrant dance teachers, moved to Winnipeg and began creating a dance scene there. The Royal Winnipeg Ballet first became fully professional in 1949, and in 1953 it was granted a royal charter, the first company in the British Commonwealth to achieve this status. It survived a terrible fire in 1954 that destroyed all its portable property. Arnold Spohr, who took over as artistic director in the late 1950s, presided over the company's rebirth and subsequent climb to international fame. Spohr built an efficient company and organized many tours. He also hired resident choreographers of the calibre of Brian Macdonald and drew on the work of some of the best foreign choreographers. Full-length single works were mounted, partially as a vehicle for the company's reigning star, Evelyn Hart. In 1990, John Meehan, an Australian who had worked with the American Ballet Theatre, became artistic director. He and William Whitener, who took over in 1993, broadened the repertory further and expanded the scope of the dancing style. Whitener, however, resigned in 1995 amid controversy. He was replaced by André Lewis, who remains the artistic director. The company is widely known across Canada because of its extensive and lengthy tours. In recent years it

has gained more foreign exposure in both Europe and Asia. The RWB's artistic focus, however, is often questioned: has it ever really found a comfortable synthesis between past and present? Its traditional fare is often unenlivened by new thoughts and smacks of dowager art, sitting uncomfortably on programs with more contemporary offerings. Despite all its achievements, the RWB might still be characterized (to use computer terminology) as "a site under development." Which doesn't mean that it can't be fun to watch, as the 1998 "Dracula" of its former resident choreographer, Mark Godden, proved. **380 Graham Ave., Winnipeg**, MB, R3C 4K2. Phone: **(204) 956 • 0183**; **(204) 956 • 2792** (box office); Fax: **(204) 943 • 1994**; Internet: **http://www.rwb.org**

ONTARIO

Canadian Children's Dance Theatre and Training School, Toronto: This group was founded in 1981 by Deborah Lundmark and Michael de Coninck Smith, with the object of training young dancers by appropriate methods, including the professional staging of original ballets in which they participate. Sixteen dancers (ages 11 to 18) are chosen in an annual audition process, from apprentices prepared by the company at the school or otherwise recruited. Works are commissioned from leading Canadian choreographers and composers; stage venues have varied. There has been an artist-in-residence program since 1997. Tours in Canada and, recently, to China, have demonstrated the quality of this company. **509 Parliament St., Toronto**, ON, M4X 1P3. Phone: **(416) 924 • 5657**; Fax: **(416) 924 • 4141**; Internet: **http://www.ccdt.org**

Dancemakers, Toronto: Marcie Radler and Andrea Smith founded Dancemakers in 1974 as a mainstream modern-dance company. Since 1990, the artistic director has been Serge

Bennathan (who came from France, by way of Ottawa and Ballet British Columbia). The company is associated with the boundary-breaking "new dance" movement, with its focus on complex and singular pieces emphasizing a universal symbolism emotionally rendered through extreme versions of ballet vocabulary. Under Bennathan, whose *Sand Trilogy* is a company highlight, the nine-member troupe, noted for its strong, restless, expressive style and powerful thematics, has toured abroad with success. **927 Dupont St., Toronto, ON, M6H 1Z1**. Phone: **(416) 535 • 8880**; Fax: **(416) 535 • 8929**; Internet: **http://www.dancemakers.org**

Desrosiers Dance Theatre, Toronto: This company, founded in 1980, is a vehicle of the modern-dance choreography of Robert Guy Desrosiers, a brilliant talent who graduated from the National Ballet School in 1971. Desrosiers himself has explored many aspects of dance creation, beginning with unconventional techniques, including multimedia, song and speech, and evolving into a more mainstream, dance-centred expression in the 1990s. The company has toured widely in Canada and abroad. **276 Carlow St., Unit 201, Toronto**, ON, M4M 3L1. Phone: **(416) 463 • 5341**.

Danny Grossman Dance Company, Toronto: Founded in 1977 by the dancer Danny Grossman, this is a very popular modern-dance troupe, noted for its unbuttoned style and general pizzazz. Jazz, folk music and classical works, acutely chosen, are married to scenarios that challenge stereotypes and delineate complex experience. The company has performed some 30 Grossman pieces but has since branched out to include work by other choreographers, including Judy Jarvis and Paula Ross. Tours have included seven countries and the company's self-declared mission is to "educate and transform" the public. **425 Queen**

St., Toronto, ON, M5V 2A5. Phone: (416) 408 • 4543; Fax: (416) 408 • 2518.

Dogs in Space, Toronto: A small postmodern dance company, founded in New York in 1987 by co-directors, husband-and-wife team Jane Townsend and Michael Kirsch, who moved to Toronto in 1993. Their works are often pungent and witty, and sometimes play on folk and nature themes; they also use props and sounds with some ingenuity. **24 Bellevue Ave., Toronto, ON, M5T 2N4**. Phone: (416) 603 • 1499; Fax: (416) 603 • 1521.

Kaeja d'Dance, Toronto: Since 1995, a permanent company of about 13 to 15 dancers, directed by the husband-and-wife team of Allen and Karen Kaeja, who work with "structured innovations," or improvisations within a set pattern, to create an athletic and theatrical kind of dance. One of their works, *Witnessed*, which deals with the holocaust, was made into a short film with the collaboration of BRAVO! in 1997. **789 Manning Ave., Toronto, ON, M6G 2W7**. Phone: (416) 537 • 5153; Fax: (416) 537 • 5205.

Le Groupe de la Place Royale (The Dance Lab), Ottawa: Founded in Montréal in 1966 by Jeanne Renaud, this is one of Canada's first and most innovative multimedia dance groups. Under Jean Pierre Perrault's and Peter Boneham's direction, the company moved to Ottawa in 1978. It functions now as a "dance lab," i.e., as a workshop and development vehicle for choreographers. Boneham continues as artistic director. While Le Groupe is not exactly a conventional dance company it does perform, providing dance/media demonstrations in an intellectually strong and aesthetically probing manner. **2 Daly Ave., Suite 2, Ottawa, ON, K1N 6E2**. Phone: (613) 235 • 1492; Fax: (613) 235 • 1651; Internet: http://www.legroupe.org

The National Ballet of Canada (NBC), Toronto: When she founded this company as long ago as 1951, the indomitable Celia Franca didn't hesitate to appropriate the title and mission of a truly "national" ballet. (The adjunct National Ballet School was founded in 1959.) With its nearly $15-million budget (down from past years), some 50 dancers, and its own symphony orchestra, the National Ballet is Canada's largest dance operation, and one of our major arts institutions of any kind. In the course of becoming known around the world, the company has produced more than one genuine Canadian arts superstar and has attracted, throughout its history, some of the major international dance talents of the century. Thanks to Celia Franca and partially to the arrival of Rudolf Nureyev in 1972, the deeper talent of prima ballerina Karen Kain blossomed with this company (she had graduated from the ballet school and was already a talent to watch at NBC, but by the time she retired in 1997 she had become probably Canada's best-known arts personality). Veronica Tennant and Frank Augustyn also developed in close connection with the National Ballet. While Pavarotti has never sung with the Canadian Opera Company, Rudolf Nureyev and Erik Bruhn have been prominent in the history of the National Ballet, which has done the big single-evening story ballets as well as any company, while not neglecting the work of Canadian choreographers (the names of James Kudelka, Danny Grossman and Edouard Lock suggest the diversity of commissions), nor of the non-Canadian 20th-century masters such as George Balanchine, Sir Frederick Ashton, Jerome Robbins and Anthony Tudor. Alexander Grant was artistic director of the National Ballet 1976 – 83. Reid Anderson, who took over in 1989, commissioned many new works from Canada's most innovative choreographers and also strengthened the classical roots of the company. James Kudelka assumed direction in 1996 and has had an

eventful tenure. The National Ballet's 1998 visit to New York was a critical success but with its million-dollar price tag, and poorly attended performances, the trip was no financial coup. At the same time, Kudelka's 1999 *Swan Lake* has been much praised. The company continues to tour major centres, while the National Ballet Concert Group, with an alternating roster, performs in smaller communities across Canada. The O'Keefe Centre continues as resident home. **470 Queens Quay W, Toronto, ON, M5V 3K4.** Phone: **(416) 345 • 9686; (416) 345 • 9595** (ticket services); Fax: **(416) 345 • 8323;** Internet: **http://www.national. ballet.ca**

Toronto Dance Theatre (TDT): Founded in 1968 by Patricia Beatty, David Earle and Peter Randazzo, this is one of Canada's best-known modern-dance companies. This Martha Graham-influenced trio continued to direct the company until 1983, when Kenneth Pearl arrived to perform a financial rescue operation that resulted in an overall revivification of the company. TDT's repertory, much of it choreographed by the founders, has involved many commissions for Canadian composers. The company has toured around the world and runs a very successful school for dancers. David Earle, who took over as sole artistic director in 1987, remains artist-in-residence. Christopher House replaced him as artistic director in 1994. **80 Winchester St., Toronto, ON, M4X 1B2.** Phone: **(416) 967•1365.**

QUÉBEC

Compagnie Marie Chouinard, Québec City: Marie Chouinard founded her company of 10 dancers in 1990. She is a highly respected, multi-talented dancer and choreographer, who occasionally composes music and designs costumes and lighting for her pieces. Her dancing career began in 1979 and she performed as a soloist in many countries,

gaining respect over the years. Her choreography has been described as one that "celebrates the body and its inner life." A few of her major works include *Les trous du ciel, Le sac du printemps* (to Igor Stravinsky's music) and *L'amade et le diamant*, probably her most erotic work to date. **715, 3981, boul. St-Laurent, Montréal, QC, H2W 1Y5.** Phone **(514) 843 • 9036;** Fax: **(514) 843 •7616;** Internet: **http://www.mariechouinard.com**

Les Ballets Jazz de Montréal: This company was founded in 1972 by Eva von Gencsy, Eddie Toussaint and Geneviève Salbaing, and has since given some 1,800 performances in 57 countries. Les Ballets Jazz de Montréal blends classical, modern and jazz techniques in an animated and urbane style, resulting in an explosive vitality of stage movement. Many Canadian and foreign choreographers, including James Kudelka and Brian Macdonald, have been inspired to create for this group. The present artistic director is Yvan Michaud. **3450, rue St. Urbain, 4th Floor, Montréal, QC, H2X 2N5.** Phone: **(514) 982•6771.**

Les Grands Ballets Canadiens, Montréal: Founded by Ludmilla Chiriaeff in 1958, this has evolved into one of our major dance companies, employing 35 to 40 dancers. It performs traditional and modern works in styles that range from ballet to modern. The repertory has ranged from an adaptation of The Who's *Tommy* to the works of the modern master George Balanchine. Chiriaeff guided the company until 1974, and ran the attached École supérieure de danse du Québec until her death in 1995. A succession of individuals and committees succeeded her through the 1980s and 1990s. James Kudelka was resident choreographer from 1984 to 1990, and the company has commissioned and premiered a great many important Canadian works. The troupe has toured in North and South America, and was the first Canadian ballet company invited to

perform in China. Lawrence Rhodes is the current artistic director. **4816, rue Rivard, Montréal, QC, H2J 2N6.** Phone: **(514) 849•8681.**

Sylvain Émard Danse, Montréal: This modern-dance company was founded in 1986 by the choreographer and artistic director after whom the group is named. Émard describes his work as being marked by "a rigorous style that moves between abandon and control." Émard's creations, such as *Terrains vagues* and *Rumeurs*, have been presented in Glasgow and at the Canada Dance Festival. The company also offers workshops, classes and demonstrations. **303, 1881, rue Saint-André, Montréal, QC, H2L 3T9.** Phone **(514) 598•1733;** Fax: **(514) 598•1763.**

Margie Gillis Fondation de Danse, Montréal: Commitment is the key word here. Margie Gillis, well-known solo dancer, creates her powerfully expressive works with a strong awareness of social and political issues. She has toured widely across Canada and in various countries, as both a Canadian and Québecois cultural ambassador, and has recently worked in collaboration with other choreographers and dancers. **502, 3575, boul. Saint-Laurent, Montréal, QC, H2X 2T7.** Phone: **(514) 845•3115;** Fax: **(514) 845 • 3424;** Internet: **http://www.margiegillis.org**

La La La Human Steps, Montréal: "A choreographer's duty is to continually deconstruct and unstabilize the senses, because the way we perceive our universe is very shallow and superficial to begin with." So writes Edouard Lock, who founded this 8 to 10 member company in the 1970s. The group has evolved a vigorous, complex style emphasizing an explosive physicality that over the years has been more and more directed to the powerful expression of a strong idea. **5655, av. du Parc, Montréal, QC, H2V 4H2.** Phone: **(514) 277•9090.**

Compagnie Flak, Montréal: Venezuelan-born choreographer José Navas, with some dozen works to his credit, is one of the bright lights of Québec's nouvelle danse, or postmodern dance movement. Since starting his Compagnie Flak in 1995, he has toured in more than a dozen countries abroad as well as within Canada. He made a big hit at the Canada Dance Festival in Ottawa in 1998 with his *One Night Only*. Navas has also made several films. **2093, rue Saint-Denis, Montréal, QC, H2X 3K8.** Phone: **(514) 284•4222;** Fax: **(514) 525•0172.**

O Vertigo Danse, Montréal: Ginette Laurin founded this modern-dance group in 1984 and she remains the artistic director. O Vertigo has toured extensively in Europe and North America. Laurin's 30 or so athletic, innovative, on-the-edge works form the company's central repertory. **4455, rue de Rouen, Montréal, QC, H1V 1H1.** Phone: **(514) 251•9177;** Fax: **(514) 251•7358;** Internet: **http://www.cam.org/~overtigo/home.htm**

Sixteen Illustrious Names in Canadian Dance

Reid Anderson (1949–): Born in British Columbia and trained in Canada and Europe, Anderson is one of Canada's leading ballet directors, choreographers and dancers. After a successful phase with the renowned Stuttgart Ballet, Anderson became the director of Ballet

British Columbia and in 1989 of the National Ballet, from which he resigned in 1996 after several successful but stressful years during which he guided the company on all levels during a time of economic uncertainty. In 1996, he became the artistic director of the Stuttgart Ballet, where he had previously been principal dancer.

Ludmilla Chiriaeff (1924 – 96): A Latvian choreographer and dancer who emigrated to Canada in 1952, she founded the company that in 1958 became Les Grands Ballets Canadiens and remained artistic director until 1974, establishing ballet in Québec at a time when many of the performing arts were viewed with suspicion by the clerical establishment. Her choreographic talent, demonstrated in works such as *Suite canadienne* (1957) and *Cendrillon* (1962), linked Canada with the great European balletic traditions, and she has received many honours, including a Governor General's Performing Arts Award in 1993.

Betty Farrally (1915 – 89): A dancer, teacher and ballet director, she came from England in 1938 to co-found (with Gweneth Lloyd) the Royal Winnipeg Ballet, where she remained as artistic director until 1957. She later taught in B.C. and at the Banff Centre.

Celia Franca (1921 –): Born Celia Franks in England, Franca trained there and later became a dancer, choreographer and administrator. In 1950, she was invited to come to Canada to help found a classical ballet company, which she did in 1951. The new company was called the National Ballet of Canada, and Franca directed it until 1974. A woman of phenomenal energy, she brought the National Ballet to a position of national and international prominence, establishing in a relatively short time a solid artistic and educational tradition for the company. Later she served on the board of the Canada Council. The Molson Prize, which she received in 1974, is only one of many honours.

Margie Gillis (1953 –): One of Canada's outstanding exponents of modern dance, Gillis is noted for her great musical sensitivity and her ability to spellbind audiences with her sometimes flamboyant but always dramatically appropriate movements and gestures. She has also expressed strong commitments to social and political causes and has travelled around the world, performing mostly as a solo dancer, as well as demonstrating and teaching modern dance. Her ballet *Mercy*, first seen in 1977, is well known and represents her characteristic style, which includes interesting use of her long, flowing hair, and typically, elaborately enveloping costumes. She was named Canadian cultural ambassador in 1981 and Québec cultural ambassador in 1986, and she assisted in opening the new Canadian Embassy in Tokyo in 1991. She has appeared with Les Grands Ballets Canadiens and with the Paul Taylor Dancers, among other groups. Gillis was appointed to the Order of Canada in 1988.

Evelyn Hart (1956 –): With the retirement of Karen Kain, Evelyn Hart became Canada's sole reigning ballet superstar. Grace, lyricism, powerfully dramatic expression and strong emotional conviction—Hart's outstanding qualities as a dancer have carried her to the top, and her amazing self-discipline and professional focus have kept her there. She was born in Toronto, and most of her early training took place at the Royal Winnipeg Ballet school. She joined that company in 1976. In 1980, she won a bronze medal in Japan and the gold medal for best female dancer in Varna, Bulgaria. She is one of the main reasons why the Royal Winnipeg Ballet has been a consistently popular artistic attraction from her arrival through the late 1990s. With a steel-wire body and the ability to communicate emotion through simple gestures, Hart is a riveting performer. She has toured Europe and North America and has appeared in films, while several documentaries have been made on her life and

work. In 1999, at age 43, she was still dancing well and declared that she was by no means ready to retire. She was awarded the Order of Canada in 1983 and raised to the rank of Companion of the Order of Canada in 1994.

Christopher House (1955 –): A distinguished dancer and choreographer of modern dance, originally from Newfoundland, House is adept at creating thematic nuance and dramatic conflict through abstract movement, and widely respected for his acute musical sense. He became artistic director of the Toronto Dance Theatre in 1994 after being resident choreographer there from 1981. Under House, the company has become one of Canada's finest and has achieved international recognition through its successful tours.

Karen Kain (1951 –): Canada's famous prima ballerina was born in Hamilton, Ontario. She became principal dancer at the National Ballet of Canada in 1970, at the age of 19. After an important trip to Russia in 1973, where she won a silver medal in a major competition, she quickly became a national celebrity (as pianist Van Cliburn had done in the United States after a similar trip). Her professional and personal connection with dancing partner Frank Augustyn soon put them both high on the list of public favourites among Canadian artists. A fiercely devoted professional, Kain went from strength to strength. Her partnerships with Rudolf Nureyev and Roland Petit of Ballets de Marseilles furthered her artistic growth. By the 1980s, Kain was one of Canada's genuine artistic superstars and she successfully negotiated the later years of her career, dancing an enormous number of roles and always surprising her fans with her versatility and confidence. Her retirement tour in 1997 was the occasion for celebration and sadness: it was the end of an era in Canadian dance.

James Kudelka (1955 –): An Ontario-born dancer and leading choreographer, he has created many major works for companies as diverse as the National Ballet, Les Grands Ballets Canadiens, Toronto Dance Theatre, the Joffrey Ballet and the American Ballet Theatre. His choreography (for example, *Fifteen Heterosexual Duets* [1991], *The Miraculous Mandarin* [1993]) draws from both classical ballet and modern dance movement and he often meets the challenge of serious contemporary themes; he is adept at both the dramatic and the lyrical modes. In 1996, he became artistic director of the National Ballet of Canada, taking on this major responsibility at a very difficult period for the company, which was just emerging from a period of financial crisis. During the next few years he proved himself fully equal to the task, making difficult budgetary decisions, overseeing interesting new productions and taking the company on a successful tour to New York City.

Brian Macdonald (1928 –): Born in Montréal, where he began his career as a child radio actor, Macdonald later studied ballet and modern dance. In 1953, however, he was forced to retire from the National Ballet of Canada after he suffered a serious arm injury. Macdonald founded Montréal Theatre Ballet and was subsequently resident choreographer for Les Grands Ballets Canadiens. He mounted productions for the La Scala and San Francisco Operas, among others, and created successful dance creations for eminent companies around the world. He worked 16 seasons at the Stratford Festival and spent 15 summers as director of dance at the Banff Centre for the Arts. In 1996, Macdonald was appointed senior artistic director of the National Arts Centre. He continues to create new works for dance theatres across the country and for television.

Jennifer Mascall (1952 –): A dancer, teacher and choreographer of modern dance, Mascall

was born in Winnipeg and trained in Canada and the United States. In 1982, she co-founded the Vancouver-based Experimental Dance and Music group (EDAM) and created numerous works for her own company, Dance Arts, founded as Mascall Dance in 1989. She is an original creator who is noted for her ability to expand notions of dance expression.

Betty Oliphant (1918–): Born in England, Oliphant arrived in Canada in 1947 where she became ballet mistress at the National Ballet of Canada. From 1959 to 1989, she was principal of the National Ballet School and was responsible for training some of Canada's greatest dancers, while serving as associate artistic director of the company. Her expertise is respected around the world and she has assisted in reorganizing major ballet schools in Europe. She has received, among many honours, the Molson Prize in 1979.

Grant Strate (1927–): A dancer and later an educator, he was born in Alberta, and moved to Toronto to work with the National Ballet, where he became one of Canada's leading choreographers, embodying in his own career the breaking down of barriers between classical ballet and modern dance. As a teacher and inspiration to other choreographers he has had few rivals, and he was a leading figure in promoting dance in Canada and establishing both professional organizations and university-based training programs emphasizing dance. He was awarded the Order of Canada in 1995 and received a Governor General's Performing Arts Award in 1996.

Veronica Tennant (1947–): Born in England but trained at the National Ballet of Canada, she became, after her debut in 1965, a world-famous dancer, partnered by all the great male dancers of the day. She also inspired several works choreographed to display her great technique and communicative power. A multi-talented person, Tennant has distinguished herself as choreographer, writer, producer and actor. She has received many awards in recognition of her work as an artist and arts advisor and for her activities on behalf of humane causes outside the arts world.

Boris Volkoff (1900–74): Born Boris Baskakoff in Russia, Volkoff was trained at the Bolshoi and eventually settled in Canada in the 1930s. He established a school of dance, which by the end of the decade had become the Canadian Ballet. He showed off Canadian dance at the Berlin Olympics in 1936, commissioned works from Canadian composers and became a master teacher at the Toronto Skating Club, for which he created the group's first ice ballet. Later, he contributed his studio to the fledgling National Ballet and as a teacher developed such notable talents as Melissa Hayden and Barbara Ann Scott.

Eva von Gencsy (1924–): Von Gencsy was born in Hungary, where she worked as a teacher and choreographer before coming to Canada in 1948. She was a principal dancer with the Winnipeg (later the Royal Winnipeg) Ballet from 1948 to 1953 and Les Ballets Chiriaeff in Montréal from 1953 to 1957. She founded Les Ballet Jazz de Montréal and served as artistic director and choreographer until 1979.

5
Film

CANADA's film history is rich and complex, with a few high points, some setbacks and a seemingly endless struggle to turn the next corner. In recent years, despite problems, Canadian filmmakers have increasingly made their presence felt on the world scene. They have created elegant, sophisticated and often effective cinema: Denys Arcand's *Jésus de Montréal*, Atom Egoyan's *The Sweet Hereafter*, Robert Lepage's *Le confessional*, David Cronenberg's *Crash* and François Girard's *The Red Violin*, among others, carry on the tradition of mostly low-key—or else bizarre and oddly imagined—narrative that many see as the essence of our celluloid vision.

In no obvious sense does Canada have a film industry; certainly nothing rivalling the scope of Hollywood, with its undreamed of technical apparatus, seemingly endless talent at every level and a marketing power that relies half on strong-armed economics and half on the chutzpah of its own mythology. Canada has Alliance Films, which in recent years has joined with the other Canadian giant, Atlantis, to create a really big player on the world cinema scene. Canada has talented professionals, technicians and specialists of all kinds, an inheritance of the tax shelter era. This talent is employed not only on Canadian projects, but also when the Americans make films north of the border. There are sophisticated production facilities in Toronto, Vancouver and Calgary, although Canadians do not always have ownership or full control of these. To be sure, this country has its National Film Board, always a great source of talent in documentary, special effects and experimental filmmaking. Canada also is strong in a few special areas, for example, in animation, with much talent furthered at excellent facilities such as Sheridan College in Oakville, renowned for its training in computer graphics.

Despite these strengths, many express disappointment with Canada's film industry and compare, for example, our cinema to Australia's, pointing out how definitely the movie-makers from Down Under have established themselves on the world scene, and suggesting that to do likewise we shall have to reform ourselves in quite a radical manner. These critics argue that we have the makings of a national

Director of such films as Exotica, Felicia's Journey *and the Academy Award-nominated* The Sweet Hereafter, *Atom Egoyan has gained an international reputation as a creator of layered and literate films.*

cinema without the political will to secure it. They suggest that Canadians have a national inferiority complex about their movies and refuse to accept anything cinematic that has not first obtained the imprimatur of the American market. They mention examples of Canadian filmmakers who go to great lengths *not* to run their films in this country first, simply in order to avoid that seemingly inevitable kiss of death, the indifference of Canadians to their own cinema. One such case was that of Vancouver filmmaker Mina Shum, whose *Double Happiness* was carefully steered away from a Canadian-only opening in 1995 for fear of having it die here. Paradoxically, Canadians seem more than willing to rent cassettes of Canadian films when they are identified as such—are we allergic only to big-screen Canada?

The critics who look at Canadian cinema with a sharp eye also point to the fact that our films are too cheaply made, and suggest that quality and finish are often lacking in our products. They argue pointedly that our movie theatres are only partially controlled by Canadians. They note that the actual distribution companies are even more decidedly foreign-owned (80 percent). Thus, although Canada is the largest foreign market for American films, the money earned by showing them here flows straight out of the country. And, these critics argue, since Canadian films get only two or three percent of our total screen time, we lose both ways. This goes far to explain, they say, why the $150 – $200 million that the National Film Board (NFB) and Telefilm Canada invest annually in our films does not turn us into an Australia. Whereas the Australians passed legislation to ensure screen time for their own productions (thus making them a presence in world cinema, giving Australian life and culture a much higher profile everywhere), we in Canada are too intimidated by the Hollywood Mafia and its power over the U.S. government to insist that images of Canada and Canadians occupy a fair share of our screen time.

The Canadian film industry is seen by most cultural nationalists as a bulwark of Canadian identity. Yet, as is the case with radio, television and publishing, it is very vulnerable to pressure from foreign industries with agendas that have nothing to do with rendering Canadian experience. If we make no effort to ensure that Canada is represented in such media, nationalists argue, we yield one of our most valuable powers and risk the possibility of being caricatured by others, of being effectively colonized by the world cinema giants. (Hollywood's Canada, notably chronicled by Pierre Berton, gives some idea of what to expect.) On the other hand, few Canadians seem to want cultural chauvinism or a parochial vision generated by the narrowest kind of national focus. The issues at hand have made a difficult road for Heritage Minister Sheila Copps, who showed a willingness to introduce protective measures,

while backing away from major confrontations when such measures threatened to trigger them.

Early in 1998, Heritage Canada announced a comprehensive review of Canadian feature film policy, but when information surfaced that the federal government might be planning to require foreign filmmakers to file for Canadian income tax, and that a tax might be placed on movies and video sales to support the development of Canadian feature films, the government quickly retreated.

In a much less sensational vein, during the second half of the 1990s, audiovisual co-production agreements were signed between Canada and some 38 countries, generating an average annual investment of about $300 million. All of this seemed to suggest the obvious: the interests of the Canadian film industry were easier to further at the margins than by means of a head-on conflict with the giant American industry.

If there seem to be some uncertainties in recent federal film policy, this is nothing new. The history of Canadian filmmaking itself is full of such inhibitions and uncertainties, replete with setbacks amid a few isolated triumphs. It all began at the turn of the century when James Freer, a Manitoba farmer, made some documentaries about life on the Prairies. Canada's first fiction film, *Evangeline*, based on Longfellow's poem, appeared in 1913. At the time of the First World War it might have seemed that Canadians were destined to have a strong national cinema, but in fact it was not to be. During the 1920s the key distribution companies came under Hollywood control and a long winter ensued for Canadian filmmaking, broken only in the late 1930s by the creation of the Canadian-owned Odeon Cinema chain, and by the establishment in 1939 of the National Film Board, which became the training ground par excellence for future Canadian filmmakers.

During the 1940s and 1950s there was some sporadic filmmaking, especially in English Canada, but the failure of the federal government to follow the lead of many other countries and take steps to protect our film industry from the American giant meant that progress was slow and tentative. The invention of the 16-millimetre camera and the appearance of a new well-educated generation of film buffs in universities throughout English Canada led to the creation of a number of inexpensive, sometimes interesting, but amateurish films in the 1960s. In 1967, the federal government established the Canadian Film Development Corporation (CFDC, later dubbed Telefilm Canada) which was designed to stimulate production, and did so. Don Shebib's 1970 feature film *Goin' Down the Road* was the most notable work of the creative phase of anglophone filmmaking that followed the establishment of the CFDC,

but there were several other high spots during the 1970s and 1980s, including Ján Kadár's *Lies My Father Told Me*, Sylvio Narizzano's *Why Shoot the Teacher?* and Richard Benner's *Outrageous!* A little later came David Cronenberg's *Videodrome*, Phillip Borsos's *The Grey Fox* and Atom Egoyan's *Family Viewing*.

During the post-war decades, Québec film also came of age. A number of production companies appeared and documentaries and feature films reflecting contemporary Québec life began to be released. When the NFB moved from Ottawa to Montréal in 1956, francophone filmmakers could apprentice to the craft in their own backyard. Radio had always provided a strong market for drama in Québec and, during the 1950s and 1960s, television did the same for fledgling directors. The advent of the Quiet Revolution prepared the ground for an uninhibited and sophisticated industry and many films were directed at establishing the specifics of francophone Québec identity. Such films as Pierre Perrault's *Un pays sans bon sens!* for example, suggest the link between the new cinema and the new Québec, which was beginning to focus its historical resentments and its nationalistic aspirations. During the early 1970s, some Québec work achieved unprecedented artistic and popular success, for example Claude Jutra's *Mon oncle Antoine* and Denys Arcand's *Réjeanne Padovani*. In 1975, the Institut Québecois du Cinema was established with a mandate to promote the creation, production and distribution of high-quality films in Québec; its annual budget (in the 1990s) ran around $5 million.

Meanwhile, it was argued in Ottawa that since federal funding of production was in place there should be some guarantee that the public would actually see the films created. When a tentative movement in the direction of establishing voluntary box office quotas in favour of Canadian films failed, what emerged was the practice of catching public interest by using American stars in conjunction with Canadian films. The late 1970s became the era of the glossy co-production and of the tax shelter, resulting in some huge profits for enterprising producers, and in some of the worst films ever made (*Porky's*, for example), with very minimal benefits for cinema art and Canadian identity. This was especially true in English Canada, yet as Québec cinema expanded and broadened its popular appeal it ran into the same conflicts between art and money-making, as well as the same distribution problems that plagued anglophone cinema. Thus, more sensational films such as Denis Héroux's *Valérie* appeared, along with the serious and dedicated ones, which in later years included Francis Mankiewicz's *Les bons débarras*, Léa Pool's *Anne Trister*, Yves Simoneau's *Pouvoir intime*, Denys Arcand's *Le déclin de l'empire américain* and Jean-Claude Lauzon's *Un zoo, la nuit*.

Throughout the 1960s and the 1970s, astoundingly, there was almost no attempt on the part of the federal government to help interpret the two separate strands of Canadian filmmaking to each other. The Québec cultural revolution might have been taking place on the moon as far as English Canada was concerned. The new Québec films, which should have been part of anglophone education (subtitled and presented on the CBC) were invisible in English Canada, while Québec filmmakers treated the rest of Canada with lofty indifference. As a result, Canadian cinema developed its own two solitudes, united only by having to face the American dominance, and contributing virtually nothing to national unity, despite much huffing and puffing on the part of the federal mandarins of the day. Fortunately, the talents that were appearing in Québec and English Canada at the end of the 1990s seemed anything but isolated from one another, and films in both languages were more generally known throughout the country, although this was largely due not to government decree, but to the dynamics of the private sector.

In fact, the most striking event in recent Canadian cinema history had nothing to do with federal policy, but involved the creation of a new Canadian cinema giant through the amalgamation of the Alliance and Atlantis Communications Corporations. The stockholders of Robert Lantos's Alliance Communications Corporation, the largest of its kind in the country, with 1997 revenues of almost $400 million, retained 60 percent of the new company's stock under the terms of the merger. Michael MacMillan of Atlantis became CEO and brought his management team and style to the new operation, along with a commitment—which he repeated in several interviews—to produce new Canadian drama of quality. With annual revenues at the end of the 1990s reaching approximately $750 million, the new company has become one of the largest in the world. Major feature films have already begun to emerge from Alliance-Atlantis, several of them Lantos projects, and its range and quality of television production (from *Black Harbour* to *Traders*), its control of Cineplex Odeon (purchased in 1998), and its ownership of several speciality television channels, gave it an unprecedented power in the marketplace. Inevitably, this has caused some fears among the less-well-heeled production companies (will there be a place for smaller players?). It has also raised some doubts about the focus of the new mega-giant: will it be on feature films, or will the emphasis shift more into television production? Also, it should be recalled that the largest television audience ever to watch a Canadian drama watched neither an Alliance nor an Atlantis production but *Anne of Green Gables*, which was created, with some help from the Disney Channel, by Sullivan Entertainment of Toronto, a small independent company.

The unofficial ambassador of Canadian film abroad, David Cronenberg—shown here with longtime collaborator, production designer Carol Spier—has directed many controversial yet critically acclaimed films including Videodrome, Naked Lunch *and* Crash.

CBC Television / Fred Phipps

Significantly perhaps, when the same company more than a decade later produced a less nostalgic Canadian drama, *Wind at My Back*, about a depression-era Ontario town, no American money was forthcoming.

Robert Lantos's Alliance films had earlier fostered such Canadian film talents as David Cronenberg and Atom Egoyan. As the 1990s ended, the schedule of upcoming Lantos projects included some strong Canadian content: a Cronenberg science fiction film, a film by Denys Arcand, a movie based on Mordecai Richler's novel *Barney's Version* and a Norman Jewison adaptation of a novel by Brian Moore. Although Lantos's Alliance Corporation was often funded by Telefilm Canada, these events might cause some to reflect that, after all, the best way to ensure Canadian content in films is to let the free market have its way.

If Canadian companies are proving themselves remarkably adept at organizing big feature film projects of quality, and at hatching genre film fare for the world cable market, the achievements of our animators and experimental filmmakers are certainly worth noting. The work of Norman McLaren at the NFB is, of course, one of this

country's major artistic achievements. McLaren's experiments in drawing and painting directly on film and his work in cutout animation and stop-motion photography were only the means—although bold means—to an artistic expression that encompassed, as in the famous short film *Neighbours*, some wry commentary on the human condition.

Other Canadian animators of note include Jacobus Hoedeman, Pierre Hébert, Jean-Phillipe Dallaire and Frédéric Back. Some of their work encompasses fruitful connections with painting, as McLaren's did with music. The decades of experimentation represented by such diverse talents, and the NFB's steady presence in the area of animation, along with some remarkable early work on special effects, have brought many honours to Canada, including several Academy Awards.

Experimental film itself is an area in which Canadians came late to the game, but it is one in which they have nonetheless achieved a great deal. Starting in the 1960s, many Canadian artists began to explore the very act of seeing, as well as the techniques by which visual signs are given meaning and social reference. Michael Snow, Jack Chambers, Joyce Wieland, David Rimmer and Bruce Elder are among those who have made significant contributions to this form of postmodern cinema. The mutual interaction and counterpoint that can exist between a photograph and a film; the tension between representation and abstraction; the interaction of light and human consciousness; the alienation of the individual from a known world and the reconciliation of the spectator to the image—these are some of the concerns of the avant-garde filmmakers.

Experimental film often seems pointless to the general public, and may become offensive actually when it is combined, as it has been in Canada in recent decades, with provocative political content. Whether or not there is a case for public support of such cinema, it is undeniable that a country's artistic development profits from its existence.

Much of the creative work just mentioned, as indicated, has occurred in connection with Canada's NFB, which, like many of our major arts operating bodies, suffered some near-fatal shocks and changes in the mid-1990s. Fortunately, this useful institution has survived, and in 1999 celebrated its 60th year of existence. Under its new chair, Sandra MacDonald, who took over in 1996, the NFB has divided its facilities: the head office is now in Ottawa, while the NFB operational centre remains in Montréal, with production centres spread across the country. The revamped NFB officially concentrates on documentary and animation, arguably always its strengths, but many think of it now not so much as a source of artistic innovation but rather as

a force for education and for the recording of Canada's changing social life. The NFB's archives contain more than 8,000 films, which represent nothing less than a visual history of this country since the 1930s, one that if systematically explored would yield as much or more information about what Canadians have thought, done and been as any extensive newspaper or magazine archive.

The future of Canada as a filmmaking country is increasingly bright. Heritage Minister Sheila Copps, who in 1996 created a special $100-million fund for film and television, initiated, as the decade ended, a much-needed complete review of national film policy. At the same time, the Canadian private filmmaking sector, as noted above, has never been stronger. Despite many obstacles, such as the difficulty of coordinating policy and legislation with the changing realities of the media and the marketplace, the realities of Canadian life are increasingly visible in our mass cinema (if not in our made-for-television productions). This is a tribute not only to the boldness of our entrepreneurs, but to the talent of our creative artists in this field. Such efforts may in the end ensure that, despite the increasingly international character of the cinema of the 21st century, Canadian life and values will be well represented there.

Sixteen Indispensable Canadian Films

A RE you one of those Canadians who sneer at our homegrown cinema? If so, I suggest you take in the following. Great films you won't find, but the diversity and vitality of these movies may convince you that Canadian cinema has a future and is worth defending against the insatiable American industry.

Neighbours (1952), **Norman McLaren**: P. D. Ouspensky, the Russian sage, talked about the mechanical side of human beings, our tendency to let stimulus and response patterns rule us like a code of iron. The truth of this contention—and the resulting sadness and stupidity of much of human life—has never been more precisely embodied than in this brilliant film by Norman McLaren. In this short film McLaren animates living actors to show us how we become robots in conflict over trifles. The crescendo of hostility and idiocy is dispiriting, but alas, all too credible.

Goin' Down the Road (1970), **Don Shebib**: You may remember the scene where one of the young Cape Breton heroes listens with a "sophisticated" Toronto girl, a stranger, to one of Erik Satie's beautiful *Gymnopédies*. Their rapport is complete until he opens his mouth and betrays his Maritime origins. She departs and he gouges the record with the needle. Was there ever a better image of the frustration that comes when we discover that a certain kind of beauty is unattainable? This film, like most really effective art, fixes on a specific historical and social situation and creates universal truth from it.

Mon oncle Antoine (1971), **Claude Jutra**: Another confident focus on the local environment yields one of our touchstone Canadian films, a movie that blends skills derived from the National Film Board's documentary art with a touching and very

personal *recherche des temps perdu*. Christmas Eve as a time of both magic and sorrow, and the coming of age of the young hero, are handled with great mastery by Jutra, whose film was an important milestone in the acceptance of Québec cinema as world-class.

Le vraie nature de Bernadette (1972). **Gilles Carle**: A fine director's iconoclastic film about a very unsaintly and sexually promiscuous Bernadette (played by the lovely Micheline Lanctôt) who departs from the city and becomes the miraculous flesh of life for a number of rural men who are "saved" and transported by her body. In fascinating style the film exploits the metaphorical territory that connects religious and sensual passion. Only a Catholic society like Québec, having achieved a leap toward secularism in the Quiet Revolution, could have provided such a convenient setting, and only a director as clever as Gilles Carle could have deployed the necessary ironies with so cool a hand. This film earned Carle and Lanctôt a great deal of international attention.

The Apprenticeship of Duddy Kravitz (1974), **Ted Kotcheff**: Of course, Mordecai Richler's novel was better, but this film reminded us that soulful poet and balladeer Leonard Cohen wasn't the only kind of boychick in Montréal. Ruthlessness and petty ambition were never so funny. And no bar mitzvah would ever be the same after the takeoff par excellence in this flick.

Lies My Father Told Me (1975), **Ján Kadár**: A Chekhovian spirit invests this low-key poetic tale of a boy and his junk-dealing grandfather in the Montréal of the 1920s. Some great films used to be made in this vein—Vittorio de Sica's *The Bicycle Thief* represents the peak of the genre—but those were the days when junk was really junk and family values spoke more of poetry, social awareness and of a lost childhood than they did of conservative ideology.

J.A. Martin, photographe (1976), **Jean Beaudin**: Set in turn-of-the-century Québec, this film delicately limns the troubled relationship between an itinerant photographer and his wife as they travel through the hard beauty of the province's countryside. Monique Mercure shines as the wife (she won a Best Actress Award at the Cannes Film Festival for her portrayal), and once again, as in so many Québec films, the land itself is a powerful, brooding character.

Videodrome (1983), **David Cronenberg**: Leopold von Sacher-Masoch, the Austrian master of latent porno who gave his name (or at least half of it) to the word *masochism,* would have loved this film. In particular, he might have doted, as I did, on one of the opening scenes where sex between the inimitable Deborah Harry and the fortunate James Woods is assisted by some jabbing and stabbing with a long, shiny needle. Maude Barlow didn't like this at all, however, and—I am told—a complaint from her caused the film to be banned for a while in Ottawa. What Maude perhaps missed was how Cronenberg's sense of the grotesque here intersects with the McLuhanistic worldview, providing both a parable and a send-up of our Canadian media guru, whose deep cultural insights sometimes emerged as learned bafflegab. And, anyway, who can forget James Woods's built-in VCR?

The Grey Fox (1982), **Phillip Borsos**: This is a film so low-key that Americans wonder what we see in it. Richard Farnsworth's performance, however, has the tough delicacy of a good 19th-century western engraving. There is smoke and dust and longing in this movie, but also humour and vulnerability. Perhaps it is just that combination of the latter two or three elements that makes *The Grey Fox* so quintessentially Canadian.

Family Viewing (1987), **Atom Egoyan**: This early Egoyan film has that indefinable low-budget look. Its focus is petty lives played out in implacably unpoetic high-rise buildings. I recall tiny apartments with banal furnishings where sad plots founder and life's banalities remain unredeemable. More authentic in many ways than Egoyan's later movies, *Family Viewing* gave Canadians a glimpse of what life could be like beyond the English Canada/Québec polarities of our past.

Jésus de Montréal (1989), **Denys Arcand**: What an idea for a film! A play within a play and an encapsulation of almost all of Québec's history in the tensions between religion and worldliness, pretence and reality, history and dream. Director Arcand's lauded *Le déclin de l'empire américain* seems almost tedious and certainly narrow in scope by comparison. A justly celebrated film, *Jésus de Montréal* won the coveted Jury Prize at the Cannes Film Festival in 1989.

Léolo (1992), **Jean-Claude Lauzon**: This autobiographical extravaganza is a visual delight. Lauzon's first film, *Un zoo, la nuit*, was highly praised, but his second feature is much more original and fresh in its approach. This story of an imaginative little boy and his dysfunctional working-class family seems light years away from the classic contemplation of rural Québec as seen in earlier films such as *Isabel, Mon oncle Antoine,* and *Les bons débarras.*

Thirty-two Short Films About Glenn Gould **(1993), François Girard**: A series of tableaux unfold the life of Canadian master pianist Glenn Gould. It is the story of a great artist who was also a strange, rather narrow and sometimes pathetic human being, but Girard makes the main point with the opening and closing scenes, which show Gould appearing and finally disappearing in the eternal landscape of the North. I do wonder, though, if Girard hired that plane to fly over and distract broadcaster Margaret Pacsu during her interview. The performance by Colm Feore is amazing but, as in the case of Anthony Hopkins's Nixon, the original rises up in the viewer's mind to haunt the semblance.

Margaret's Museum **(1995), Mort Ransen**: Ostensibly a movie about life in a Nova Scotia mining town in the 1940s, this film goes beyond documentation to touch on the craziness of life on the margin. Although the relationship of the lovers had no chemistry for me, despite the shower scene, and the ending seemed contrived, Ransen's film made its point in between with many quiet moments of comical and very human frustrations. The settings are wonderful in their reality, and the gimcrack house the lovers build overlooking the ocean is a leap into the absurd worthy of François Truffaut.

The English Patient **(1996), Anthony Minghella**: Strictly speaking, this film is only part-Canadian (based on a Canadian novel; co-produced by Alliance Communications), since its director/screenwriter is British and its main actors are British, American and French, but how many serious, highly polished international films (with nine Academy Awards to their name) have allowed Canadians to hear some of their geographical and personal reference points ("Picton, did he say *Picton*?") named with such unselfconscious confidence and ease. The plot of this film is absurd when you reflect on it, but the spectacular scenery, the music, the exotic settings and the superb acting and editing leave you almost too breathless for critical cavil. And, no, I *don't* think the film is marred by what the "original" *English Patient* did or didn't do for or with the Nazis. Earth, air, fire and water tell the story.

Last Night **(1998), Don McKellar**: This end-of-the-world story conveys a subtle sense of impending doom, depicting the inner moods and life-options of several very different and fascinating characters as they face the prospect of a millennial quietus. Quintessentially Canadian in its low-key approach, stark, elegant and perfectly constructed, *Last Night* draws on some of our major talent, including McKellar as writer, director and actor, with David Cronenberg, Geneviève Bujold, Jackie Burroughs, Sandra Oh, Callum Keith Rennie and Sarah Polley in some of the other key roles. An odd and intriguing film that is about as far removed as possible from the recent American versions of Armageddon, much more closely related to 1930s and 1940s cinema than it is to today's action spectacles, *Last Night* is sure to become one of a small list of Canadian cult films, along with *Outrageous*, *Videodrome* and *The Grey Fox*.

The Golden Reel Award

THIS award was instituted in 1976. Its full title is the KPMG Peat Marwick Thorne Golden Reel Award, and it goes to the producer of the Canadian dramatic feature film that has achieved the highest gross box office in Canadian theatres in the past year.

1999: Richard Goudreau, *Les Boys II*

1998: Richard Goudreau, *Les Boys*

1997: Robert Vince, William Vince, *Air Bud*

1996: Robert Lantos, Jeremy Thomas and David Cronenberg, *Crash*

1995: Robert Lantos, Victoria Hamburg, Staffan Ahrenberg and Don Carmody, *Johnny Mnemonic*

1994: Richard Sadler and Jacques Dorfmann, *Louis 19, Le roi des ondes*

1993: Claude Bonin and Pierre Sarrazin, *La Florida*

1992: Robert Lantos, Stephane Reichel and Sue Milliken, *Black Robe*

90/91: Roger Frappier, *Ding et Dong, Le Film*

1989: Roger Frappier and Pierre Gendron, *Jésus de Montréal*

1988: Rock Demers, *La grenouille et la baleine*

1987: John Kemeny and Andras Hamori, *The Gate*

1986: René Malo and Roger Frappier, *Le déclin de l'empire américain*

1985: Michael Hirsch, Patrick Loubert and Clive Smith, *The Care Bears Movie*

1984: Rock Demers and Nicole Robert, *La guerre des tuques*

1983: Jack Grossberg and Louis M. Silverstein, *Strange Brew*

1982: Harold Greenberg, *Porky's*

1981: Ivan Reitman, *Heavy Metal*

1980: Garth H. Drabinsky and Joel B. Michaels, *The Changeling*

1979: Dan Goldberg and Ivan Reitman, *Meatballs*

1978: Allan King, *Who Has Seen the Wind?*

1977: Lawrence Hertzog, *Why Shoot the Teacher?*

1976: Harry Gulkin and Anthony Bedrich, *Lies My Father Told Me*

Genie Awards

IN 1949, the first Canadian film awards were presented. From that year until 1968, when the awards were reorganized to include craft categories, the early awards were a spotty affair and reflected the sad state of feature filmmaking in Canada. In 1968, sculptor Sorel Etrog was commissioned to create what came to be known as the Etrog Award. Happily, this curious name was dropped when the newly founded Academy of Canadian Cinema and Television took over the awards in 1980 and decided to call the revamped awards the Genies. As a result of the changeover, no awards were given in 1979. Today's Genies apply to films released in the previous year. Voting is conducted in a two-step process whereby the winners are chosen by all academy members from among the five nominees selected in each category by their respective craft branches. The following list is, of course, only a partial one.

1999
- Feature Film: *Sunshine*
- Best Director: Jeremy Podeswa, *The Five Senses*
- Best Actor: Bob Hoskins, *Felicia's Journey*
- Best Actress: Sylvie Moreau, *Post Mortem*

1998
- Feature Film: *The Red Violin*
- Best Director: François Girard, *The Red Violin*
- Best Actor: Roshan Seth, *Such a Long Journey*
- Best Actress: Sandra Oh, *Last Night*

1997
- Feature Film: *The Sweet Hereafter*
- Best Director: Atom Egoyan, *The Sweet Hereafter*
- Best Actor: Iam Holm, *The Sweet Hereafter*
- Best Actress: Molly Parker, *Kissed*

1996
- Feature Film: *Lilies*
- Best Director: David Cronenberg, *Crash*
- Best Actor: William Hutt, *Long Day's Journey into Night*
- Best Actress: Martha Henry, *Long Day's Journey into Night*

1995
- Feature Film: *Le confessionnal*
- Best Director: Robert Lepage, *Le confessionnal*
- Best Actor: David La Haye, *L'enfant d'eau*
- Best Actress: Helena Bonham Carter, *Margaret's Museum*

1994
- Feature Film: *Exotica*
- Best Director: Atom Egoyan, *Exotica*
- Best Actor: Maury Chaykin, *Whale Music*
- Best Actress: Sandra Oh, *Double Happiness*

1993
- Feature Film: *Thirty-two Short Films About Glenn Gould*
- Best Director: François Girard, *Thirty-two Short Films About Glenn Gould*
- Best Actor: Tom McCamus, *I Love a Man in Uniform*
- Best Actress: Sheila McCarthy, *The Lotus Eaters*

1992
- Feature Film: *Naked Lunch*
- Best Director: David Cronenberg, *Naked Lunch*
- Best Actor: Tony Nardi, *La sarrasine*
- Best Actress: Janet Wright, *Bordertown Café*

1991
- Feature Film: *Black Robe*
- Best Director: Bruce Beresford, *Black Robe*
- Best Actor: Rémy Girard, *Amoureux fou*
- Best Actress: Pascale Montpetit, *H*

1990
- Feature Film: *Jésus de Montréal*
- Best Director: Denys Arcand, *Jésus de Montréal*
- Best Actor: Lothaire Bluteau, *Jésus de Montréal*
- Best Actress: Rebecca Jenkins, *Bye Bye Blues*

1989
- Feature Film: *Dead Ringers*
- Best Director: David Cronenberg, *Dead Ringers*
- Best Actor: Jeremy Irons, *Dead Ringers*
- Best Actress: Jackie Burroughs, *A Winter Tan*

1988
- Feature Film: *Un zoo, la nuit*
- Best Director: Jean-Claude Lauzon, *Un zoo, la nuit*

- Best Actor: Roger Le Bel, *Un zoo, la nuit*
- Best Actress: Sheila McCarthy, *I've Heard the Mermaids Singing*

1987

- Feature Film: *Le déclin de l'empire américain*
- Best Director: Anne Wheeler, *Loyalties*
- Best Actor: Gordon Pinsent, *John and the Missus*
- Best Actress: Martha Henry, *Dancing in the Dark*

1986

- Feature Film: *My American Cousin*
- Best Director: Sandy Wilson, *My American Cousin*
- Best Actor: John Wildman, *My American Cousin*
- Best Actress: Margaret Langrick, *My American Cousin*

1985

- Feature Film: *The Bay Boy*
- Best Director: Micheline Lanctôt, *Sonatine*
- Best Actor: Gabriel Arcand, *Le crime d'Ovide Plouffe*
- Best Actress: Louise Marleau, *La femme de l'hotel*

1984

- Feature Film: *The Terry Fox Story*
- Best Director: Bob Clark, *A Christmas Story*
 and David Cronenberg , *Videodrome*
- Best Actor: Eric Fryer, *The Terry Fox Story*
- Best Actress: Martha Henry, *The Wars*

1983

- Feature Film: *The Grey Fox*
- Best Director: Phillip Borsos, *The Grey Fox*
- Best Actor: Donald Sutherland, *Threshold*
- Best Actress: Rae Dawn Chong, *Quest for Fire*

1982

- Feature Film: *Ticket to Heaven*
- Best Director: Gilles Carle, *Les Plouffe*
- Best Actor: Nick Mancuso, *Ticket to Heaven*
- Best Actress: Margot Kidder, *Heartaches*

1981

- Feature Film: *Les bons débarras*
- Best Director: Francis Mankiewicz, *Les bons débarras*
- Best Actor: Thomas Peacocke, *The Hounds of Notre Dame*
- Best Actress: Marie Tifo, *Les bons débarras*

1980

- Feature Film: *The Changeling*
- Best Director: Bob Clark, *Murder By Decree*
- Best Actor: Christopher Plummer, *Murder By Decree*
- Best Actress: Kate Lynch, *Meatballs*

1979

- The Academy of Canadian Cinema was born. No awards were given and the *Etrog* became the *Genie*.

1978

- Feature Film: *The Silent Partner*
- Best Director: Daryl Duke, *The Silent Partner*
- Best Actor: Richard Gabourie, *Three Card Monte*
- Best Actress: Helen Shaver, *In Praise of Older Women*

1977

- Feature Film: *J. A. Martin, Photographe*
- Best Director: Jean Beaudin, *J. A. Martin, Photographe*
- Best Actor: Len Cariou, *One Man*
- Best Actress: Monique Mercure, *J. A. Martin, Photographe*

1976
- Feature Film: *Lies My Father Told Me*
- Best Director: Harvey Hart, *Goldenrod*
- Best Actor: André Melançon, *Partis pour la gloire*
- Best Actress: Marilyn Lightstone, *Lies My Father Told Me*

1975
- Film of the Year (1974): *The Apprenticeship of Duddy Kravitz*
- Film of the Year (1975): *Les ordres*
- Feature Film: *Les ordres*
- Best Director: Michel Brault, *Les ordres*
- Best Actor: Stuart Gillard, *Why Rock The Boat?*
- Best Actress: Margot Kidder, *Black Christmas* and *A Quiet Day in Belfast*

1974
- The Awards were reorganized this year and no prizes were presented.

1973
- Film of the Year: No award
- Feature Film: *Slipstream*
- Best Director: David Acomba, *Slipstream*
- Best Actor: Jacques Godin, *OK... la liberté*
- Best Actress: Geneviève Bujold, *Kamouraska*

1972
- Film of the Year: No award
- Feature Film: *Wedding in White*
- Best Director: Gilles Carle, *La vraie nature de Bernadette*
- Best Actor: Gordon Pinsent, *The Rowdyman*
- Best Actress: Micheline Lanctôt, *Le vraie nature de Bernadette*

1971
- Film of the Year: No award
- Feature Film: *Mon oncle Antoine*
- Best Director: Claude Jutra, *Mon oncle Antoine*
- Best Actor: Jean Duceppe, *Mon oncle Antoine*
- Best Actress: Ann Knox, *The Only Thing You Know*

1970
- Film of the Year: *Psychocratie*
- Feature Film: *Goin' Down the Road*
- Best Director: Paul Almond, *The Act of the Heart*
- Best Actor: Paul Bradley, Doug McGrath, *Goin' Down the Road*
- Best Actress: Geneviève Bujold, *The Act of the Heart*

1969
- Film of the Year: *The Best Damn Fiddler from Calabogie to Kaladar*
- Feature Film: No award
- Best Non-Feature Director: Peter Pearson, *The Best Damn Fiddler from Calabogie to Kaladar*
- Best Non-Feature Actor: Chris Wiggins, *The Best Damn Fiddler from Calabogie to Kaladar*
- Best Non-Feature Actress: Jackie Burroughs, *Dulcima*

1968
- Film of the Year: *A Place to Stand*
- Feature Film: *The Ernie Game*
- Best Director: Don Owen, *The Ernie Game*
- Best Actor: Gerard Parkes, *Isabel*
- Best Actress: Geneviève Bujold, *Isabel*

Source: Academy of Canadian Cinema and Television

Canadian Film Agencies, Distributors and Producers

- **Academy of Canadian Cinema and Television**:
172 King St. E, Toronto, ON, M5A 1J3.
Phone: (416) 591 • 2040
Montréal: 3575, boul. Saint-Laurent,
Bureau 709, QC, H2X 2T7.
Phone: (514) 849 • 7448
Vancouver: 1385 Homer St., BC,
V6B 5M9. Phone: (604) 684 • 4528

- **Allegro Films Distribution Inc.**:
2187, rue Larivière, Montréal, QC,
H2K 1P5. Phone: (514) 529 • 0320

- **Alliance Atlantis Communications Inc.**:
800, 121 Bloor St. E, Toronto, ON,
M4W 3M5. Phone: (416) 967 • 0022

- **Astral Distribution Group**:
1020, 33 Yonge St., Toronto, ON,
M5E 1S9. Phone: (416) 956 • 2000
Montréal: 2100, rue Sainte-Catherine O,
Bureau 900, QC, H3H 2T3.
Phone: (514) 939 • 5000

- **Canadian Film Centre**:
2489 Bayview Ave., Toronto, ON,
M2L 1A8. Phone: (416) 445 • 1446

- **CFP Distribution Inc.**:
1901, 2 Bloor St. W, Toronto, ON,
M4W 3E2. Phone: (416) 944 • 0104
Montréal: 8275, rue Meynard, QC,
H4P 2C7. Phone: (514) 342 • 2340

- **Cinar Films Inc.**:
1055, boul. René Lévesque E, Montréal,
QC, H2L 4S5.
Phone: (514) 843 • 7070

- **Cinematheque ON**:
This institution consists of archival
resources and is associated with the
Toronto International Film Festival. Film
retrospectives and series are shown at the
Cinematheque film theatre, which is
located in the:
Art Gallery of Ontario,
1600, 2 Carleton St., Toronto, ON,
M5B 1J3. Phone: (416) 967 • 7371

- **Cinémathéque Québécoise**:
Recently $165 million of provincial
money and $3 million in federal funds
were used to renovate the Cinémathéque
and enlarge the space. Montréalers now
have a facility that combines a museum of
Québec film (permanent and temporary
exhibitions) with personal screening
terminals and a number of film theatres
that present retrospectives and series.
When will English Canada get such a
treat?
335, boul. de Maisonneuve E, Montréal,
QC, H2X 1K1.
Phone: (514) 842 • 9763

- **Cineplex Odeon Films**:
1303 Yonge St., Toronto, ON, M4T 2Y9.
Phone: (416) 323 • 6600

- **Creative Exposure**:
2236 Queen St. E, Toronto, ON,
M4E 1G2. Phone: (416) 690 • 0775

- **Ellis Enterprises**:
201, 1231 Yonge St., Toronto, ON,
M4T 2T8. Phone: (416) 924 • 2186

- **Fireworks Entertainment Inc.**:
3rd Floor – 111 George St., Toronto, ON,
M5A 2N4. Phone: (416) 360•4321

- **Malofilm Distribution Inc.**:
3575, boul. Saint-Laurent,
Bureau 650, Montréal, QC, H2X 2T7.
Phone: (514) 844•4555

- **Montréal World Film Festival**:
1432, rue de Bleury, Montréal, QC,
H3A 2J1. Phone: (514) 848•3883

- **National Film Archives of Canada
Visual and Sound Archives**:
344Wellington St., Ottawa, ON, K1A 0N3.
Phone: (613) 995•5138

- **National Film Board**:
1560, 360 Albert St., Ottawa, ON,
K1A 0M9. Phone: 1 (800) 267•7710
Montréal: PO Box 6100, Station Centre-
ville, QC, H3C 3H5.
Phone: (514) 283•9000

- **Norstar Film Entertainment**:
4th Floor – 86 Bloor St. W, Toronto, ON,
M5S 1M5. Phone: (416) 961•6278

- **Ontario Film Development
Corporation**:
300, 175 Bloor St. E,
North Tower, Toronto, ON, M4W 3R8.
Phone: (416) 314•6858

- **Pacific Cinematheque**:
Some archival resources; film theatre is
located on the premises.
200, 1131 Howe St., Vancouver, BC,
V6Z 2L7. Phone: (604) 688•8202

- **Paragon Entertainment**:
900, 119 Spadina Ave., Toronto, ON,
M5V 2L1. Phone: (416) 977•2929

- **Prima Film Inc.**:
1435, rue de Bleury, Montréal, QC,
H3A 2H7. Phone: (514)289•0837

- **Société de développement des
entreprises culturelles (SODEC)**:
1755, boul. René Lévesque E, Montréal,
QC, H2K 4P6.
Phone: (514) 873•7768

- **Société de distribution cinéma libre,
Inc.**:
4067, boul. Saint-Laurent,
Bureau 403, Montréal, QC, H2W 1Y7.
Phone: (514) 849•7888

- **Sullivan Entertainment Inc.**:
110 Davenport Rd., Toronto, ON,
M5R 3R3. Phone: (416) 921•7177

- **Telefilm Canada**:
Tour de la Banque Nationale,
600, rue de la Gauchetière O, 14th Floor,
Montréal, QC, H3B 4L8.
Phone: (514) 283•6363

- **THA Media Distributors**:
307, 1200 Pender St., Vancouver, BC,
V6E 2S9. Phone: (604) 687•4215

- **Toronto International Film Festival**:
1600, 2 Carlton St., Toronto, ON,
M5B 1J3. Phone: (416) 967•7371

- **Vancouver International Film Festival**:
410, 1008 Homer St., Vancouver, BC,
V6B 2X1. Phone: (604) 685•0260

- **Winnipeg Film Group Distribution**:
304, 100 Arthur St., Winnipeg, MB,
R3B 1H3. Phone: (204) 925•3456

6

Literature & Book Publishing

A s the new century begins, Canadian literature is complex, rich and multifaceted. While in the view of many there are serious deficiencies in the structures connected with publishing and marketing, and while many lament the seeming shrinkage of a literate public, Canada has transformed itself in a remarkably short period from a colonial backwater into a country whose best writers are read around the world and compete for the most notable international literary prizes.

Canadians who take this situation for granted should be made to climb into the nearest time-machine to be transported back—not to prehistoric times, but merely to the 1940s and 1950s, when all of the published novelists in this country could have been easily accommodated in a medium-size hotel conference room. Travelling farther back, one would encounter a literary scene that was anything but promising. Apart from the songs, stories and myths of our Native Canadians, except for a few remarkable diaries and historical memoirs and journals by wonderfully vivid characters such as Samuel Hearne and Susanna Moodie, Canadian writing—almost until the years before the Second World War—was a wasteland of futile gestures, a chamber of literary echoes, a bush garden of the second-rate.

Anyone who disbelieves this contention should go back and read the works that are held up as part of our central literary heritage. Begin with the early and mid-19th century: sample the poetic ruminations of Charles Heavysege, dip into the lumbering historical narratives of John Richardson (our James Fenimore Cooper *manqué*), try the poetic work of Charles Sangster or Charles Mair, or the unfocused, interminable lyrical outbursts of Isabella Valancy Crawford. Here you have the very essence of a tradition based on what one critic has called "IHFs" (Interesting Historical Figures), rather than on living voices.

If there is an exception, it is Thomas Chandler Haliburton's *The Clockmaker*, but that is the exception that proves the rule. To be sure, things improved to some degree in the latter part of the 19th century with William Kirby's *The Golden Dog* and James DeMille's *A Strange Manuscript Found in a Copper Cylinder* and, above all, with the poets Duncan Campbell Scott and Archibald Lampman. But even at their most intense, such poets are heavily derivative, relying on literary fashions created elsewhere, as indeed do the Québec writers of the earlier period: Phillipe de Gaspé (influenced by Sir Walter Scott), Louis Fréchette (derived from Victor Hugo) and Émile Nelligan who, like Scott and Lampman, is a worthy and occasionally powerful practitioner rather than a voice that creates a literature.

Unlike such countries as Denmark, Norway and Sweden, smaller European countries that defined themselves thanks to languages that were not shared with the surrounding great powers, Canada was burdened with a doubly colonized reality. It was the terminus of literary and cultural signals coming from two of the world's greatest and most confident nations, England and France, with the additional burden of a long border with the startlingly original American culture to the south.

No wonder our literature languished for so long. Canada's English tradition ensured endless repetitions of genteel irrelevancy, minor romantic poetizing and hesitant attempts at rendering the overwhelming facts of our landscape and our winter, attempts that were foiled by the lack of a vital literary speech. On the French side, the dominance of the Roman Catholic Church, the preponderance of rural society and the failure of morale following the defeat on the Plains of Abraham produced a tradition of apology and reconciliation. Québecois literature sang the praises of piety and the soil, or indulged in fantasies of romantic escape. It was a literature seeking cultural redemption in visions of social stasis or natural splendour—anything rather than deep analysis in psychological or social terms.

The early 20th century brought welcome changes, especially in English Canada, where E. J. Pratt and Frederick Philip Grove dealt squarely with the fact of post-Darwinian nature and wrote powerfully of social struggle. Meanwhile, Lucy Maud Montgomery's *Anne of Green Gables* gave us a cherishable genre heroine, rooted in the idyllic rural world of Prince Edward Island. Also, Stephen Leacock began the process of undermining the more absurd preciosities of our anglophile gentility. But despite the work of Morley Callaghan and Hugh MacLennan, and some excellent regional writers, it was only after the Massey-Lévesque report and the creation of the Canada Council in the 1950s that Canadian literature in English began to come to full maturity. It was then, too, that Québec, after transforming itself in the Quiet

Revolution, began to produce a new and exciting literature, thus beginning the healthy search for identity within the bilingual and bicultural world envisaged by the federal mandarins of the 1960s and 1970s.

The past four decades have seen what amounts to a miracle: the maturing of Canadian literature to such a point that, taking into account our population, it ranks very high in the world. Part of the evidence for this maturity is the fact that the old colonialist way of writing, the desire to establish the details of the Canadian environment at all costs, is no longer evident in our texts. Our writers no longer feel that they have to spend many pages proving that the Canada they know exists and is worth writing about. With the notable exceptions of Robert Kroetsch, Daphne Marlatt, Ray Smith and Michael Ondaatje, few of our anglophone writers have gone very far into postmodernism, but they have produced a generous stock of successful traditional and modernist novels that are accessible to an international public. This output has been remarkably supplemented by an influx of new immigrants and by the emergence of fiction documenting the life of recently arrived or "forgotten" ethnic groups, of which Nino Ricci's *Lives of the Saints*, Rohinton Mistry's *A Fine Balance* and *Obasan* by Joy Kogawa represent outstanding examples.

Meanwhile, francophone writers have been more experimental, far more in touch with European trends, more centred on the politics of identity, more obsessed with history, and in general more diverse and daring, and at the same time—because of their recurring obsessions—more provincial than the English. The problem remains that the critics, reviewers and plain readers who move easily between the two languages and literatures are still far outnumbered by those Canadians who know little about the literary production of their own group and almost nothing about any other.

Nonetheless, the stars of Canadian literature shine brightly, if on two separate cultural landscapes. The names of Margaret Laurence, Alice Munro, Robertson Davies, Margaret Atwood, Mordecai Richler, Irving Layton, Mavis Gallant, Michael Ondaatje, Rohinton Mistry, Gabrielle Roy, Jacques Ferron, Hubert Aquin, Marie-Claire Blais, Antonine Maillet and Yves Beauchemin

Canada's answer to William Faulkner? Margaret Lawrence is the author of such Canadian classics as The Diviners *and* The Stone Angel. *Lawrence is seen here in her Lakefield home in 1981.*

The Margaret Lawrence Estate / Doug Boult

(and many others might be mentioned) give a sense of the richness and scope of our contemporary traditions.

Creative nonfiction is also flourishing. The excellent blockbuster historical studies of Pierre Berton, Peter C. Newman and others are still visible and relevant, while a new generation of writers has covered an even wider social and intellectual territory. These include John Ralston Saul, Michael Ignatieff, Charles Taylor, Bruce Pow, and other writers of intellectual history, as well as astute chroniclers and analysts of the contemporary scene such as Richard Gwyn, Stevie Cameron and Charles Gordon. In fact, it could well be argued that our literature—especially if we include theatrical work along with prose and poetry—has developed further and in a more substantial fashion than any of the other Canadian arts in the post-war period. And this is surely true even if one allows for the hyperbole of publishers, agents, booksellers and the press—even if one takes into account the recent frenzy of literary contests and the lack of really excellent and challenging literary criticism seen by many as a serious deficiency on the Canadian scene.

The maturing of Canadian writers, in fact, has taken place during a period of some uncertainty in the key areas of publishing, marketing and readership. Part of this uncertainty can be traced to international causes and is shared by other countries. This includes the demise of the old family publishing houses and the subsequent creation of the accountant-driven firms, almost always part of large international conglomerates with interests in many areas outside literature. Thanks to mergers, foreign penetration and other factors, by the late 1990s there were fewer large independent publishers in Canada in both the trade and educational fields than there had been in previous decades. Even the continued existence of an old stalwart like McClelland & Stewart, for many years one of the mainstays of Canadian writing, seems no longer a sure thing. This situation has resulted in the death of the midlist book and in an obsession with high-profile marketing that leads many companies toward a "make or break" attitude in compiling their front lists. As one agent put it, as far as fiction goes, they only want to see "literary masterpieces" (read "prizewinners") or else genre novels with a reasonably predictable market share. Under today's conditions, it is a sure bet that no large publisher would accept Mordecai Richler's first novel, for example, nor many other fledgling works that launched our older successful writers. This make-or-break situation has naturally created the new breed of high-powered agents capable of wheeling and dealing with corporate giants eager for huge sales and willing to accept literary achievement most of all when it guarantees profits.

Besides the multinational firms—almost all located in Toronto—and a few independent Canadian-owned publishers, Canada is served by a plethora of small presses, some of them even one or two-person operations run out of basements and farmhouses. Although many of these presses are heavily subsidized by government funding, unlike most of the multinationals they pay taxes in Canada and operate on a very small profit margin. Such presses might be assumed to be the salvation of the beginning writer, but unfortunately this has not always been the case. If the large publishers are sometimes too ready to make judgements based wholly on marketplace factors, the alternative presses are often completely out of touch with what may sell or not sell, or else have no idea how to market what they produce, or are so cliquish that it is impossible for an outsider to break in. When they do succeed in turning out good books—as notably in the case of Cormorant Books in Ontario, publisher of Nino Ricci's award-winning *Lives of the Saints*—they are often bought up by the larger firms, as indeed Cormorant was in 1996 by Stoddart Publishing (just in time, it seems, to save it from closing down).

The small presses, however, serve some useful cultural purposes, and in some cases fill their niches with skill and panache. Fiction and poetry volumes edited by John Metcalf of Porcupine's Quill Press in Erin, Ontario, have won several Governor General's Awards, while Arsenal Pulp Press of Vancouver publishes and distributes excellent books in the areas of social and cultural studies. Broadview Press, operating out of Calgary and Toronto, is a Canadian small press noted for its relevant and well-edited textbooks and scholarly publications.

While some have questioned the funding of the more inefficient of the Canadian small presses, and see this as one of the curious and rather unsatisfying results of Canada's cultural protectionism, for others, such funding constitutes a noble attempt to foster new creativity and to provide markets for Canadian writers who could not expect to make their way into mainstream publishing. They see the issue as one of economic and cultural "biodiversity," and argue that it would be most unhealthy to allow the marketplace to be taken over by a few giants with head offices in foreign countries.

In recent years Canadian-owned publishers have originated about 80 percent of Canadian-authored titles, although this comprises only about 17 percent of total book sales in Canada. In the 1970s, the federal government stepped in to prevent the complete Americanization of the industry, and it still subsidizes Canadian publishers to a figure that approaches $10 – $15 million in most years. Some of our domestic firms have done well by negotiating Canadian distribution rights with the publishers

of popular American books, funnelling some of the profits into new Canadian works. Unfortunately, Canadian publishers have also lost much profit when foreign rights of successful Canadian books have been sold separately by author's agents. And if one equates the health of our literature with domestic control of the publishing industry, the situation can only be deemed precarious. In the mid-1990s, when the federal funding cuts were felt by the publishing houses, several of them were threatened with collapse, and one—the well-known Coach House Press of Toronto—did collapse, even though it was subsequently revived, after incorporating some new Web-based marketing arrangements.

The arrival in the 1990s of the big bookstores, Chapters and Indigo, on the Canadian scene (the former with strong support from the redoubtable American chain Barnes & Noble) also caused some alarm among small presses, writers and cultural nationalists. Chapters' entrance did eventually lead to (or in some cases merely hastened) the demise of many small bookstores and even one or two regional chains, such as the seemingly solid Duthie Books chain in Vancouver. Despite this, many observers (Robert Fulford was one of the first) welcomed the arrival of the giants, on the grounds that they actually gave bookselling a brighter profile, made it easier for buyers to pick up specific books on the spot and created pleasant urban spaces where people could congregate and enjoy themselves with books, magazines, newpapers, coffee, etc. Many observers deemed the situation to be one of healthy competition: those independent bookstores that were capable of surviving were driven to find their own niche markets and quickly established pleasant personal connections with customers in parts of town lacking one of the book superstores. The superstores for their part went out of their way to stock Canadian writers and Canadian-press books, and to promote readings and events that would bring authors closer to the public.

After a year or two their presence seemed to be a very positive factor in the communities in which they established themselves, which is not to say that there were not some rough passages. For one thing, Chapters aroused howls of protest when it published newspaper book reviews on its Web site without authorial permission or payment, usually cutting out the negative parts, if there were any, and thus enlisting the reviewer as part of their house-advertising campaign. Some saw this as similar to what occurs in print form every day in order to sell books, movies, plays, etc.; others were not so certain. A more serious issue was raised, however, by Chapters' 82 percent control of Pegasus, a company that has the potential to dominate the distribution market in Canada. Some argued that because Pegasus required discounts on retail prices from Canadian small presses, which tended to cut their profit margins

to the bone, it left them far too little financial maneuverability. In the fall of 1999, the Canadian Booksellers Association (CBA) made representations to the Department of Canadian Heritage, suggesting that Chapters's vertical integration with Pegasus could provide it "with preferential treatment with respect to volume discounts and priority." The CBA filed a formal complaint with the Canadian Competition Bureau, urging an inquiry into the situation; it also began to recruit booksellers and the public to its cause by arguing that the whole system of book production and distribution in Canada might be negatively affected.

On the other hand, no one seemed to be sure of the general future of live bookselling in an era when so much trade was moving onto the Web. The best proof of this is that when buyers approached Chapters with requests for books not stocked by the local store they were usually referred directly to the Chapters Web site. It was not hard to see that by the year 2020 the bookselling trade in Canada and elsewhere would probably have changed beyond recognition and that the arrival of the superstores was only the first in a long line of shocks and changes that would confront Canadian writers and publishers. The surprised, and sometimes delighted, book-buying public, on the other hand, seemed to be getting more value for money and better service. And some of these events on the publishing and bookselling scene have worked to create much more lucrative contracts and a higher recognition factor in Canada and internationally for Canadian writers.

The Canadian book world was overtaken by several other striking new phenomena during the 1990s. These included the penchant for large cash awards and literary prizes; the "festivalizing" of the book experience (which matched what was happening in theatre and music); the reading club and writing workshop fads and the increasing link between the successful Canadian book and the making of what would invariably be described as a "major motion picture."

If the "festivalizing" of literature seems a stranger thing than its equivalent in theatre or music, it has equally deep roots in the cultural past. In terms of recent Canadian culture, the literary festival entered the game early, thanks to Greg Gatenby's Harbourfront International Authors Festival in Toronto, founded in 1979, and certainly one of the best of its kind in the world. Now we have many similar, if not quite so prestigious, gatherings, notably the "Word on the Street" events, which spread across Canada during the 1990s.

The phenomenon of the literary prize may lack the psychic intensity of the festivals, but it stirs up more healthy competition and also connects us to a far past of contests. It evokes ancient awards of palm or laurel leaf, and public gift-giving to

those who excel at their art. In recent years our literary scene has been enriched (some would say inundated) with awards, most of which seem to have more to do with the necessities of marketing books in a competitive world than they do with the need to acknowledge talent for the greater glory of the social body. The Governor General's Awards, first in the field and still very important simply because of their public resonance, are now joined by the Canada Council Molson Prize (established in 1964), the Prix Athanase-David (1968), the Trillium Book Award (1987), the Giller Prize (1994), the Books in Canada First Novel Award (1982)—which has been taken over by Chapters—and others, too numerous to mention. This is all in addition to the many annual prizes for short stories and poetry awarded by almost every Canadian literary magazine that survives for more than a year or two. Toward the end of the 1990s, Margaret Atwood actually declared herself to be "unawardable," meaning, presumably, that she had won so many prizes that the prospect of another was almost unpalatable. Unfortunately, there seemed to be no indication that she would be spared the prospect.

The reading club and writing workshop phenomena were other curious aspects of the literary scene in the 1990s. The clubs or "circles," composed mostly of middle-class

Maclean's / Peter Bregg

Margaret Atwood is, perhaps, Canada's most famous literary figure—certainly one of the most widely read and respected.

people who met monthly to discuss the latest fiction, showed an incredible resilience (some of them have lasted 10 or 15 years) and tended to focus on serious contemporary writing, often by Canadian writers. This seems to be a genuine grassroots movement that does locally and unobtrusively what Oprah Winfrey, for example, does with a big splash on national American television. Predictably, some enterprising "consultants" have sprung up to provide such groups with organizational guidance, for a fee, of course. The workshops go farther back, but by the end of the 1990s they were almost endemic, not only in colleges and universities, but as small commercial ventures run by professional writer-entrepreneurs across the country, while some of them were spreading rapidly into the world of the Web.

Many of the participants in the reading clubs also enrolled in the writing workshops, and the predominance of women in both suggests that literature has become a creative outlet for a generation of women. The phenomenon is not new. Many scholars trace the birth of the Gothic novel in England in the late 18th and early 19th centuries to a new drive for expression (and for increased social power) on the part of women lacking other avenues to these. Today, talented female writers are strongly visible in the numerous literary contests mentioned above.

Most of the literary activity described above revolves around prose. When we consider the question of Canadian poetry we encounter a cultural problem of major significance. While it is true that in anglophone poetry the rivalry once felt between the nationalists and the American-derived modernists seems to have faded, it hardly seems to matter since—except for a small number of university students and professors, and the poets themselves—almost no one in Canada reads poetry. The situation is similar in most developed Western countries. While in Asia, the Near East, and to some extent in eastern Europe and South America, the poet may still have a highly visible role, including vital contact with an extended audience, in Canada even excellent poets such as Margaret Atwood and Michael Ondaatje are most widely known for their prose works.

It is true that Irving Layton in his prime had a considerable audience and that Leonard Cohen—before he settled down to meditation—played the role of singing bard for the nation, and that Milton Acorn, Al Purdy and one or two others found an eager readership. If we think, however, of William Wordsworth's suggestion that the poet should be "a man speaking to men" (in today's terms, "a human being speaking to humanity") we must be disheartened about the state of poetry in Canada. Among the League of Canadian Poets we find few names that would mean anything to most Canadians. Alongside some effective mainstream verse we find political and aesthetic

Chris Miner

The late Al Purdy wrote strong and seasoned poetry, making him one of the most distinguished Canadian poets of the 20th century.

ideologies—so-called sound poets and language poets, poets influenced by science, regional poets, ethnic poets, feminist poets and poets redefining their masculinity. Some of these may be examples of human beings speaking to humanity, but no one seems to be listening. Is it possible that the situation will change in the next century? Will a new poet, one whose words will affect our lives, find a receptive audience on the Web? Will some national crisis produce a true bardic voice for Canada? Sad to say, it is probably more likely that the cultural narcissism and fractionalization that mars our poetic scene will only grow more acute.

In 1996, another major shift—this one of seismic proportions—struck the Canadian literary scene, when a film based on Michael Ondaatje's novel *The English Patient* (which had previously shared Britain's prestigious Booker Prize) won the Oscar for Best Picture in Hollywood. As fine an achievement in sustained lyrical story-telling as that novel is, when it appeared in book form in 1992 there was nothing to suggest that it would reach media heaven, not only becoming a chic international film, but also playing a part in one episode of *Seinfeld*.

The success of *The English Patient* as a film raises some interesting questions about the production and marketing of Canadian fiction at the end of the century. A perhaps surprising fact is that long before *The English Patient*, both the media and the awarding of literary prizes served to promote major fiction in Canada. Fictional bestsellers that garnered important prizes over the years include: Phillipe Panneton's *Trent arpents*, Gwethalyn Graham's *Earth and High Heaven*, Hugh MacLennan's *Two Solitudes*, Gabrielle Roy's *Bonheur d'occasion*, Margaret Laurence's *A Jest of God*, Robertson Davies' *Fifth Business*, Antonine Maillet's *Pélagie-la-charrette* and Margaret Atwood's *The Handmaid's Tale*. While in a few cases it is difficult to prove a cause-and-effect relationship between a prize and the initial sales, in every case the prize or award served to increase the sales, or resulted in the book staying in print longer and reaching a wider circle of readers (often an international audience) than might have otherwise been the case.

Historically, radio, film and television have also played a role in promoting our fiction. Even those well-established popular classics, L. M. Montgomery's *Anne of Green Gables* and Mazo de la Roche's *Jalna* series, thanks to television acquired huge new audiences decades after their first publication. Claude-Henri Grignon's *Un homme et son péché* (1933) and Roger Lemelin's *Les Plouffes* (1948) also benefited enormously from media connections. The former ran for 23 years as a radio serial; in addition it was produced on television and made into two movies; the latter became famous as a radio serial in Québec, while its television versions (in both French and English) rank among the most popular Canadian productions ever made in that medium. It was the film *Rachel, Rachel* that markedly increased sales of the paperback edition of *A Jest of God*—the book on which the film is based—making it probably Margaret Laurence's bestselling book. Meanwhile, the successful filming of Mordecai Richler's *The Apprenticeship of Duddy Kravitz*, many years after its publication as a novel, also pushed up sales. Media versions also promoted W. O. Mitchell's *Who Has Seen the Wind* and Yves Beauchemin's *Le matou* (1981). *Field of Dreams*, the successful

University of Calgary Archives 79-0112

W. O. Mitchell (right), master chronicler of life on the Canadian Prairies, and filmmaker Robert Duncan look through a collection of Mitchell's papers during the shooting of W. O. Mitchell: Novelist in Hiding.

film version of W. P. Kinsella's *Shoeless Joe* (1982) also helped sell the book, although in a notable incident, the Canadian author of this book saturated in American baseball folklore received no kudos whatsoever at the Academy Awards. Even the rather poor film version of Atwood's *A Handmaid's Tale* helped sell the novel; here, however, as in the case of Laurence and Richler, a sizable number of the new readers were Americans, not Canadians.

The representative list of Canadian bestsellers I refer to above suggests in what direction our mainstream fiction has moved through this century; it confirms what our literary historians tell us: that our writers first concerned themselves with making images of our land and people, portraying rural life and agriculture, depicting specific regions and small towns, while moving across an emotional spectrum that included nostalgia, romance, comedy and bitter realism. Increasing urbanization brought city life into focus: the clash of social groups, the question of "making it," ironic perspectives on the past—these became the new modes after the Second World War and were accepted with few qualms by an expanded and more sophisticated reading public. A growing sense of national identity resulted in a new appreciation of artistic achievement and in the multiplication of literary rewards, while the amplification of the media helped popularize serious fiction, but no great gulf divided the reader from the text. If we compare the serious Canadian fiction of those earlier decades with its counterparts in the United States, it is clear that the challenge of modernism in such books as *U.S.A.* by John Dos Passos and *The Sound and the Fury* by William Faulkner was much greater than anything that appeared in Canada. By and large, Canadian writers who could be considered part of the central literary tradition played it safe—both in terms of technique and of subject matter—and established a cosy middlebrow relationship with their audience.

The Ondaatje phenomenon appears all the more curious in this light, since it typifies the latest trend of Canadian fiction in this century, that is, it is an important example of the coming to the fore of the multicultural or "immigrant" perspective, while at the same time, thanks to Anthony Minghella's film, it makes postmodernism-as-chic the new trump card of the astute marketers. Among the purchasers of the text, a minority perhaps actually read it and enjoyed the allusive, poetic style and the information they got about characters whose roles in the film are rather limited. On the other hand, many bought the book possibly with the good intention of reading it, but after a few desperate forays found the text quite impenetrable. For them, *The English Patient*, especially the edition with the movie-inspired cover, served the purpose of an icon. It is something that gave them a sense of being part of a chic

phenomenon; in short, they could use the text as a mnemonic device to recall the lush romanticism of the film. For example, on a Toronto talk show the host asked the panel to accept the possibility of reincarnation and to tell who or what they would like to "come back" as. One of the guests opted to come back as a film and the film he chose was *The English Patient.* (Although he had some trouble recalling the title!)

One of the big issues in marketing Canadian culture in general is the issue of localism versus internationalism. Almost everyone believes that the international marketing of Canadian art is one of the biggest challenges of the present, but there are differing view on how this relates to the content of our art. Should writers and artists suppress in their work elements that may be seen as parochial in New York or Paris? Or does art spring most powerfully from a commitment to the local and particular? One striking fact about the film version of *The English Patient* was its international aura. Yet Canadian viewers certainly enjoyed an extra thrill when places like Montréal and even Picton, Ontario, were mentioned quite unselfconsciously and without apology on the screen in what was not actually a "Canadian" film.

The new Canadian bestseller, I think, will have increasingly little to do with the familiar anglophone or Québec traditions. It will exude a cosmopolitan chic arrayed on behalf of subjects formerly forbidden and on behalf of individuals formerly invisible, excluded and marginalized. In many cases, this fiction will not even concern itself with depicting life in Canada. This new novel is coming to the fore in a world where the middlebrow reader (if there is such an animal) prefers to buy biographies, self-help books or how-to-manuals, and reads very little fiction. Even writers who have some links with the Canadian past and who might be thought to have an audience similar to that of the traditional novelist—I'm thinking of Margaret Atwood, Timothy Findley and Ann-Marie MacDonald—have accommodated their writing, in subject matter, and sometimes in technique, to many aspects of this new fiction.

CBC Television

Timothy Findley, acclaimed author of nine novels, has helped bring postmodern writing techniques into mainstream Canadian fiction.

If the Ondaatje example tells us anything, it suggests that in the brave new world of the postmodern Canadian bestseller, marketing will be directed toward carefully targeted groups. If these respond in sufficient numbers, then media treatment will inevitably follow. And media production will take into account the fact that Canada is now part of a global market, one increasingly obsessed with "entertainment." This market, dominated and partially created by the new technology, can afford to be open to every subject, since it is capable of co-opting everything to its own purposes. The new Canadian fiction, which plays with ideologies, techniques and the glamour of writing itself—and in some cases it is the best fiction we have ever had—is not writing that derives its power from contact with a mass readership (as with the novels of Charles Dickens or Jack London), nor even with the majority of the educated public (as with the work of Ernest Hemingway and William Faulkner, Morley Callaghan and Hugh MacLennan). Nor in the new media world can it ever aspire to such a readership. Perhaps one measure of the change is the fact that when the older fiction was translated into the new medium of film or television, the ideal was to activate a story already internalized in the minds of the audience. With the new fiction, the task of the media is to create a story that most of the audience will never have experienced in print at all, although they will certainly "have heard about the book."

Present-day Canadian writers are creating the most diverse, the most challenging and the most technically complex fiction in our history. Some of this fiction admittedly commands an audience comparable to the traditional Canadian readership of "good novels," but thanks to the historical shifts mentioned above, there is an increasing possibility that in the future, paradoxically, the most popular fiction will be the least read. *The English Patient* as a popular novel is a mirage, but the mirage was carefully created by the new extra-literary art of tailoring written products for the media. The case of *The English Patient* suggests that in the 21st century more and more written texts will be reconstructed and repackaged for audiences that have few skills at deciphering them in their original form. For those with no interest in reading, for an audience that cannot establish empathy with a written text, the Ondaatje solution seems to be just about perfect.

Creative Writing Schools, Workshops and Retreats

- **Banff Centre for the Arts**:
Office of the Registrar, PO Box 1020,
Stn. 28, 107 Tunnel Mountain Dr., Banff,
AB, T0L 0C0.
Phone: (403) 762•6180;
Fax: (403) 762•6345;
Internet: http://www.banffcentre.ab.ca/
CFAindex.html

- **En'owkin International School of Writing**:
Office of the Registrar, En'owkin Centre,
257 Brunswick St., Penticton, BC,
V2A 5P9.
Phone: (604) 493•7181

- **Humber School for Writers**:
Nancy Abell, Humber College,
205 Humber College Blvd., Toronto, ON,
M9W 5L7.

Phone: (416) 675•6622, ext. 4436;
Fax: (416) 675•1249

- **Maritime Writers' Workshop**:
Glenda Turner, Coordinator,
Department of Extension and Summer
Session, University of New Brunswick,
PO Box 4400, Fredericton, NB, E3B 5A3.
Phone: (506) 454•9153

- **Sage Hill Writing Experience**:
PO Box 1731, Saskatoon, SK, S7K 3S1.
Phone: (306) 652•7395

- **Saskatchewan Writers/Artist Colonies and Retreats**:
c/o PO Box 3986, Regina, SK, S4P 3R9.
Phone: (306) 757•6310;
Fax: (306) 565•8554

Trillium Book Award

THIS award was established by the Ontario provincial government in 1987 to promote writers living in the province. It is open to books in any genre, fiction and nonfiction, except for anthologies and translations. In 1994, the award was expanded to include the Prix Trillium, a separate prize for francophone Ontarians. The award is $12,000 to the winner and $2,500 to the publisher, for both English and French prizes.

1999: Alistair MacLeod, *No Great Mischief*
1998: André Alexis, *Childhood*; Alice Munro, *The Love of a Good Woman*
1997: Dionne Brand, *Land to Light On*
1996: Anne Michaels, *Fugitive Pieces*
1995: Wayson Choy, *The Jade Peony*; Margaret Atwood, *Morning in the Burned House*

1994: Donald Harmon Akenson, *Conor: A Biography of Conor Cruise O'Brien, Volume 1*
1993: Jane Urquhart, *Away*; Margaret Atwood, *The Robber Bride*
1992: Michael Ondaatje, *The English Patient*
1991: Margaret Atwood, *Wilderness Tips*

1990: Alice Munro, *Friend of My Youth*
1989: Modris Eksteins, *Rites of Spring*

1988: Timothy Findley, *Stones*
1987: Michael Ondaatje, *In the Skin of a Lion*

Prix Trillium

1999: Andrée Christensen and Jacques
Flamand, *Lithochronos*
1998: Daniel Poliquin, *L'homme de paille*;
Stefan Psenak, *Du chaos et de l'ordre
des choses*

1997: Roger Levac, *Petite Crapaude!*
1996: Anne Claire, *Le pied de Sappho*; Alain
Bernard, *Tintinau pays de la ferveur*
1995: Maurice Henrie, *Le balcon dans le ciel*
1994: Andrée Lacelle, *Tant de vie s'égare*

Some Important Canadian Publishing Companies

- **Altitude Publishing**:
Stephen Hutchings, President.
Nonfiction about the Rocky Mountains
and western Canada.
1500 Railway Ave., Canmore, AB,
T1W 1P6.
Phone: (403) 678 • 6888;
Fax: (403) 678 • 6951

- **Annick Press Ltd.**:
Rick Wilks and Anne Millyard,
Co-Directors.
Books for younger children.
15 Patricia Ave., Willowdale, ON,
M2M 1H9.
Phone: (416) 221 • 4802;
Fax: (416) 221 • 8400

- **Anvil Press**:
Brian Kaufman, Managing Editor.
Small literary press, publishes
contemporary work in all genres.
204A, 175 Broadway, Vancouver, BC,
V5T 1W2.
Phone: (604) 876 • 8710;
Fax: (604) 879 • 2667;
Internet: http://www.anvilpress.com

- **Arsenal Pulp Press**:
Brian Lam, President and Publisher.
I hear good things about this press.
103, 1014 Homer St., Vancouver, BC,
V6B 2W9.
Phone: (604) 687 • 4233;
Toll-Free: 1 (888) 600 • PULP;
Fax: (604) 669 • 8250;
Internet: http://www.arsenalpulp.com

- **Bantam Books Canada (Random House)**:
Publishes mass-market fiction and
nonfiction.
4th Floor – 105 Bond St., Toronto, ON,
M5B 1Y3.
Phone: (416) 340 • 0777;
Fax: (416) 340 • 1069;
Internet: http://www.randomhouse.com

- **Beach Holme Publishers**:
Michael Carroll, Managing Editor.
Literary small press.
226, 2040 12th Ave., Vancouver, BC,
V6J 2G2.
Phone: (604) 733 • 4868;
Fax: (604) 733 • 4860;
Internet: http://www.beachholme.bc.ca

- **Borealis/Tecumseh Presses**:
Glenn Clever, Editor.
They live on their backlist.
110 Bloomingdale St., Ottawa, ON, K2C 4A4.
Phone: (613) 798•9299;
Fax: (613) 829•7783;
Internet: http://www.borealispress.com

- **Breakwater Books**:
Clyde Rose, President.
100 Water St., PO Box 2188, St. John's, NF,
A1C 6E6.
Phone: (709) 722•6680;
Fax: (709) 753•0708;
Internet: http://www.breakwater.nf.net

- **Broken Jaw Press/Maritimes Arts Projects Productions**:
Joe Blades, Publisher.
Publishes mostly literary (poetry and
fiction) titles alongside some general
nonfiction (self-help/psychology, essays,
memoirs, local history, photography).
PO Box 596, Stn. A, Fredericton, NB,
E3B 5A6.
Phone: (506) 454•5127;
Fax: (506) 454•5127;
Internet: http://www.brokenjaw.com

- **Brick Books**:
Kitty Lewis, General Manager.
Poetry only.
431 Boler Rd., PO Box 20081, London, ON,
N6K 4G6.
Phone: (519) 657•8579

- **Broadview Press**:
Don Le Pan, President.
Michael Harrison, Vice-President
A lively bunch; focus is academic adoptions.
71 Princess St., PO Box 1243,
Peterborough, ON, K9J 7H5.
Phone: (705) 743•8990;
Fax: (705) 743•8353;
Internet: http://www.broadviewpress. com

- **Cormorant Books**:
Jan Geddes, Publisher.
They were inundated after the Nino Ricci
triumph. No poetry; Stoddart subsidiary.
RR 1, Dunvegan, ON, K0C 1J0.
Phone: (613) 527•3348;
Fax: (613) 527•2262

- **Coteau Books**:
Nik L. Burton, Managing Editor.
Regional.
401, 2206 Dewdney Ave., Regina, SK,
S4R 1H3.
Phone: (306) 777•0170;
Fax: (306) 522•5152;
Internet: http://coteau.unibase.com

- **Doubleday Canada (Random House)**:
Kathryn Exner, Associate Editor.
105 Bond St., Toronto, ON, M5B 1Y3.
Phone: (416) 340•0777, ext. 402;
Fax: (416) 977•8488;
Internet: http://www.randomhouse.com

- **Douglas & McIntyre/Greystone Books**:
Scott McIntyre, President and Publisher.
Trade books.
201, 2323 Quebec St., Vancouver, BC,
V5T 4F7.
Phone: (604) 254•7191;
Fax: (604) 254•9099
Toronto office: 500, 720 Bathurst St.,
Toronto, ON, M5S 2R4.
Phone: (416) 537•2501;
Fax: (416) 537•4647

- **Dundurn Press**:
Kirk Howard, Publisher.
History, biography, literary and art
criticism, social issues.
200, 8 Market St., Toronto, ON,
M5E 1M6.
Phone: (416) 214•5544;
Fax: (416) 214•5556;
Internet: http://www.dundurn.com

• **ECW Press**:
Jack David, President and Publisher.
Literary.
200, 2120 Queen St. E, Toronto, ON,
M4E 1E5.
Phone: (416) 694 • 3348;
Fax: (416) 694 • 9906;
Internet: http://www.ecw.ca/Press

• **Exile Editions**:
Barry Callaghan, President.
PO Box 67, Stn. B, Toronto, ON,
M5T 2C0.
Phone: (416) 969 • 8877;
Fax: (416) 969 • 9556

• **Fitzhenry & Whiteside Ltd.**:
Sharon Fitzhenry, President and Publisher.
195 Allstate Pky., Markham, ON,
L3R 4T8.
Phone: (905) 477 • 9700;
Fax: (905) 477 • 9179

• **Goose Lane Editions/Fiddlehead Poetry Books**:
Julie Scriver, President.
Laurel Boone, Acquisitions Editor.
Literary. If they look at it at all they'll give
it a good critique.
469 King St., Fredericton, NB, E3B 1E5.
Phone: (506) 450 • 4251;
Fax: (506) 459 • 4991

• **Harbour Publishing**:
Howard White, President.
Publishes books on West Coast regional
history and culture.
PO Box 219, Madeira Park, BC, V0N 2H0.
Phone: (604) 883 • 2730;
Fax: (604) 883 • 9451

• **Harlequin Enterprises**:
Birjit-Davis-Todd, Editor, Retail
Marketing and Editorial.
225 Duncan Mill Rd., Don Mills, ON,
M3B 3K9.
Phone: (416) 445 • 5860;
Fax: (416) 445 • 8655;
Internet: http://www.romance.net

• **HarperCollins Publishers**:
Iris Tupholme, Editor-in-Chief.
2900, 55 Avenue Rd., West Tower at
Hazelton Lanes, Toronto, ON. M5R 3L2.
Phone: (416) 975 • 9334;
Fax: (416) 975 • 9884;
Internet: http://www.harpercanada.com

• **Hartley & Marks Publishers**:
Publishes self-help, how-to books, health,
crafts, gardening and typography books.
3661 Broadway, Vancouver, BC,
V6R 2B8.
Phone: (604) 739 • 1771;
Fax: (604) 738 • 1913

• **House of Anansi Press**:
Martha Sharpe, Publisher.
Adrienne Leaky, Editorial Assistant.
Another Stoddart subsidiary.
34 Lesmills Rd., Toronto, ON, M3B 2T6.
Phone: (905) 660 • 0611;
Fax: (905) 660 • 0676;
Internet: http://www.anansi.ca

• **Insomniac Press**:
Mike O'Connor, Publisher.
Publishes novels and short stories.
403, 192 Spadina Ave., Toronto, ON,
M5T 2C2.
Phone: (416) 504 • 6270;
Fax: (416) 504 • 9313;
Internet: http://www.insomniacpress.com

- **Irwin Publishing**:
Norma Pettit, Managing Editor.
Stoddart-related. Educational, also young adult fiction.
325 Humber College Blvd., Toronto, ON, M9W 7C3.
Phone: (41) 798 • 0424;
Fax: (416) 798 • 1384;
Internet: http://www.irwin-pub.com

- **James Lorimer & Co.**:
James Lorimer, President.
Diane Young, Editor-in-Chief.
Issue-related nonfiction.
35 Britain St., Toronto, ON, M5A 1R7.
Phone: (416) 362 • 4762;
Fax: (416) 362 • 3939

- **Key Porter Books**:
Susan Renouf, President and Editor-in-Chief.
Celebrity stuff, coffee-table books.
3rd Floor – 70 The Esplanade, Toronto, ON, M5E 1R2.
Phone: (416) 862 • 7777;
Fax: (416) 862 • 2304

- **Kids Can Press**:
Valerie Hussey, President and Publisher.
Strictly children's.
29 Birch Ave., Toronto, ON, M4V 1E2.
Phone: (416) 925 • 5437;
Fax: (416) 960 • 5437

- **Malcolm Lester Books**:
Malcolm Lester, President.
Nonfiction, fiction and some children's.
25 Isabella St., Toronto, ON, M4Y 1M7.
Phone: (416) 944 • 3634;
Fax: (416) 944 • 3122

- **Lobster Press**:
Alison Fripp, Publisher.
Quality children's books in English and French.
2200, 1250, boul. René-Lévesque O, Montréal, QC, H3B 4W8.
Phone: (514) 989 • 3121;
Fax: (514) 989 • 3168;
Internet: http://www.lobsterpress.com

- **MacFarlane, Walter & Ross**:
Jan Walter, President.
Politics, business trade books.
37A Hazelton Ave., Toronto, ON, M5R 2E3.
Phone: (416) 924 • 7595;
Fax: (416) 924 • 4254

- **Macmillan Canada (CDG Books)**:
Robert Harris, Publisher.
400, 99 Yorkville Ave., Toronto, ON, M5R 3K5.
Phone: (416) 963 • 8830;
Fax: (416) 923 • 4821

- **McClelland & Stewart**:
Douglas Gibson, Publisher.
A central Canadian publisher from way back. Take away this list and half of Canadian serious literature disappears.
900, 481 University Ave., Toronto, ON, M5G 2E9.
Phone: (416) 598 • 1114;
Fax: (416) 598 • 7764;
Internet: http://www.mcclelland.com

- **McGraw-Hill Ryerson**:
Joan Homewood, Publisher, Consumer and Trade Division.
Consumer and reference.
300 Water St., Whitby, ON, L1N 9B6.
Phone: (905) 430 • 5000;
Fax: (905) 430 • 5044;
Internet: http://www.mcgrawhill.ca

- **The Mercury Press**:
Donald and Beverley Daurio, Publishers.
Quality fiction and quality crime. Submit
in proper form and they'll look at it.
22 Prince Rupert Ave., Toronto, ON,
M6P 2A7.
Phone: (416) 531 • 4338;
Fax: (416) 531 • 0765

- **NeWest Publishers**:
Liz Grieve, General Manager.
Western Canadian focus.
201, 8540 – 109th St., Edmonton, AB,
T6G 1E6.
Phone: (403) 432 • 9427;
Fax: (403) 432 • 9429

- **Nuage Editions**:
Karen Haughian, Managing Editor.
A literary press that publishes fiction,
nonfiction, drama, some poetry and
children's literature.
PO Box 206, RPO Corydon, Winnipeg, MB,
R3M 3S7.
Phone: (204) 779 • 7803;
Fax: (204) 779 • 6970

- **Oberon Press**:
Nicholas Macklem, General Manager.
They have published some good things
but can be cliquish, and their distribution
is poor.
400, 350 Sparks St., Ottawa, ON,
K1R 7S8.
Phone: (613) 238 • 3275;
Fax: (613) 238 • 3275;
Internet: www3.sympatico.ca/oberon/

- **Oolichan Books**:
Ron Smith, Publisher.
General trade.
PO Box 10, Lantzville, BC V0R 2H0.
Phone: (604) 390 • 4839;
Fax: (604) 390 • 4839;
Internet: http://www.oolichan.com

- **Orca Book Publishers**:
Bob Tyrrell, President/Publisher
Ann Featherstone, Children's Editor.
West Coast focus.
PO Box 5626, Stn. B, Victoria, BC,
V8R 6S4.
Phone: (250) 380 • 1229;
Fax: (250) 380 • 1892;
Internet: http://swifty.com/orca

- **Pemmican Publications**:
Sue MacLean, Managing Editor.
Publishes children's picture books that
depict Métis and aboriginal cultures and
lifestyles.
1635 Burrows Ave., Unit 2, Winnipeg, MB,
R2X 3B5.
Phone: (204) 589 • 6346;
Fax: (204) 589 • 2063

- **Penumbra Press**:
John Flood, President.
Publishes poetry series, art books, b&w
children's books and books concerning
Northern and First Nations issues.
1225 Potter Dr., Manotick, ON, K4M 1C9.
Phone: (613) 692 • 5590

- **Penguin Books Canada**:
Cynthia Good, President and Publisher.
300, 10 Alcorn Ave., Toronto, ON,
M4V 3B2.
Phone: (416) 925 • 2249;
Fax: (416) 925 • 0068;
Internet: http://www.penguin.ca

- **Playwrights Canada Press**:
Angela Rebeiro, Publisher/Managing
Editor.
Publishes Canadian plays.
2nd Floor – 54 Wolseley St., Toronto, ON.
M5T 1A5.
Phone: (416) 703 • 0201;
Fax: (416) 703 • 0059;
Internet: http://www.puc.ca

- **Polestar Press**:
Michelle Benjamin, Associate Publisher.
General trade. An imprint of Raincoast Books.
8680 Cambie St., Vancouver, BC, V6P 6M9.
Phone: (604) 323•7100;
Fax: (604) 323•2600

- **The Porcupine's Quill**:
Elke Inkster, Office Manager.
Canadian literary fiction of the highest quality.
68 Main St., Erin, ON, N0B 1T0.
Phone: (519) 833•9158;
Fax: (519) 833•9845

- **Pottersfield Press**:
Lesley Choyce, Editor.
Atlantic Canada focus.
83 Leslie Rd, East Lawrencetown, NS, B2Z 1P8.

- **Prentice-Hall Canada**:
Tony Banderwood, President.
Ed Carson, Director, Trade Group.
1870 Birchmount Rd., Scarborough, ON. M1P 2J7.
Phone: (416) 293•3621;
Fax: (416) 299•2540;
Internet: http://www.phcanada.com

- **Press Gang Publishers**:
Barbara Kuhne, Managing Editor.
Radical feminist.
1723 Grant St., Vancouver, BC, V5L 2Y6.
Phone: (604) 251•3315;
Fax: (604) 251•3329;
Internet: http://www.pressgang.bc.ca

- **Quarry Press**:
Bob Hilderley, President.
A good old small press, but have the Quarry bunch (also connected with *Poetry Canada*, *Quarry Magazine* and *Canadian Fiction Magazine*) spread

themselves too thin?
General literary, local history.
PO Box 1061, Kingston, ON, K7L 4Y5.
Phone: (613) 548•8429;
Fax: (613) 548•1556

- **Ragweed Press Inc./Gynergy Books**:
Sibyl Frei, Managing Editor.
Mostly feminist.
PO Box 2023, Charlottetown, PE, C1A 7N7.
Phone: (902) 566•5750;
Fax: (902) 566•4473

- **Raincoast Books**:
Kevin Williams, Publisher.
Trade books; both West Coast and national themes.
8680 Cambie St., Vancouver, BC, V6P 6M9.
Phone: (604) 323•7100;
Fax: (604) 323•2600;
Internet: http://www.raincoast.com

- **Red Deer Press**:
Dennis Johnson, Managing Editor;
Peter Carver, Children's Editor;
Joyce Doolittle, Drama Editor;
Nicole Narkotic, Poetry Editor.
Some adult but mostly children's.
PO Box 5005, Red Deer, AB, T4N 5H5.
Phone: (403) 342•3321;
Fax: (403) 357•3639

- **Ronsdale Press**:
R. B. Hatch, Director.
Literary.
3350 21st Ave., Vancouver, BC, V6S 1G7.
Phone: (604) 738•4688;
Fax: (604) 731•4548;
Internet: http://www.ronsdalepress.com

- **Scholastic Canada**:
Diane Kerner, Editorial Director.
175 Hillmount Rd., Markham, ON,
L6C 1Z7.
Phone: (905) 887 • 7323;
Toll Free: 1 (800) 387 • 4944;
Internet: http://www.scholastic.ca

- **Seal Books (Random House)**:
Maya Mavjee, Editor.
105 Bond St., Toronto, ON, M5B 1Y3.
Phone: (416) 340 • 0777;
Fax: (416) 977 • 8488

- **Sister Vision Press**:
Makeda Silvera, Managing Editor.
A Canadian feminist publisher of fiction,
poetry and theoretical works and plays by
women.
PO Box 217, Stn. E, Toronto, ON,
M6H 4E2.
Phone: (416) 533 • 9353;
Fax: (416) 533 • 9676

- **Somerville House Books**:
Margaret McClintock, Editorial Director;
Jane Somerville, Publisher.
Literary, including children's; quality
nonfiction.
5000, 3080 Yonge St., Toronto, ON,
M4N 3N1.
Phone: (416) 488 • 5938;
Fax: (416) 488 • 5506;
Internet: http://www.sombooks.com

- **Sono Nis Press**:
Diane Morriss, Publisher;
Dawn Loewen, Editor.
Trade books, B.C. orientation.
PO Box 5550, Stn. B, Victoria, BC,
B8R 6S4.
Phone: (250) 598 • 7807;
Fax: (250) 598 • 7866;
Internet: http://www.islandnet.com/
~sononis

- **Stoddart Publishing Co./General**:
Don Bastian, Managing Editor.
Very broad list, with various subsidiaries.
34 Lesmill Rd., North York, ON, M3B 2T6.
Phone: (416) 445 • 3333;
Fax: (416) 445 • 5967;
Internet: http://www.genpub.com/stoddart

- **Talonbooks**:
Karl Siegler, President.
Literary.
104, 3100 Production Way, Burnaby, BC,
V5A 4R4.
Phone: (604) 444 • 4889;
Fax: (604) 444 • 4119;
Internet: http://www.swifty.com/talon

- **Tesseract Books**:
Candas Jane Dorsey, Publisher.
A publishing collective. It took over the
science fiction list from Beach Holme in
1994.
330, 10113 – 104th St., Edmonton, AB,
T5J 1A1.
214, 21 – 10405 Jasper Ave., Edmonton,
AB, T5J 3S2.
Phone: (780) 448 • 0590;
Fax: (780) 448 • 0192

- **Theytus Books Ltd.**:
Greg Young-Ing, Manager.
Publishes adult and children's novels with
emphasis on First Nations themes.
Green Mountain Rd., Lot 45, RR 2,
Site 50, Comp. 8, Penticton, BC, V2A 6J7.
Phone: (250) 493 • 7181;
Fax: (250) 493 • 5302

- **Thistledown Press**:
Patrick O'Rourke, Editor-in-Chief.
Local and national literary works.
633 Main St., Saskatoon, SK, S7H 0J8.
Phone: (306) 244 • 1722;
Fax: (306) 244 • 1762;
Internet: http://www.thistledown.sk.ca

- **Tundra Books**:
 Katherine Lowinger, Publisher.
 Elegantly produced children's books.
 900, 481 University Ave., Toronto, ON,
 M5G 2E9.
 Phone: (416) 598 • 4786;
 Fax: (416) 598 • 0247

- **Turnstone Press**:
 Manuela Dias, Managing Editor.
 Regional literary.
 607, 100 Arthur St., Winnipeg, MB,
 R3B 1H3.
 Phone: (204) 947 • 1555;
 Fax: (204) 942 • 1555;
 Internet: http://www.turnstonepress.com

- **Véhicule Press**:
 Simon Dardick, General Editor/Publisher.
 Quality fiction and nonfiction.
 PO Box 125, Place du Parc Station,
 Montréal, QC, H2W 2M9.
 Phone: (514) 844 • 6073;
 Fax: (514) 844 • 7543;
 Internet: http://www.vehiculepress.com

- **XYZ Publishing**:
 Rhonda Bailey, Editorial Director
 (English).
 PO Box 250, Lantzville, BC, V0R 2H0.
 Phone/Fax: (250) 390 • 2329
 Head office: XYZ éditeur, André Vanasse,
 Publisher and Editorial Director (French).
 1781 Saint Hubert St., Montréal, QC,
 H2L 3Z1.
 Phone: (514) 525 • 2170;
 Fax: (514) 525 • 7537;
 Internet: http://www.xyzedit.com

A Panoply of Popular Literature

Leo Bachle (1929 –): Creator of Johnny Canuck, a Second World War comic-book hero, and of Nelvana of the North, the icy superwoman of our (short-lived) 1940s Canadian comics. Under the name Les Barker, Bachle has since become a nightclub entertainer on the Royal Viking Norwegian Cruise Line.

Robert Barr (1850 – 1912): In addition to many other popular stories, this Canadian magazine writer (born in Scotland) wrote *The Triumphs of Eugene Valmont* (1906), a mystery featuring a Poirot-like detective.

Jehane Benoît (1904 – 87): She wrote *Enjoying the Art of Canadian Cooking* (1974), only one of many successful food books by this Julia Child of Canadian cooking.

Pierre Berton (1920 –): Journalist, media personality and popular historian, Berton began by writing about the Klondike (he had grown up in Dawson City), but became most famous as the author of *The National Dream* (1970) and *The Last Spike* (1971), which described the building of the first transcontinental railroad. Another great success was *Vimy* (1986). Berton's narrative skill and his sure instinct for topics that would crystallize something essential about Canada have made his many books popular, while his congenial television personality helped carry the long-running television show *Front Page Challenge*.

Algernon Blackwood (1869 – 1951): He wrote many horror tales, including *The Lost Valley and Other Stories* (1910). Here and elsewhere, Blackwood's theme was sometimes hunters encountering the strange spirits of the Canadian North woods.

John Buchan (1875 – 1940): Governor General of Canada (1935 – 40) and creator of the Richard Hannay novels and other well-known adventure stories, his *Sick Heart River* (1941) a late, sombre tale, is set in wild Canada.

John Robert Colombo (1936 –): Canada's well-known creator of indispensable reference books is both an anthologist of science fiction and fantasy (*Other Canadas*, 1979) and a poet whose work (for example, *Monsters*, 1977) reflects his love of the genre.

Howard Engel (1931 –): One of Canada's most popular mystery writers, creator of the private eye Benny Cooperman and a founding member of the Crime Writers' Association of Canada.

Hal Foster (1892 – 1982): Born in Halifax, Foster drew one of the greatest of the Tarzan comics and created the famous Prince Valiant strip.

Phyllis Gotlieb (1926 –): Among other titles, she has written *Sunburst* (1964), set in Toronto and one of the best Canadian science fiction novels.

Grey Owl (Archibald Belaney, 1888 – 1938): Born in England, he moved to Canada at age 17 and here fulfilled a boyhood dream by adopting the mask of "Grey Owl," under which name he wrote several extremely popular books about nature and wildlife, retailing in them information and ideas of his own and others picked up from his associations with the Ojibwa of northern Ontario and from his Iroquois wife. Distinguished visitors such as the governor general of the time, John Buchan, sought an audience with him to share his lore. *Pilgrims of the Wild* (1934), *The Adventures of Sajo and Her Beaver People* (1935) and *Tales of an Empty Cabin* (1936) lost some of their credibility when Belaney's masquerade was discovered after his death, which is perhaps unfair to this benign and useful con artist. He is the subject of a Richard Attenborough-directed bio-pic, *Grey Owl* (1999).

Claude-Henri Grignon (1894 – 1976): Author of the immensely popular novel *Un homme et son péché* (1933), which became one of the most fantastically successful radio series on Radio-Canada, running from 1939 to 1965. Audiences seemed to love its brutal male figure, Séraphin Poudrier, and although the text's sadomasochism was condemned as arbitrary, Grignon defended it as pure realism.

Arthur Hailey (1920 –): Born in England, Hailey moved to Canada in 1947. Beginning in the 1960s, he became a Midas of the popular "inside focus" novel (i. e., the well-researched entertainment novel that builds its story around some typical institution or activity). *In High Places* (1962) deals with the Ottawa scene; this was followed by *Hotel* (1965), *Airport* (1968) and a string of others, for some of which Hailey also wrote the screenplays.

***The Laura Secord Canadian Cook Book* (1966):** One of the (slightly tongue-in-cheek) pop icons of Canadian 1960s nationalism, named after the heroine of the War of 1812.

Roger Lemelin (1919 – 92): The author of *Les Plouffe* (1948), a popular novel about Québec life that, especially in its television

versions, broke down the barriers between the two solitudes.

Judith Merril (1923 – 97): A great anthologist of science fiction, Merril was at the centre of new developments in the field for decades. She settled in Toronto in the 1960s and donated her extensive library of science fiction and fantasy to form the Spaced-Out Library, a research section of the Toronto Public Library that is one of the largest and best of its kind in the world.

Margaret Millar (1915 –): Canadian-born, Millar received a Grand Master Award from the Mystery Writers of America in 1983. A distinguished mystery writer whose *Beast in View* (1955) is a classic of the genre, she was married to the even more famous mystery writer Ross Macdonald, who was raised in Canada.

Farley Mowat (1921 –): Controversial and colourful, he is one of Canada's all-time bestselling authors, with a special interest in nature and wildlife, exploration and Native peoples. Some of his well-known books are *People of the Deer* (1952), *Lost in the Barrens* (1956), *Never Cry Wolf* (1963) and *Westviking* (1965).

Peter C. Newman (1929 –): Newspaperman and editor (*The Financial Post, Maclean's, Toronto Star*) who is best known for his books *Renegade in Power: The Diefenbaker Years* (1963), *The Canadian Establishment* (1975 – 81) and his history of the Hudson's Bay Company. A bestselling author of intelligence and great industry, he— rather than the professional historians or sociologists—has been responsible for educating the Canadian public about national power structures, the personal factor in politics and the business and economic roots of Canada.

Mazo de la Roche (1879 – 1961): Born in Ontario, she is one of the most popular Canadian writers ever to put fingers on keys or pen to paper. Beginning in 1927, she wrote the Jalna novels that have sold something like nine million copies worldwide and have been translated into innumerable languages. At the beginning, at least, she was highly regarded by the critics and her books continue to provide zesty television and film fare.

Richard Rohmer (1924 –): A military man, distinguished counsel and advocate of the North, but also the author of some 10 novels, of which *Ultimatum* (1973) is typical in its blend of smooth narrative and sensational premise, making it a bestseller of a kind that is surprisingly rare in Canada.

Robert J. Sawyer (1960 –): Canada's premier contemporary science fiction writer. Born in Ottawa (where A. E. van Vogt wrote *Slan*), Sawyer published some 10 novels through the 1990s. Besides winning many of the major Canadian and American awards (five Auroras, two Hugos and a Nebula), his novels and stories have also copped prizes in Japan, France and Spain. He is a member of the Crime Writers of America and past president of the Science Fiction and Fantasy Writers of America.

Robert W. Service (1874 – 1958): He moved from England to Canada in 1894 and settled eventually in Whitehorse and Dawson City, where, like T. S. Eliot, he earned his living as a bank employee. *Songs of a Sourdough* appeared in 1907, the first of several volumes of ballads and songs that made Service world-famous. "The Shooting of Dan McGrew" and "The Cremation of Sam McGee" were recited throughout my childhood by relatives who had never heard of that other bank-clerk poet and his *Waste*

Land. A young poet of my acquaintance who tried reciting modern Canadian poetry aloud on Bank Street in Ottawa watched the strollers grimly pass by, until she began to chant "The Cremation of Sam McGee," which immediately drew a crowd of fascinated listeners.

Ernest Thompson Seton (1860 – 1946): Although born in England, like Service, Seton had extensive connections with Canada. His illustrations, children's books about Native life such as *Two Little Savages*, (1906) and his natural history and travel books (several dealing with Canada) were among the most famous of the century.

Joe Shuster (1914 – 92): Born in Toronto, Shuster, a cousin of comedian Frank Shuster, was one of the two creators of the immortal Superman comic.

Jules-Paul Tardivel (1851 – 1905): In 1895 this popular journalist published the craziest novel imaginable about the separation of Québec. This work, *Pour la patrie*, has become a literary curiosity (it was reprinted in the 1930s in Québec and translated into English in 1974). Tardivel's novel tells how a gang of devil-worshipping freemasons attempts to take over *la belle province* and subvert the glorious and enriching influence of the Roman Catholic Church. Luckily God intervenes to stop them. I bet they loved this one in the Vatican.

A. E. van Vogt (1912 –): Manitoba-born van Vogt wrote much of *Slan* (1946), a well-known science fiction novel, when he was working for the Department of National Defence in Ottawa.

Eric Wright (1929 –): In *The Night the Gods Smiled* (1983) and other novels, Wright's Inspector Charlie Salter solves crimes in Toronto.

L. R. Wright (1940 –): She is a detective-story writer of distinction who writes in the vein of Ruth Rendell and P. D. James. Her stories, however, take place on British Columbia's Sunshine Coast. Her first novel, *The Suspect* (1985), is outstanding.

A Selection of Essential Canadian Novels

- Thomas Chandler Haliburton (1796 –1865): *The Clockmaker* (1836)
- Lucy Maud Montgomery (1874 – 1942): *Anne of Green Gables* (1908)
- Louis Hémon (1880 – 1913): *Maria Chapdelaine* (1916)
- Frederick P. Grove (1879 – 1948): *Settlers of the Marsh* (1925)
- Philippe Panneton, "Ringuet" (1895 –1960): *Trente arpents* (*Thirty Acres*, 1938)
- Sinclair Ross (1908 – 96): *As For Me and My House* (1941)
- Gabrielle Roy (1909 – 83): *Bonheur d'occasion* (*The Tin Flute*, 1945)
- W. O. Mitchell (1914 – 98): *Who Has Seen the Wind?* (1947)
- Malcolm Lowry (1909 – 57): *Under the Volcano* (1947)
- Ernest Buckler (1908 – 84): *The Mountain and the Valley* (1952)
- Hugh MacLennan (1907 – 90): *The Watch That Ends the Night* (1959)

- Marie-Claire Blais (1939 –): *La belle bête* (*Mad Shadows*, 1959)
- Sheila Watson (1909 –) *The Double Hook* (1959)
- Hubert Aquin (1929 – 77): *Prochain épisode* (*Final Episode*, 1965)
- Roch Carrier (1937 –): *La guerre, Yes Sir!* (1968)
- Jacques Ferron (1921 – 85): *Le ciel du Québec* (*The Sky of Québec*, 1969)
- Robert Kroetsch (1927 –) *The Studhorse Man* (1969)
- Robertson Davies (1913 – 95): *The Deptford Trilogy* (1970 – 75)
- Margaret Atwood (1939 –): *Surfacing* (1972)
- Margaret Laurence (1926 – 87): *The Diviners* (1974)
- Timothy Findley (1930 –): *The Wars* (1977)
- Antonine Maillet (1929 –): *Pélagie-la-charrette* (1979)
- Yves Beauchemin (1941 –): *Le matou* (*The Alleycat*, 1981)
- Mordecai Richler (1931 –): *Solomon Gursky Was Here* (1989)
- Michael Ondaatje (1943 –): *The English Patient* (1992)
- Carol Shields (1935 –): *The Stone Diaries* (1993)
- Rohinton Mistry (1952 –): *A Fine Balance* (1995)

Outstanding Short Story Collections

- Stephen Leacock (1869 – 1944): *Sunshine Sketches of a Little Town* (1912)
- Yves Thériault (1915 – 83): *Contes pour un homme seul* (*Tales for a Solitary Man*, 1944)
- Alain Grandbois (1900 – 75): *Avant le chaos* (*Before Chaos*, 1944)
- P. K. Page (1916 –): *The Sun and the Moon* (1944)

- Ethel Wilson (1888 – 1980): *The Equations of Love* (1952)
- Morley Callaghan (1903 – 90): *Stories* (1959)
- Jacques Ferron (1921 – 85): *Contes du pays incertain* (*Tales From a Doubtful Country*, 1962)
- Hugh Garner (1913 – 79): *Hugh Garner's Best Stories* (1963)
- Mavis Gallant (1922 –): *My Heart Is Broken* (1964)
- Audrey Thomas (1935 –): *Ten Green Bottles* (1967)
- Ray Smith (1941 –): *Cape Breton Is the Thought Control Centre of Canada* (1969)
- Alice Munro (1931 –): *Lives of Girls and Women* (1971)
- Anne Hébert (1916 – 2000): *Le torrent* (*The Torrent*, 1973)
- Clark Blaise (1940 –): *A North American Education* (1973)
- Alice Munro (1931 –): *Something I've Been Meaning to Tell You* (1974)
- Jack Hodgins (1938 –): *Spit Delaney's Island* (1976)
- Hugh Hood (1928 –): *Selected Stories* (1978)
- Roch Carrier (1937 –): *Les enfants du bonhomme dans la lune* (*The Hockey Sweater and Other Stories*, 1979)
- Sheila Watson (1909 –): *Four Stories* (1980)
- Mavis Gallant (1922 –): *Home Truths: Selected Canadian Stories* (1981)
- Rudy Wiebe (1934 –): *The Angel in the Sands and Other Stories* (1982)
- Leon Rooke (1934 –): *The Birth Control King of Upper Volta* (1982)
- John Metcalf (1938 –): *Selected Stories* (1982)
- Margaret Atwood (1939 –): *Bluebeard's Egg* (1983)
- Norman Levine (1923 –): *Champagne Barn* (1984)

Significant Poetry Volumes

- Émile Nelligan (1879 – 1941): *Poésies complétes* (1896 – 99)
- Archibald Lampman (1861 – 99): *The Poems of Archibald Lampman* (1900)
- Saint-Denys Garneau (1912 – 43): *Regards et jeux dans l'espace* (1937)
- Alain Grandbois (1900 – 75): *Rivages de l'homme* (1948)
- Duncan Campbell Scott (1868 – 1947): *Selected Poems* (1951)
- Anne Hébert (1916 – 2000): *Le tombeau des rois* (1953)
- Jay Macpherson (1931 –): *The Boatman* (1957)
- E. J. Pratt (1883 – 1964): *The Collected Poems of E. J. Pratt* (1958)
- Paul Morin (1889 – 1963): *Ouevres poétiques* (1961)
- Paul Chamberland (1939 –): *L'afficheur hurle* (1964)
- F. R. Scott (1899 – 1985): *Selected Poems* (1966)
- Earle Birney (1904 – 96): *Selected Poems* (1966)
- Margaret Avison (1918 –): *The Dumbfounding* (1966)

- A. M. Klein (1909 – 72): *The Collected Poems of A. M. Klein* (1966)
- Dennis Lee (1939 –): *Civil Elegies* (1968)
- Gwendolyn McEwen (1941 – 1987) *The Shadow-Maker* (1969)
- Barrie Phillip (bp) Nichol (1944 – 1988) *The True Eventual Story of Billy the Kid* (1970)
- Gaston Miron (1928 –): *L'homme repaillé* (1970)
- Margaret Atwood (1939 –): *The Journals of Susanna Moodie* (1970)
- Michael Ondaatje (1943 –): *The Collected Works of Billy the Kid* (1970)
- Irving Layton (1912 –): *The Collected Poems of Irving Layton* (1971)
- Alfred DesRochers (1901 – 78): *Ouevres poétiques* (1977)
- John Newlove (1938 –): *The Fatman: Selected Poems 1962 – 1972* (1977)
- A. J. M. Smith (1902 – 80): *The Classic Shade: Selected Poems* (1978)
- Al Purdy (1918 –): *Being Alive* (1978)
- George Johnson (1913 –): *Auk Redivivus: Selected Poems* (1981)
- Robert Zend (1929 – 85): *Oab 1&2* (1983 –84)

A Selection of Cultural Magazines in Canada

C ANADA has an impressive number of newspapers and periodicals that report on the arts, including *The Globe and Mail, The National Post, Maclean's, Books in Canada*, yet this country seems to lack specialized arts magazines that feature criticism and analysis, opinion and controversy. *Saturday Night, Canadian Forum, The Georgia Straight* and one or two other Canadian magazines certainly deal with important cultural issues, but this is only a small part of their content. And while we have specialized journals in art, music, film and literature, most of these are hard to find, marginal or just plain unexciting. Our literary magazines, for example, although solid, serious and attractively produced, are just too similar to each other in format and content. They seldom tackle issues connected with writing and publishing, and one sees the same writers (and the same kind of writing) in nearly all of them. We need magazines devoted to art, music and literature that are unique and special and not afraid to ignore the shibboleths of the day, and others that reach out to a broad audience without stinting on intellectual challenge. In this connection, *Confluences* , Robert Richard's Montréal-based magazine of opinion, offers a useful model. Not only is it published in two languages (and separate editions), but it opens its pages to a host of intellectual perspectives, refusing to smooth out its contributions in the name of "editorial consistency" or ideological control. Of course magazines with specific points of view are fine, so long as there are a lot of them! It doesn't matter greatly whether such magazines are short-lived— even the residue of excitement and diversity that they create can have its uses. Given what Canada already has, is it unreasonable to ask for more? I don't think so.

- *The Antigonish Review*
 (quarterly; circulation 800).
 George Sanderson, Editor.
 Publishes fiction and poetry from across Canada.
 St. Francis Xavier University, PO Box 5000, Antigonish, NS, B2G 2W5.
 Phone: (902) 867 • 3962;
 Fax: (902) 867 • 5563

- *ARC*
 (twice a year; circulation 750).
 John Barton and Rita Donovan, Co-Editors.
 Canada's oldest and only national magazine that concentrates exclusively on poetry and poetry-related articles, interviews and book reviews.
 PO Box 7368, Ottawa, ON, K1L 8E4.

- *Arts Atlantic*
 (three times a year; circulation 2,500).
 Joseph Sherman, Editor.
 145 Richmond St., Charlottetown, PE, C1A 1J1.
 Phone: (902) 628 • 6138;
 Fax: (902) 566 • 4648

- *B&A New Fiction* (formerly *Blood and Aphorisms*)
 (quarterly; circulation 2,000).
 Michelle Alfano, Fiction Editor.
 Publishes mostly short fiction à la mode, including work by new writers.
 PO Box 702, Stn. P, Toronto, ON, M5S 2Y4.
 Phone/Fax: (416) 535 • 1233;
 Internet: http://www.io.org/~blood

- *Books in Canada*
(nine times a year; circulation 8,000).
Adrian Stein, Publisher.
An essential medium of review and
literary commentary.
50 St. Clair Ave. E, 4th Floor, Toronto, ON,
M4T 1M9.
Phone: (416) 924 • 2777;
Fax: (416) 924 • 8682;
Internet: http://www.inscroll.com

- *Border Crossings*
(quarterly; circulation 4,000).
Meeka Walsh, Editor.
A well-edited magazine of commentary,
criticism and review.
500, 70 Arthur St., Winnipeg, MB,
R3B 1G7.
Phone: (204) 942 • 5778;
Fax: (204) 949 • 0793

- *Broken Pencil*
(three times a year; circulation 3,000).
Hal Niedzviecki, Editor.
A guide to zines and alternative culture in
Canada.
PO Box 203, Stn. P, Toronto, ON,
M5S 2S7.
Phone: (416) 538 • 2813.
Internet: http://www.brokenpencil.com

- *Canadian Art*
(quarterly; circulation 20,000).
Richard Rhodes, Editor.
Reliable, although not very exciting.
Aimed at the well-informed art
connoisseur or collector.
56 The Esplanade, Suite 310, Toronto, ON,
M5E 1A7.
Phone: (416) 368 • 8854;
Fax: (416) 368 • 6135

- *Canadian Fiction Magazine*
(twice a year; circulation 2,000).
Rob Payne, Editor.
Now appears (but very irregularly) in
anthology form.
PO Box 1061, 240 King St. E, Kingston,
ON, K7L 4Y5.
Phone: (613) 548 • 8429, ext. 16;
Fax: (613) 548 • 1556

- *Canadian Literature*
(quarterly; circulation 1,400).
E. M. Kröller, Editor.
Central scholarly journal with articles on
all aspects of Canadian literature.
University of British Columbia,
1855 West Mall, Suite 167, Vancouver, BC,
V6T 1Z2.
Phone: (604) 822 • 2780;
Fax: (604) 822 • 5504;
Internet: http://www.cdn-lit.ubc.ca

- *Canadian Theatre Review*
(quarterly; circulation 850).
Editorial Committee: Alan Filewod,
Ric Knowles, Harry Lane, Allan Watts,
Ann Wilson.
A useful academic journal.
University of Toronto Press – Journals,
5201 Dufferin St., North York, ON,
M3H 5T8.
Phone: (416) 667 • 7810;
Internet: http://www.utpress.utoronto.ca/
journal/ctr.htm

- *The Capilano Review*
(three times a year; circulation 1,000).
Ryan Knighton, Editor.
Fiction and poetry in the contemporary
manner.
2055 Purcell Way, North Vancouver, BC,
V7J 3H5.
Phone: (604) 984 • 1712;
Fax: (604) 990 • 7837;
Internet: http://www.capcollege.bc.ca/
dept/TRC

• *Confluences*
(bi-monthly).
Robert Richard, Editor.
A lively magazine of opinion, mostly on
politics, culture and the arts, published in
separate editions in French and English.
PO Box 47524, Postal Outlet Plateau
Mont-Royal, Montréal, QC, H2H 1S8.
Phone: (514) 527 • 5258.

• *The Dalhousie Review*
(three times a year; circulation 400).
Ronald Huebert, Editor.
A well-established academic journal;
publishes some fiction and poetry.
Dalhousie University, Halifax, NS,
B3H 3J5.
Phone: (902) 494 • 2541;
Fax: (902) 494 • 3561;
Internet: http://www.dal.ca/
dalhousiereview

• *Dance International: The Dance Arts in
Canada and Abroad.*
(quarterly; circulation 3,500).
Maureen Riches, Editor.
Published by the Vancouver Ballet Society;
comprises feature articles on dance,
performance and book reviews, and
commentaries from major dance centres.
302, 601 Cambie St., Vancouver, BC,
V6B 2P1.
Phone: (604) 681 • 1525;
Fax: (604) 681 • 7732

• *Descant*
(quarterly; circulation 1,200).
Karen Mulhallen, Managing Editor.
Fiction and poetry in the contemporary
manner.
PO Box 314, Stn. P, Toronto, ON,
M5S 2S8.
Phone: (416) 593 • 2557;
Fax: (416) 593 • 9362;
Internet: http://www.descant.on.ca

• *Essays on Canadian Writing*
(three times a year; circulation 1,000).
Jack David and Robert Lecker, Editors.
High-quality literary and academic
criticism.
200, 2120 Queen St. E, Toronto, ON,
M4E 1E2.
Phone: (416) 694 • 3348;
Fax: (416) 698 • 9906;
Internet: http://www.ecw.ca

• *Event: The Douglas College Review*
(three times a year; circulation 1,000).
Calvin Wharton, Editor.
A typical, solid university literary journal.
Douglas College, PO Box 2503,
New Westminster, BC, V3L 5B2.
Phone: (604) 527 • 5293;
Fax: (604) 527 • 5095

• *Exile*
(quarterly; circulation 1,200).
Barry Callaghan, Publisher.
Well-known, high-quality Toronto literary
magazine, features mostly established
writers.
PO Box 67, Stn. B, Toronto, ON,
M5T 2C0.
Phone: (416) 969 • 8877;
Fax: (416) 969 • 9556

• *The Fiddlehead*
(quarterly; circulation 1,000).
Ross Leckie, Editor.
An old established literary journal that
often publishes work by new writers.
Campus House,
University of New Brunswick,
PO Box 4400, Fredericton, NB, E3B 5A3.
Phone: (506) 453 • 3501;
Fax: (506) 453 • 5069

- *Fuse Magazine*
(quarterly; circulation 5,000).
Petra Chevrier, Editor.
Lively, opinionated arts commentary,
often speaks for marginalized groups.
454, 401 Richmond St. W, Toronto, ON,
M5V 3A8.
Phone: (416) 340 • 0494.

- *Geist*
(quarterly; circulation 6,000).
Stephen Osborne, Editor-in-Chief.
A magazine of Canadian ideas and
culture.
103, 1014 Homer St., Vancouver, BC.
Phone: (604) 681 • 9161;
Fax: (604) 669 • 8250;
Internet: http://www.geist.com

- *Grain*
(quarterly; circulation 1, 300).
Elizabeth Philips, Editor.
Fiction and poetry from established or à
la mode writers.
PO Box 1154, Regina, SK, S4P 3B4.
Phone: (306) 244 • 2828;
Fax: (306) 244 • 0255;
Internet: http://www.skwriter.com

- *The Malahat Review*
(quarterly; circulation 1,200).
Marlene Cookshaw, Editor.
Fiction and poetry.
University of Victoria, PO Box 1700,
Victoria, BC, V8W 2Y2.
Phone: (250) 721 • 8524;
Internet: http://web.uvic.ca/malahat

- *Matrix*
(three times a year; circulation 1,800).
Robert Allen, Editor.
The magazine features a lively format and
fiction and à la mode writing from
anglophone Québec and elsewhere.
502, 1400, boul. de Maisonneuve O,
Montréal, QC, H3G 1M8.
Phone: (514) 848 • 2344;
Fax: (514) 848 • 4501

- *The Mystery Review*
(quarterly; circulation 5,000).
Barbara Davey, Editor.
Covers the mystery-writing scene in
Canada extensively, if not in depth.
PO Box 233, Colborne, ON, K0K 1S0.
Phone: (613) 475 • 4440;
Fax: (613) 475 • 3400;
Internet: http://www.inline-online.com/
mystery/

- *The New Quarterly*
(quarterly; circulation 500).
Mary Merikle, Managing Editor.
A committee of editors chooses the
content—fiction and poetry from well-
established or à la mode writers.
University of Waterloo,
English Language Proficiency Program,
PAS 2082, Waterloo, ON, N2L 3G1.
Phone: (519) 885 • 1211, ext. 2837.

- *ON SPEC: The Canadian Magazine of
Speculative Writing*
(quarterly; circulation 2,000).
Kathy MacRay, Publishing Assistant.
A good idea for a magazine. If it were
bigger, livelier and easier to find in the
magazine stores, Canadian SF fans would
be better pleased.
PO Box 4727, Edmonton, AB, T6E 5G6.
Phone: (780) 413 • 0215;
Fax: (780) 413 • 1538;
Internet: http://www.icomm.ca/onspec

• *Opera Canada*
(quarterly; circulation 5,000).
Wayne Gooding, Editor.
The articles do sometimes rise above the
level of opera puff pieces, but even more
splash and dash, not to mention more
challenging content, would be welcome.
244, 366 Adelaide St. E, Toronto, ON,
M5A 3X9.
Phone: (416) 363 • 0395;
Fax: (416) 363 • 0396

• *Parachute*
(quarterly; circulation 3,000).
Chantal Pontbriand, Editor.
Distinguished French-language Québec
arts journal. Poetry, criticism, fiction.
4060, boul. St-Laurent, Bureau 501,
Montréal, QC, H2W 1Y9.
Phone: (514) 842 • 9805;
Fax: (514) 287 • 7146

• *Performing Arts & Entertainment in Canada*
(quarterly; circulation 44,000).
George Henez, Publisher.
104 Glenrose Ave., Toronto, ON, M4T 1K8.
Phone: (416) 484 • 4534;
Fax: (416) 484 • 6214

• *Poetry Canada*
(quarterly; circulation 1,500).
Bob Hilderley, Managing Editor.
Publishes a good cross-section of work by
Canadian poets.
PO Box 1061, Kingston, ON, K7L 4Y5.
Phone: (613) 548 • 8429;
Fax: (613) 548 • 1556

• *Prairie Fire*
(quarterly; circulation 1,500).
Andris Taskans, Editor.
A typical, solid literary journal.
423, 100 Arthur St., Winnipeg, MB, R3B 1H3.
Phone: (204) 943 • 9066;
Fax: (204) 942 • 1555

• *PRISM International*
(quarterly; circulation 1,000).
Jennica Harper and Kiera Miller, Editors.
Changes editors often; literary contests
are a big feature.
Department of Creative Writing,
University of British Columbia,
Buch E462, 1866 Main Mall, Vancouver,
BC, V6T 1Z1.
Phone: (604) 822 • 2514;
Fax: (604) 822 • 3616;
Internet: http://www.arts.ubc.ca/prism/

• *Quarry*
(quarterly; circulation 1,200).
Bob Hilderley, Managing Editor.
An old established academic literary
journal.
PO Box 1061, Kingston, ON, K7L 4Y5.
Phone; (613) 548 • 8429;
Fax: (613) 548 • 1556

• *Queen's Quarterly*
(quarterly; circulation 3,000).
Boris Castel, Editor.
Stories, poems and thoughtful articles.
Much more unbuttoned than it used to be;
inviting format.
Queen's University, Kingston, ON,
K7L 3N6.
Phone: (613) 533 • 2667;
Fax: (613) 545 • 6822;
Internet: http://info.queensu.ca/quarterly

• *Quill & Quire*
(monthly; circulation 7,000).
Scott Anderson, Editor.
Essential reading for the Canadian book
trade.
210, 70 The Esplanade, Toronto, ON,
M5E 1R2.
Phone: (416) 360 • 0044;
Fax: (416) 955 • 0794

- *Sub-TERRAIN Magazine*
 (quarterly; circulation 3,000).
 Brian Kaufman, Managing Editor.
 Terse, off-the-wall, sometimes trenchant
 fiction, poetry and commentary.
 204A, 175 Broadway, Vancouver, BC,
 V5T 1W2.
 Phone: (604) 876 • 8710;
 Fax: (604) 879 • 2667

- *Zygote Magazine*
 (quarterly, 750).
 Cindy Little, Kerry Ryan, Tom Schmidt,
 Editors.
 Publishes poetry, short stories, book
 reviews and interviews by new writers as
 well as established writers.
 1474 Wall St., Winnipeg, MB, R3E 2S4.

Stephen Leacock Medal for Humour

NAMED after the unofficial inventor of Canadian comedy, the Stephen Leacock Medal for Humour is awarded every April to a Canadian author for a book of humour, or a humorous book, published in the previous year. It is administered by Stephen Leacock Associates and a $5,000 cash award is sponsored by the Laurentian Bank of Canada.

CBC Television / Fred Phipps

Host of the CBC Radio program The Vinyl Café, *Stuart MacLean won the 1999 Stephen Leacock Medal for Humor for his book* Home From the Vinyl Café.

1999: Stuart MacLean, *Home From the Vinyl Café*
1998: Mordecai Richler, *Barney's Version*
1997: Arthur Black, *Black in the Saddle Again*
1996: Marsha Boulton, *Letters From the Country*
1995: Josh Freed, *Fear of Frying and Other Fax of Life*
1994: Bill Richardson, *Bachelor Brothers' Bed & Breakfast*
1993: John Levesque, *Waiting for Aquarius*
1992: Roch Carrier, *Prayers of a Very Wise Child*
1991: Howard White, *Writing in the Rain*
1990: W. O. Mitchell, *According to Jake and the Kid*
1989: Joseph Kertes, *Winter Tulips*
1988: Paul Quarrington, *King Leary*
1987: W. P. Kinsella, *The Fencepost Chronicles*
1986: Joey Slinger, *No Axe too Small to Grind*
1985: Ted Allan, *Love is a Long Shot*
1984: Gary Lautens, *No Sex Please... We're Married*

1983: Morley Torgov, *The Outside Chance of Maximilian Glick*

1982: Mervyn J. Huston, *Gophers Don't Pay Taxes*

1981: Gary Lautens, *Take My Family . . . Please!*

1980: Donald Jack, *Me Bandy, You Cissie*

1979: Sondra Gotlieb, *True Confections*

1978: Ernest Buckler, *Whirligig*

1977: Ray Guy, *That Far Greater Bay*

1976: Harry J. Boyle, *The Luck of the Irish*

1975: Morley Torgov, *A Good Place to Come From*

1974: Donald Jack, *That's Me in the Middle*

1973: Donald Bell, *Saturday Night at the Bagel Factory*

1972: Max Braithwaite, *The Night They Stole the Mounties Car*

1971: Robert Thomas Allen, *Wives, Children and Other Wildlife*

1970: Farley Mowat, *The Boat Who Wouldn't Float*

1969: Stuart Trueman, *You're Only as Old as You Act*

1968: Max Ferguson, *And Now...Here's Max*

1967: Richard J. Needham, *Needham's Inferno*

1966: George Bain, *Nursery Rhymes to be Read Aloud by Young Parents with Old Children*

1965: Gregory Clark, *War Stories*

1964: Harry J. Boyle, *Homebrew and Patches*

1963: Donald Jack, *Three Cheers for Me*

1962: W. O. Mitchell, *Jake and the Kid*

1961: Norman Ward, *Mice in the Beer*

1960: Pierre Berton, *Just Add Water and Stir*

1958: Eric Nicol, *Girdle Me a Globe*

1957: Robert Thomas Allen, *The Grass is Never Greener*

1956: Eric Nicol, *Shall We Join the Ladies?*

1955: Robertson Davies, *Leaven of Malice*

1954: Joan Walker, *Pardon My Parka*

1953: Lawrence Earl, *The Battle of Baltinglass*

1952: Jan Hilliard, *The Salt-Box*

1951: Eric Nicol, *The Roving I*

1950: Earle Birney, *Turvey*

1949: Angeline Hango, *Truthfully Yours*

1948: Paul Hiebert, *Sarah Binks*

1947: Harry L. Symons, *Ojibway Melody*

Source: Stephen Leacock Associates

Giller Prize

THIS prize, which was established in 1994 to honour Doris Giller, the late Canadian journalist, is awarded to the author of the best Canadian novel or collection of short stories published in English. The winner receives a bronze sculpture by sculptor Yehouda Chaki and $25,000, making this award the most generous prize for English-language fiction in Canada.

1999: Bonnie Burnard, *A Good House*

1998: Alice Munro, *The Love of a Good Woman*

1997: Mordecai Richler, *Barney's Version*

1996: Margaret Atwood, *Alias Grace*

1995: Rohinton Mistry, *A Fine Balance*

1994: M.G. Vassanji, *The Book of Secrets*

The Governor General's Literary Awards

THESE awards were founded in1937 by the Canadian Authors' Association and first given for the year 1936. John Buchan, Lord Tweedsmuir, a noted literary man in his own right, was governor general during those years. In 1959, the Canada Council took over partial administration of the awards and French titles were also honoured. In 1971, the Canada Council took sole responsibility. A few writers have rejected the prize. Winners receive $10,000, a medal from the governor general and a specially bound copy of their award-winning book.

1999

- Fiction: Matt Cohen, *Elizabeth and After*
- Poetry: Jan Zwicky, *Songs for Relinquishing the Earth*
- Drama: Michael Healey, *The Drawer Boy*
- Nonfiction: Marq de Villiers, *Water*
- Children's Literature (Text): Rachna Gilmore, *A Screaming Kind of Day*
- Children's Literature (Illustration): Gary Clement, *The Great Poochini*
- Translation (from French to English): Patricia Claxton, *Gabrielle Roy: A Life*
- Fiction (French): Lise Tremblay, *La danse juive*
- Poetry (French): Herménégilde Chiasson, *Conversations*
- Drama (French): Jean Marc Dalpé, *Il n'y a que l'amour*
- Nonfiction (French): Pierre Perrault, *Le mal du nord*
- Children's Literature (French Text): Charlotte Gingras, *La Liberté? Connais pas...*
- Children's Literature (French Illustration): Stéphane Jorisch, *Charlotte et l'île du destin*
- Translation (from English to French): Jacques Brault, *Transfiguration*

- Drama: Djanet Sears, *Harlem Duet*
- Nonfiction: David Adams Richards, *Lines on the Water: A Fisherman's Life on the Miramichi*
- Children's Literature (Text): Janet Lunn, Hillier, *The Hollow Tree*
- Children's Literature (Illustration): Kady MacDonald Denton, *A Child's Treasury of Nursery Rhymes*
- Translation (from French to English): Sheila Fischman, *Bambi and Me*
- Fiction (French): Christiane Frenette, *La terre ferme*
- Poetry (French): Suzanne Jacob, *La part de feu preceded by Le Deuil de la rancune*
- Drama (French): François Archambault, *15 secondes*
- Nonfiction (French): Pierre Nepveu, *Intérieurs du nouveau monde : Essais sur les littératures du Québec et des Amériques*
- Children's Literature (French Text): Angèle Delaunois, *Variations sur un même & laqno t'aime*
- Children's Literature (French Illustration): Pierre Pratt, *Monsieur Il était une fois*
- Translation (from English to French): Charlotte Melançon, *Les sources du moi – La formation de l'identité moderne*

1998

- Fiction: Diane Schoemperlen, *Forms of Devotion*
- Poetry: Stephanie Bolster, *White Stone: The Alice Poems*

1997

- Fiction: Jane Urquhart, *The Underpainter*
- Poetry: Dionne Brand, *Land to Light On*
- Drama: Ian Ross, *fareWel*

- Nonfiction: Rachel Manley, *Drumblair – Memories of a Jamaican Childhood*
- Children's Literature (Text): Kit Pearson, *Awake and Dreaming*
- Children's Literature (Illustration): Barbara Reid, *The Party*
- Translation (from French to English): Howard Scott, *The Euguelion*
- Translation (from English to French): Marie José Thériault, *Arracher les montagnes*
- Fiction (French): Aude, Sainte-Foy, *Cet imperceptible mouvement*
- Poetry (French): Pierre Nepveu, for *Romans-fleuves*
- Drama (French): Yvan Bienvenue, *Dits et Inédits*
- Nonfiction (French): Roland Viau, *Enfants du néant et mangeurs d'âmes – Guerre, culture et société en Iroquoisie ancienne*
- Children's Literature (French Text): Michel Noël, *Pien*
- Children's Literature (French Illustration): Stéphane Poulin, *Poil de serpent, dent d'araignée*

1996

- Fiction: Guy Vanderheghe, *The Englishman's Boy*
- Poetry: E. D. Blodgett, *Apostrophes: Woman at a Piano*
- Drama: Colleen Wagner, *The Monument*
- Nonfiction: John Ralston Saul, *The Unconscious Civilization*
- Translation (from French to English): Linda Gaboriau, *Stone and Ashes*
- Children's Literature (Illustration): Eric Beddows, *The Rooster's Gift*
- Children's Literature (English Text): Paul Yee, *Ghost Train*
- Fiction (French): Marie-Claire Blais, *Soifs*
- Poetry (French): Serge Patrice Thibodeau, *Le quatuor de l'errance suivi de la traversée du désert*

- Drama (French): Normand Chaurette, *Le passage de l'Indiana*
- Nonfiction (French): Michel Freitag, *Le naufrage de l'université – Et autres essais d'épistémologie politique*
- Translation (from English to French): Christiane Teasdale, *Systèmes de survie: Dialogue sur les fondements moraux du commerce et de la politique*
- Children's Literature (French Illustration): Gilles Tibo, *Noémie: Le secret de Madame Lumbago*
- Children's Literature (French Text): Gilles Tibo, *Noémie: Le secret de Madame Lumbago*

1995

- Fiction: Greg Hollingshead, *The Roaring Girl*
- Poetry: Anne Szumigalski, *Voice*
- Drama: Jason Sherman, *Three in the Back, Two in the Head*
- Nonfiction: Rosemary Sullivan, *Shadow Maker: The Life of Gwendolyn MacEwen*
- Translation (from French to English): David Homel, *Why Must a Black Writer Write About Sex?*
- Children's Literature (Illustration): Ludmila Zeman, *The Last Quest of Gilgamesh*
- Children's Literature (Text): Tim Wynne-Jones, *The Maestro*
- Fiction (French): Nicole Houde, *Les oiseaux de Saint-John Perse*
- Poetry (French): Émile Martel, *Pour orchestre de poète seul*
- Drama (French): Carole Fréchette, *Les quatre morts de Marie*
- Nonfiction (French): Yvan Lamonde, *Louis-Antoine Dessaulles: Un seigneur libéral et anticlérical*
- Translation (from English to French): Hervé Juste, *Entre l'ordre et la liberté*
- Children's Literature (French Illustration): Annouchka Gravel Galouchko, *Sho et les dragons d'eau*

- Children's Literature (French Text): Sonia Sarfati, *Comme une peau de chagrin*

1994
- Fiction: Rudy Wiebe, *A Discovery of Strangers*
- Poetry: Robert Hilles, *Cantos from a Small Room*
- Drama: Morris Panych, *The Ends of the Earth*
- Nonfiction: John A. Livingston, *Rogue Primate: An Exploration of Human Domestication*
- Translation (from French to English): Donald Winkler, *The Lyric Generation: The Life and Times of the Baby Boomers*
- Children's Literature (Illustration): Murray Kimber, *Josepha: A Prairie Boy's Story*
- Children's Literature (Text): Julie Johnston, *Adam and Eve and Pinch-Me*
- Fiction (French): Robert Lalonde, *Le petit aigle à tête blanche*
- Poetry (French): Fulvio Caccia, *Aknos*
- Drama (French): Michel Ouellette, *French Town*
- Nonfiction (French): Chantal Saint-Jarre, *Du sida*
- Translation (from English to French): Jude Des Chênes, *Le mythe du sauvage*
- Children's Literature (French Illustration): Pierre Pratt, *Mon chien est un éléphant*
- Children's Literature (French Text): Suzanne Martel, *Une belle journée pour mourir*

1993
- Fiction: Carol Shields, *The Stone Diaries*
- Poetry: Don Coles, *Forests of the Medieval World*
- Drama: Guillermo Verdecchia, *Fronteras Americanas*
- Nonfiction: Karen Connelly, *Touch the Dragon*
- Translation (from French to English): D. G. Jones, *Categories One, Two and Three*

- Children's Literature (Illustration): Mireille Levert, *Sleep Tight, Mrs. Ming*
- Children's Literature (Text): Tim Wynne-Jones, *Some of the Kinder Planets*
- Fiction (French): Nancy Huston, *Cantique des plaines*
- Poetry (French): Denise Desautels, *Le saut de l'ange*
- Drama (French): Daniel Danis, *Celle-là*
- Nonfiction (French): François Paré, *Les littératures de l'exiguïté*
- Translation (from English to French): Marie José Thériault, *L'oeuvre du gallois*
- Children's Literature (French Illustration): Stéphane Jorisch, *Le monde selon Jean de…*
- Children's Literature (French Text): Michèle Marineau, *La route de Chlifa*

1992
- Fiction: Michael Ondaatje, *The English Patient*
- Poetry: Lorna Crozier, *Inventing the Hawk*
- Drama: John Mighton, *Possible Worlds, A Short History of Night*
- Nonfiction: Maggie Siggins, *Revenge of the Land: A Century of Greed, Tragedy and Murder on a Saskatchewan Farm*
- Translation (from French to English): Fred A. Reed, *Imagining the Middle East*
- Children's Literature (Illustration): Ron Lightburn, *Waiting for the Whales*
- Children's Literature (Text): Julie Johnston, *Hero of Lesser Causes*
- Fiction (French): Anne Hébert, *L'enfant chargé les songes*
- Poetry (French): Gilles Cyr, *Andromède attendra*
- Drama (French): Louis-Dominique Lavigne, *Les petits orteils*
- Nonfiction (French): Pierre Turgeon, La Radissonie, *Le pays de la baie James*
- Translation (from English to French): Jean Papineau, *La mémoire postmoderne: Essai sur l'art canadien contemporain*

- Children's Literature (French Illustration): Gille Tibo, *Simon et la ville de carton*
- Children's Literature (French Text): Christiane Duchesne, *Victor*

1991
- Fiction: Rohinton Mistry, *Such a Long Journey*
- Poetry: Don McKay, *Night Field*
- Drama: Joan MacLeod, *Amigo's Blue Guitar*
- Nonfiction: Robert Hunter and Robert Calihoo, *Occupied Canada*
- Translation (from French to English): Albert W. Halsall, *A Dictionary of Literary Devices A – Z*
- Children's Literature (Illustration): Joanne Fitzgerald, *Doctor Kiss Says Yes*
- Children's Literature (Text): Sarah Ellis, *Pick-Up Sticks*
- Fiction (French): André Brochu, *La croix du nord*
- Poetry (French): Madeleine Gagnon, *Chant pour un Québec lointain*
- Drama (French): Gilbert Dupuis, *Mon oncle Marcel qui vague près du métro Berri*
- Nonfiction (French): Bernard Arcand, *Le jaguar et le tamanoir*
- Translation (from English to French): Jean-Paul Sainte-Marie and Brigitte Chabert Hacikyan, *Les enfants d'Aataentsic: l'histoire du peuple huron*
- Children's Literature (French Illustration): Sheldon Cohen, *Un champion*
- Children's Literature (French Text): François Gravel, *Deux heures et demie avant Jasmine*

1990
- Fiction: Nino Ricci, *Lives of the Saints*
- Poetry: Margaret Avison, *No Time*
- Drama: Ann-Marie MacDonald, *Goodnight Desdemona (Good Morning Juliet)*
- Nonfiction: Stephen Clarkson, *Trudeau and Our Times*

- Translation (from French to English): Jane Brierley, *Yellow-Wolf and Other Tales of the Saint Lawrence*
- Children's Literature (Illustration): Paul Morin, *The Orphan Boy*
- Children's Literature (Text): Michael Bedard, *Redwork*
- Fiction (French): Gérald Tougas, *La mauvaise foi*
- Poetry (French): Jean-Paul Daoust, *Les cendres bleues*
- Drama (French): Jovette Marchessault, *Le voyage magnifique d'Émily Carr*
- Nonfiction (French): Jean Francois Lisee, *Dans l'oeil de l'aigle*
- Translation (from English to French): Charlotte and Robert Melançon, *Le second rouleau*
- Children's Literature (French Illustration): Pierre Pratt, *Les fantaisies de l'oncle Henri*
- Children's Literature (French Text): Christiane Duchesne, *La vraie histoire du chien de Clara Vic*

1989
- Fiction: Paul Quarrington, *Whale Music*
- Poetry: Heather Spears, *The Word for Sand*
- Drama: Judith Thompson, *The Other Side of the Dark*
- Nonfiction: Robert Calder, *Willie: The Life of W. Somerset Maugham*
- Translation (from French to English): Wayne Grady, *On the Eighth Day*
- Children's Literature (Illustration): Robin Muller, *The Magic Paintbrush*
- Children's Literature (Text): Diana Wieler, *Bad Boy*
- Fiction (French): Louis Hamelin, *La rage*
- Poetry (French): Pierre Desruisseaux, *Monème*
- Drama (French): Michel Garneau, *Mademoiselle Rouge*
- Nonfiction (French): Lise Noël, *L'intolérance: Une problématique générale*

- Translation (from English to French): Jean Antonin Billard, *Les âges de l'amour*
- Children's Literature (French Illustration): Stéphane Poulin, *Benjamin et la saga des oreillers*
- Children's Literature (French Text): Charles Montpetit, *Temps mort*

1988

- Fiction: David Adams Richards, *Nights Below Station Street*
- Poetry: Erin Mouré, *Furious*
- Drama: George F. Walker, *Nothing Sacred*
- Nonfiction: Anne Collins, *In the Sleep Room*
- Translation (from French to English): Philip Stratford, *Second Chance*
- Children's Literature (Illustration): Kim LaFave, *Amos's Sweater*
- Children's Literature (Text): Welwyn Wilton Katz, *The Third Magic*
- Fiction (French): Jacques Folch-Ribas, *Le Silence ou le parfait bonheur*
- Poetry (French): Marcel Labine, *Papiers d'épidémie*
- Drama (French): Jean Marc Dalpé, *Le chien*
- Nonfiction (French): Patricia Smart, *Écrire dans la maison de père*
- Translation (from English to French): Didier Holtzwarth, *Nucléus*
- Children's Literature (French Illustration): Philippe Béha, *Les jeux de pic-mots*
- Children's Literature (French Text): Michèle Marineau, *Cassiopée ou l'été polonais*

1987

- Fiction: M. T. Kelly, *A Dream Like Mine*
- Poetry: Gwendolyn MacEwen, *Afterworlds*
- Drama: John Krizanc, *Prague*
- Nonfiction: Michael Ignatieff, *The Russian Album*
- Translation (from French to English): Patricia Claxton, *Enchantment and Sorrow: The Autobiography of Gabrielle Roy*

- Children's Literature (Illustration): Marie-Louise Gay, *Rainy Day Magic*
- Children's Literature (Text): Morgan Nyberg, *Galahad Schwartz and the Cockroach Army*
- Fiction (French): Gilles Archambault, *L'obsédante obèse et autres agressions*
- Poetry (French): Fernand Ouellette, *Les heures*
- Drama (French): Jeanne-Mance Delisle, *Un oiseau vivant dans la gueule*
- Nonfiction (French): Jean Larose, *La petite noirceur*
- Translation (from English to French): Ivan Steenhout and Christiane Teasdale, *L'homme qui se croyait aimé, ou La vie secrète d'un premier ministre*
- Children's Literature (Illustration, French): Darcia Labrosse, *Venir au monde*
- Children's Literature (French Text): David Schinkel and Yves Beauchesne, *Le don*

1986

- Fiction: Alice Munro, *The Progress of Love*
- Poetry: Al Purdy, *The Collected Poems of Al Purdy*
- Drama: Sharon Pollack, *Doc*
- Nonfiction: Northrop Frye, *Northrop Frye on Shakespeare*
- Fiction (French): Yvon Rivard, *Les silences de corbeau*
- Poetry (French): Cécile Cloutier, *L'écouté*
- Drama (French): Anne Legault, *La visite des sauvages*
- Nonfiction (French): Régine Robin, *Le réalism socialiste: Une esthétique impossible*

1985

- Fiction: Margaret Atwood, *The Handmaid's Tale*
- Poetry: Fred Wah, *Waiting for Saskatchewan*
- Drama: George F. Walker, *Criminals in Love*

- Nonfiction: Ramsay Cook, *The Regenerators: Social Criticism in Late Victorian English Canada*
- Fiction (French): Fernand Ouellette, *Lucie ou en midi en novembre*
- Poetry (French): André Roy, *Action Writing*
- Drama (French): Maryse Pelletier, *Duo pour voix obstinées.*
- Nonfiction (French): François Ricard, *La littérature contre elle-même*

1984

- Fiction: Josef Skvorecky, *The Engineer of Human Souls*
- Poetry: Paulette Jiles, *Celestial Navigation*
- Drama: Judith Thompson, *White Biting Dog*
- Nonfiction: Sandra Gwyn, *The Private Capital: Ambition and Love in the Age of Macdonald and Laurier*
- Fiction (French): Jacques Brault, *Agonie*
- Poetry (French): Nicole Brossard, *Double Impression*
- Drama (French): René-Daniel Dubois, *Ne blâmez jamais les Bédouins*
- Nonfiction (French): Jean Hamelin and Nicole Gagnon, *Le XXe siècle: Histoire du catholicisme québécois*

1983

- Fiction: Leon Rooke, *Shakespeare's Dog*
- Poetry: David Donnell, *Settlements*
- Drama: Anne Chislett, *Quiet in the Land*
- Nonfiction: Jeffrey Williams, *Byng of Vimy: General and Governor General*
- Fiction (French): Suzanne Jacob, *Laura Laur*
- Poetry (French): Suzanne Paradis, *Un goût de sel*
- Drama (French): René Gingras, *Syncope*
- Nonfiction (French): Maurice Cusson, *Le contrôle social du crime*

1982

- Fiction: Guy Vanderhaeghe, *Man Descending*
- Poetry: Phyllis Webb, *The Vision Tree: Selected Poems*
- Drama: John Gray with Eric Peterson, *Billy Bishop Goes To War*
- Nonfiction: Christopher Moore, *Louisbourg Portraits: Life in an Eighteenth-Century Garrison Town*
- Fiction (French): Roger Fournier, *Le cercle des arènes*
- Poetry (French): Michel Savard, *Forages*
- Drama (French): Réjean Ducharme, *Ha ha! . . .*
- Nonfiction (French): Maurice Lagueux, *Le marxisme des années soixante: Une saison dans l'histoire de la pensée critique*

1981

- Fiction: Mavis Gallant, *Home Truths: Selected Canadian Stories*
- Poetry: F. R. Scott, *The Collected Poems of F. R. Scott*
- Drama: Sharon Pollock, *Blood Relations*
- Nonfiction: George Calef, *Caribou and the Barren-Lands*
- Fiction (French): Denys Chabot, *La province lunaire*
- Poetry (French): Michel Beaulieu, *Visages*
- Drama (French): Marie Laberge, *C'était avant la guerre à l'Anse à Gilles*
- Nonfiction (French): Madeleine Ouellette-Michalska, *L'échappée des discours de l'oeil*

1980

- Fiction: George Bowering, *Burning Water*
- Poetry: Stephen Scobie, *McAlmon's Chinese Opera*
- Nonfiction: Jeffery Simpson, *Discipline of Power: The Conservative Interlude and the Liberal Restoration*
- Fiction (French): Pierre Turgeon, *La première personne*

- Poetry (French): Michel van Schendel, *De l'oeil et de l'écoute*
- Nonfiction (French): Maurice Champagne-Gilbert, *La famille et l'homme à délivrer du pouvoir*

1979

- Fiction: Jack Hodgins, *The Resurrection of Joseph Bourne*
- Poetry: Michael Ondaatje, *There's a Trick with a Knife I'm Learning to Do*
- Nonfiction: Maria Tippet, *Emily Carr: A Biography*
- Fiction (French): Marie-Claire Blais, *Le sourd dans la ville*
- Poetry (French): Robert Melançon, *Peinture aveugle*
- Nonfiction (French): Dominique Clift and Sheila McLeod Arnopoulos, *Le fait anglais au Québec*

1978

- Fiction: Alice Munro, *Who Do You Think You Are?*
- Poetry: Patrick Lane, *Poems New and Selected*
- Nonfiction: Roger Caron, *Go Boy*
- Fiction (French): Jacques Poulin, *Les grandes marées*
- Poetry (French): Gilbert Langevin, *Mon refuge est un volcan*
- Nonfiction (French): François-Marc Gagnon, *Paul-Émile Borduas: Biographie critique et analyse de l'oeuvre*

1977

- Fiction: Timothy Findley, *The Wars*
- Poetry: D. G. Jones, *Under the Thunder the Flowers Light Up the Earth*
- Nonfiction: Frank Scott, *Essays on the Constitution*
- Fiction (French): Gabrielle Roy, *Ces enfants de ma vie*
- Poetry: (French): Michel Garneau, *Les célébrations suivi de Adidou Adidouce* (declined)

- Nonfiction (French): Denis Monière, *Le développement des idéologies au Québec des origines à nos jours*

1976

- Fiction: Marian Engel, *Bear*
- Poetry: Joe Rosenblatt, *Top Soil*
- Nonfiction: Carl Berger, *The Writing of Canadian History*
- Fiction (French): André Major, *Les rescapés*
- Poetry (French): Alphonse Piché, *Poèmes,1946 – 1968*
- Nonfiction (French): Fernand Ouellet, *Le bas Canada, 1791 – 1840: Changements structuraux et crise*

1975

- Fiction: Brian Moore, *The Great Victorian Collection*
- Poetry: Milton Acorn, *The Island Means Minago*
- Nonfiction: Anthony Adamson and Marion MacRae, *Hallowed Walls*
- Fiction (French): Anne Hébert, *Les enfants du sabbat*
- Poetry (French): Pierre Perrault, *Chouennes*
- Nonfiction (French): Louis-Edmond Hamelin, *Nordicité canadienne*

1974

- Fiction: Margaret Laurence, *The Diviners*
- Poetry: Ralph Gustafson, *Fire on Stone: A Collection of Poetry*
- Nonfiction: Charles Ritchie, *The Siren Years*
- Fiction (French): Victor-Levy Beaulieu, *Don Quichotte de la démanche*
- Poetry (French): Nicole Brossard, *Mécanique jongleuse suivi de masculin grammaticale*
- Nonfiction (French): Louise Dechêne, *Habitants et marchands de Montréal au XVIIe siècle*

1973
- Fiction: Rudy Wiebe, *The Temptations of Big Bear*
- Poetry: Miriam Mandel, *Lions at Her Face*
- Nonfiction: Michael Bell, *Painters in a New Land*
- Fiction (French): Réjean Ducharme, *L'hiver de force*
- Poetry (French): Roland Giguère, *La main au feu* (declined)
- Nonfiction (French): Albert Faucher, *Québec en Amérique au XIXe siècle*
- Special Award: Roland Giguere, *La main au feu* (declined)

1972
- Fiction: Robertson Davies, *The Manticore*
- Poetry: Dennis Lee, *Civil Elegies and Other Poems*; John Newlove, *Lies*
- Fiction (French): Antonine Maillet, *Don l'original*
- Poetry (French): Gilles Hénault, *Signaux pour les voyants*
- Nonfiction (French): Jean Hamelin and Yves Roby, *Histoire économique du Québec 1851 – 1896*

1971
- Fiction: Mordecai Richler, *St. Urbain's Horseman*
- Poetry: John Glassco, *Selected Poems*
- Nonfiction: Pierre Berton, *The Last Spike*
- Fiction (French): Gérard Bessette, *Le cycle*
- Poetry (French): Paul-Marie Lapointe, *Le réel absolu*
- Nonfiction (French): Gérald Fortin, *La fin d'un règne*

1970
- Fiction: Dave Godfrey, *The New Ancestors*
- Poetry: Michael Ondaatje, *The Collected Works of Billy the Kid*; bp Nichol, *Still Water, The True Eventual Story of Billy the Kid, Beach Head, The Cosmic Chef: An Evening of Concrete*

- Fiction (French): Monique Bosco, *La femme de Loth*
- Drama (French): Jacques Brault, *Quand nous serons heureux*
- Nonfiction (French): Fernand Ouellett, *Les actes retrouvés* (declined)

1969
- Fiction: Robert Kroetsch, *The Studhorse Man*
- Poetry: George Bowering, *Rocky Mountain Foot and The Gangs of Kosmos*; Gwendolyn MacEwen, *The Shadow-Maker*
- Fiction (French): Louise Maheux-Forcier, *Une forêt pour Zoé*
- Poetry (French): Jean-Guy Pilon, *Comme eau retenue*
- Nonfiction (French): Michel Brunet, *Les canadiens après la conquête*

1968
- Fiction: Alice Munro, *Dance of the Happy Shades*
- Fiction: Mordecai Richler, *Cocksure*
- Essays: Mordecai Richler, *Hunting Tigers Under Glass*
- Fiction (French): Hubert Auin, *Trou de mémoire* (declined); Marie-Claire Blais, *Manuscrits de Pauline Archange*
- Nonfiction (French): Fernand Dumont, *Le lieu de l'homme*
- Poetry: Leonard Cohen, *Selected Poems 1956 – 68* (declined).

1967
- Poetry: Eli Mandel, *An Idiot Joy*
- Poetry: Alden A. Nowlan, *Bread, Wine and Salt*
- Nonfiction: Norah Story, *The Oxford Companion to Canadian History and Literature*
- Fiction (French): Jacques Godbout, *Salut Galarneau*
- Drama (French): Françoise Loranger, *Encore cinq minutes*

- Nonfiction (French): Robert-Lionel Séguin, *La civilisation traditionelle de l'"Habitant" aux XVIe et XVIIIe siècles*

1966
- Fiction: Margaret Laurence, *A Jest of God*
- Poetry: Margaret Atwood, *The Circle Game*
- Nonfiction: George Woodcock, *The Crystal Spirit: A Study of George Orwell*
- Fiction (French): Claire Martin, *Le joue droite*
- Poetry and theatre (French): Réjean Ducharme, *L'avalée des avalés*
- Nonfiction (French): Marcel Trudel, *Le comptoir, 1604–1627* (volume 2 of *Histoire de la Nouvelle France*)

1965
- Poetry: Al Purdy, *The Cariboo Horses*
- Nonfiction: James Eayrs, *In Defence of Canada*
- Fiction (French): Gérard Bessette, *L'incubation*
- Poetry (French): Gilles Vigneault, *Quand les bateaux s'en vont*
- Nonfiction (French): André S. Vachon, *Le temps et l'espace dans l'oeuvre de Paul Claudel*

1964
- Fiction: Douglas LePan, *The Deserter*
- Poetry: Raymond Souster, *The Colour of the Times*
- Nonfiction: Phyllis Grosskurth, *John Addington Symonds*
- Fiction (French): Jean-Paul Pinsonneault, *Les terres sèches*
- Poetry (French): Pierre Perrault, *Au coeur de la rose*
- Nonfiction (French): Réjean Robidoux, *Roger Martin du Gard et la religion*

1963
- Fiction: Hugh Garner, *Hugh Garner's Best Stories*

- Nonfiction: J.M.S. Careless, *Brown of the Globe*
- Poetry (French): Gatien Lapointe, *Ode au Saint-Laurent*
- Nonfiction (French): Gustave Lanctôt, *Histoire du Canada*

1962
- Fiction: Kildare Dobbs, *Running to Paradise*
- Poetry: James Reaney, *Twelve Letters to a Small Town*
- Drama: James Reaney, *The Killdeer and Other Plays*
- Nonfiction: Marshall McLuhan, *The Gutenberg Galaxy*
- Fiction (French): Jacques Ferron, *Contes de pays incertain*
- Drama (French): Jacques Languirand, *Les Insolites et les violons de l'automne*
- Nonfiction (French): Gilles Marcotte, *Une littérature qui se fait*

1961
- Fiction: Malcolm Lowry, *Hear Us O Lord from Heaven Thy Dwelling Place*
- Poetry: Robert Finch, *Acis in Oxford*
- Nonfiction: T. A. Goudge, *The Ascent of Life*
- Fiction (French): Yves Thériault, *Ashini*
- Nonfiction (French): Jean Le Moyne, *Convergences*

1960
- Fiction: Brian Moore, *The Luck of Ginger Coffey*
- Poetry: Margaret Avison, *Winter Sun*
- Nonfiction: Frank H. Underhill, *In Search of Canadian Liberalism*
- Poetry (French): Anne Hébert, *Poèmes*
- Nonfiction (French): Paul Toupin, *Souvenirs pour demain*

1959
- Fiction: Hugh MacLennan, *The Watch That Ends the Night*

- Poetry: Irving Layton, *A Red Carpet for the Sun*
- Fiction (French): André Giroux, *Malgré tout, la joie*
- Nonfiction (French): Félix-Antoine Savard, *Le barachois*

1958
- Fiction: Colin McDougall, *Execution*
- Poetry: James Reaney, *A Suit of Nettles*
- Nonfiction: Pierre Berton, *Klondike*
- Nonfiction: Joyce Hemlow, *The History of Fanny Burney*
- Juvenile: Edith L. Sharp, *Nkwala*

1957
- Fiction: Gabrielle Roy, *Street of Riches*
- Poetry: Jay Macpherson, *The Boatman*
- Nonfiction: Bruce Hutchison, *Canada: Tomorrow's Giant*
- Nonfiction: Thomas H. Raddall, *The Path of Destiny*
- Juvenile: Kerry Wood, *The Great Chief*

1956
- Fiction: Adele Wiseman, *The Sacrifice*
- Poetry: Robert A. D. Ford, *A Window on the North*
- Nonfiction: Pierre Berton, *The Mysterious North*
- Nonfiction: Joseph Lister Rutledge, *Century of Conflict*
- Juvenile: Farley Mowat, *Lost in the Barrens*

1955
- Fiction: Lionel Shapiro, *The Sixth of June*
- Poetry: Wilfred Watson, *Friday's Child*
- Nonfiction: N. J. Berrill, *Man's Emerging Mind*
- Nonfiction: Donald G. Creighton, *John A. Macdonald: The Old Chieftain*
- Juvenile: Kerry Wood, *The Map-Maker*

1954
- Fiction: Igor Gouzenko, *The Fall of a Titan*

- Poetry: P. K. Page, *The Metal and the Flower*
- Nonfiction: Hugh MacLennan, *Thirty and Three*
- Nonfiction: A.R.M. Lower, *This Most Famous Stream*
- Juvenile: Marjorie Wilkins Campbell, *The Nor'westers*

1953
- Fiction: David Walker, *Digby*
- Poetry: Douglas LePan, *The Net and the Sword*
- Nonfiction: N. J. Berrill, *Sex and the Nature of Things*
- Nonfiction: J. M. S. Careless, *Canada: A Story of Challenge*
- Juvenile: John F. Hayes, *Rebels Ride at Night*

1952
- Fiction: David Walker, *The Pillar*
- Poetry: E. J. Pratt, *Towards the Last Spike*
- Nonfiction: Bruce Hutchison, *The Incredible Canadian*
- Nonfiction: Donald G. Creighton, *John A. Macdonald: The Young Politician*
- Juvenile: Marie McPhedran, *Cargoes on the Great Lakes*

1951
- Fiction: Morley Callaghan, *The Loved and the Lost*
- Poetry: Charles Bruce, *The Mulgrave Road*
- Nonfiction: Josephine Phelan, *The Ardent Exile*
- Nonfiction: Frank MacKinnon, *The Government of Prince Edward Island*
- Juvenile: John F. Hayes, *A Land Divided*

1950
- Fiction: Germaine Guèvremont, *The Outlander*
- Poetry: James Wreford Watson, *Of Time and the Lover*

- Nonfiction: Marjorie Wilkins Campbell, *The Saskatchewan*
- Nonfiction: W. L. Morton, *The Progressive Party in Canada*
- Juvenile: Donalda Dickie, *The Great Adventure*

1949
- Fiction: Philip Child, *Mr. Ames Against Time*
- Poetry: James Reaney, *The Red Heart*
- Nonfiction: Hugh MacLennan, *Cross-country*
- Nonfiction: R. MacGregor Dawson, *Democratic Government in Canada*
- Juvenile: R. S. Lambert, *Franklin of the Arctic*

1948
- Fiction: Hugh MacLennan, *The Precipice*
- Poetry: A. M. Klein, *The Rocking Chair and Other Poems*
- Nonfiction: Thomas H. Raddall, *Halifax: Warden of the North*
- Nonfiction: C. P. Stacey, *The Canadian Army, 1939–1945*

1947
- Fiction: Gabrielle Roy, *The Tin Flute*
- Poetry: Dorothy Livesay, *Poems for People*
- Nonfiction: William Sclater, *Haida*
- Nonfiction: R. MacGregor Dawson, *The Government of Canada*

1946
- Fiction: Winifred Bambrick, *Continental Revue*
- Poetry: Robert Finch, *Poems*
- Nonfiction: Frederick Philip Grove, *In Search of Myself*
- Nonfiction: A.R.M. Lower, *Colony to Nation*

1945
- Fiction: Hugh MacLennan, *Two Solitudes*
- Poetry: Earle Birney, *Now Is Time*

- Nonfiction: Evelyn M. Richardson, *We Keep a Light*
- Nonfiction: Ross Munro, *Gauntlet to Overlord*

1944
- Fiction: Gwethalyn Graham, *Earth and High Heaven*
- Poetry: Dorothy Livesay, *Day and Night*
- Nonfiction: Dorothy Duncan, *Partner in Three Worlds*
- Nonfiction: Edgar McInnes, *The War: Fourth Year*

1943
- Fiction: Thomas H. Raddall, *The Pied Piper of Dipper Creek*
- Poetry: A.J.M. Smith, *News of the Phoenix*
- Nonfiction: John D. Robins, *The Incomplete Anglers*
- Nonfiction: E. K. Brown, *On Canadian Poetry*

1942
- Fiction: G. Herbert Sallans, *Little Man*
- Poetry: Earle Birney, *David and Other Poems*
- Nonfiction: Bruce Hutchison, *The Unknown Country*
- Nonfiction: Edgar McInnes, *The Unguarded Frontier*

1941
- Fiction: Alan Sullivan, *Three Came to Ville Marie*
- Poetry: Anne Marriott, *Calling Adventurers*
- Nonfiction: Emily Carr, *Klee Wyck*

1940
- Fiction: Ringuet (Philippe Panneton), *Trente arpents (Thirty Acres)*
- Poetry: E. J. Pratt, *Brébeuf and His Brethren*
- Nonfiction: J.F.C. Wright, *Slava Bohu*

1939
- Fiction: Franklin D. McDowell, *The Champlain Road*
- Poetry: Arthur S. Bourinot, *Under the Sun*
- Nonfiction: Laura G. Salverson, *Confessions of an Immigrant's Daughter*

1938
- Fiction: Gwethalyn Graham, *Swiss Sonata*
- Poetry: Kenneth Leslie, *By Stubborn Stars*
- Nonfiction: John Murray Gibbon, *Canadian Mosaic*

1937
- Fiction: Laura G. Salverson, *The Dark Weaver*
- Poetry: E. J. Pratt, *The Fable of the Goats*
- Nonfiction: Stephen Leacock, *My Discovery of the West*

1936
- Fiction: Bertram Brooker, *Think of the Earth*
- Nonfiction: T. B. Robertson, *T.B.R.* (newspaper pieces)

Chapters, Books in Canada, First Novel Award

THIS prize's $5,000 award is the largest Canadian prize for a first novel.

1999: André Alexis, *Childhood*
1998: Margaret Gibson, *Opium Dreams*
1997: Anne Michaels, *Fugitive Pieces*
1996: Keath Fraser, *Popular Anatomy*
1995: Shyam Selvadurai, *Funny Boy*
1994: Deborah J. Corey, *Losing Eddie*
1993: John Steffler, *The Afterlife of George Cartwright*
1992: Rohinton Mistry, *Such a Long Journey*

1991: Nino Ricci, *Lives of the Saints*
1990: Sandra Birdsell, *The Missing Child*
1989: Rick Salutin, *A Man of Little Faith*
1988: Marian Quednau, *The Butterfly Chair*
1987: Karen Lawrence, *The Life of Helen Alone*
1986: Wayne Johnson, *The Story of Bobby O'Mally*
1985: Geoffrey Ursell, *Perdue: or How the West was Won*
1984: Heather Robertson, *Willie: A Romance*
1983: W. P. Kinsella, *Shoeless Joe*

Source: Chapters Books

The Most Popular Canadian Books Ever?

No one in this country seems to have historically accurate sales figures for books sold inside Canada's borders, never mind foreign sales of Canadian books. You can get a rough idea of how many copies of a recent novel or nonfiction work have sold by monitoring the bestseller lists (as Professor Claude Martin of the Université de Montréal has done in Québec) or by querying publishers, but even these methods are notoriously approximate. The following list is based on my own estimates, supplemented by information received from various sources (such as the Canadian Booksellers Association, the Children's Book Centre in Toronto, and *The Canadian*

Encyclopedia), not one of which could give me accurate tallies. I have excluded how-to books, self-help manuals, cookbooks, educational and reference books, coffee-table tomes and the like, which would skew the list radically. I know, for example, that David Chilton's *The Wealthy Barber*, a how-to-get-rich-and-stay-rich book, published by Stoddart, Toronto, with sales of approximately 1.3 million copies, tops most of the books I list here. In fact, it is certainly one of the bestselling titles in Canadian publishing history. Here I attempt to document the taste of Canadians in more imaginative realms over the past 100 years or so.

Top 25 All-Time Fiction Bestsellers

- Gilbert Parker: *The Seats of the Mighty* (1896)
- Ralph Connor (C. W. Gordon): *Black Rock* (1898)
- Robert Service: *Songs of a Sourdough* (1907)
- Stephen Leacock: *Sunshine Sketches of a Little Town* (1912)
- Louis Hémon: *Maria Chapdelaine* (1916)
- Mazo de la Roche: The *Jalna* Series (1927 and following)
- Ringuet (Phillipe Panneton): *Trente arpents* (*Thirty Acres*, 1938)
- Gwethalyn Graham: *Earth and High Heaven* (1944)
- Hugh MacLennan: *Two Solitudes* (1945)
- Gabrielle Roy: *Bonheur d'occasion* (*The Tin Flute*, 1945)
- Roger Lemelin: *Les Plouffes* (1948)
- Thomas Raddall: *The Nymph and the Lamp* (1952)
- Mordecai Richler: *The Apprenticeship of Duddy Kravitz* (1959)
- Margaret Laurence: *A Jest of God* (1966)
- Anne Hébert: *Kamouraska* (1970)
- Robertson Davies: *Fifth Business* (1970)
- Alice Munro: *Lives of Girls and Women* (1971)
- Richard Rohmer: *Ultimatum* (1973)
- Antonine Maillet: *Pélagie-la-charrette* (1979)
- Yves Beauchemin: *Le matou* (1981)
- Arlette Cousture: *Les filles de Caleb, 1 et 2* (1985 – 86)
- Margaret Atwood: *The Handmaid's Tale* (1986)
- Michael Ondaatje: *The English Patient* (1992)
- Carol Shields: *The Stone Diaries* (1993)
- Jane Urquhart: *Away* (1993)

Top 25 All-Time Nonfiction Bestsellers

- Ernest Thompson Seton: *Wild Animals I Have Known* (1898)
- Vilhjalmur Steffansson: *The Friendly Arctic* (1921)
- Bruce Hutchison: *The Unknown Country* (1942)
- Donald Creighton: *Dominion of the North* (1944)
- Farley Mowat: *People of the Deer* (1952)
- Thomas P. Kelley: *The Black Donnellys* (1958)
- John Kenneth Galbraith: *The Affluent Society* (1958)
- Northrop Frye: *The Educated Imagination* (1963)
- Marshall McLuhan: *Understanding Media* (1964)
- Pierre Berton: *The National Dream* (1970)
- Pierre Berton: *The Last Spike* (1971)
- Lester B. Pearson: *Mike* (1972 – 75)
- Jean Provencher: *René Lévesque* (1973)
- Peter C. Newman: *The Canadian Establishment* (1975)

- John Diefenbaker: *One Canada* (1975 – 77)
- William Stevenson: *A Man Called Intrepid* (1976)
- Richard Gwyn: *The Northern Magus* (1980)
- Jean Chrétien: *Straight from the Heart* (1985)
- René Lévesque: *Attendez que je me rappelle* (1986)
- Pauline Gill: *Les enfants de Duplessis* (1991)
- Francois Ricard: *La génération lyrique* (1992)
- Pierre Trudeau: *Memoirs* (1993)
- Stevie Cameron: *On the Take* (1994)
- John Ralston Saul: *The Unconscious Civilization* (1995)
- David Foot and Daniel Stoffman: *Boom, Bust and Echo* (1996)

Top 25 All-Time Children's Bestsellers

- Margaret Marshall Saunders: *Beautiful Joe* (1894)
- Laure Conan (Félicité Angers): *L'oublié* (1900)
- Charles G. D. Roberts: *Red Fox* (1905)
- Ernest Thompson Seton: *Two Little Savages* (1906)
- Lucy Maud Montgomery: *Anne of Green Gables* (1908)
- Marie-Claude Daveluy: *Les aventures de Perrine et de Charlot* (1923)

- Maxine (M.C.A. Taschereau-Fortier): *Le petit page de Frontenac* (1930)
- Mary Grannan: *Just Mary Stories* (1942)
- Roderick Haig-Brown: *Starbuck Valley Winter* (1943)
- W. O. Mitchell: *Who Has Seen the Wind?* (1947)
- Fred Bodsworth: *The Last of the Curlews* (1954)
- Farley Mowat: *Lost in the Barrens* (1956)
- Sheila Burnford: *The Incredible Journey* (1961)
- Christie Harris (Lucy Christie Irwin): *Raven's Cry* (1966)
- William Kurelek: *A Prairie Boy's Winter* (1973)
- Dennis Lee: *Alligator Pie* (1974)
- Mordecai Richler: *Jacob Two-Two Meets the Hooded Fang* (1975)
- William Kurelek: *A Prairie Boy's Summer* (1975)
- Eric Wilson: *Murder on the Canadian* (1976)
- Ted Harrison: *Children of the Yukon* (1977)
- Gordon Korman: *This Can't Be Happening at Macdonald Hall!* (1978)
- Roch Carrier: *Les enfants du bonhomme dans la lune* (*The Hockey Sweater and Other Stories*, 1979)
- Robert Munsch: *The Paperbag Princess* (1980)
- Robert Munsch: *Love You Forever* (1986)
- David Bouchard: *If You're Not from the Prairie . . .* (1993)

Prix Athanase-David

CONSIDERED to be the highest literary distinction bestowed by the government of Québec, this prize of $30,000 is awarded annually to a writer of Québecois origin. The Prix Athanase-David was established in 1922 following the Québec government's creation—at the insistence of

Athanase David, provincial secretary of the province at the time—of literary and scientific competitions. The prize, which has existed in its present form since 1968, recognizes the recipient's outstanding overall contribution to the canon of Québecois literature. The Ministry of Culture administers the award by selecting a jury which, at the end of May or beginning of June of each year, submits its recommendation for the prize. The winner is announced in the fall, followed by a ceremony in which the prize is formally presented to the recipient.

1999: Roland Giguere
1998: André Langevin
1997: Gilles Marcotte
1996: Monique Bosco
1995: Jacques Poulin
1994: Réjean Ducharme
1993: Gilles Hénault
1992: André Major
1991: Nicole Brossard
1990: Andrée Maillet
1989: Jean Éthier-Blais
1988: Michel Tremblay
1987: Fernand Ouellette
1986: Jacques Brault
1985: Jacques Godbout
1984: Jean-Guy Pilon

1983: Gaston Miron
1982: Marie-Claire Blais
1981: Gilles Archambault
1980: Gérard Bessette
1979: Yves Thériault
1978: Anne Hébert
1977: Jacques Ferron
1976: Pierre Vandeboncoeur
1975: Fernand Dumont
1974: Rina Lasnier
1973: Marcel Dubé
1972: Hubert Aquin
1971: Paul-Marie Lapointe
1970: Gabrielle Roy
1969: Alain Grandbois
1968: Félix-Antoine Savard

Source: Conseil des arts et des lettres du Québec

7

Television & Radio

INSOFAR as television habits are concerned, Canadians are pretty much like the rest of the world. They routinely flip on their sets and sit down to watch (or half-watch) just over three hours of programming each day. Sports, drama, comedy, films, talk shows, news clips, commentary on everything under the sun—all these fly by on Canadian screens, as elsewhere, with only the presence of the two major languages, French and English, and the increasing visibility of our multicultural mosaic to suggest something uniquely Canadian. Yet, despite this familiar flow of material, to anyone looking past the glib screen formats Canadian television at the end of the century was nothing less than a field of labyrinthine complexity, a hard-to-focus reality marked by competing commercial interests, odd organizational structures and alliances, unpredictable government interventions, and new delivery systems that were seen to be affecting content in a manner famously predicted by Canada's own media guru, Marshall McLuhan.

In Canada, as elsewhere at the end of the century, free broadcast television was giving way to a multiplicity of specialized cable channels, while satellite facilities were making old-fashioned protectionism-by-legislation virtually impossible. At the same time, television and radio were converging with computers and telephones to create the first stages of the predicted telecomputer revolution, one that would eventually involve the replacement of television as we know it—passive television—by interactive media capable of establishing a new relationship between broadcasters and audiences. While all the developed countries were being forced to deal with such changes, Canada's situation had some unique aspects. These derived not only from this country's position next door to the American media giant, but also from our tradition of government intervention and protectionism in cultural matters. In addition, there were important initiatives from private-sector industries, reacting to

CBC Television

Canada's original comedy team was Johnny Wayne and Frank Shuster.

the new opportunities created by technology, legislation, government funding and the realpolitik of international broadcasting and marketing.

In order to understand the situation we have to backtrack to the early 1950s, when the CBC's decade-long monopoly of network broadcasting was just beginning. This is a period that no one in Canada has yet dared to call "the golden age" of Canadian television. What older viewers are likely to remember from those days is a blur of images, a visual stew in which Don Messer rubs shoulders with the *Friendly Giant* and *The Plouffe Family* shares a stage with *Front Page Challenge*'s Gordon Sinclair and Betty Kennedy. Such a viewer might recall the now-rather-ghostly presences of Patrick Watson and Laurier Lapierre, of Lise Payette and Roy Bonisteel, or perhaps a Wayne and Shuster skit may come alive on the screen of half-forgotten memories. While there was perhaps a dearth, especially in English Canada, of innovative arts programming, those years saw a reasonable array of popular entertainment (*Juliette, La nez de Cléopâtre*), sports (hockey in particular), drama (*La pension Valder, General Motors Presents*) and a pleasing variety of news, commentary (*Point de mire, Close-Up*) and documentary broadcasting. By the end of this golden decade, around 1962, the CBC French and English services reached more than four out of five Canadian households.

The instability of our broadcasting arrangements, however, soon became evident. For one thing, the CBC began to drop American-made shows into its prime-time slots, not only because it saved enormous production costs, but also because Canadian viewers were increasingly seeing these shows on the American channels. To keep such viewers tuned to the CBC they had to be given what they wanted. At the same time, the CBC's attempt to create competitive Canadian entertainment shows on a relatively low budget failed. When the Board of Broadcast Governors (a predecessor to the Canadian Radio-television and Telecommunications Commission [CRTC]) introduced new content rules in 1959, it was assumed the Canadian commercial networks as they appeared would create popular television shows for Canada. But,

like the CBC, these networks found it much simpler and much more profitable to buy the American-made comedy, adventure and variety programs. As a result Canadian viewers were treated to a steady diet of Milton Berle, Ed Sullivan, *The Honeymooners, I Love Lucy*, and later, *Mission Impossible, Bewitched,* and *The F.B.I.*

Since the demand of many nationalists for the creation of a true public broadcasting service by the CBC was never met, some feared that American television entertainment, with the help of Canada's own private networks, would obliterate homegrown television as it had once obliterated Canadian-made movies. Thanks to the language barrier, Québec's Radio-Canada at first fared a little better in resisting Americanization, though Québecers were given the American shows in translation and they loved—and still love—to watch them. Radio-Canada, however, featured much more creative programming than its English equivalent and kept a strong grip on the provincial audience despite the appeal of its commercial rival, Télé-Diffuseurs Associés (TVA).

In English Canada, however, the commercial networks began to dominate the market in a significant way. By the 1980s, despite the excellence of its news and public-affairs broadcasting, *Hockey Night in Canada,* and other favourite broadcasts (*The Nature of Things, Man Alive*), the CBC and Radio-Canada had slipped to less than a quarter share of the market while 65 to 70 percent of what English-language viewers were watching was foreign-produced. Thus, even though it consumed the lion's share

of the total federal cultural budget, the CBC seemed incapable of fulfilling, in the television sector, the large cultural mission placed upon it. It was not enough to create some excellent programs: the task—an impossible one with the budget that was available—was nothing less than to lure viewers away from American pop culture. And through the 1990s, after decades of reports by such high-powered commissions as the Massey-Lévesque, Fowler, Apple-baum-Hébert and Juneau—to mention only the official, specially constituted inquiries—the issue of how to best shape the CBC as an instrument of national cul-tural expression has remained problematic.

CBC Television / Fred Phipps

Hockey Night in Canada, *hosted by the dynamic duo of Don Cherry and Ron MacLean, is the backbone of Canadian sports television.*

The television issue in Canada involves what amounts to a Lewis Carroll world of incompatibles and contradictions. While we are a nation dedicated to free enterprise, we have a long tradition of regulating the private sector in order to achieve national goals. In 1968, we created the CRTC as a permanent entity, partially in order to deal with the complexities of free market versus subsidized broadcasting. When the CRTC brought in new Canadian-content rules for television in 1970, demanding that 60 percent of all television programs on Canadian stations should be domestic, it was trying to make good on the failure, up to then, of the commercial networks to create popular entertainment shows and other indigenous material for Canadians. The idea, as it had been from the beginning of federal media legislation, was to ensure that Canadians were weaned from their increasing dependence on American shows with their overwhelming apparatus of United States popular culture. In subsequent years, however, many of the content regulations were met by the commercial networks with sports broadcasts or with a plethora of marginal programming. Despite this, continued federal regulation—not to mention the infusion of funding from the same source—eventually began to work changes.

Neither the free-enterprise drives of commercial television, nor the various reshapings of the CBC, quite produced the cultural mix envisaged by the CRTC. This fact was evident in June 1999, when, following months of extensive hearings, the CRTC made some adjustments to its formula: 60 percent Canadian content during a broadcast day and 50 percent during evening hours. The definition of "priority" programming was broadened: in addition to drama, comedy, music and variety, this was now to include documentaries, regional programs and shows introducing new Canadian talent. Meanwhile, the showing of Canadian drama during prime time (the definition of which was changed by the CRTC) would result in increased credit toward the fulfillment of the broadcasting quotas. While such regulations may be outrun by the new technology, those producers dedicated to providing Canadian fare clearly had nothing to complain about. One very big player in the television game, Michael MacMillan, chairperson of Atlantis Corporation, had suggested in an interview even before the hearings began that "any real grown-up country, at the end of this century, has to have a popular culture it can call its own."

MacMillan and his Atlantis Corporation had been foremost among the many private entrepreneurs who jumped into the television game in the early 1980s. These were not broadcasters but production companies that, with some significant help from public funding, began to produce films for television and eventually a plethora of miniseries, many of them of dubious content, but with "made in Canada"

CBC Television / Fred Phipps

Megan Follows starred as Anne Shirley and Colleen Dewhurst co-starred as Marilla Cuthbert in the CBC's hit series Anne of Green Gables.

emblazoned on the credits. By the time MacMillan and Atlantis joined forces with Robert Lantos's Alliance Corporation in 1998, MacMillan's company had grown into a $175-million operation, marketing television films and miniseries packages around the globe. Kevin Sullivan, whose *Anne of Green Gables* sold to 143 countries, was another, smaller-scaled entrepreneur, while other groups such as Alliance, Nelvana, Paragon and Cinar likewise profited by turning out marketable miniseries or films to peddle in international markets. The undoubted financial success of such companies may be attributed not only to the imagination and acumen of the entrepreneurs themselves, but also to the federal government's willingness to subsidize them. As one commentator in the film and television journal *Take One* put it: "There was a period in 1983, 1984 and 1985 when things jelled for Canadian television. Telefilm Canada had come on stream with its Broadcast Fund, Pay TV had been successfully launched. *Empire Inc.* had been broadcast on the CBC with Denys Arcand directing. Atlantis came along and won an Oscar and Kevin Sullivan was shooting *Anne of Green Gables ...*"

Despite this creative "second period" of Canadian television, some commentators still harboured doubts about its cultural focus. As late as 1998, John Haslett Cuff, media reporter for *The Globe and Mail*, complained that despite the boom in the

CBC Television / Fred Phipps

The Royal Canadian Air Farce *crossed over from radio to bring its insane brand of Canadian comedy to the world of television.*

television business "producers are still cynically manipulating the Canadian-content regulations to produce tacky, fake Canadian TV shows while giving short shrift to high-quality indigenous programs." He compared what he deemed to be "ersatz American" shows such as *FX: The Series, Outer Limits, The PSI Factor* and others with what "most of us" think of as worthier Canadian fare, such as *This Hour Has 22 Minutes, The Royal Canadian Air Farce, The Newsroom, North of 60* and *The Kids in the Hall.* Michael McCabe, president of a major lobby group, the Canadian Association of Broadcasters (CAB), responded by making a distinction between indigenous and "industrial" shows, claiming that the latter were necessary for the survival of producers who could draw on only a limited amount of public funding to make the much-less-profitable indigenous shows. This distinction was seen by some as an invidious one: to associate indigenous shows with "quality" and to conceive of the "industrial" or exportable shows as calculated schlock to fill screen time, hardly seems a healthy production formula. Even in the heyday of the Hollywood moguls, B movies were often imaginatively conceived and executed with technical brilliance, and in retrospect constitute some of the best films of that era. One suspects, however, that the "industrial" products referred to by McCabe will never rival *Cat People* or *I Walked With a Zombie,* two B-movie classics in the horror genre. Perhaps it would be better to concentrate not on filling quotas but, instead, on achieving quality.

Clearly, the complexity of Canadian television's spectrum of sometimes harmonious and sometimes competing interests was often daunting. On the one hand, the producers remained eager to make money by marketing programs abroad, but were increasingly alert to the necessity of making shows with genuine Canadian content. Underlying the discontent of commentators who argue for more indigenous television is the fact that the private networks in aggregate spend less than 27 percent of their revenues on Canadian programs. Yet while a network such as CTV naturally looks for profitability, in 1997 it nonetheless spent close to a third of its revenues on Canadian programming. Over the years there has been some tension between CTV and the CAB, the network being much more amenable to the CRTC's quota demands for Canadian content. CanWest Global, by contrast, has been strongly allied with the CAB, and in 1997 spent only 18 percent of its revenues on Canadian programming.

While the argument for unrestricted free enterprise in broadcasting was being made by such thinktanks as the conservative Fraser Institute, other advocacy groups, such as the Friends of Canadian Broadcasting, pressed for tighter regulations in the name of Canadian cultural identity. That Canada's television history, and the relationship between the private and public sectors in particular, is nothing if not dynamic has been emphasized by all parties and may be summed up in the words of Doug Saunders, media reporter for *The Globe and Mail*, who wrote: "1998 may be remembered as Year Zero for Canadian television: by year's end both the CTV and Global networks will have become powerful national entities, the CBC will be nearly all Canadian in content for the first time in its history, and Alliance Atlantis will be one of the world's larger TV-production companies."

As this comment indicates, toward the end of the 1990s the commercial television networks in Canada were themselves going through major changes. Izzy Asper and sons, CanWest Global's team out of Winnipeg, had shaken up the private broadcasting sector with the sheer scope and panache of their corporate ambition. After conquering Canada's most lucrative market in the greater Toronto area by importing such American hits as *Seinfeld*, *The X-Files* and *Friends*, and by running the big-budget corporate soap, *Traders*, made by Atlantis Films in Toronto, they went after outlets or shares of the market in New Zealand and Australia (successful ventures), in Chile (a failure) and in the United Kingdom (where they were beaten out). Finally, in 1998, they achieved a $950-million swap of radio and television stations with Shaw Communications Inc., picking up 11 stations, including four in Alberta, and catapulting themselves into national-network status. If all unfolds as expected, CanWest Global will go into the new century with advertising revenues in excess of

CanWest Global

Marty (Patrick McKenna) discusses options with Sally (Sonja Smits) in an episode of Traders.

those of CTV, owned by Baton Broadcasting, and would be, in terms of such revenue, the largest television network in Canada.

In English Canada, as we have seen, competition between the CBC and the private broadcasters has not always generated good things for Canadian culture. In Québec, by contrast, something like a fine balance was struck, with Radio-Canada and Radio Québec (strong cultural assets) on the one side and Télé-Métropole and Télévision Quatre Saisons (commercial broadcasters compelled to respond to local realities) on the other. Yet at the end of the 1990s, Radio-Canada was hit by huge cuts (sure to lessen its power to compete with T-M), and Radio Québec was limited to educational broadcasting. At the same time, the survival of TQS was placed in doubt.

Such changes seemed minor, however, compared with the coup of Ted Rogers— the most energetic mover and shaker in the industry who managed, as usual, to steal a march on the opposition by acquiring, early in 2000, the Montréal-based Groupe Vidéotron Lteé. This not only gave Rogers Communications Incorporated (RCI) a network covering most of the territory of its major rival, Bell Canada, but promised to be the first large step in the "synergizing" of the private communications media in Canada. For decades, analysts have predicted that the old specialized communications firms would be succeeded by corporations with a diversity of outreach. Television, cable, telephone and Web facilities, since they overlap technologically, seem to belong

in a single corporate package. In the United States the synergizing process is well under way (Microsoft, for example, is already buying into the cable industry, probably to set it up for Web TV) and one can see the same process at work in Canada, where Shaw Communications of Calgary, Canada's second-largest cable company, and Bell Canada Enterprises have begun to move in the same direction as Rogers. The inevitable next step would be cross-border corporate affiliations, although these would be limited somewhat by Canada's foreign-ownership laws.

What this means for the public, however, is an almost complete transformation of the old "box in the corner" television experience. Television is presently being digitalized; it will be integrated with the Web, turning the TV into a kind of computer (with e-mail facilities) and encouraging interactive content. Pay-per-view opportunities will expand. The household will be wired and everything, including telephone services, may well function through coaxial cable, creating a futuristic system visible previously only in science fiction scenarios.

Clearly, communications in Canada are entering a new and dynamic phase, one that will change the nature of consumer interaction with the media forever.

Even considered by itself, however, the situation in cable television at the end of the 1990s was anything but static. As the new century dawned, Canadians were seeing the continued arrival of an almost dizzying array of new specialty cable channels, owned by such diverse groups as Alliance Atlantis, Astral Communications, CHUM-CITY, Molson Companies Ltd., Baton Broadcasting and several others. BRAVO!, Discovery, the Life Network, Space, the Sports Network, New Country, Showcase, the Women's Television Network, the History Channel—these represent only part of the amazing new avalanche of niche or specialty broadcasting that seems to mark a diversion from, if not the end of, the era of television programming for a single prime-time audience. Yet, to many critics, the initial offerings of most of these channels leave much to be desired. Programming has suffered from a too blatant reliance on recycled material, there has been too much reliance on American providers, and viewers have often been inundated with talk at the expense of almost everything else. Even though by the end of the 1990s—despite some inexperienced marketing—their advertising revenues were showing steady growth, the cable channels have attracted fewer subscribers than expected. As a result, cable providers are offering their subscribers more program choice, more and more options and combinations, while heavily marketing their new digital capability and other special features.

Other notable recent initiatives in television broadcasting include those of Moses Znaimer, founder of MuchMusic, CITY-TV and BRAVO!, who in 1994 ventured west

(with the backing of CHUM-CITY, the fourth big player in the Canadian private-television sweepstakes) to buy out Alberta's education station, Access. The purchase price, exactly $1, shows that this is a case of a provincial government unloading an unwanted structure for budget-cutting purposes. Znaimer immediately rolled over his new purchase into Learning and Skills Television of Alberta Ltd., which has been guaranteed $9.4 million worth of contracts and production money from the Alberta government. This venture, in which Znaimer was joined by Ron Keast, formerly of Vision TV and TV Ontario (TVO), was dubbed by one critic "publicly financed private television." The move, as reported by *Maclean's*, alienated TVO and B.C.'s Open Learning Agency, with whom Keast-Znaimer had planned to launch the Canadian Learning Television Network, a cross-country service that envisaged international links with such groups as Britain's Open University. The ideological split between Keast and Znaimer and the traditional advocates of TVO is clear. The former want private corporate control of educational stations and an emphasis on high-technology instruction units, packaged and marketed in smooth commercial style. They look forward to a "virtual university" that would connect broadcasters and the computer-hardware companies and make obsolete such quaint notions as professors merely lecturing on television. The traditional TVO mode, by contrast, involves not only educational presentations, but large commitments to public affairs and drama, or as Znaimer's negative version has it: "TVO wants to be CBC ... and nobody does the job they were licensed for."

Television to meet social needs of another sort appeared at the end of 1999, when the Aboriginal Peoples Television Network (APTN) was launched. This was not only a new departure for Canada but the first of its kind in the world. APTN was in fact an offshoot of an existing satellite network called Television Northern Canada, based in Yellowknife. Like many of the other fledgling cable channels, APTN was launched on a wing and a prayer, and lacked personnel with extensive television experience. While it fuelled some resentment among competitors and created some dissatisfaction among viewers by being given a preferred spot on the basic cable tier for what might end up being a very small and scattered audience, others immediately affirmed its positive social value. They supported the notion that cable channels must be aligned not only with respect to viewer interest, but in terms of the social and political necessities of the nation.

Even a brief look at television broadcasting in this country raises many questions for Canadians. What kind of service do we want? Who controls our television screens and for what purpose? Can our commitment to the free-enterprise pursuit of profit

be maintained without making television an instrument for the obliteration of Canadian national identity? How does national policy encompass the very different relationships of French-language and English-language television to the question of national identity and of foreign content? Is the CRTC, which is traditionally at the centre of some of these issues, a sufficient instrument to guide us through what will clearly be a complex future passage?

Amid all of the attention being paid to new developments in television, a much-harried CBC Radio was still managing to maintain its contact with a traditionally loyal audience, created by many years of creative Canadian programming. Radio, in fact, had been one of the first battlegrounds in the struggle of cultural nationalists to protect Canadian culture. Its advent in the early part of the century meant the virtual abolition of the border between Canada and the United States. By the 1920s, Canadians were already tuning in large numbers to American programs, and local stations were increasingly controlled by American interests. However, in the early 1930s, the establishment between 1932 and 1936 of a publicly owned national broadcasting corporation changed all that. CBC Radio did foster culture: drama in particular was excellent and ubiquitous, especially after the Second World War, and classical music, critical arts commentary and ideas programs flourished on such venues as *CBC Wednesday Night*.

During the 1950s and 1960s, radio changed its focus as talk shows, continuous music and frequent news broadcasts came on the scene. The CBC experienced some rough passages, and adjustments had to be made, but by the 1970s it had revived and reinvented itself. Even the tinkering with structures and programs necessitated by the funding cutbacks of the 1990s has not eroded the loyalty of CBC Radio's middlebrow and highbrow listeners. Many have paid tribute to the achievements of CBC Radio over the years and indeed its worth—as an educational force, an entertainment source and a cultural instrument—can hardly be overstated. Few

Retired host of CBC Radio's Morningside, *Peter Gzowski was for years the avuncular king of Canadian radio.*

Maclear's / Peter Bregg

radio services anywhere have been as impressive. Highlights include programs such as *Les nouveatés dramatiques* and *Stage,* which provided excellent dramatic fare; *Wednesday Night* and the still-extant *Ideas,* which presented high culture in fine style; and *This Country in the Morning* with the now-retired Peter Gzowski, which became a national thoroughfare of ideas and issues, a forum for Canadians, a connection point and a place of shared experience. As Robert MacNeil, the Canadian expatriate of MacNeil-Lehrer fame, once put it: "When I've been away and want to get reacquainted with Canada I simply tune in to Gzowski." And it is hardly necessary to mention the CBC's excellence in news and news-feature shows, of which *As it Happens* has been one of the most memorable.

Many Americans who have lived close to the Canadian border have described to me their delight in discovering the wonders of CBC Radio. Over the years the United States has produced some excellent radio programming, but with the advent of television much of it vanished—at least on the national networks. There is presently a very large "old-time radio" boom south of the border and while nostalgia is a factor, this boom also signals that something is missing in contemporary American radio. That something is continuity, including the connection with a past that reaches beyond popular culture, and also the ability to assume an audience that shares certain values, interests and an admirable kind of civility. The best American stations, such as WQXR in New York, remain admirable, but the CBC's position as a national broadcaster is very special. Whether or not this position has been strengthened as a result of Canada's marginality relative to the "Coca-Cola" culture to the south, the fact is that CBC Radio has almost never failed to promote the best Canadian talent, while remaining a unique medium for Canadian self-understanding and self-expression.

The private radio stations, by contrast, have often been too enslaved by the lowest common denominator of popular taste and far too heavily commercialized. Yet after the CRTC's 30 percent ruling of 1970 (see chapter two), they also carried significant Canadian music content, while years before they had adapted themselves to the new notions of targeting specialized audience tastes. In fact, they had anticipated the cable television stations in this by as much as a decade. The commercial stations now cover the popular music scene extensively and blanket the airwaves with talk and phone-in shows, many of them over-calculating in their provocative nature and manipulative of their audiences. Yet the university radio stations have been a creative force in innovative programming, and local stations as different as CKNW in Vancouver (news and talk), CJRT in Toronto (music and lectures), as well as CIBL (alternative) and CFMB (multilingual) in Montréal, among many others, are fulfilling vital functions

and contributing a great deal to the liveliness of contemporary Canadian radio broadcasting. Such stations have circumvented the largely genteel style of the CBC without descending to the cheap tricks of much commercial radio.

As the 1990s ended, however, it was clear that the major transformation of traditional radio may well occur in relation to Web broadcasting. A listener connected to the Internet who has downloaded Real Audio may browse among radio stations from all over the world. More and more listeners ignore local broadcasts and "bookmark" favourite stations in other cities and countries to listen to as they work at their computers. With the further improvement of the new technologies, including such revolutionary developments as the downloading of music from the Internet via such formats as MP3, future effects on broadcasting and recording are as inevitable as they are unpredictable.

In the new century both television and radio will undergo radical changes. These will affect not only delivery systems, but also corporate structures and marketing techniques. The end result may be that all of this will give more power to the private entertainment interests and less to the government regulators. The reassuring thing for Canadians is that in almost all areas Canada is technologically well-advanced, while this country's long experience of striving to harmonize ideal social prescriptions with basic economic realities in the broadcasting field may yet serve it in good stead.

Some Memorable Canadian Television Shows

I concentrate here on regular television fare, excluding news, sports and special events, and ignore documentaries or films that played on television. The sheer number of serials, made-for-television dramas and plays, as well as children's shows, historical shows, shows about immigrants, et cetera, broadcast on Radio-Canada between the 1950s and the 1990s makes it impossible to cover the Québec scene adequately in a summary list. Interested readers should consult Jean-Yves Croteau's survey *Répertoire des séries, feuilletons et téléromans québécois de 1952 à 1992*, or *The Canadian Encyclopedia*, for more information and reference sources. English television—above all in the field of drama—has been a wasteland by comparison.

Children's Shows

- *The Friendly Giant*: This quiet, lovely, unforgettable show ran on CBC for 27 years, from 1958 to 1985. Episodes aired every weekday morning and were 15 minutes long. Bob Homme was the creator and title character who lived with his puppet friends Rusty and Jerome. "Pull up a chair and sit down by the fire. Now look up, waaay up!"

- *The Kids of Degrassi Street*: This show, which was produced by Playing with Time Inc. from 1980 until 1990, eventually morphed into *Degrassi Junior High*, and then just

Ernie Coombes delighted children for 29 years with his easygoing and imaginative television persona, Mr. Dressup.

CBC Television / Fred Phipps

Degrassi High, as its cast of non-professional child actors grew up. Possibly one of the most successful Canadian television exports ever to be conceived, *Degrassi* presented a no-frills, frank view of life in Toronto's multicultural East End as seen from the kids' point of view. A quintessential Canadian tonic to U.S. shows like *Beverly Hills 90210*.

- *Mr. Dressup*: A CBC show that ran for 29 seasons from 1967 to 1996. Episodes aired every weekday morning and were 30 minutes long. Ernie Coombes played the title character, who hosted with his puppet friends Casey and Finnegan. Energetic and imaginative.

- *Polka Dot Door*: This TVOntario show, with a series of hosts carefully chosen to present different gender and racial styles, varied in quality but was always a pleasant alternative to the more hyperactive *Sesame Street*. It aired from 1970 to 1993.

- *Razzle Dazzle*: With Al Hamel and first Michele Finney and then Trudy Young as co-hosts, this CBC show and its resident turtle, Howard, had a 100,000-strong fan club and

an exuberant blend of skits, quizzes and contests. It aired from 1961 to 1967.

• *Romper Room*: It ran on CTV for 26 seasons from 1966 to 1992. The show was hosted by Miss Fran, who was very competent and smooth but uptight, supercilious and in general pretty hard to take.

Game Shows

• *Definition*: Playing for 16 seasons on CTV between 1974 and 1990, this show was a sophisticated word-game program hosted by Jim Perry.

• *Front Page Challenge*: This iconic Canadian show luxuriated on CBC for nearly 40 years, an astonishing record. First aired in 1957, it chattily probed current events as the sophisticated but reassuringly middlebrow panel questioned newsmakers (everyone from Malcolm X to the Singing Nun). The original panel consisted of Alex Barris, Gordon Sinclair and Toby Robins, with occasional appearances by Pierre Berton or Scott Young. When it was all over in 1995, the panel featured Berton, Betty Kennedy, Jack Webster and Allan Fotheringham. Geniality has never had such a long life.

Public Affairs

• *the fifth estate*: Long-running (since 1975) CBC newsmagazine. Noted for its hard-hitting, newsmaking investigative reporting, particularly the work of pugnacious, irrepressible Eric Malling, who later jumped ship to head up *W5* on CTV.

• *The Nature of Things*: It first aired on CBC in 1960. Very well-researched and edited, and smoothly hosted by the knowledgeable David Suzuki, this weekly prime-time program about science at first seemed

almost too respectful of mainstream establishment science, but in recent years it has taken many chances and been refreshingly controversial, without sacrificing its intellectual credibility. If Suzuki sticks around, it could conceivably go on forever.

• *This Hour Has Seven Days*: Along with the cancellation of the Avro Arrow and the trading of Wayne Gretzky to the Los Angeles Kings, the CBC's axing of this controversial public-affairs show in 1966 seems to rank as one of the great Canadian traumas. Hosted by Laurier Lapierre and Patrick Watson, the show was provocative and unpredictable. Where else could one get a chance to see Pierre Trudeau and René Lévesque square off long before they traded punches as political adversaries?

• *W5*: Once CTV's alternative to *the fifth estate*, this show eventually bore more than a passing resemblance to the U.S. program *60 Minutes*. Gradually, it was jazzed up for the age of fast-food journalism. *W5* first aired in 1966.

Dramas

• *The Beachcombers*: The CBC's most popular and longest-playing family drama. It eventually earned a worldwide audience and starred Bruno Gerussi. The series about life on British Columbia's Sunshine Coast ran for 19 seasons from 1972 to 1991, but was not a terribly gripping show despite its popularity.

• *The Collaborators*: A typical low-key CBC police show, it aired in the early 1970s and centred on the cases of a couple of forensic scientists.

- *Da Vinci's Inquest*: Vancouver never looked so gritty as in this CBC crime drama about Dominic Da Vinci (Nicholas Campbell), an aggressive, world-weary coroner whose passion for justice is matched only by his impatience with bureaucracy. A far cry from *Quincy* reruns.

- *La Famille Plouff*: This CBC series, written by Roger Lemelin, made its debut in 1953. It was the first serial on Canadian television and is one of the landmarks of our television drama. Unfortunately, very few episodes have been preserved. It was redone on Radio-Canada as a miniseries in the 1980, and titled *Les Plouffes*.

- *A Gift to Last*: A 22-part CBC series spread over three seasons in the 1970s, it told the story of the Sturgess family of Tamarack, Ontario, at the turn of the century and starred Gordon Pinsent.

- *A Great Detective*: A CBC police series from the early 1980s; the catch was that it was set in 19th-century Ontario.

- *Home Fires*: It ran from fall 1980 to fall 1983 and centred on the Lowes, a Toronto family on the Second World War home front.

- *Quentin Durgens, M.P.*: A pretty good political drama that played in the 1960s and starred Gordon Pinsent.

- *Seeing Things*: A CBC mystery/comedy series featuring a Toronto newspaper reporter who has regular ESP seizures. It was created by and starred Louis Del Grande and co-starred Martha Gibson and Janet Laine-Green. Thanks to Del Grande's antics, this show had a refreshingly zany edge to it. Reruns show it to be not quite as good as remembered, but the real drag is that nothing more could be done with Del Grande's talents than this and *King of Kensington*.

- *Traders*: This Global nighttime drama—first aired in 1996—revolves around the personal and professional lives of Bay Street bankers and investors. For good or bad, this program has been praised by critics for being "un-Canadian" (read: "slick and entertaining"). Full of urban angst, *Traders* asserts that not *all* of Canada is provincial.

- *Wojeck*: This well-remembered CBC show aired in the late 1960s and featured actor John Vernon as a Toronto coroner who is obsessed with discovering how and why people died. Do corpses and Canadian drama go hand in hand?

Made-for-Television Movies & Miniseries

- *The Boys of St. Vincent*: Easily one of the most talked-about miniseries shown on Canadian television. A fictionalized account of such child-molesting incidents as the goings-on at Newfoundland's Mount Cashel Orphanage, this series featured a tour-de-force performance by Henry Czerny as the victimizing priest and memorable acting from its cast of largely non-professional child actors. It was produced in the early 1990s by Les Productions Télé-Action and the National Film Board.

- *Charlie Grant's War*: A CBC production written by Anna Sandor, produced by Bill Gough, and starring R. H. Thomson. Set in pre-Second World War Austria, it deals with a Canadian who tries to help Jews escape the Nazis. This made-for-television film got quite some kudos when it appeared in the 1980s.

• *Conspiracy of Silence*: Based on the Betty Osborne murder case, this CBC miniseries from the early 1990s showed what could be done in television drama when talent and vision coincided. Osborne was the young Manitoba Native woman whose white killers were finally brought to justice many years after her savage killing. The award-winning series was directed by film director Francis Mankiewicz and written by Suzette Couture.

• *Duplessis*: A premiere French-language CBC production. One of the best political dramas ever done on the CBC, it was a seven-part biography of the wily Québec politician and was shown on Radio-Canada in winter 1978. Jean Lapointe played the title character. The series was conceived and directed by Mark Blandford, the script written by *Jésus of Montréal* director Denys Arcand. It rivetted Québec viewers and everyone else who saw it.

• *Life with Billy*: A hard-hitting, disturbing portrait of a Maritime woman's tragic solution to the savage beatings inflicted on her by her husband. Stephen McHattie's performance as the husband is chilling. The miniseries was a co-production of Salter Street Films and The Film Works.

• *Love and Hate*: Knockout performances by Kate Nelligan and Kenneth Welsh in a much-exported 1989 CBC miniseries that documented the misdeeds and trial of convicted Saskatchewan wife murderer Colin Thatcher.

• *The Newcomers*: Produced by CBC and funded by Imperial Oil, this was a seven-part fiction series shown in 1979. It depicted immigrant life in Canada from the perspectives of various newcoming nationalities and had some excellent

scriptwriters, including Alice Munro, who wrote the Irish episode, the best of the bunch. On a personal note, I should say that this episode was partially filmed at my farm. However, I didn't get a penny out of it, although the crew did reinstall my television aerial.

Comedy

• *The Kids in the Hall*: Easily the opposite of Wayne and Shuster, the Kids (Bruce McCulloch, Kevin McDonald, Mark McKinney, Scott Thompson and Dave Foley [now star of the American sitcom *Newsradio*]) shunned the parody and skit spoofery of Wayne and Shuster, *SCTV* or Second City for a more conceptual approach that veered toward lunacy and the absurdly surreal. Initially a co-production of CBC and HBO, with *Saturday Night Live*'s Lorne Michaels as impresario, *The Kids in the Hall* burned brightly if briefly in the United States and Canada from 1989 to 1995.

• *King of Kensington*: First aired by CBC in 1975, this domestic comedy set in Toronto starred Al Waxman and Fiona Reid, who played his wife. Most of the early scripts were written by Louis Del Grande and Jack Humphrey, who produced. This show, which left the air in 1980, was never as good as it should have been, although it was easily the most-watched Canadian sitcom ever, that is until the advent of Ken Finkleman's *The Newsroom*.

• *The Newsroom*: Canada's television *auteur* Ken Finkleman wrote, directed and starred in this jet-black comedy about network news. The program ran for only one season (1996–97) but caused enough of a sensation to ensure Finkleman a virtual *carte blanche* from the CBC for future projects—*More Tears* and *Foolish Heart*.

CBC Television / Fred Phipps

Ken Finkleman wrote, directed and starred in the unique CBC programs, The Newsroom, More Tears *and* Foolish Heart.

The Globe and Mail praised *The Newsroom* as "the hippest, most hilarious show the CBC or any network has ever produced."

- *SCTV*: Running on Global TV in the late 1970s and CBC in the early 1980s, this television spoof was undoubtedly the most influential Canadian comedy series ever. It was also the first Canadian television series to be sold to a U.S. network (NBC). The original cast members, all veterans from Toronto's version of Second City, included John Candy, Eugene Levy, Joe Flaherty, Andrea Martin, Harold Ramis, Catherine O'Hara, Rick Moranis and Dave Thomas; Martin Short joined later. Amazing even in reruns.

- *Wayne and Shuster*: This veteran borscht-circuit, skit-clown team (Johnny Wayne and Frank Shuster) was never far-out or challenging. Beginning on CBC Radio in the late 1940s, they seemed pretty outdated at the end, but had terrific energy and panache. Their CBC Television programs and specials, which spanned four decades, had an abundance of funny moments, including such classic skits as "Rinse the Blood Off My Toga" and "Shakespearean Baseball."

Variety

- *Don Messer's Jubilee*: Many found this CBC icon dreadful, but from 1959 to 1969 it was the favourite program of every Canadian Ma and Pa Kettle and once attracted as many as three million viewers a week. Even though Don Messer, Charlie Chamberlain, Marg Osburne and company were still pulling in hundreds of thousands of viewers, the CBC cancelled the program because the corporation's executives found it too provincial! Recently, although with less reaction from the public, the CBC cut the successful *Rita & Friends*—featuring Maritime singer Rita MacNeil—which had seemed for a time to be a kind of 1990s reincarnation of Don Messer's program. The corporation's reason: it was time. The real reason: down-home music may be popular with many Canadians, but to the CBC's Toronto executives it still signifies cornpone.

- *Juliette*: Dare it be said—Canada's first television superstar? Juliette Augustina Sysak was a Manitoba chanteuse who began her broadcasting career on radio, then graduated to CBC Television in the early 1950s. "Our Pet, Juliette" was one of the corporation's most popular entertainers well into the 1970s.

- *90 Minutes Live*: The CBC's 1976 Peter Gzowski experiment proved that Canadians would rather hear him than see him. This directionless foray into late-night variety was one of the big bombs of Canadian television, although some wished the network had stayed with it a little longer. Still, in comparison with *Friday Night! With Ralph Benmergui*, a later CBC embarrassment in the variety talk-show field, Gzowski's turn on the tube was almost endearing.

- *Open Mike with Mike Bullard*: This program, which runs on Canada's Comedy Channel, is arguably the most successful late-night talk show in Canadian television history— which isn't saying much. It doesn't go far beyond the Letterman/Leno blueprint, but does offer a humorous Canadian alternative.

- *The Réne Simard Show*: The 1970s version of CBC smart programming; a B.C. program hosted by the Québecois Simard and featuring mainly American guests!

- *The Tommy Hunter Show*: Running on the CBC for 27 years between 1965 and 1992, this country and western songfest was soporific in the extreme, although many doted on it.

Major Canadian Television Networks

- **Bravo!:**
299 Queen St. W,
Toronto, ON, M5V 2Z5.
Phone: (416) 591 • 5757

- **Canadian Broadcasting Corporation (CBC):**
1500 Bronson Ave.,
PO Box 8478, Ottawa, ON, K1G 3J5.
Phone: (613) 724 • 1200

- **Canadian Television Network (CTV):**
1800, 250 Yonge St.,
Toronto, ON, M5B 2N8
Phone: (416) 595 • 4100

- **Canal Famille:**
2100, rue Sainte-Catherine O,
Bureau 800, Montréal, QC, H3H 2T3.
Phone: (514) 939 • 3150

- **CanWest/Global Communications Corporation:**
201 Portage Ave., 31st Floor, TD Centre,
Winnipeg, MB, R3B 3L7.
Phone: (204) 956 • 2025

- **Chum Limited:**
1331 Yonge St.,
Toronto, ON, M4T 1Y1.
Phone: (416) 925 • 6666

- **CTV–Television:**
PO Box 9, Stn. O,
Toronto, ON, M4A 2M9
Phone: (416) 332• 5000

- **Discovery Channel:**
100, 2225 Sheppard Ave. E,
Willowdale, ON, M2J 5C2.
Phone: (416) 494 • 2929

- **The Family Channel**:
BCE Place, 181 Bay St., PO Box 787,
Toronto, ON, M5J 2T3.
Phone: (416) 956•2030

- **Global Television Network**:
81 Barber Greene Rd.,
Don Mills, ON, M3C 2A2.
Phone: (416) 446•5311

- **Inuit Broadcasting Corporation (IBC)**:
301, 331 Cooper St.,
Ottawa, ON, K2P 0G5.
Phone: (613) 235•1892

- **Life Network**:
800, 121 Bloor St. E,
Toronto, ON, M4W 3M5
Phone: (416) 967•0022

- **The Movie Network/First Choice**:
BCE Place, 181 Bay St., PO Box 787,
Toronto, ON, M5J 2T3.
Phone: (416) 956•2010

- **MuchMusic Network**:
299 Queen St. W,
Toronto, ON, M5V 2Z5.
Phone: (416) 591•5757

- **MusiquePlus**:
209, rue Sainte-Catherine E,
Montréal, QC, H2X 1L2.
Phone: (514) 284•7587

- **Open Learning Agency/Knowledge Network**:
4355 Mathissi Pl.,
Burnaby, BC, V5G 4S8.
Phone: (604) 431•3000

- **Premier Choix TVEC**:
2100, rue Sainte-Catherine O,
Bureau 800, Montréal, QC, H3H 2T3.
Phone: (514) 939•3150

- **Radio-Canada International**:
1400, boul. René Lévesque E,
Montréal, QC, H3H 3A8.
Phone: (514) 597•5000

- **Le Reseau des Sports**:
1755, boul. René Lévesque E,
Bureau 300, Montréal, QC, H2K 4P6.
Phone: (514) 599•2244

- **Showcase Television**:
800, 121 Bloor St. E,
Toronto, ON, M4W 3M5.
Phone: (416) 967•0022

- **Société Radio-Canada (SRC)**:
1400, boul. René Lévesque E,
Montréal, QC, H3C 3A8.
Phone: (514) 597•5970

- **Société Radio-Télévision du Québec (Radio-Québec)**:
800, rue Fullum,
Montréal, QC, H2K 3L7.
Phone: (514) 521•2424

- **The Sports Network (TSN)**:
100, 2225 Sheppard Ave. E,
Willowdale, ON, M2J 5C2.
Phone: (416) 494•1212

- **Télé-Métropole**:
1600, boul. de Maisonneuve O,
Montréal, QC, H2L 4P2.
Phone: (514) 790•0461

- **TVOntario (TVO)**:
2180 Yonge St., Box 200, Stn. Q,
Toronto, ON, M4T 2T1.
Phone: (416) 484•2600

- **Vision TV**:
80 Bond St.,
Toronto, ON, M5B 1X2.
Phone: (416) 368•3194

- **The Weather Network:**
 1755, boul. René Lévesque E,
 Bureau 251, Montréal, QC, H2K 4P6.
 Phone: (514) 597 • 1700.

- **Western International Communications (WIC):**
 1960, 505 Burrard St.,
 Vancouver, BC, V7X 1M6.
 Phone: (604) 687 • 2844

- **Women's Television Network:**
 300, 1661 Portage Ave.,
 Winnipeg, MB, R2J 3T7.
 Phone: (204) 783 • 5116

- **YTV Canada:**
 64 Jefferson Ave., Unit 18,
 Toronto, ON, M6K 3H3.
 Phone: (416) 534 • 1191

Ten Outstanding Canadian Radio Shows

- *As It Happens*: The CBC's famous phone-out show, which was at its best with Barbara Frum and Alan Maitland. Frum's manner was riveting—feisty, subtle, and humorous. She chatted with world leaders, folk heroes, scoundrels, and kooks, always with the right tone. Frum did the show between 1971 and 1981, and it has continued after her death, retaining something of its former panache.

- *The Farm Radio Forum*: It ran from 1941 to 1963 on the CBC, a kind of town meeting on the air for rural Canada. Information was exchanged, action was initiated and views were expressed on everything from country gardens and decor to wheat prices. The Monday night broadcasts directly fostered community action and did not go unnoticed around the world, where the format was several times imitated. Many Canadians, driven to the cities, listened for fun. This show was one of our most popular shows ever. If only we had something like it for the arts!

- *Hockey Night in Canada*: No, it wasn't always that Saturday night television loudmouth and his chauvinist ravings. It was once Foster Hewitt, whose first radio report on

hockey dated from 1923. Hewitt's first Maple Leaf Gardens radio broadcast was in 1932, and he lasted for 15 years into the era of television. Hewitt's climactic "He shoots! He scores!" became the most famous Canadian quote ever. You didn't need illuminated pucks or calculated insults improvised between periods: the real game was all there in the Hewitt delivery.

- *Un homme et son péché*: Based on the 1933 novel by Claude-Henri Grignon (the English version is entitled *The Woman and the Miser*), this radio-drama serial ran for an astonishing 26 years between 1939 and 1965. It was strong, naturalistic stuff, socially revealing in its portrait of rural life in Québec, and compulsive listening for audiences there. In fact, this program managed to exude the kind of subliminal (and not so subliminal) sadomasochism that audiences everywhere seem to get hooked on.

- *Ideas*: A CBC daily one-hour feature show created in the 1960s and continuing to the present day. The series has gone through various phases; some think it has gotten too self-conscious in recent years. At its best (in

the 1960s and 1970s) this show allowed imaginative producers like Lister Sinclair, the poet Robert Zend and the offbeat scientist Paul Buckley to roam the cosmos of ideas. Zend topped everyone by doing a two-part show on Marcel Marceau, the famous mime—on radio!

• *Les nouveautés dramatiques*: This Radio-Canada Québec drama series was produced by Guy Beaulnes and ran from 1950 to 1962. It presented work by some outstanding Québec dramatists, including Jacques Godbout, Yves Thériault and Marcel Dubé.

• *Off the Record*: Cancelled in 1996, after 30 years on the CBC, Bob Kerr's three-hour afternoon classical music show was regular listening for almost all Canadians with an interest in Bach, Mozart, Tchaikovsky and the other great masters. In his later years, Kerr also played quite a bit of Canadian music and welcomed the original instrument recordings. To his credit he also advocated emotion in music and was not afraid to wallow in the best kind of schmaltz. At his (forced) retirement Kerr was characterized as "opinionated." Translation: he had thought seriously about music and could express his opinions forcefully. In today's atmosphere of mushy mediocrity and bad taste, Kerr's intelligence and connoisseurship had obviously become a liability.

• *Stage*: This CBC drama series was devised and hosted by famed radio pioneer Andrew

Allan. It ran from 1944 until 1956 and featured the work of many emerging Canadian playwrights, including Lister Sinclair, Len Peterson and Mavor Moore. It was one of the harbingers of the cultural explosion that would come in the 1960s and 1970s.

• *This Country in the Morning*: The initial value of this CBC program, which soon became Canada's morning check-in show, ran with the inimitable Peter Gzowski as host between 1971 and 1974. Its successor, *Morningside*, originally featured Don Harron as host, but in 1982 Gzowski returned to radio to take up where he left off in the early 1970s. The show carried on until Gzowski's retirement in 1998.

• *Wednesday Night*: This CBC show began in 1947, and under the aegis of Harry Boyle it provided a wonderful enclave of culture amid the raucous nonsense of most North American broadcasting. Many Canadians and Americans close to the border who could listen marvelled at the show's substantial content: important plays, art criticism, discussions of literature, chamber music, opera and documentaries. The show later metamorphosed into *Tuesday Night*, then *Anthology*, and stayed on the air well into the 1970s under the direction of Robert Weaver. It was radio as a civilizing force, and its very essence must have influenced such Canadian gurus of the media experience as Glenn Gould and Marshall McLuhan.

Gemini Awards

T HE Gemini Awards, honouring outstanding achievement in the English-language Canadian
television industry, were inaugurated by the Academy of Canadian Cinema and Television
in 1986 to replace the former ACTRA Awards, which were last given in 1985. Recommendations
for the special awards categories are solicited from members. Juries, made up of academy members
from across the country, screen the recommendations and select a short list in November;
nominees are announced in January. The final awards ceremonies are elaborate and take place at
the end of February. They are broadcast on CBC Television. The following list is only a partial one.
There were no Geminis awarded in 1991.

Program Awards

Best Television Movie or Miniseries

1999: *The Sleep Room* (Cinar Films Inc.)
1998: *Hiroshima* – Paul Painter, Andrew
Adelson, Tracey Alexander, Michael
Campus, Robin Spry, Kazutoshi
Wadakura (Telescene Film Group Inc.,
Cine Bazar)
1997: *Net Worth* – Bernard Zukerman (CBC)
1996: *Butterbox Babies* – Kevin Sullivan,
Trudy Grant (Sullivan Entertainment)
1995: *Due South* – Paul Haggis, Jean
Desmormeaux, Jeff King (Alliance
Communications Corporation)
1994: *The Diviners* – Kim Todd, Derek
Mazur, Bill Gray, Peter Sussman
(Atlantis Communications, Credo
Group Limited)
1993: *Scales of Justice: Regina vs. Nelles* –
George Jonas (CBC)
1992: *Journey Into Darkness: The Bruce
Curtis Story* – Seaton McLean, Barry
Cowling, Peter Sussman (Atlantis
Communications)
1990: *Where The Spirit Lives* – Paul
Stephens, Heather Goldin, Eric Jordan,
Mary Young Leckie (Amazing Spirit
Productions)

1989: *The Squamish Five* – Bernard
Zukerman (CBC)
1988: *Skate* – Alan Burke, Bernard
Zukerman (CBC)
1987: *The Marriage Bed* – Bill Gough (CBC)
1986: *Love & Larceny* – Robert Sherrin
(CBC)

Best Dramatic Miniseries

1995: *Dieppe* – Bernard Zukerman (CBC)
1994: *The Boys of St. Vincent* – Claudio Luca,
Sam Grana (Les Productions Télé-
Action Inc. in co-production with The
National Film Board of Canada)
1993: *Conspiracy of Silence* – Bernard
Zukerman (CBC)
1992: *Young Catherine* – W. Paterson Ferns,
Michael Deeley, Stephen Smallwood
(Primedia Productions)
1990: *Love and Hate* – Bernard Zukerman
(CBC)
1989: *Glory Enough For All* – Gordon Hinch,
Joseph Green, W. Paterson Ferns,
David Elstein (Gemstone Productions,
Primedia Productions)
1988: *Anne of Green Gables: The Sequel* –
Kevin Sullivan (Sullivan
Entertainment)
1987: *Ford: The Man And The Machine* –
David J. Patterson (Filmline
International Ltd.)

1986: *Anne of Green Gables* – Kevin Sullivan, Ian McDougall (Sullivan Entertainment)

Best Dramatic Series

1999: *Traders* (Season III) (Alliance Atlantis Communications, in association with Sandie Pereira)
1998: *Traders* – Alyson Feltes, Hart Hanson, Mary Kahn, Seaton McLean (Allicance Atlantis Communications)
1997: *Due South* – Jeff King, Bob Wertheimer, George Bloomfield, Kathy Slevin (Alliance Communications Corporation)
1996: *Due South* – Paul Haggis, Jeff King, Kathy Slevin, George Bloomfield (Alliance Communications Corporation)
1995: *Due South* – Paul Haggis, Kathy Slevin, Jeff King (Alliance Communications Corporation)
1994: *E.N.G.* – Robert Lantos, Jennifer Black, Greg Copeland (Alliance Communications Corporation)
1993: *E.N.G.* – Robert Lantos, Jeff King, R. B. Carney, Jennifer Black (Alliance Communications Corporation)
1992: *E.N.G.* – Robert Lantos, Jeff King, R. B. Carney, Jennifer Black (Alliance Communications Corporation)
1990: *E.N.G.* – Robert Lantos, Jeff King, R. B. Carney, Jennifer Black (Alliance Communications Corporation)
1989: *Degrassi Junior High* – Linda Schuyler, Kit Hood (Playing With Time Inc.)
1988: *Degrassi Junior High* – Kit Hood, Linda Schuyler (Playing With Time Inc.)
1987: *Night Heat* – Sonny Grosso, Andras Hamori, Larry Jacobson, Stephen J. Roth (RSL Entertainment Corporation, Grosso-Jacobson Productions Inc. in association with CTV Television Network Ltd.)

1986: *Night Heat* – Andras Hamori (RSL Entertainment Corporation, Grosso-Jacobson Productions Inc. in association with CTV Television Network Ltd.)

Best Comedy Series

1999: *This Hour Has 22 Minutes* – Michael Donovan, Jack Kellum, Marilyn Richardson, Gerald Lunz, Geoff D'eon (Salter Street Films)
1998: *This Hour Has 22 Minutes* – Michael Donovan, Jack Kellum, Marilyn Richardson, Gerald Lunz, Geoff D'eon (Salter Street Films)
1997: *This Hour Has 22 Minutes* (Series III) – Michael Donovan, Jack Kellum, Marilyn Richardson, Gerald Lunz, Geoff D'eon (Salter Street Films)
1996: *This Hour Has 22 Minutes* – Michael Donovan, Jack Kellum, Gerald Lunz, Jenipher Ritchie, Geoff D'eon (Salter Street Films)
1995: *This Hour Has 22 Minutes* – Michael Donovan, Jack Kellum, Gerald Lunz, Jenipher Ritchie, Geoff D'eon (Salter Street Films)
1994: *The Kids in the Hall* – Lorne Michaels, John Blanchard, Jeffery Berman, Cindy Park, Joe Forristal (Broadway Video International)
1993: *The Kids in the Hall* – Lorne Michaels, Joe Forristal, Jeffery Berman, Cindy Park (Broadway Video International)
1992: *CODCO* – Michael Donovan, Stephen Reynolds, J. W. Ritchie, Jack Kellum (Salter Street Films)
1990: *Material World* – Katie Ford, Joe Partington (CBC)
1989: *CODCO* – Michael Donovan, J. William Ritchie (Salter Street Films)
1987: *Seeing Things* – David Barlow, Louis Del Grande, Martin Wiener (CBC)

1986: *Seeing Things*, "The Night has a Thousand Eyes" – David Barlow, Louis Del Grande, Martin Wiener (CBC)

Best Documentary Program (Donald Brittain Award)

1999: *Gerrie & Louise* (Blackstock Pictures Inc., Eurasia Motion Pictures Inc., CBC)

1998: *The Selling of Innocents* – Elliott Halpern, William Cobban, Simcha Jacobovici (Associated Producers)

1997: *Utshimassits* – Mike Mahoney, Peter D'entremont (Triad Film Productions Ltd., John Walker Productions Ltd., National Film Board of Canada)

1996: *Ms. Conceptions* – Ric Bienstock, Linda Frum (Good Soup Productions Inc., CBC, National Film Board of Canada)

1995: *Shadows and Light: Joaquin Rodrigo at 90* – Larry Weinstein, Niv Fichman (Rhombus Media Inc.)

1994: *Donald Brittain Filmmaker* – Adam Symansky (National Film Board of Canada)

1993: *Timothy Findley: Anatomy of a Writer* – Terence Macartney-Filgate, Don Haig (Tiffin Productions)

1992: *Island of Whales* – Jack Silberman, Gillian Darling, George Johnson, Jerry Appleton (Island of Whales Productions)

1990: *The Journal*, "At the Lodge" – Jim Williamson, Sharon Bartlett, Christine Nielsen (CBC)

1989: *Straight Shooter: The Story of John Phillips and the Mamas & the Papas* – Gregory Hall (Hallway Productions Inc.)

1988: *Runaways: 24 Hours on the Street* – Lon Appleby, Howard Bernstein, David Sobelman (CBC)

1987: *The Champions, Part III: The Final Battle* – Donald Brittain, Adam Symansky (National Film Board of Canada)

Best Documentary Series

1999: *The Nature of Things* (CBC)

1998: *Man Alive* – Robin Christmas, Joy Crysdale, Sydney Suissa (CBC)

1997: *Witness* – Mark Starowicz, Hilary Armstrong (CBC)

1996: *Man Alive* – Louise Lore (CBC)

1995: *Witness* – Mark Starowicz (CBC)

1994: *Acts of War* – Michael Maclear, David Kirk (Screenlife Incorporated)

1993: *The Valour and the Horror* – Arnie Gelbart, Andre Lamy, Adam Symansky (Galafilm Inc.)

1992: *The Nature of Things* – James Murray (CBC)

1990: *The Nature of Things* – James Murray (CBC)

1989: *The Struggle for Democracy* – Ted Remerowski, Nancy Button, Michael Levine (Democracy Films Ltd.)

1988: *The Nature of Things* – James Murray (CBC)

1987: *The Nature of Things* – James Murray (CBC)

Best Information Series

1999: *Undercurrents* (CBC)

1998: *the fifth estate* – David Studer, Susan Teskey (CBC)

1997: *the fifth estate* – David Studer, Susan Teskey (CBC)

1996: *Venture* – Joe Crysdale, Linda Sims (CBC)

1995: *the fifth estate* – Kelly Crichton, David Studer (CBC)

1994: *Market Place* – Sig Gerber, Paul Moore (CBC)

1993: *the fifth estate* – Kelly Crichton, David
Nayman (CBC)
1992: *The Journal* – Mark Starowicz (CBC)
1990: *The Journal* – Mark Starowicz (CBC)
1989: *The Journal* – Mark Starowicz (CBC)
1988: *Venture* – Duncan McEwan (CBC)
1987: *The Journal* – Mark Starowicz (CBC)

Best Children's or Youth Program or Series

1999: *Ready or Not* (Insight Production Co.
Ltd.)
1998: *Street Cents* – John Nowlan, Jonathan
Finkelstein, Barbara Kennedy (CBC)
1997: *The Adventures of Dudley the Dragon* –
Ira Levy, Peter Williamson, Paula
Smith (Dragon Tales Productions Ltd.)
1996: *Are You Afraid of the Dark?* – Ronald
A. Weinberg, Micheline Charest,
D. J. Machale (Cinar Films Inc.,
Nickelodeon, YTV Canada)
1995: *The Big Comfy Couch* – Cheryl Wagner,
Robert Mills (Radical Sheep
Productions Inc.)
1994: *Lamb Chop's Play-Along* – Jon Slan,
Richard Borchiver, Bernard Rithman
(Paragon Entertainment Corporation)
1993: *Shining Time Station* – Britt Allcroft,
Rick Siggelkow, Nancy Chapelle
(Catalyst Entertainment Inc.)
1992: *The Garden* – Stephen Onda
(Saskatchewan TV Network, Heartland
Motion Pictures Inc.)
1990: *Raffi in Concert with the Rise and
Shine Band* – Richard Mozer, David
Devine, Raffi (Devine Videoworks
Corporation)
1989: *Mr. Dressup* – Shirley Greenfield (CBC)
1988: *Ramona* – Kim Todd (Atlantis
Communications)
1987: *Degrassi Junior High* – Kit Hood, Linda
Schuyler (Playing With Time Inc.)
1986: *Fraggle Rock*, "The Perfect Blue Rollie" –
Larry Mirkin (Henson Assoc. and CBC)

Craft Categories

Best Direction in a Dramatic Program or Miniseries

1999: Anne Wheeler – *The Sleep Room*
1998: Roger Spottiswoode – *Hiroshima*
1997: Jerry Ciccoritti – *Net Worth*
1996: Christian Duguay – *Million Dollar
Babies*
1995: Paul Donovan – *Life with Billy*
1994: John N. Smith – *The Boys of St. Vincent*
1993: Francis Mankiewicz – *Conspiracy of
Silence*
1992: Graeme Campbell – *Journey Into
Darkness: Bruce Curtis Story*
1990: Francis Mankiewicz – *Love and Hate*
1989: Harvey Hart – *Passion and Paradise*
1988: Don McBrearty – *A Child's Christmas
In Wales*
1987: Martin Lavut – *The Marriage Bed*

Best Direction in a Dramatic or Comedy Series

1999: Bruce McDonald – *Twitch City*, "Killed
by Cat Food"
1998: E. Jane Thompson – *Madison*, "With a
Bullet"
1997: Jerry Ciccoritti – *Straight Up*, "Small
Bank Theory"
1996: Jerry Ciccoritti – *Due South*, "The Gift
of the Wheelman"
1995: George Bloomfield – *Due South*, "Free
Willie"
1994: Jerry Ciccoritti – *Catwalk*, "Here
Today"
1993: Allan King – *Road To Avonlea*, "Felix
and Blackie"
1992: Stacey Stewart Curtis – *Street Legal*,
"Presumed Toxic"
1990: Stuart Gillard – *Road to Avonlea*,
"Conversations"

1989: Randy Bradshaw – *Diamonds*, "Man with a Gun"
1988: Kit Hood – *Degrassi Junior High*, "A Helping Hand"
1987: Kit Hood – *Degrassi Junior High*, "It's Late"
1986: Donald Brittain – *Canada's Sweetheart: The Saga of Hal C. Banks*

Best Writing in a Dramatic Program or Miniseries

1999: Heather Conkie – *Pit Pony*
1998: David Adams Richards – *For Those Who Hunt the Wounded Down*
1997: Dennis Foon – *Little Criminals*
1996: David Adams Richards – *Small Gifts*
1995: Barry Stevens – *The Diary of Evelyn Lau*
1994: Des Walsh, John N. Smith, Sam Grana – *The Boys of St. Vincent*
1993: Suzette Couture – *Conspiracy of Silence*
1992: Keith Ross Leckie – *Journey Into Darkness: The Bruce Curtis Story*
1990: Suzette Couture – *Love and Hate*
1989: Grahame Woods – *Glory Enough for All*
1988: Suzette Couture – *Skate*
1987: Sharon Riis – *Daughter of the Country*, "The Wake"

Best Writing in a Dramatic Series

1999: Paul Gross, Robert B. Carney, John Krizanc – *Due South*, "Mountie on the Bounty – Part 2"
1998: Rob Forsyth – *North of 60*, "The Watchers"
1997: Hart Hanson – Traders, "Dancing with Mr. D."
1996: David Shore, Paul Haggis – *Due South*, "Hawk and Handsaw"

1995: Kathy Slevin, Paul Haggis – *Due South*, "Free Willie"
1994: Rebecca Schechter – *North of 60*, "Sisters of Mercy"
1993: David Barlow – *Max Glick*, "We Stand on Guard for Thee"
1992: Wayne Grigsby – *E.N.G.*, "Seeing Is Believing"
1990: R. B. Carney – *E.N.G.*, "Division of Labour"
1989: Chris Haddock – *Night Heat*, "False Witness"
1988: Tim Dunphy, Peter Norman – *Night Heat*, "Dead Ringer"
1987: R. B.Carney – *Night Heat*, "The Hat"

Best Writing in a Comedy or Variety Program or Series

1999: Cathy Jones, Mark Farrell, Chris Finn, Edward Kay, Rick Mercer, Tim Steeves, Greg Thomey, Mary Walsh – *This Hour Has 22 Minutes* (Series V), "Episode 22"
1998: Ken Finkleman – *The Newsroom*, "Campaign"
1997: Mary Walsh, Cathy Jones, Rick Mercer, Greg Thomey, Alan Resnick, Paul Bellini, Ed Macdonald – *This Hour Has 22 Minutes* (Series III), "Public Service Strike/Airbus Affair"
1996: Cathy Jones, Mary Walsh, Rick Mercer, Greg Thomey, Alan Resnick, Ed Macdonald, Paul Bellini – *This Hour Has 22 Minutes*
1995: Mary Walsh, Rick Mercer, Greg Thomey, Cathy Jones, Alan Resnick – *This Hour Has 22 Minutes*, Episode #9 (Dec. 31/93), "New Year's Eve Special"
1994: Mary Walsh, Cathy Jones, Tommy Sexton, Greg Malone – *CODCO*, Show #53 "Lil And Buster"
1993: Tommy Sexton, Greg Malone, Cathy Jones, Mary Walsh – *CODCO*, "The House Of Budgell"

1992: Andy Jones, Cathy Jones, Greg Malone, Tommy Sexton, Mary Walsh – *CODCO*, "JFK/Barbara Frum/Friday Night Girls"

1990: Dave Foley, Bruce McCullough, Kevin McDonald, Mark McKinney, Scott Thompson – *The Kids in the Hall*, Show #1

1989: Dave Foley, Bruce McCullough, Kevin McDonald, Mark McKinney, Scott Thompson – *The Kids in the Hall*

1987: Greg Malone, Tommy Sexton – *S&M Comic Book*, Episode #1

Performance Categories

Best Performance by an Actor in a Leading Role in a Dramatic Program or Miniseries

1999: Nicholas Campbell – *Major Crime*
1998: Kenneth Welsh – *Hiroshima*
1997: Aidan Devine – *Net Worth*
1996: Michael Riley – *Adrienne Clarkson Presents* "The Facts Behind the Helsinki Roccamatios"
1995: Stephen McHattie – *Life with Billy*
1994: Henry Czerny – *The Boys of St. Vincent*
1993: Michael Mahonen – *Conspiracy of Silence*
1992: Bernard Behrens – *Saying Goodbye*, "A Home Alone"
1990: Kenneth Welsh – *Love and Hate*
1989: R. H. Thomson – *Glory Enough for All*
1988: Kenneth Welsh – *And Then You Die*
1987: Booth Savage – *The Last Season*

Best Performance by an Actress in a Leading Role in a Dramatic Program or Miniseries

1999: Lisa Repo-Martell – *Nights Below Station Street*

1998: Brooke Johnson – *Dangerous Offender*
1997: Barbara Williams – *Diana Kilmury: Teamster*
1996: Jessica Steen – *Small Gifts*
1995: Nancy Beattie – *Life with Billy*
1994: Kelly Rowan – *Adrift*
1993: Kate Nelligan – *Diamond Fleece*
1992: Brenda Bazinet – *Saying Goodbye*, "A Grief Shared"
1990: Michelle St. John – *Where the Spirit Lives*
1989: Martha Henry – *Glory Enough for All*
1988: Megan Follows – *Anne of Green Gables: The Sequel*
1987: Victoria Snow – *Daughter of the Country*, "The Wake"

Best Performance by an Actor in a Continuing Leading Dramatic Role

1999: Patrick McKenna, *Traders* (Season III), "In Vacuo"
1998: Bruce Gray – *Traders*, "Trudy Kelly"
1997: David Cubitt – *Traders*, "Into that Good Night"
1996: Paul Gross – *Due South*, "The Gift of the Wheelman"
1995: Paul Gross – *Due South*, "Free Willie"
1994: James Purcell – *Counterstrike*, "Going Home"
1993: Cedric Smith – *Road to Avonlea*, "Friends and Relations"
1992: Eric Peterson – *Street Legal*, "The Divine Image"
1990: Art Hindle – *E.N.G.*, "Division of Labour"
1989: Eric Peterson – *Street Legal*, "The Homecoming"
1988: Pat Mastroianni – *Degrassi Junior High*, "Great Expectations"
1987: Eric Peterson – *Street Legal*, "Even Lawyers Sing the Blues"
Winston Rekert – *Adderly*, "Adderly with Eggroll"

1986: Robert Clothier – *The Beachcombers*, "Blue Plate Special"

Best Performance by an Actress in a Continuing Leading Dramatic Role

1999: Sheila McCarthy – *Emily of New Moon*, "The Enchanted Doll"
1998: Patti Harras – *Jake and the Kid*, "The Wedding"
1997: Tina Keeper – *North of 60*, "The River"
1996: Joely Collins – *Madison*
1995: Lally Cadeau – *Road to Avonlea*
1994: Jackie Burroughs – *Road to Avonlea*, "Hearts and Flowers"
1993: Sara Botsford – *E.N.G.*, "The Best Defense"
1992: Jackie Burroughs – *Road to Avonlea*, "Aunt Hetty's Ordeal"
1990: Jackie Burroughs – *Road to Avonlea*, Episode #3, "Malcolm and the Baby"
1989: Stacie Mistysyn – *Degrassi Junior High*, "Loves Me, Loves Me Not"
1988: Sonja Smits – *Street Legal*, "Assault"
1987: Dixie Seatle – *Adderly*, "A Matter of Discretion"
1986: Marnie McPhail *The Edison Twins*, "Running on Empty"

Best Performance by an Actor in a Featured Supporting Role in a Dramatic Program or Miniseries

1999: Diego Matamoros – *The Sleep Room*
1998: Aidan Devine – *The Arrow*
1997: Al Waxman – *Net Worth*
1996: Brent Carver – *Street Legal Finale: The Last Rights*

Best Performance by an Actress in a Featured Supporting Role in a Dramatic Program or Miniseries

1999: Nicky Guadagni – *Major Crime*
1998: Jayne Eastwood – *Dangerous Offender*
1997: Teresa Stratas – *Under the Piano*
1996: Catherine Finch – *Butterbox Babies*

Best Performance by an Actor in a Featured Supporting Role in a Dramatic Series

1999: Kris Lemche – *Emily of New Moon*, "Falling Angels"
1998: Patrick McKenna – *Traders*, "Separation Anxiety"
1997: Lubomir Mykytiuk – *North of 60*, "Refugees"
1996: Nigel Bennett – *Forever Knight*
1995: Bernard Behrens – *Coming of Age*
1994: Wayne Robson – *The Diviners*
1993: Jonathan Welsh – *E.N.G.*, "Secrets"
1992: Kenneth Welsh – *Journey Into Darkness: The Bruce Curtis Story*
1990: Joe Flaherty – *Looking for Miracles*
1989: Jan Rubes – *Two Men*
1988: Wayne Robson – *And Then You Die*
1987: Eugene Clark – *Night Heat*, "Fire and Ice"
1986: Richard Farnsworth – *Anne of Green Gables*

Best Performance by an Actress in a Featured Supporting Role in a Dramatic Series

1999: Kim Huffman – *Traders* (Season III), "Hope Chasers"
1998: Robin Craig – *Wind at My Back*, "Train to Nowhere"

1997: Kay Tremblay – *Road to Avonlea: The Final Season*, "After the Ball is Over"
1996: Patricia Hamilton – *Road to Avonlea*
1995: Jennifer Phipps – *Coming of Age*
1994: Lise Roy – *The Boys of St. Vincent*
1993: Brooke Johnson – *Conspiracy of Silence*
1992: Sarah Polley – *Lantern Hill*
1990: Ann-Marie MacDonald – *Where the Spirit Lives*
1989: Martha Gibson – *Two Men*
1988: Colleen Dewhurst – *Anne of Green Gables: The Sequel*
1987: Vivian Reis – *The Marriage Bed*
1986: Colleen Dewhurst – *Anne of Green Gables*

Special Awards

Margaret Collier Award (Outstanding Body of Work by a Television Writer)

1999: Johnny Wayne and Frank Shuster
1998: Douglas Bowie
1997: no award
1996: Anna Sandor
1995: Timothy Findley
1994: Alex Barris
1993: George Robertson
1992: Harry Rasky
1990: Ted Allan
1989: Donald Brittain
1988: M. Charles Cohen
1987: Grahame Woods
1986: Charles E. Israel

John Drainie Award (Distinguished Contribution to Broadcasting)

1999: Bernie Lucht
1998: Peter Herrndorf
1997: Joe Schlesinger
1996: Dodi Robb
1995: Knowlton Nash
1994: Max Ferguson
1993: Barbara Frum (posthumous)
1992: Gordon Pinsent
1990: Allan S. McFee
1989: Peter Gzowski
1988: Davidson Dunton
1987: Ross McLean
1986: Pat Patterson

Earle Grey Award (Outstanding Body of Work in Television by an Actor or Actress)

1999: Al Waxman
1998: Kenneth Welsh
1997: Gordon Pinsent
1996: Bruno Gerussi
1995: SCTV Comedy Troupe – John Candy, Joe Flaherty, Eugene Levy, Andrea Martin, Catherine O'Hara, Rick Moranis, Harold Ramis, Martin Short, Dave Thomas
1994: Ernie Coombs
1993: Barbara Hamilton
1992: Colleen Dewhurst
1990: Jan Rubes
1989: Sean McCann
1988: Kate Reid
1987: Lorne Greene
1986: Ed McNamara

Source: Academy of Canadian Cinema and Television

8
Cultural Spaces & Showplaces

SOME of Canada's most striking architecture was created to present the arts or to showcase aspects of our culture. The Winnipeg Art Gallery, the Canadian Museum of Civilization in Hull, the Royal Alexandra Theatre and Massey Hall in Toronto—such buildings would be worth a visit even if no arts events or exhibitions were on hand. Despite the existence of such gems, the problem of finding appropriate spaces to present arts and culture is a perennial one in Canada. The old opera houses built at the end of the 19th century (some of which had excellent acoustics and were aesthetic treasures in their own right) lasted through many decades. Those that survived often became movie palaces, only to be torn down or abandoned when the multiplex cinemas arrived. As a result, our post-war arts boom began mostly in basements and high school auditoriums, at least until the creation of new facilities during or after the centennial year of 1967.

Many of the latter arts spaces—such as the Place des Arts in Montréal—are now several decades old and are showing their age. Some of the best of them were built as multi-purpose centres between the 1960s and the mid-1980s and it is difficult to imagine replacing them now, given the enormous financial commitments that would be required. In a similar vein, the city of Toronto's long-suffering endurance of the inadequate Hummingbird Centre (formerly called the O'Keefe Centre, and not an arts complex, of course, but a makeshift performance venue), illustrates the difficulty of getting commitments to build arts mega-projects at the end of the 1990s. In 1998, when plans were announced for a new facility that would finally allow the Canadian Opera Company and the National Ballet of Canada to perform in an appropriate setting, there was a general sigh of relief among members of the arts community.

Even those who have not given much thought to the matter seem to recognize that personal encounters with great works of art, or the enjoyment of performances

of special beauty, are notably enhanced by the spaces in which such things take place. No doubt one can find beauty anywhere, but the ancient notion that certain places should be set aside for the experience of art is at the very root of our sense of leisure. Human beings have always needed to escape the humdrum world to enter into a special communion with the arts. The surroundings in which performances take place, or in which the arts are displayed, do contribute to, or detract from, the magical transformation induced by great works themselves. Which is not to deny, that, as the well-known Wallace Stevens poem has it, one can place a jar in Tennessee (or in the east end slum of a city) and bring some order to chaos, some beauty to the wasteland.

As I have emphasized throughout this book, ideological shifts have combined with sheer necessity to break down the barriers of the old elitism. Many of our arts institutions, now deprived of the comfort margin formerly provided by lavish public funding, have felt it necessary to transform their once-privileged or intimidating spaces in order to woo a much wider audience. Indeed, beginning in the 1980s and continuing through the next decade we have seen one example after another of arts institutions of all kinds actively, even aggressively, wooing the public by means of over-the-top advertising, technological gimmickry or the ad hoc and opportunistic linking of the so-called elite arts with popular culture. One can easily sympathize with the problems facing the harried presenters of the arts in Canada: their premise is that the greater the number of their audience and patrons, the more their institutions will be perceived as an integral part of the community. Community acceptance, they assume, will render them immune to the charge of "wasting money" on culture. In addition, such presenters often have a genuine sense of mission: they know the arts can be a wonderful, life-enhancing experience and they wish to make it possible for the public at large to find this out for themselves.

This new democratic passion (if that is what it is), this laudable desire to share the artistic wealth and to create access to culture where there was none before, has, however, a negative side, which it would be foolish to ignore. It is a long time since that great democratic elitist, the conductor Leopold Stokowski, shook hands with Mickey Mouse in Walt Disney's classic film *Fantasia*. Released in 1940, *Fantasia* was an early attempt to bridge the gap between elite and popular culture, and today, despite its flaws, the movie appears as an artifact far ahead of its time. In fact, on one or more occasions, almost every gallery and museum director, every presenter of opera and ballet, every purveyor of marginal culture in Canada has by now not only shaken hands with, but emphatically embraced, Mickey Mouse.

Many critics have noted, for example, that the Canadian Museum of Civilization in Hull has carried the Disney principle to an extreme in its children's museum. Its attempt to provide child and/or adult visitors with some minimal sense of other cultures, or of our own traditional Canadian life, has gone awry, some argue, because the museum is plagued by plastic exhibits and stagy settings, while presenting to the child-visitors in particular a Fisher-Price or Ikea-like world of bright colours and accident-proof edges. Similar outcries were heard when, in the mid-1990s, the Royal Ontario Museum opted for an exhibition of "teenage life," and another showing classic television sets, without making any profound attempt to situate either of them within the broader perspectives of Western culture. Equally unpalatable to some was the Art Gallery of Ontario's 1996 "OH! Canada" exhibition, where the technology and tricks sometimes seemed to overwhelm the art itself.

Opinion is divided on the question as to how far the so-called elite arts should go to attract a new audience. Some suggest that those who are drawn to such art will seek it out anyway and that the majority, bamboozled and bemused by popular culture, simply will not make the effort required to develop their taste, no matter how presenters sugarcoat their fare. Others feel that if serious art is shorn of its elitist trappings, it can appeal to almost anyone, and point to the increasing interplay between various levels of culture in the most exciting 20th-century artworks.

One of the problems noted by some is that technology often undermines mystery. Critics from Lewis Mumford to those of the present have reminded us of the special quality of the art space as a place to dream, to contemplate, to learn and to imagine. Visiting an art space, one should ideally be carried off in spirit to Greece, Africa, India, to early Canada, to some unfamiliar cultural or historical environment. Such an experience, these critics argue, must be capable of arousing joy and wonder, or of stirring grave reflection; it should perhaps awaken resistance to the follies of history and human nature.

In arts spaces or museums, visitors should encounter artifacts and images, texts or music—the treasures of human culture—on their own terms, and be moved by this encounter to understand the world a little differently. No doubt there was an unhealthy air of elitism in some of the arts presentations of a few generations ago. But if, as a young man or woman, you went to Massey Hall to hear a lecture by Thomas Mann or a recital by Sergei Rachmaninoff, or visited the Royal Ontario Museum (ROM) to see Egyptian artifacts, or on a trip to New York you walked up the steep stairs of the old Museum of Modern Art to find Henri Rousseau's *The Sleeping Gypsy* awaiting you, you probably recollect this as the experience of visiting a special place,

one where you were transported from the banalities of everyday life into a world of beautiful objects, new sounds or intriguing ideas.

Such experiences, fortunately, are still possible at the ROM, the Museum of Anthropology in Vancouver, at the National Gallery of Canada in Ottawa, indeed, at almost any location where specific presentations are not filtered through too obtrusive a technology, and where the aesthetically rare arts are not forced into a marriage of convenience with a blatant popular culture. Indeed, the traditionalists and the promoters of a thoroughly egalitarian art may both be served by the arrival of the World Wide Web, a natural medium for technical tricks and advertising pizzazz, one that, despite some limitations, is already showing its huge educational potential. The real challenge to arts presenters in the new century may be to exploit such technology to the full, while retaining something of the traditional ambiance of the gallery, museum or concert hall. Such a balance, many would argue, is needed today more than ever, simply because we live in a society where many people spend so much of their time in obtrusively ugly, banal and unaesthetic surroundings, or busy themselves day and night interpreting dots of light on television and computer screens.

The increasingly popular idea that arts spaces should be rooted in the local community has not meshed well with the vision of such facilities as national centres or showcases, a notion that originated in the federal cultural politics of the Trudeau era. Two major casualties of the changing times have been the National Arts Centre in Ottawa and, to a much lesser degree, the Confederation Centre of the Arts in Charlottetown. Both of these differ from the large galleries and museums in that the latter have an easier outreach. Going to look at paintings, anthropological exhibits and the like is a more broadly popular pastime than attending concerts of classical music or taking in new plays. The Confederation Centre, on the other hand, might be thought to have a (red-headed) ace in the hole in the person of the redoubtable *Anne of Green Gables*. Possibly, but if so, it has not always seemed to play this card correctly. In some ways it may have been trapped by the Anne mythology rather than freed to do other things by its power to attract visitors. Having marketed the "Anne show" since as early as 1965, the Confederation Centre in 1998 was looking hard for some fresh musical fare (it had staged no new musical in six years). Its directors were appealing across Canada for additional funding, on the grounds that not only tourists but artists from across the country were served by its existence.

The problems in Charlottetown were nothing, however, in comparison with the woes of the National Arts Centre (NAC) in Ottawa. The history of that institution is very instructive. Originally, it was to be a national showcase with year-round

programming and a full complement of in-house artistic groups. Touring capabilities were expected to develop, and a summer festival was planned and executed in the late 1970s. The $46-million start-up cost of the facility was deemed extravagant by many, however, and—although federal Liberal support for the concept of a national showcase remained strong—NAC programs were never guaranteed the massive funding that would have been required to fulfill such an ambitious mandate. Artists outside Ottawa, who had built or adapted facilities in the communities they served, often saw the NAC as an artificially imposed and rather hollow shrine to culture. At the same time, the NAC loftily ignored local artists and the Ottawa community, although part of its mandate was "to develop the performing arts in the National Capital Region."

The 1970s brought some brilliant years: many gifted performers passed through, but despite this, and even though several of its summer festival programs were successful, the NAC failed to become the national creative force that many, including its director general of the time, Donald MacSween, envisaged. By the beginning of the 1980s, the NAC was in serious decline. It remained in a limbo of non-event and mounting deficits for nearly a decade. Between 1995 and 1999, decline turned into crisis while at the same time taking on the proportions of a comic opera or farce.

After the embattled Joan Pennefather resigned as chief executive, without really having made a start, the NAC board of directors in September 1996 appointed John Cripton, a local impresario and former bureaucrat, to the post. There was hope that Cripton's arrival might mean a turnabout of fortune for the NAC, which had suffered, among its other woes, a year-long contract dispute between the National Arts Centre Orchestra musicians and management. Yet conflict ensued almost immediately between the new director general and a board, widely seen as meddlesome, led by the very visible and outspoken Jean-Thérese Riley. Cripton presided over the creation of two ambitious summer arts festivals, neither of which was as artistically or as financially successful as had been hoped. This exacerbated his conflict with the board, some of whose political appointees deemed him "an artistic visionary without fundraising or management experience."

Exit Cripton, and enter, as unexpected benefactor, Alexei Yashin, émigré Russian star of the Ottawa Senators hockey team, who astounded everyone by announcing in early 1999 that he was contributing $1 million to the NAC. Unfortunately, Yashin soon pulled the plug on his bequest, and a tangled mess of backroom negotiations was revealed. The original idea of a Yashin Foundation for the NAC, it seemed, had been somehow sidetracked in favour of a complex deal, or "side deal," involving Yashin's

parents, his agent and the originator of the foundation plan, Pat Reid, an Ottawa consultant. When the NAC finally decided that this arrangement had potentially "illegal" aspects, involving, as they claimed, a "fake invoice" and an alleged kickback to Yashin's parents, the so-called "pucks and tux" deal collapsed. Weeks of recrimination followed, which enmeshed both Cripton, who had been involved in the original negotiations with Yashin, and his successor, Elaine Calder, who had demurred at the implications of the deal. By the late summer of 1999, however, the NAC's "Russian winter" was only a sour memory. Calder was gone, and a new chairperson of the board, Donald Leighton, had replaced Riley, while Peter Herrndorf, a respected media executive, had been appointed to lead the NAC into the new century.

The NAC affair, despite some absurd touches, caused many to reflect on the issues of publicly funded arts spaces and on the marketing of culture in general. Although often conceived of as modern temples where the harried public can get a glimpse of beauty, public arts institutions are just as likely to become explosive arenas of intrigue, politics, ambition and manipulation. If the fallout from this affects the presentations—as it did in Ottawa—then new management structures, perhaps involving even privatization, would seem to be called for. No taxpayer could have taken pleasure from the fiasco at the NAC. But support might materialize for such institutions, even in their most dire moments, if they are perceived to be fulfilling their mandates artistically. No NAC director in recent years has turned the institution into an artistically exciting place. And what opportunities were missed. Yashin's money, instead of being invested in a "Vision of the North" festival, featuring all the great and popular Russian art alongside similar Canadian creations, resulted only in a few bits of Russian music being added to one or two concert programs.

Some critics have argued that no government decrees, no bureaucratic maneuvering, can substitute for the vision of a gifted impresario. One of the greatest of these was Serge Diaghilev, who brought Russian opera and ballet to Europe and fostered the art of Modest Mussorgsky, Igor Stravinsky, Maurice Ravel, Richard Strauss, the painters Alexander Benois and Nicholas Roerich, the renowned dancer Vaslav Nijinsky and the singer Feodor Chaliapin. Diaghilev, it is pointed out, was not funded by the czar or the Russian government. Compared with such legendary freewheeling promoters, mere mandarins, with huge accountability to legislatures, have little scope. Yet perhaps the very concept of a national facility for producing or showcasing art is foreign both to Canadian history and to our present reality.

As the 1990s drew to a close, both the Confederation Centre in Charlottetown and the NAC in Ottawa seemed to have good prospects for recovery from their bleak

decades. Nonetheless, their problems highlighted for many the difficulty of creating national centres in a nation that is so geographically diverse and so historically fragmented, and in a contemporary scene in which grassroots and community-related art, street festivals, artist-impresarios and small-scale management have produced such exciting results. Large museums and galleries will clearly always have a place, but some see a bleaker future for the performance centres. Are they all doomed to extinction? Are we returning to a time when art flourished by meeting the common citizen in the streets and the marketplaces, in the agora of the Greek city or in the raucous and wide-open theatres of Shakespeare's London? If such indeed is the case, then the "national arts centres," for all their aura of high culture, would have few mourners.

Barrett & MacKay

The Confederation Centre of the Arts in Charlottetown is making an effort to expand beyond being merely an arena of Anne of Green Gables *mythology.*

231

Major Canadian Museums

ALBERTA

Calgary Science Centre: This museum features the usual science exhibits. The facility includes Discovery Dome, a 70-millimetre film theatre, and Discovery Hall, a multimedia interactive resource with special features for children. Admission charge. Open Tuesday through Sunday. **701 – 11th St. SW**, **Calgary**, **AB**, **T2P 2M5**. Phone: **(403) 221 • 3700**; Fax: **(403) 237 • 0186**; Internet: **http://www. calgary sciencecentre.ca**

Glenbow Museum, **Calgary**: This 21,000-square-metre building is operated by the Glenbow-Alberta Institute and located in the heart of Calgary between the Calgary Tower and the Olympic Plaza. It features an outstanding collection of Inuit and Prairie Native art, also a good collection of military memorabilia, as well as various smaller items, coins, maps and rare books. A must if you are in Calgary. Admission charge. Open Tuesday through Sunday. **130 – 9th Ave. SE**, **Calgary**, **AB**, **T2G 0P3**. Phone: **(403) 268 • 4100**; Fax:

The *Royal Tyrrell Museum of Paleontology in Drumheller, Alberta features many prehistoric exhibits, sculptures and reconstructions such as this triceratops.*

(403) 265 • 9769; Internet: **http://www. glenbow.org**

Royal Tyrrell Museum of Palaeontology, **Drumheller**: Named after geologist Joseph Tyrrell—who, in 1994, found the first dinosaur bones in the area—this $30-million museum and research centre features a Palaeoconservatory, more than 40 dinosaur reconstructions, a vast number of skeletons and bones, plus various ways of accessing information about the dinosaur era. There is also an ancient landscape re-creation. This is a wonderful place to take kids. Admission charge. Open Tuesday through Sunday. **PO Box 7500**, **Midland Provincial Park**, **Drumheller**, **AB**, **T0J 0Y0**. Phone: **(403) 823 • 7707**; Fax: **(403) 823 • 7131**; Internet: **http://www.tyrrellmuseum.com**

Edmonton Space and Science Centre: This complex includes western Canada's first IMAX theatre, a planetarium star theatre, science exhibit galleries, a science shop, a public observatory and a café. Admission charge. Open Tuesday through Sunday. **11211 – 142nd St.**, **Edmonton**, **AB**, **T5M 4A1**. Phone: **(780) 451 • 3344**; Fax: **(780) 455 • 5882**; Internet: **http://www.edmontonscience.com**

Provincial Museum of Alberta, **Edmonton**: This museum offers lectures, natural science exhibits and special archaeological exhibitions from around the world. Admission charge. Open Tuesday through Sunday. **12845 – 102nd Ave.**, **Edmonton**, **AB**, **T5N 0M6**. Phone: **(780) 453 • 9100**; Fax: **(780) 454 • 6629**.

BRITISH COLUMBIA

Museum of Anthropology, **Vancouver**: Situated on the University of British Columbia

campus, Arthur Erickson's glass-and-concrete building—inspired by Native cedar houses—is justly celebrated, and the views of the Strait of Georgia are spectacular. Inside, once you proceed down a ramp, there are all kinds of Pacific Northwest Native art treasures, including Bill Reid's magnificent *Raven and the First Men* in the Great Hall and a veritable forest of totem poles and other tangible examples of Pacific First Nations cultural genius. You can browse through the collection, open drawers to inspect artifacts and do your own thing. Or you can stroll around the grounds on the Point Grey cliffs and discover many more totem poles, a Native family dwelling and a mortuary chamber. There is a small gift shop. Admission charge. Open Tuesday through Sunday. **6393 NW Marine Dr., Vancouver, BC, V6T 1Z2.** Phone: **(604) 822•3825.**

Science World, Vancouver: Built for Expo '86, this building's distinctive "golf ball" dome is now a well-known landmark in Vancouver. The museum features the usual interactive exhibits for children (such as the re-creation of a beehive); three main galleries that explore biology, physics and music; the OMNIMAX theatre, one of the world's largest wrap-around movie screen; and a very good gift shop, of course. Admission charge. Open daily. **1455 Québec St., Vancouver, BC, V6A 3Z7.** Phone: **(604) 443•7440** (admin.); **(604) 443•7443** (info.); Fax: **(604) 443•7430.**

Vancouver Museum: With a spectacular site in Vanier Park on False Creek, this museum's white cone-shaped roof suggests the traditional woven hats of the Coast Salish people. Inside there are thousands of Native artifacts, including masks, carvings and ceremonial objects. There are also displays of early B.C. pioneer life and depictions of the development of Vancouver. The complex also includes a planetarium. Small gift shop. Admission charge. Open daily May through September;

Tuesday to Sunday October through April. **1100 Chestnut St., Vancouver, BC, V6J 3J9.** Phone: **(604) 736•4431; (604) 736•5417;** Internet: **http://www.vanmuseum.bc.ca**

Royal British Columbia Museum, Victoria: This world-class museum's Northwest Native Canadian art puts it on any shortlist of "most worth a visit." The museum has excellent dioramas re-creating different historical aspects of British Columbia, the natural history of the province and the culture of the province's First Nations. Gift shop and café. Admission charge. Open daily. **675 Belleville St., Victoria, BC, V8V 1X4.** Phone: **(250) 387•3701;** Fax: **(250) 356•8197;** Internet: **http://rbcm1. rbcm.gov.bc.ca**

MANITOBA

Manitoba Museum of Man and Nature, Winnipeg: A large collection covering the human and natural history of Manitoba. All aspects of natural history are well documented, and there are numerous archaeological items. In addition, there is a replica of a 17th-century fur-trading ship. The multicultural history of Manitoba is well presented, and the adjoining planetarium offers multimedia presentations on astronomy. Admission charge. Open daily.

Science World

Housed in a distinctive dome built for Expo '86, *Vancouver's Science World is full of displays and exhibits that explore the wonders of science.*

Royal British Columbia Museum

Tim Paul's "Ma-ii l-pa-tu—How We Revere the Family" *is one of the many First Nations pieces on display at the Royal British Columbia Museum in Victoria.*

190 Rupert Ave., **Winnipeg**, MB, R3B 0N2. Phone: **(204) 956 • 2830**; Fax: **(204) 942 • 3679**; Internet:**http://www.manitobamuseum.mb.ca**

NEW BRUNSWICK

New Brunswick Museum, **Saint John**: The collection here includes ornithology, mammals, fish and geology specimens and exhibits. There are also historical maps and military and transportation items of provincial significance. The exhibition of old models, built as part of the planning process for the construction of 19th-century sailing ships, is outstanding. The art department displays the work of New Brunswick artists of the 19th and 20th centuries. Admission charge. Open Tuesday through Sunday. **277 Douglas Ave.**, **Saint John**, NB, E2K 1E5. Phone: **(506) 658 • 1842**;

Fax: **(506) 643 • 2360**; Internet: **http://www.gov.nb.ca/nbmuseum/index.html**. Second site: **1 Market Square**, **Saint John**, NB, E2Z 4Z6. Fax: **(506) 643 • 6081**.

NEWFOUNDLAND

Newfoundland Museum, **St. John's**: Specializing in Newfoundland archaeology and ethnology, this museum features aboriginal Canadian artifacts, particularly from the Inuit and Beothuk cultures. There are also many examples of provincial folk arts and crafts, including furnishings and tools. Military, maritime and natural history collections round out the exhibits. Admission free. Open daily. **285 Duckworth St.**, **St. John's**, NF, A1C 1G9. Phone: **(709) 729 • 2329**; Fax: **(709) 729 • 2179**; Internet:**http://www.del.web.com/nfmuseum**

NOVA SCOTIA

Nova Scotia Museum of Natural History, **Halifax**: This museum is the terminus for 24 branch museums throughout the province. The whole collection includes furniture, ceramics, glass, textiles, marine artifacts and historic houses and mills, all with some significance in provincial history. Here the visitor may find such diverse items as stagecoaches, items from old lighthouses, spinning wheels and venerable household implements. The museum's holdings also include Native Canadian artifacts, especially those of the Micmac. And there is a large natural history collection. Admission free. Open daily (closed Mondays in winter). **1747 Summer St.**, **Halifax**, NS, B3H 3A6. Phone: **(902) 424 • 7353**; Fax: **(902) 424 • 0560**; Internet: **http://www.ednet.nature.ca**

ONTARIO

Canadian War Museum, **Ottawa**: A terrific museum, with such delights as a model layout of the Normandy invasion scene, Hermann

Göring's staff car, a full-size simulation of a First World War trench and a Sopwith Camel airplane suspended from the ceiling. The exhibit includes war art by noted Canadian artists and much more. You get a real sense of Canada's past here. A fair gift shop. Admission charge. Open daily. **330 Sussex Dr., Ottawa, ON, K1A 0M8.** Phone: **(613) 776 • 8600**; Fax: **(613) 776 • 8279**; Internet: **http://www. warmuseum.ca**

National Aviation Museum, Ottawa: First opened in 1988, this museum boasts a fine collection of antique aircraft and more recent vintage planes. The exhibition hall is huge and holds up to 50 planes of various sizes. There is a smaller upstairs gallery. Some possibility of hands-on experience, but it is the beauty of the old planes that makes it worthwhile. Admission charge. Open Tuesday through Sunday. Location: **Rockcliffe and Aviation Parkways**; Administration: **PO Box 9724, Stn. T, Ottawa, ON, K1G 5A3**. Phone: **(613) 993 • 2010**; Fax: **(613) 990 • 3655**; Internet: **http://www.aviation.nmstc.ca**

National Museum of Science and Technology, Ottawa: This is a favourite museum with kids because of the hands-on gimmickry, measuring devices, bells and electrical items. How much of this interactive trickery gets across ideas of science is an open question. Nonetheless, it can be exciting to see the space exhibits (including Soviet examples), the cars and the locomotives; these are well displayed and may stir the requisite sense of awe that will bring someone close to the spirit of scientific discovery in our time. As with the National Aviation Museum, this museum is located a little off the beaten track, and with Ottawa's lamentable public transport, unless you have a lot of time, you really need a car to get to it. Admission charge. Open Tuesday through Sunday. **1867 St. Laurent Blvd., Ottawa, ON, K1G 5A3**. Phone: **(613) 991 • 3044**; Fax: **(613) 990 • 3654**; Internet: **http://www. nmstc.com**

Science North, Sudbury: Located on a rocky spur overlooking Ramsey Lake, 2.6 kilometres south of the Trans-Canada Highway, this $28-million science museum comprises a snowflake structure (partially designed by architect Raymond Moriyama), a glass-walled walk-up ramp and intriguing tunnels and annexes. Simply visiting the building can be a unique and powerful experience, since the design harmonizes with and amplifies the ruggedly beautiful environment, but the exhibits, mostly hands-on, are ingeniously laid out and varied. They present not only every aspect of northern geology and all facets of the landscape of the Canadian Shield, but also the area's technological history, including the very human story of the first prospectors and miners. You can "go underground" at the Big Nickel mine exhibit, one of the few authentic hard-rock mines open to the public in Canada. Restaurant, lounge bar and cafeterias. Admission charge. Open year-round with extended hours in summer. **100 Ramsey Lake Rd., Sudbury, ON, P3E 5S9**. Phone: **(705) 522 • 3700**; Fax: **(705) 522 • 4954**; Internet: **http://sciencenorth. on.ca**

Bata Shoe Museum, Toronto: A collection spanning 4,000 years, with nearly 10,000 artifacts, guaranteed to drive fetishists wild. Only in Toronto, right? Admission charge. Open Tuesday through Sunday. **327 Bloor St. W, Toronto, ON, M5S 1W7**. Phone: **(416) 979 • 7799**; Fax: **(416) 979 • 0078**.

George R. Gardiner Museum of Ceramic Art, Toronto: This collection consists of 2,000 pieces, including pre-Columbian pottery that dates back to 3000 BC. The museum is a clean, well-documented place opposite the Royal Ontario Museum (of which it is now a part), admission to which is included in your ticket to the Gardiner. This place seems a little sterile, but maybe that is the way of pottery museums. Terrific if you are passionate about pots. Open

Tuesday through Sunday. **111 Queen's Park, Toronto, ON, M5S 2C7.** Phone: **(416) 586 • 8080.**

Hockey Hall of Fame Museum, Toronto: The Stanley Cup is housed here, as are most of the major Canadian hockey trophies. Memorabilia to make you weep: uniforms, hockey sticks and skates of the great and famous. Photographs, audiovisual shows, many postcards and posters, as well as special exhibits on various aspects of the game. Also some great inter-active features: find out how hard your slapshot is! A must for even the casual fan. Open daily except Christmas Day and New Year's Day. Admission charge. **BCE Place, 30 Yonge St., Toronto, ON, M5E 1X8.** Phone: **(416) 360 • 7765**; Fax: **(416) 360 • 1316**; Internet: **http://www.hhof.com**

Ontario Science Centre, Toronto: Designed by architect Raymond Moriyama and built in 1967, this facility, with its fine modern ambiance and interactive exhibits, has several special areas: the Food/Earth Hall, Exploring Space, the Hall of Communication, the Hall of Life, the Hall of Transportation, the Science Arcade and the Hall of the Atom. A pleasant place to wander through, with innumerable hands-on exhibits. There is much information here, providing solid access to various fields of science. No guided tours. Admission charge. Open daily except Christmas Day. **770 Don Mills Rd., Toronto, ON, M3C 1T3.** Phone: **(416) 429 • 4100**; Fax: **(416) 696 • 3166**; Internet: **http://www.osc.on.ca**

Royal Ontario Museum (ROM), Toronto: The ROM is Canada's largest public museum, with a total of 20 departments. It is one of the great Canadian cultural experiences; the Chinese art alone is stupendous. The museum was established by an act of the Ontario Legislature in 1912. The original building, now the west wing, was officially opened in 1914 by the Duke of Connaught, then governor general of

Canada. In 1933, two additions were built; two more went up after that, including the McLaughlin Planetarium, and the George R. Gardiner Museum of Ceramic Art, which was added in 1987. There were extensive renovations during the late 1970s and the early 1980s. Three administrative divisions, 10 science departments, and nine art and archaeology departments make up the ROM. The Egyptian, Greek, Roman and Chinese collections are large and rich; everyone in Canada should make an effort to see them. (The ROM gets about one million visitors a year.) The galleries themselves are organized around comprehensive subjects or areas, for example, life sciences, East Asia, the Mediterranean world. The museum also boasts impressive dinosaur displays and a simulated bat cave (always a hit with children). The Garfield Weston Hall houses travelling exhibitions and some of the larger museum presentations. Recent controversies, in particular a fiasco surrounding the *Into the Heart of Africa* exhibition, and a few superficial presentations have woken up the staid old ROM to the dangerous life curators can lead in a world in which institutional walls have become largely transparent. During 1998 and 1999, the museum opened 30,000 square feet of new gallery space and carried on field expeditions and excavations around the world. The museum offers public programs: demonstrations, concerts, dramatic performances, special events, lectures and films and identification of specimens and artifacts for the public. Cafeteria and large gift shop. Admission charge (includes George R. Gardiner Museum of Ceramic Art). Closed Mondays between Labour Day and Victoria Day, as well as Christmas Day and New Year's Day. Open all other days. **100 Queen's Park, Toronto, ON, M5S 2C6.** Phone: **(416) 586 • 8000** (info); Fax: **(416) 586 • 5863**; Internet: **http://www.rom.on.ca**

QUÉBEC

Canadian Museum of Civilization, Hull: Opened in 1989, this $225-million museum designed by part-Métis architect Douglas Cardinal is located across the river from Ottawa. It is a great sight, but views of it stir up some ironical reflection in the knowing, since its authentic North American Native non-geometrical and "organic" style (which derives from Europe and Frank Lloyd Wright!) surrounds many exhibits that seem more like items from a Los Angeles shopping mall. The museum contains a Grand Hall, which is 91 metres long and five stories high—very impressive indeed—and a theatre showing IMAX and OMNIMAX movies. There is also a resource centre and a children's museum. The building is lovely to look at, but the museum is very disappointing and has been so from the start. At first it seemed to be mostly empty, then a series of exhibits was created in the Canada Hall, which some critics describe as artificial and uninvolving, slick and lacking in texture. Some find the dioramas too reminiscent of Hollywood stage sets or back-lot scenery. At the very least they are rather superficial and without much "feel" of the past. The children's museum has also been criticized as too slick and "plastic." In all this, Disneyland is not far away. Even so, the museum is a spectacular sight and a pleasant enough place to visit when the temporary exhibits warrant it—as they often do—and the ambiance of the great hall itself is memorable. Admission charge. Open daily (except Mondays in winter). **100, rue Laurier, Hull, QC, J8X 4H2.** Phone: **(819) 776 • 7000;** Internet: **http://www.civilization. ca**

Musée de la Civilisation, Québec City: The museum features a huge collection of artifacts organized to show various aspects of Québec tradition, including European connections with the province, as well as First Nations and Inuit artifacts and traditions. The building, designed by architect Moshe Safdie, blends beautifully into the traditional architecture that surrounds it in the city's Old Port. Visitors will enjoy the important artifacts on display in the permanent and temporary exhibitions. Notable permanent exhibits include La Barque, a 250-year-old boat (the oldest of its kind in North America) that was found at the site of the museum. Admission charge for adults. Closed Mondays from November to May. Open all other days. **85, rue Dalhousie** (near Place Royale), **Québec City, QC, G1K 7A6.** Phone: **(418) 643 • 2158;** Fax: **(418) 646 • 9705;** Mailing address: **PO Box 155, Stn. B.**

SASKATCHEWAN

Saskatchewan Museum of Natural History, Regina: This museum specializes in three areas—First Nations artifacts, Saskatchewan wildlife and earth sciences as they relate to the regional environment. Excellent dioramas and paintings. Admission free. Open daily except Christmas Day. **2445 Albert St., Regina, SK, S4P 3V7.** Phone: **(306) 787 • 2815;** Fax: **(306) 787 • 2820.**

Major Canadian Performance Centres

ALBERTA

Calgary Centre for the Performing Arts: Opened in 1985, this complex contains the 1,800-seat Jack Singer Concert Hall (home of the Calgary Philharmonic) and four theatre spaces, including the 750-seat Max Bell Theatre, home of Theatre Calgary. Alberta Theatre Projects and One Yellow Rabbit are also housed in the centre. **205 – 8th Ave. SE, Calgary, AB, T2G 0K9**. Phone: **(403) 294•7455**; Fax: **(403) 294•7457**; Internet: **http://www.thearts centre.org**

Citadel Theatre, Edmonton: Renovated in the 1980s and 1990s, this is one of Canada's architectural gems. (See chapter one.) **9828 – 101A Ave., Edmonton, AB, T5J 3C6**. Phone: **(780) 426•4811**.

BRITISH COLUMBIA

Shadbolt Centre for the Arts, Burnaby: As a performance and educational resource centre, this facility has produced graduates such as Michael J. Fox and Jon Kimura Parker. The centre offers some performances, but the focus is on teaching dance, film, acting, photography, stage-managing, pottery, painting and piano. **6450 Deer Lake Ave., Burnaby, BC, V5G 2J3**. Phone: **(604) 291 • 6864**; Fax: **(604) 205 • 3001**.

Presentation House Gallery, North Vancouver: This facility is a multi-purpose performing-arts centre that serves as a transfer house for many fringe festival productions. It also acts as a venue for small Lower Mainland theatre companies. **333 Chesterfield Ave., North Vancouver, BC, V7M 3G9**. Phone: **(604) 986•1351**; Fax: **(604) 986•5380**; Internet: **http://www.presentationhouse.gall.com**

Firehall Arts Centre, Vancouver: This multi-purpose facility specializes in dance and theatre. It is the home of the Karen Jamieson Dance Company and Kokoro Dance. It also houses resident theatre companies such as Touchstone. **280 Cordova St. E, Vancouver, BC, V6A 1L3**. Phone: **(604) 689•0926**; Fax: **(604) 684•5841**.

Orpheum Theatre, Vancouver: Restored in 1975, this building is an art deco wonder of sorts. It is the home of the Vancouver Symphony Orchestra. Location: **Smithe at Seymour**. Administration: **649 Cambie St., Vancouver, BC, V6B 2P1**. Phone: **(604) 665•3050**.

Queen Elizabeth Theatre and Playhouse, Vancouver: Vancouver's answer to Toronto's Hummingbird Centre, this 2,800-plus-seat facility serves as a roadhouse for big, glitzy touring productions such as the Broadway hit *Angels in America*, presents dance and music events and is the home of the Vancouver Playhouse and Vancouver Opera. **630 Hamilton St., Vancouver, BC, V6B 2R3**. Phone: **(604) 665•3050**.

Vancouver East Cultural Centre, Vancouver: Once a church, this immaculately restored building now houses a 350-seat theatre space. "The Cultch," as it is known locally, presents an intriguing mix of dance, music, performance art, theatre and children's events. It is also the home of Green Thumb Theatre for Young People and Touchstone Theatre. **1895 Venables St., Vancouver, BC, V5L 2H6**. Phone: **(604) 254•9578**; Fax: **(604) 251•1730**; Internet: **http://www.vecc.bc.ca**

Vogue Theatre, Vancouver: This venerable old theatre in downtown Vancouver is a little worn

around the edges, but the city has a soft spot for it. Like many old-time urban theatres, it has seen a lot of transformations. Today it serves as a roadhouse for all manner of live events. **918 Granville St., Vancouver, BC, V6Z 1L2.** Phone: **(604) 331 • 7900.**

Carousel Theatre, Vancouver: Located on Granville Island, this facility plays host to a number of small theatre companies. **1411 Cartwright St., Vancouver, BC, V6H 3R7.** Phone: **(604) 685 • 6217.**

MANITOBA

Manitoba Centennial Concert Hall, Winnipeg: Home of the Royal Winnipeg Ballet and the Winnipeg Symphony Orchestra, this facility dates back to 1968. **555 Main St., Winnipeg, MB, R3B 1C3.** Phone: **(204) 956 • 1360**; Fax: **(204) 944 • 1390.**

ONTARIO

Hamilton Place: This complex was opened in the early 1970s and contains 2,181-seat and 350-seat theatres. The performance centre is located on **Summers Lane.** Mailing address: **10 Macnab St. S, Hamilton, ON, L8P 4Y3.** Phone: **(905) 546 • 3100**; Fax: **(905) 521 • 0924**; Internet: **http://www.hecfi.on.ca**

National Arts Centre, Ottawa: Includes a 2,236-seat opera house, a 969-seat theatre, a 350-seat studio and a 150-seat salon. The facility, perhaps because of its concrete-bunker style and because it faces the Rideau Canal and not Elgin Street, has always been underrated. However, it certainly hit the headlines during 1999 when the board of trustees and management clashed and Alexei Yashin, the Russian hockey star, got into the act with a $1-million donation that he later withdrew. Street location: **53 Elgin St.** Mailing address: **PO Box 1534, Stn. B, Ottawa, ON, K1P 5W1.** Phone: **(613) 996 • 5051.**

Elgin and Winter Garden Theatre Centre, Toronto: These theatres from the 1920s were beautifully restored in the 1980s by the provincial government. For a long time, the Elgin was a second-run movie house (it even did a stint as a purveyor of adult films). The Winter Garden, above the Elgin, actually lay dormant for 60 years until it was rescued. Today the theatres host big-budget musicals (in the Elgin) such as *Cats* and concerts (usually in the Winter Garden). **189 Yonge St., Toronto, ON, M5B 1M4.** Phone: **(416) 314 • 2901; (416) 872 • 5555** (tickets); Fax: **(416) 314 • 3583.**

Ford Centre for the Performing Arts, North York: After the fall of Garth Drabinsky in 1998, this theatre found itself near chaos, with cancellations, lawsuits over tickets, pleas for bailouts and other unpleasant business. Although Drabinsky's Livent did not actually own this facility, it managed and operated it. Heavily entangled with Livent productions and commitments, the centre struggled through 1999, trying mightily to save some performances, and actually went to court in an attempt to recover ticket revenue it claimed the Drabinsky operation owed the public. Although the future of this excellent facility was not in doubt, the era of *Show Boat* and *Sunset Boulevard* at this North York location seem to be over. **5040 Yonge St., North York, ON, M2N 6R8.** Phone: **(416) 872 • 2222.**

Harbourfront, Toronto: A versatile complex presenting theatre, dance, the most prestigious author-reading series in Canada (perhaps the world) and other events in a number of venues, most notably the Premiere Dance Theatre and the du Maurier Theatre Centre. Recently threatened by real and proposed funding cuts, it continues in a scaled-down form and may not be out of the woods yet. **235 Queens Quay W, Toronto, ON, M5J 2G8.** Phone: **(416) 973 • 4000** (box office); **(416) 973 • 3000** (info.); Internet: **http://www.harbourfront.on.ca**

Hummingbird Centre for the Performing Arts, Toronto: Formerly called the O'Keefe Centre, this has long been the home of the Canadian Opera Company and the National Ballet of Canada. Despite expensive renovations, the place has always resembled an airport terminal, and the news of a planned $113-million replacement facility for the opera and ballet companies, to be completed early in the new century, came as welcome news to all. **1 Front St. E, Toronto, ON, M5E 1B2**. Phone: **(416) 872•2262** (tickets).

Massey Hall, Toronto: This noble old building opened in 1894, underwent major renovations in the 1930s, and got something of a subsequent facelift in the early 1990s. The facility seats just less than 3,000. A lot of history has been made here; some may think the hall echoes with the sounds of Charlie Parker and Jascha Heifetz and the voices of Enrico Caruso and Thomas Mann—they all paid it a visit. Northrop Frye even took part in a typewriting competition on the stage when he was a teenager. **178 Victoria St., Toronto, ON, M5B 1T7**. Phone: **(416) 872•4255** (tickets).

Pantages Theatre, Toronto: This fine old theatre in the heart of Toronto was renovated and turned into a glittering gem by Garth Drabinsky's Livent group. With the demise of Livent, the theatre was taken over in 1999 by SFX Entertainment, a New York company that promotes and produces drama and runs some 82 other venues across North America. **263 Yonge St., Toronto, ON, M5B 1N8**. Phone: **(416) 872•2222** (tickets).

Princess of Wales Theatre, Toronto: Ed Mirvish already had a theatre on King Street, but as the mega-musical sweepstakes heated up, he decided he needed another one, cheek-by-jowl with the Royal Alexandra. This 2,000-plus-seat facility features decorative paintings by American abstract expressionist Frank Stella. It is also permanently devoted to such overblown fare as *Miss Saigon*. **300 King St. W, Toronto, ON, M5V 1H9**. Phone: **(416) 593•0351**; Internet: **http://www.onstage now.com**

Royal Alexandra Theatre, Toronto: This treasured building was bought and restored by Toronto entrepreneur Ed Mirvish in 1963. Mirvish presents a subscription theatre season that is usually a mix of British and American chestnuts and hits. In the past, though, Ed's son, David, has brought in some interesting fare such as the Berliner Ensemble, a British production of Shakespeare's *King Henry* plays and a remounting of Tomson Highway's *Dry Lips Oughta Move to Kapuskasing*. The theatre has also been the venue for big-budget musicals such as *Les Misérables*. **260 King St. W, Toronto, ON, M5V 1H9**. Phone: **(416) 593•4211**; Internet: **http://www.onstagenow.com**

Roy Thomson Hall, Toronto: Designed by Canadian architect Arthur Erickson and opened in 1982, this hall is the home of the Toronto Symphony Orchestra, which formerly resided in Massey Hall. The fancy facility with the curious exterior has state-of-the-art technology but questionable acoustics. **60 Simcoe St., Toronto, ON, M5J 2H5**. Phone: **(416) 593•4828** (tickets).

St. Lawrence Centre, Toronto: This centre, the home of the Canadian Stage Company's principal theatres, has seen many renovations to improve seating and acoustics. Although it has something of the institutional about it, it is vastly superior to the nearby barn called the Hummingbird Centre. **27 Front St. E, Toronto, ON, M5E 1B4**. Phone: **(416) 366•7723** (box office); Fax: **(416) 947•1387**.

Theatre Centre, Toronto: This facility is the venue for a number of Toronto's smaller theatre companies. **1032 Queen St. W, Toronto, ON,**

M6J 1H7. Phone: (416) 538 • 0988; Fax: (416) 532 • 8603.

NEWFOUNDLAND

Arts and Culture Centre, St. John's: This centre is a small multi-purpose performing arts space. **PO Box 1854, St. John's, NF, A1C 5P9.** Phone: **(709) 729 • 3900** (box office); **(709) 729 • 3650** (admin.); Fax: **(709) 729 • 0247.**

NORTHWEST TERRITORIES

Northern Arts and Cultural Centre, Yellowknife: A cultural centre in the Far North? Yes, indeed. This 313-seat facility opened in 1984 to a great deal of fanfare, which was justly deserved. **PO Box 1025, Yellowknife, NT, X1A 2N7.** Fax: (867) 669 • 7826.

PRINCE EDWARD ISLAND

Confederation Centre of the Arts, Charlottetown: Anne of Green Gables and her troupers need a face-lift. **145 Richmond St., Charlottetown, PE, C1A 1J1.** Phone: **(902) 566 • 1267** (box office); **(902) 628 • 1864** (admin.); Fax: **(902) 566 • 4648**; Internet: **http://www.confederationcentre.com**

QUÉBEC

Place des Arts, Montréal: Salle Wilfrid-Pelletier, which opened in 1963, is the largest facility, with a seating capacity of about 3,000. The two theatres accommodate 1,300 and 750 respectively. There is also an intimate theatre that seats 130. This is the home of the Montréal Symphony Orchestra, Les Grands Ballets Canadiens and Opéra de Montréal. Very pleasant but, like a lot of its performance-centre cousins across the country, it is getting a little shopworn. **175, rue Sainte-Catherine O, Montréal, QC, H2X 1Z8.** Phone: **(514) 842 • 2112.**

Saidye Bronfman Centre, Montréal: In the late 1980s things looked grim for this performance centre—activities were even suspended for a time—but it has rebounded with subscription theatre seasons, usually two or three English and a couple of Yiddish works each year. It is the home of the Yiddish Theatre and often features the latest hits from New York. The centre also does in-house productions and encourages the work of younger theatre people. **5170, Ch Côte-Sainte-Catherine, Montréal, QC, H3W 1M3.** Phone: **(514) 739 • 7944.**

Grand Théâtre du Québec, Québec City: This facility is the home of the Québec Symphony Orchestra. **Phone: (418) 643 • 8131.**

SASKATCHEWAN

Saskatchewan Centre of the Arts, Regina: This facility contains a 2,000-plus-seat theatre and also serves as a convention centre. **200 Lakeshore Dr., Regina, SK, S4P 3V7.** Phone: **(306) 565 • 4500**; Fax: **(306) 565 • 3274.**

Saskatoon Centennial Auditorium: This is a multi-use facility. **35 – 22nd St. E, Saskatoon, SK, S7K 0C8.** Phone: **(306) 975 • 7777; (306) 938 • 7800** (box office); Fax: **(306) 975 • 7804.**

Gardens, Special Buildings and Intriguing Cityscapes

ALBERTA

West Edmonton Mall, Edmonton: This is the largest mall/amusement park in the world, according to *The Guinness Book of Records*. The mall occupies over 1.4 million square metres and contains 800 shops and services, which include the 20-ride Fantasyland and its namesake hotel, a water park, and a miniature golf course. Admission charge for most attractions. Open daily. **87th Ave. and 170th St., Edmonton, AB**. Phone: **(780) 444•5200**.

BRITISH COLUMBIA

Barkerville: At one time, during the 1860s Fraser River gold rush, this town boasted 10,000 people. By the turn of the century, gold fever was long gone. By the 1950s, Barkerville was a ghost town. Later in the decade the provincial government restored the once-proud boomtown and turned it into a historical site, which it still is today. Relive the days of gold fever. **Tourism British Columbia**, Toll Free: **1 (800) 663•6000**.

Butchart Gardens, Vancouver Island: Jennie Butchart's estate, a limestone quarry approximately 90 years ago, is now 20 hectares of various styles of garden: formal Italian, Japanese and English. A restaurant and gift shop are found on the premises. A lovely place to visit while staying in nearby Victoria. Phone: **(250) 652•4422**.

Chinatown, Vancouver: With North America's second-largest Chinese community (San Francisco still has the largest), it is not surprising that Vancouver boasts one of the most significant Chinatowns on the continent. This crowded, exuberant area, located between Carrall Street and Gore Avenue in downtown Vancouver, features the "world's thinnest office structure," the Sam Kee Building, as well as phone booths topped by pagoda-style roofs, dragon-decorated streetlights, and a host of shops selling everything under the sun, not to mention some of the best Chinese food in the country. **Vancouver Tourist Infocentre**, Phone: **(604) 683•2000**.

Gastown, Vancouver: Even if it is a little cheesy and crowded with tourists, it is Vancouver's historic first settlement. The original town grew up in the 1860s around the Globe Saloon, owned by Gassy Jack Deighton, a local character and river pilot known for his gift of the gab. As the city grew, Gastown became its skid row until renovation and restoration reclaimed the venerable area in the 1960s. Cobblestones, old-fashioned streetlights, a steam clock, courtyards, boutiques and cafés bring tens of thousands of tourists and locals into the area for a grand old time. Gassy Jack would approve, or would he? Located between Hastings, Water, Homer and Columbia streets. **Vancouver Tourist Infocentre**, Phone: **(604) 683•2000**.

Granville Island, Vancouver: A large indoor market (offering fresh seafood, meat, fruits and vegetables and various specialty items) located under the south end of the Granville Bridge is only one of the many pleasures of this enjoyable cityscape. Granville is, in fact, a demi-island of pleasure almost in the heart of the city, where you can find a quiet or noisy bar or restaurant, theatres, many shops, a bookstore or two, one

of Canada's best art schools (Emily Carr Institute of Art and Design) and in general meditate, vegetate or people-watch to your heart's content. **Administration office, 1661 Duranleau St., Vancouver, BC, V6H 3S3.** Phone: **(604) 666 • 5784.**

Fort Langley, near Vancouver: Established in 1827, this was the first fur-trading post in the lower Fraser Valley. Now it is one of the finer examples of a restored Hudson's Bay Company fort in western Canada. **Tourism British Columbia,** Toll Free: **1 (800) 663 • 6000.**

Fort Steele, near Cranbrook: Once known as Stud Horse Creek, this 1880s gold boomtown was originally established by the Mounties' famous Sam Steele. In those days, the raucous mini-town was a powder keg of tension between impatient miners and angry Kootenay Natives. At the turn of the century, Fort Steele became a ghost town; the province restored the fort and turned it into a historical site in the 1960s. **Tourism British Columbia,** Toll Free: **1 (800) 663 • 6000.**

Vancouver Aquarium, Stanley Park, Vancouver: This is Canada's largest and most renowned aquarium, with more than 9,000 aquatic inhabitants. Special features include killer whale shows and public feedings. There is currently a big controversy as to whether this, or any such facility, should exist. Animal-rights people say no; many researchers say yes. The aquarium is, of course, particularly popular with children. The park itself is one of the world's great urban green spaces (400 hectares) and includes a 10.5-kilometre-long sea wall, sensational views, a forest containing totem poles. Admission charge to the aquarium; the park is free. Open daily. Phone: **(604) 268 • 9900.**

MANITOBA

Lower Fort Garry, near Winnipeg: Established 30 kilometres downriver from Winnipeg (originally Fort Garry) by the Hudson's Bay Company in the 1830s, this post, the oldest intact stone fort in western Canada, was intended to serve as the hub of the new Red River Colony. This place has seen a lot of history: anti-Louis Riel forces gathered here, the Mounties trained their first recruits at the fort, and the post later served as the province's first penitentiary and insane asylum. It even filled in as a country club for Hudson's Bay officials. Today it belongs to Parks Canada and is one of the pearls in the string of superb restored forts that adorn the country from coast to coast. **Travel Manitoba,** Phone: **(204) 945 • 3777** or **Tourist Information,** Toll Free: **1 (800) 665 • 0040.**

NEW BRUNSWICK

Acadian Village, Caraquet: Built in 1977 as a memorial to deported French settlers, this 200-hectare site features authentic Acadian homes and other public buildings, including a restaurant specializing in Acadian cooking. Open daily early June to early September. Phone: **(506) 727 • 3467.**

Kings Landing Historical Settlement, near Fredericton: Forty kilometres west of Fredericton, this outdoor museum covers about 160 hectares in the Saint John River Valley. It was established by the province in the early 1960s but didn't open officially until 1974. The United Empire Loyalist "settlement" contains more than 70 restored buildings such as homes, a church, a school, a carpenter's shop, a blacksmith forge and an inn, with the intention of re-creating long-past times from the late 18th century to the late Victorian era. **Tourist Information,** Toll Free: **1 (800) 561 • 0123.**

NEWFOUNDLAND

L'Anse aux Meadows: Designated a World Heritage Site by UNESCO in 1978, this was the first authentic Norse site found in North America. It is located on the northern tip of Newfoundland's Great Northern Peninsula and was thought to harbour evidence of Norse landings by Newfoundlander William Munn as long ago as the 15th century. However, it wasn't until 1960 that remains were actually discovered. Today the archaeological dig consists of three building complexes, each consisting of a large dwelling and related workshops. The grassy coastal site also features evidence of aboriginal Canadian cultures such as Maritime Archaic, Groswater and Dorset Inuit. **Tourist Information**, Toll Free: **1 (800) 563 • 6353**.

Port au Choix: The name of this historic site on the west side of Newfoundland's Great Northern Peninsula is a corruption of the Basque *portuichoa*, or "little harbour." Winterhouse remains and outdoor hearths of the prehistoric Dorset Inuit and a cemetery from the Maritime Archaic culture are among the many finds in here. All of the artifacts indicate that aboriginal Canadians lived here as long ago as 2000 BC. In the colonial era, a major Basque fishing station was located on the site in the early 16th century. **Tourist Information**, Toll Free: **1 (800) 563 • 6353**.

NOVA SCOTIA

Fortress of Louisbourg: Built between 1720 and 1745 on Cape Breton Island, the original was the most impressive fort and trading post in North America in the 18th century. Its restoration was a monumental task. On the top of the chateau, which is 111 metres long, with walls 60 centimetres thick, stands a 113-kilogram fleur-de-lis made of wrought iron. The site is a few miles outside Louisbourg on the Atlantic coast. The attendants play-act a bit in a harmless way. Admission charge. Open daily June 1 to Sept. 30; outside walking tours in May and October. Information: **PO Box 160**, **Louisbourg**, **NS**. Phone: **(902) 733 • 3100**.

Grand Pré: In 1755, 4,000 Acadians were forced to leave this community by British soldiers fearing a potential challenge to their military authority. One of the oldest (established circa 1680) French settlements in Nova Scotia and the setting for the Longfellow poem *Evangeline*, Grand Pré is the site of a national historic park honouring the deported Acadians. The park is 83 kilometres northwest of Halifax. **Tourist Information**, Toll Free: **1 (800) 565 • 0000**.

Halifax Public Gardens, Halifax: The oldest formal Victorian gardens in North America, first created in 1867 and enlarged to their current seven hectares in 1874. A bandstand in the centre of the gardens commemorates Queen Victoria's Golden Jubilee in 1887 and acts as a stage in the summer. **Spring Garden Rd.**, **Summer St.**, **Sackville St.** and **South Park St.**, **Halifax**, **NS**. **Tourist Information**, Toll Free: **1 (800) 565 • 0000**.

Lunenburg: This well-known Canadian civic icon was originally founded by Acadians in the early 18th century and called *Merliguesche*. The British, just before the Acadian Expulsion of 1755, settled mostly German-speaking Protestant immigrants here to create Lunenburg. Today the town is a rich part of Canada's history. As a classic fishing village of the east coast, it was designated as a World Heritage Site by UNESCO. Home to many of the country's oldest Protestant churches and the site of the launching of the famous racing schooner *Bluenose*, Lunenburg is still an important centre of the Maritimes' beleaguered fishing industry. **Tourist Information**, Toll Free: **1 (800) 565 • 0000**.

ONTARIO

Black Creek Pioneer Village, North York: This "living history" museum depicts life as it was in rural Upper Canada before Confederation. It consists of five buildings constructed on the site by Daniel Strong, including a three-room cabin built in 1816. Other buildings, which were moved to the site, include a gristmill, school, church and inn. A huge cantilever barn, called the Dalziel Barn Museum, houses the largest collection of 19th-century toys in Canada. **Tourist Information,** Toll Free: **1 (800) 668 • 2746.**

Byward Market and Mile of History, Ottawa: In addition to the Parliament Buildings and the Rideau Canal, the nation's capital has one of the country's finer walking areas in the Byward Market area, including the restored buildings along Sussex Drive's Mile of History. Art galleries, craft shops, bookstores, restaurants and cafés make this an ideal people place, particularly in spring and summer after those deadly Ottawa winters. **Tourist Information,** Toll Free: **1 (800) 668 • 2746.**

Chinatown, Toronto: The hub of Toronto's principal Chinatown (there are at least two others in the Metro area) is the corner of Dundas Street West and Spadina Avenue. Not as cosy as Vancouver's Chinatown, nevertheless this Toronto neighbourhood has plenty of great restaurants, curio shops and fruit and vegetable stalls. On a Saturday or Sunday morning the neighbourhood is packed and, if you like places where people rub elbows, this is where you should be. **Tourist Information,** Phone: **(416) 203 • 2500.**

Fort Henry, Kingston: This star-shaped fort was originally erected during the War of 1812 on Point Henry on the shore of Lake Ontario. It was intended to guard the Kingston Navy Yards, but later, after the completing of the Rideau

Canal, it served as an important military supply route between Montréal, Ottawa and Kingston. The fort served a strategic military purpose until 1890. During both world wars, it housed prisoners of war. Today it is one of the finest example of a restored 19th-century fort in the province (others being Fort York in Toronto, Fort George in Niagara-on-the-Lake, and Fort Erie). A museum of martial arms and equipment is located on the site, as well as the Fort Henry guard, a summer-time precision-drill re-creation of a 19th-century military guard. **Tourist Information,** Toll Free: **1 (800) 668 • 2746.**

Kensington Market, Toronto: An outdoor market that is both artsy (replete with cafés, buskers and shops) and ethnic (largely Jewish, Italian, Caribbean and Portuguese influences). If you go to Toronto without wandering through this market, especially on Saturday morning, you will miss something special. Between College and Dundas Streets, west of Spadina Avenue. Closed Sundays. **Tourist Information,** Phone: **(416) 203 • 2500.**

Metro Zoo, Toronto: One of the largest in the world, the Metro Zoo is a 288-hectare area situated between two arms of the Rouge River. It consists of eight pavilions designed to simulate the 4,000 animal guests' natural habitats. Modes of transportation within the zoo include a train, walking tours and "Zoo-Ski" cross-country skiing through specific areas on trails. I love it, but it is a hell of a place to get to from downtown Toronto. Even more dreadful—McDonald's has all the food concessions. Admission charge. Open daily. **Meadowvale Road, Toronto, ON, M1E 4R5.** Phone: **(416) 392 • 5900** or **(416) 392 • 5901.**

Sainte Marie Among the Hurons, near Midland: In 1634, French Jesuits led by Jean de Brébeuf founded this Roman Catholic mission to the Huron First Nations. It had been

initiated by Recollets missionaries as early as 1615. Increasing attacks by the Iroquois on Huron settlements in the 1640s resulted in the eventual abandonment of the mission in 1649, but not before five Jesuits, including Brébeuf, were killed by the Iroquois. Although much criticized by many archaeologists, the current reconstruction does feature a good museum, an engaging interpretive program and something of the spirit of life beyond the frontier in the earliest days of colonial Canada. A trip to the video store for a copy of *Black Robe*, the Canadian film based on Brian Moore's novel of the same name, may also give you an idea. Tourist Information, Toll Free: **1 (800) 668 • 2746**.

Upper Canada Village, near Morrisburg: A re-creation of a 19th-century settlement that might have existed along the St. Lawrence River, this "living history" museum includes a pioneer fair, doctor's house, tavern, general store, sawmill, cheese factory and woollen mill, among many other structures. The usual period-costume "guides" are a little precious. However, the province had its heart in the right place when a large portion of the old riverfront was wiped out by the St. Lawrence Seaway project of the 1950s and Upper Canada Village was established to memorialize past life. **Tourist Information**, Toll Free: **1 (800) 668 • 2746**.

QUÉBEC

Château de Ramezay, Montréal: Built in 1705, the chateau, now a historical museum, is a fine building with a rich history. It was the residence of both French and English governors, housed the offices of the West India Company, and the headquarters of the Continental Army during the American occupation. Old furniture, historic paintings and prints and domestic items on view. Admission charge. Closed Mondays except from June to August. **280, rue Notre Dame E, Montréal, QC, H2Y 1C5**. Phone: **(514) 861 • 7182** or **(514) 861 • 3708**.

Château Frontenac, Québec City: The city's most recognizable landmark, this grand hotel, built in 1893, is set high above the St. Lawrence River. A favourite spot of visitors is the Dufferin Terrace, built in 1834, which provides an incredible view of Old Lower Town and the Île d'Orléans. **1, rue des Carrières, Québec City, QC, G1R 5J5**. Phone: **(418) 692 • 3861**.

Jardin Botanique, Montréal: Here you'll find 30 specialized gardens, 10 greenhouses and an insectarium. I like the garden of poisonous plants in particular; also the Japanese and Chinese gardens, various hothouses—in fact, everything. Founded by naturalist Brother Marie Victorin, these are the second-largest such gardens in the world. The biodome (a cleverly designed environmental museum) is not to be missed. There is a good gift shop and bookstore. Admission charge. Open daily. **4101, rue Sherbrooke E, Montréal, QC, H1X 2B2**. Phone: **(514) 872 • 1400**.

Moorside, Gatineau Park, Hull: Part of the grounds of former prime minister William Lyon Mackenzie King's summer estate of Kingsmere are dotted with the carcasses of old Ottawa buildings. There is something half-hearted about the faux-antique ruins, which, in any case, clash with the house-restaurant. You may want to wander through the pleasant landscape and ponder the vanished spirits and Willy's chats with mother. Lunch, afternoon tea and dinner. Open daily in the afternoons from mid-May to mid-October. **Tourist Information**, Toll Free: **1 (800) 363 • 7777**.

Oratoire St-Joseph de Mont-Royal/St. Joseph's Oratory, Montréal: This church was founded in 1904 in honour of St. Joseph, the patron saint of Canada, by miracle-worker Brother André, who is entombed here. It is a

stark place, no stairway to paradise, and speaks of grim endurance and tight-lipped piety, but even so attracts a reputed two million visitors each year. Open daily. **3800, Ch Queen Mary Road, Montréal, QC, H3V 1H6**. Phone: **(514) 733•8211**.

Place d'Armes, Québec City: A small square, located in Old Upper Town served as a meeting place and parade ground during the old regime in Québec. The Monument of Faith, a granite-and-bronze memorial to the Recollets missionaries, raised above the fountain, stands in the square's centre. This is the place to begin your walk in search of old Québec. **Tourist Information**, Toll Free: **1 (800) 363•7777**.

Place Royale, Québec City: Enshrined as a special historical zone by the Québec government, this small cobblestone square was the site of Samuel de Champlain's first "habitation" in 1608. The greatest concentration of 17th- and 18th-century buildings in North America line the place and the streets leading off of it, which has caused Québec City's Old Lower Town to be designated a UNESCO World Heritage Site. **Tourist Information**, Toll Free: **1 (800) 363•7777**.

Vieux-Montréal: Despite years of urban "renewal," Montréal's celebrated Old Town, a city within a city, still remains, centred on Place d'Armes. Besides Château de Ramezay, the visitor will find the Séminaire (1685) and a few other pre-19th-century buildings. However, most of the structures here only date back to the 1800s. **Tourist Information**, Toll Free: **1 (800) 363•7777**.

Vieux Port, Montréal: The port was developed as a government project a decade ago, a move that revitalized the long-neglected harbour and turned it into a viable tourist attraction. There are many charming courtyards, outdoor cafés, a large flea market, restaurants, antiques shops, galleries and views from the water of Habitat. The proper time to go is summer; out of season it is bleak here. **Tourist Information**, Toll Free: **1 (800) 363•7777**.

Canada Council Molson Prize

Two prizes of $50,000 each are awarded annually to distinguished Canadians, one in the arts and the other in the social sciences and humanities. Established in 1964, the Canada Council Molson Prize is funded from the income of an endowment given to the Canada Council by the Molson Family Foundation and now valued at $1.9 million. The Molson Prize recognizes the recipients' outstanding contribution to the cultural and intellectual heritage of Canada. The Canada Council administers the awards and, following a nomination process, both laureates are selected by the Molson Prize jury.

1998: Michael Trebilcock, Jeanne Lamon
1997: Mary Pratt, Guy Rocher
1996: Mavis Gallant, Pierre Maranda
1995: Gerald Ferguson, Donald Akenson
1994: Michel Tremblay, Martin Friedland

1993: R. Murray Schafer, Juliet McMaster
1992: Douglas Cardinal, Fernand Dumont
1991: Denys Arcand, Charles Taylor
1990: Alice Munro, Jean-Jacques Nattiez
1989: Vera Frenkel, Fernande Saint-Martin

1988: Robertson Davies,
Terence Michael Penelhum
1987: Yvette Brind'Amour,
Marc-Adélard Tremblay
1986: J. Mavor Moore, William Dray
1985: Gaston Miron, Ronald Melzack
1984: Marcel Dubé, James G. Eayrs
1983: Brian Macdonald,
Francess Halpenny
1982: Alan C. Cairns,
Louis-Edmond Hamelin,
Jack McClelland, Gilles Vigneault
1981: Margaret Atwood, Marcel Trudel,
John Weinzweig
1980: Michel Brault, Lois Marshall,
Robert Weaver
1979: Jean Duceppe, Betty Oliphant,
Michael Snow
1978: Gabrielle Roy, Jack Shadbolt,
George Story
1977: John Hirsch, Bill Reid,
Jean-Louis Roux

1976: Orford String Quartet,
Denise Pelletier, Jon Vickers
1975: Alex Colville, Pierre Dansereau,
Margaret Laurence
1974: W. A. C. H. Dobson, Celia Franca,
Jean-Paul Lemieux
1973: John James Deutsch, Alfred Pellan,
George Woodcock
1972: Maureen Forrester, Rina Lasnier,
Norman McLaren
1971: Northrop Frye, Duncan
MacPherson, Yves Thériault
1970: Jean-Paul Audet, Morley Callaghan,
Arnold Spohr
1969: Glenn Gould, Jean Le Moyne
1968: Arthur Erickson, Anne Hébert,
Marshall McLuhan
1967: Georges-Henri Lévesque,
Hugh MacLennan
1965/66: Jean Gascon, Frank Scott
1964: Donald Creighton, Alain Grandbois

Source: The Canada Council

Governor General's Performing Arts Awards

INAUGURATED in 1992, these awards pay tribute to the lifetime achievments of exceptional artists in theatre, dance, classical and popular music, opera, film and broadcasting. The awards are presented annually in November and are administered by the Governor General's Performing Arts Awards Foundation.

1999: David Cronenberg (filmmaker); Denise Filiatrault (actor/writer/director); Mavor Moore (actor/director/producer); Louis Quilico (opera singer); Ginette Reno (singer); Michel Tremblay (playwright); Sam Sniderman (businessman/music patron); Mario Bernardi (conductor).

1998: Paul Buissonneau (stage director/actor); Bruce Cockburn (singer/songwriter); Rock Demers (film producer); The Royal Canadian Air Farce (comedy troupe); Arnold Spohr (dancer/choreographer); Jon Vickers (opera singer); Joseph H. Shoctor (theatrical producer); Denis Marleau (theatre director).

1997: Gilles Carle (filmmaker); Nicholas Goldschmidt (opera director); Monique Leyrac (entertainer); Gordon Lightfoot (singer/songwriter); Betty Oliphant (dancer/director); Jean Pierre Ronfard (theatre director); Maryvonne Kendergi (musician/writer/broadcaster); Karen Kain (dancer).

1996: François Barbeau (artist/designer); Michel Brault (film director); Martha Henry (theatre and film actor/theatre director); Joni Mitchell (singer/songwriter); Luc Plamondon (singer); Grant Strate (choreographer); Martha Lou Henley (arts patron); Jon Kimura Parker (classical pianist).

1995: Denys Arcand (film director); Maureen Forrester (opera singer); Peter Gzowski (broadcaster); Paul Hébert (actor/director);

Anne Murray (singer); Jeanne Renaud (dancer/choreographer).

1994: Frédéric Back (animator); Robert Charlebois (singer); Celia Franca (dancer/artistic director); Frances Hyland (theatre actor/director); Jean Papineau-Couture (composer/musical administrator); Neil Young (singer/songwriter).

1993: Ludmilla Chiriaeff (dancer); Leonard Cohen (poet/singer/songwriter); Don Haig (film producer); Lois Maxwell (singer); Monique Mercure (actor); Gilles Vigneault (poet/songwriter).

1992: William Hutt (theatre actor/director); Gweneth Lloyd (choreographer); Dominique Michel (singer/comedienne / actor); Mercedes Palomino (theatre founder); Oscar Peterson (jazz pianist); Léopold Simoneau (tenor).

Seven Icons of Canadian Culture

IN North American Native lore, a culture hero is a legendary figure who has given the tribe good or useful things. Interestingly enough, such figures often have a touch of the trickster—they are not simply benign benefactors. With regard to the seven modern Canadian culture heroes listed below, the message is, perhaps, be grateful for extraordinary gifts, but use with caution.

Margaret Atwood (1939–): One of the stars of the Canadian literary boom of the 1960s and 1970s, Atwood was born in Ottawa, studied at the University of Toronto and at Harvard, and has always lived in or near Toronto. A prolific writer, she has published both poetry and fiction of great quality and has developed as a writer over the decades in ways that suggest a major cultural figure. Many would argue that one of her latest novels, *Alias Grace* (1996), is one of her best, and from the perspective of more than a quarter century it is clear that her second published novel *Surfacing* (1972) was a cultural milestone, if not a literary masterpiece. That book expressed, in a terse and ironic style, the irritability and resentment—if not the exhilaration—of a newly awakened Canadian nationalism. Its nonfictional twin, *Survival*, published in the same year, was a readable and sometimes provocative study of the spirit of

Maclean's Companion to Canadian Arts and Culture

place in literature in the manner of D. H. Lawrence's *Studies in Classic American Literature* and, although lacking the intensity and fierce insights of its model, it functioned as a genteel guerrilla tract for a new generation of readers eager to define and celebrate their Canadian identity. From the perspective of the century's end, Atwood's early poetry, appearing in such books as *The Circle Game* (1966), *The Animals in that Country* (1968) and *The Journals of Susanna Moodie* (1970), seems as fresh as ever and a permanent part of the Canadian mainstream tradition. Atwood's writing often plays with ideas and it is not surprising that she has published an important work of speculative fiction, *The Handmaid's Tale* (1986), or that she has often spoken out on social and cultural issues. By the end of the 1990s, her books had been translated into many languages and sold around the world. It is probably not unreasonable to predict that a Nobel Prize for Literature, Canada's first, will be Atwood's ultimate achievement in the new century.

Herman Northrop Frye (1912–91): This vastly influential literary critic and theorist was born in Sherbrooke, Québec, but spent most of his life in Toronto. In 1939, he began his career as a professor of English at Victoria College (now University) at the University of Toronto and continued in that role until his death. In *Fearful Symmetry* (1947), Frye made an important contribution to the revival of interest in the prophetic poetry of William Blake, but it was *Anatomy of Criticism* (1957), a profound analysis of the structural archetypes that underlie all literature, that brought him wide fame in the international literary community. Curiously enough, Frye shared the tendency of Marshall McLuhan to express himself in a manner that sacrifices pleasing trajectories of style in the name of condensed and knotty insights. His work, with the notable exception of *The Educated Imagination* (1963), derived from his Massey Lecture series, is best taken in small doses. Even so, in comparison with the pretentious jargon and deconstructive antics of the most recent schools of literary criticism, Frye's work seems almost transparent and quite salutary in its affirmation of Western cultural values. Another characteristic of Frye's work is the way his evangelical background informs his insights without actually being acknowledged, for example, in his study of the Bible, *The Great Code* (1982). Frye's treatment of archetypes fell well short of the dynamic and provocative grasp of another devotee of these universals, namely, the psychologist Carl Jung, who inspired the novelist Robertson Davies. Nonetheless, by his ability to discern pattern and structure, Frye gave his readers and his thousands of students a sense of the possibility of an eternal order in the seemingly time-bound and chaotic world of the human imagination.

Glenn Gould (1932–82): Born in Toronto, this legendary pianist, writer and originator of inventive radio documentaries began as nothing more than an exceptionally promising concert artist. In 1964, however, he dropped out of the concert circuit, arguing that such appearances smacked of the circus and would disappear by the end of the century. Gould soon established a close rapport with both CBC and Columbia Records and made many celebrated recordings, especially of the music of Johann Sebastian Bach. In these works Gould adopted a remarkable linear style, downplaying romantic sentiment in favour of contrapuntal clarity and spiritual depth. Gould was nonetheless a fan of the wonderfully flamboyant conductor Leopold Stokowski, on whom he did a famous radio documentary. Like Stokowski, he defended and promoted the music of those two great diverging late romantics, Arnold Schönberg and Richard Strauss. Gould's eccentricities were well known: his shabby, half-collapsed piano chair was famous, and even his best recordings were marred by obtrusive vocalizing. Gould was a hypochondriac, an

inveterate pill taker, and was addicted to all-night telephone conversations. Yet his reputation today seems secure. His recordings have all been reissued and his way of playing Bach has forced every pianist since to rethink traditional conceptions of how baroque music should sound on the piano.

John Grierson (1898 – 1972): This documentary filmmaker and gifted arts administrator was born in Scotland and came to Canada in 1938. Here he wrote the report that led to the founding of the National Film Board, of which he was appointed commissioner. For many years Grierson guided the film board, making it a major cultural force in a Canada that in those years had nothing resembling a mainstream film industry. Grierson, an intellectual and a fiery personality, invented the term *documentary*, borrowing it from the French *documentaire*. He claimed a territory that set Canada apart from the dream factory of fiction films that dominated the American scene over many decades. During the Second World War, Grierson's control of film information shaped the perceptions of both Canadians and Americans and such productions as *Canada Carries On* and *The World in Action* were vivid, if highly slanted chronicles of that tumultuous era. When the cold war began, Grierson was caught in the nets of the "commie" hysteria and questioned in connection with the Igor Gouzenko spy case (his one-time secretary was involved with the ring). He left Canada for the United States and later became director of mass media at UNESCO but, shortly before his death, he returned to lecture at McGill University, where he was recognized by a new generation as one of the true progenitors of authentic Canadian cinema.

Herbert Marshall McLuhan (1911 – 80): Canada's renowned media guru was born in Edmonton and began his career as a professor of English at the University of Toronto in the

The Estate of Glenn Gould / Sony Classical

A complex amalgam of neuroses and genius, Glenn Gould is one of Canada's truly great musical figures.

1940s. Although he had written his Cambridge PhD thesis on Thomas Nash, an obscure English Renaissance prose writer, McLuhan ranged freely through English and American literature to buttress his "thought-mosaics" on modern communications. The results were dazzling, and some new buzzwords entered the language: "hot" and "cool" media; "the medium is the message;" "rear-view mirror" perceptions; and "the global village." *The Gutenberg Galaxy* (1962) and *Understanding Media* (1964) lie at the centre of his work and made him world-famous. If he was more cited than actually read, this was partially because of his arcane and elusive style, but his insights changed our sense of how the media have transformed our history as biological creatures and as culture makers. McLuhan later seemed to wear out his welcome, and some held his fame against him. He became an advisor to advertising firms and corporations, the inspiration of intellectual politicians such as Pierre Elliott Trudeau, and a cameo player in Woody Allen's *Annie Hall*. In a country where the traditional fashion was to keep a low profile, and where to be mentioned more than once on the national news was to be a celebrity, such renown was suspect. Yet McLuhan's work seems more relevant than ever. Although he wrote trenchantly on radio, film, the phonograph and

CBC Television

Media guru Marshall McLuhan laid the ground-work for much of the discourse surrounding modern communications. Could he considered the intellectual patron of mass media?

many other subjects, television was his real focus. If any one thinker is the intellectual patron of television, it is McLuhan. He will remain one of Canada's most innovative minds, a true original, pragmatic and quixotic in equal measure.

Gilles Marcotte (1925 –): Born in Sherbrooke, Québec, this essayist, critic, professor and novelist is perhaps best known for his collection of essays, *Une littérature qui sait fait* (1962), a seminal re-evaluation of Québec literature. In that book Marcotte succeeded in establishing some key constructs that helped define a few of the singular elements in the position of Québec writers in relation to anglophone Canada and the world at large. Over the past several decades, Marcotte has established himself as one of a handful of Québec critics who represent the central thrust in the intellectual self-definition of French Canada. Marcotte resembles American critics such as Edmund Wilson and George Steiner in his range of interests and in his ability to write profoundly about important issues without resorting to jargon or academic technical vocabulary. He has also played various roles at some of the key Québec media—at news-papers such as *Le Devoir* and *La Presse*, and at Radio-Canada and the National Film Board.

As newspaper columnist and television commentator, as editor of *L'anthologie de la littérature québecoise*, as a student of poets as distinctive as Arthur Rimbaud and St. Denys Garneau, as an anatomist of the self-conscious element in the fiction-writing process (*Le roman à l'imparfait*, 1976), Marcotte has been an able commentator who has contributed significantly to the rich play of ideas that has informed Québec society for several decades.

George Woodcock (1912 – 95): An adept biographer, historian, travel writer, poet and political analyst, Woodcock was born in Winnipeg but spent much of the first half of his life in England. He returned to Canada in 1949 and eventually settled in Vancouver, where almost at once he began to make important contributions to Canadian letters as well as to write prolifically about West Coast history, culture and First Nations people. Woodcock founded the noted quarterly journal *Canadian Literature* in 1959 and edited it until 1977. He wrote with great common sense and shrewd insight about a host of Canadian writers, almost everyone from E. J. Pratt to George Bowering. A friend and rival of George Orwell, he chronicled that writer's life in *The Crystal Spirit* (1966), although the title might better characterize Woodcock than Orwell. Woodcock was a leading proponent of anarchism and wrote one of the important modern works on the subject—*Anarchism* (1962). Despite this ideological affiliation, he supported—with some reservations—public funding of the arts, and in *Strange Bedfellows: The State and the Arts in Canada* (1985) he made extremely sensible proposals about how the Canadian system of support might be reformed. If Woodcock had a limitation, it was that his writing was sometimes merely crystalline where it might have been more probing and imaginative, but given the scope of the man's interests—and the fact that there is no one to replace him—such an objection seems petty at best.

9
Festivals

THE Toronto International Film Festival, the Edmonton Fringe Festival, the Vancouver Folk Festival, the Salon du livre and Festival international de jazz in Montréal—Canada is a country rich in special venues for the arts. Indeed, as the new century begins, Canadians can look back over several decades in which the festival experience has become almost inseparable from the presentation of music, dance, drama and even literature.

Surveys by Statistics Canada and others reveal that total attendance at arts events of all kinds has not increased much over the decades in question, yet our festivals seem to offer the possibility of a continuous expansion of audiences. Even when the numbers level off at one venue, another is sure to spring up and offer something sufficiently different to draw the crowds. And clearly it was an inspiration to build the Stratford and Shaw theatre seasons around the festival concept. Would they have prospered if they had not devoted themselves to re-creating the work of a few great masters while presenting it in special environments that serve to draw the spectator out of routine existence? Would our two most splendid theatres have had such success if they had not created a particular ambiance, if they had not, despite inevitable setbacks and limitations, conjured up that unique magic that belongs to festival art?

At first glance there would seem to be little in common between an audience packed together at an urban film or jazz festival, and crowds lounging on the grass in a beautiful natural setting to hear chamber music; nothing in common between street-roving fringe-theatre fanatics and ballet aficionados eagerly lining up for tickets. Yet they are all caught up in the same kind of excitement: they share the heightened experience of art enjoyed collectively in a special place. They enjoy being transported from mundane existence for a while; they are thrilled to rub shoulders with the great ones of music, theatre or dance—and besides, the price is right.

Economically, festivals make a lot of sense for everyone. They give artists new opportunities to encounter large and generally enthusiastic audiences. They give presenters a chance to spread their risk across a series of acts and to focus and

maximize publicity. They allow audiences to buy bargain tickets, and give them a chance to swarm and share, to see a lot of things within a limited and thus intensified time frame, and to compare notes with others as part of a collective event.

The festival, however, is more than a modern fad or a marketing bonanza. It is an ancient phenomenon and has deep connections with leisure, religion and the creation of culture. Whether Olympic games, Saturnalia, potlatch, Mardi Gras or Feast of Fools, festivals have always meant stepping outside everyday life into a special condition of being and sharing. They have meant performance, collectivity, ecstasy and often a sense of personal and social renewal. Multiplying numbers while limiting space and packing everything into a specific timeframe creates a great emotional intensity. Our modern festival-goers don't always walk away transformed, and they seem to retain, for the most part, their individuality and critical faculties. Even so, they cannot help but be affected by the special atmosphere. To be present at such a celebration, to hear the music of an inspired performer, to have a cinematic image materialize into a living, breathing body, to enter into dialogue with one of the dispensers of words or to own a book personally inscribed by its creator—these are the modern equivalents of some very ancient experiences.

The American sociologist Sebastian de Grazia makes an interesting distinction between work, free time and leisure. We all know what work is, that its time is measured by the clock of duty. And while free time is simply time off work, sitting around and doing nothing, leisure is something quite special. It has an ancient lineage and, as defined by de Grazia, refers to time spent in contemplation, in energized spiritual or mental activity.

Leisure is not empty of content, like free time; leisure is a time for thinking deep or at least new thoughts, a time for painting pictures, writing books, inventing or playing music—or a time in which we enjoy the creation of others. Plato and Aristotle passed on to later philosophers the idea that leisure, as described here, is the very root and basis of culture itself. Leisure makes for art—which involves stepping outside the everyday "real" reality and entering a special world of contemplation and vision.

When you climb off the couch (and get away from that television set, which has probably reduced you to lethargy), when you exert yourself to go to a concert, a literary reading, an art exhibition, or the like, you are turning free time into leisure. You go, hopefully, with an active mind, a mind receptive to insights and perceptions; you go, not to be put to sleep, but to be awakened to some new truth or vision.

At a festival the effect is multiplied and intensified: the singer, the dancer, the actor, the literary or film star is right there before you in the flesh and becomes the

celebrant of whatever artistic ritual is on the program. Put a number of successful artists together with several thousand fans ("fan" comes from the word "fanatic," remember), spread the encounters over several days, and you have a potent combination indeed, something that has at least the potential to stick with you for the rest of your life. When it works, the effect can be almost literally magical. Anthropologists such as Edmund Carpenter have pointed out that the rock star in full flight resembles nothing so much as the old tribal shaman, entering a state of ecstasy (getting high on rhythm or a substance) and animating the audience so that the individual is caught up in the collective, the narrow self breaks its boundaries and one feels connected with a hall full of strangers. And festivals give many artists the power to effect similar transformations.

All of this seems to me to go far to explain the fascination of the festival experience, but it doesn't answer the more specific question as to why, at century's end, the festival has become such a popular mode of arts presentation in Canada. And indeed, that question is not easy to answer. Some will point to the festival fad as a reaction to the low-key boredom induced by too much television, others will see it as a response to the solitary cocooning associated with the computer. Some may dismiss it as nothing more than a cultural feeding frenzy that has reached a critical mass, like the "100th monkey" that automatically follows the example of the first 99. Others may refer to that popular Canadian villain, the climate, and suggest that all this clustering is an antidote to cabin fever, while some may read such collective gatherings as a sanctioned escape from our notorious Canadian introversion.

Whatever the explanation, the "festivilizing" of Canadian art experience is almost certain to continue and even to intensify during the first decades of the new century. Cultural habits, once entrenched, are very hard to break. People still dress up and go to concerts to see their idols, despite the availability of CDs and films. Technology that transmits movies over the Web is unlikely to put an end to the ritual of standing in line to take in the latest cinema hit. And the connection with the arts created by the festival is very special. No one brags about having bought a CD by Maureen Forrester or Ben Heppner, or a book by Robertson Davies or Margaret Atwood, but to have congregated with many others to see the artist in person, perhaps to have garnered an autograph or to have exchanged a few words—these are experiences that carry one beyond the routines of life. As the noted critic Robert Hughes expressed it, the arts are a great unifier and art is (or can be) "the creation of mutuality, the passage from feeling into shared meaning." "Shared meaning"—nowhere is it more evident than in the festival experience. Canadians are only human in wanting to sustain this.

Canadian Superfestivals

WHEREVER you go in Canada, at whatever time of year, you are likely to find a major arts festival just down the street or in a town or village a few kilometres away. The range of events will probably be quite extraordinary, the level of talent impressive and the crowds either exhilarating or daunting, depending on your mood. I have listed a great many of Canada's major festivals below (for most seasonal theatre festivals, see the theatre listings). These events encompass just about every kind of cultural activity, every art form, every season and every ethnic group. To begin with, however, I list what I consider to be Canada's Superfestivals, the ones you really shouldn't miss no matter what your interest. Not wanting to play favourites, I have not put any ethnic festivals on our superfestivals list, although many of them are super. If you live in an urban centre anywhere in Canada, consult local listings for your own fringe theatre and Word On the Street events—I simply can't list them all here. For more information on Canada's festivals or to check out lists by date, subject or place, I recommend the festival network on the Web at **http://www.festivalseeker.com**, which gives you quite a few if not all of Canada's important festivals.

Calgary Exhibition and Stampede

One of the world's most famous rodeos takes place in Canada—at the Calgary Exhibition and Stampede, of course.

ALBERTA

Calgary Exhibition and Stampede: July. This is Canada's biggest blowout, western style. Events include a rodeo, chuckwagon races, rock concerts, agricultural exhibitions and a parade. Phone: **(403) 261•0101**; Toll Free: **1 (800) 661•1767** (tickets); Internet: **http://www.calgary-stampede.com**

Fringe Theatre, **Edmonton**: Mid- to late August. One of the most exciting theatre events in the world. Hundreds of plays from just about everywhere, ranging from serious to hilarious. Here, you will find outrageous and constantly stimulating art. Good ticket values. Phone: **(780) 448•9000**; Internet: **http://www.fringe.alberta.com/fta**

BRITISH COLUMBIA

Vancouver International Fringe Theatre Festival: September. This festival is the West Coast end of the fringe circuit, with the usual lively set of amazingly diverse performances and theatre venues. Phone: **(604)257•0350**;

Fax: **(604) 253•1924**; Internet: **http://www. vancouverfringe.com**

Vancouver Folk Music Festival: July. This weekend festival features dozens of first-rate soloists and groups offering traditional and contemporary folk and folk-fusion music. There are many side events, including workshops, art shows, etc. Phone: **(604) 602•9798**; Fax: **(604) 602•9790**; Internet: **http://www.thefestival.bc.ca**

Word On the Street (see also under Ontario entry): September. Here is Vancouver's version of the great street festival of books and writing, usually located at the Library Square downtown. Phone: **(604) 684•8266**.

MANITOBA

Winnipeg Folk Festival: July. Here, Winnipeg presents one of the oldest and best folk festivals in the country. Phone: **(204) 231•0096**; Fax: **(204) 231•0076**; Internet: **http://www.wpg folkfest.mb.ca**

Le Festival du Voyageur, Saint-Boniface: February. Canada's largest winter festival, Le Festival du Voyageur celebrates our nation's unique French-Canadian heritage. Enjoy the wonders of winter, exciting nightlife and entertainment, traditional cuisine, arts and crafts, exhibits and displays. Phone: **(204) 237•7692**; Internet: **http//www.festival voyageur.mb.ca**

NEW BRUNSWICK

Miramichi Folk Song Festival: July-August. Acadian and English folksingers are featured at this event. Phone: **(506) 623•2150**; Fax: **(506) 623•2261**; Internet: **http://www.mibc. nb.ca/folksong/default.htm**

Ian McCausland

One of the best folk festivals in the country takes place every year in Winnipeg.

NEWFOUNDLAND

Newfoundland and Labrador Folk Festival. St. John's: August. Phone: **(709) 576•8508**; Internet: **http://www.moonmusic.nfld.com/ sjfac/**

NORTHWEST TERRITORIES

Festival of the Midnight Sun, Yellowknife: July. Phone: **(867) 873•4262; (867) 873•2079**.

The Great Northern Arts Festival, Inuvik: July. This festival is a celebration of the diverse cultures and art forms of the North. Watch as carvers transform stone into mythical creatures and depictions of Northern life; as printmakers and painters translate their stories into colour and form. Phone: **(867) 777•4321**; Internet: **http://www.greatart.nt.ca**

ONTARIO

Fringe of Toronto: June-July. The 12th annual Toronto fringe theatre festival will take place in 2000, mostly in the trendy Annex neighbourhood. This festival features more than 600 performances by groups from just about everywhere and they cover just about everything: dance, comedy, serious drama—you name it.

The National Arts Centre Orchestra, led by conductor/violinist Pinchas Zukerman, performs great classical pieces at the centre's summer music festival in Ottawa.

National Arts Centre Orchestra / Randy Stille

Phone: **(416) 966 • 5072**; Fax: **(416) 966 • 5072**; Internet: **http://www.fringetoronto.com**

National Arts Centre Summer Festival, Ottawa: July. After a brief revival under the name Festival Canada in 1997 and 1998, the NAC restructured its summer programming to centre largely around the National Arts Centre Orchestra under its music director, Pinchas Zukerman. The summer festival, which in 1999 was titled the Great Composers Festival, will be expanded in coming years to include other areas of the performing arts with music as a common theme. The 1999 festival also saw the introduction of the National Arts Centre Young Artists Program, which gave young musicians from across Canada and abroad the opportunity to work with Zukerman and the orchestra. This program will also be expanded in coming summers to include young artists of other disciplines. Phone: **(613) 947 • 7000**;

Fax: **(613) 996 • 2828**; Internet: **http://www. nac-can.ca**

Harbourfront International Authors Festival, Toronto: October. Great contemporary writers from around the world are visible and audible here—and usually on contracts that make this their only Canadian appearance of the season. A feast if you like to hear texts presented by those who created them. Phone: **(416) 973 • 4760**; **(416) 973 • 4000** (tickets); Fax: **(416) 954 • 4323**; Internet: **http://www.readings.org**

Ottawa Chamber Music Festival: July-August. With many venues in crowded churches in midsummer, this festival is hot in every sense of the word. The music making is really quite wonderful, though, with great variety of programming and a nice informal ambiance. Not to be missed if you have the slightest

interest in classical music. Phone: **(613) 234 • 8008**; Internet: **http://www.chamber fest.com**

Ottawa International Animation Festival: September-October. The second-largest such festival in the world, held every other year at the National Arts Centre in Canada's capital. It is scheduled for 2000. Animation is big in Canada and here our talent shows its stuff with the best in the world. Phone: **(613) 232 • 8769**; Fax: **(613) 232 • 6315**; Internet: **http://www. awn.com/oiaf**

Toronto International Film Festival: August-September. This well-organized festival of films does not have as inclusive a selection as the festival in Montréal, but it does have more glitz and glitter, if that's what you like. Hollywood pays close attention to this one, and if film is your thing you can't afford to miss it either. Phone: **(416) 967 • 7371**; Fax; **(416) 967 • 9477**; Internet: **http://www.bell.ca/filmfest**

Winterlude, **Ottawa**: February. With the world's longest skating rink, this festival features ice sculptures, contests, musical performances and beaver tails (a unique fast food). When the weather cooperates, it's terrific. Phone: **(613) 239 • 5000**; Toll Free: **1 (800) 465 • 1867**; Internet: **http://www.cap can.ca/winterlude/english/index.html**

Word On the Street, **Toronto**: September. This is where it all began and many Canadian cities have followed the lead. A largely open-air or at least open-door celebration of books—writing and reading—with many performances, autograph sessions, contests, lunches and dinners; everything connected with the world of books, from literacy issues to marketing and book design. Since events are diverse, and now cross-country, the best way to check this out is via the Web site listings. You can also look for information at your local public library.

Phone: **(416) 504 • 7241**; Fax: **(416) 504 • 7656**; Internet: **http://www.canada.com/word onthestreet**

PRINCE EDWARD ISLAND

Charlottetown Festival: Enjoy the summer-long venues with stage musicals that reflect Anne of Green Gables mania. This festival has had its ups and downs but recently it seems to be up. Toll Free: **1 (800) 565 • 0278**; Phone: **(902) 628 • 1864**; Internet: **http://www. confederationcentre.com/anne.html**

QUÉBEC

Cirque du Soleil: A year-round moving festival. This is Canada's greatest travelling entertainment show, and like most of the best of Canadian art it has long since gone inter-national in a big way. The Cirque's two original founders, Guy Laliberté and Daniel Gautier, were born in St. Bruno, a working-class area near Montréal. Along with Gilles St. Croix from Québec City, they launched the enterprise in Québec in 1984 and it has consistently grown bigger and better ever since. The Disney Corporation now provides a huge chunk of the capital and shares the profits. The group, which has won over 200 arts awards, does more than 450 shows a year. By the year 2000, it expects to

National Capital Commission

The chilly and beautiful ice maze at Ottawa's Winterlude.

have eight different productions running on three continents and revenues in excess of $300 million. What is there to say about the shows? They are simply the apotheosis of circus art, the most imaginative, the most physically stupendous, the most sexy and stylish ever mounted. If you haven't seen them, you've missed one of the great shows of our era. Phone: **(514) 722•2324**; Fax: **(514) 722•3692**; Internet: **http://www.cirquedusoleil.com**

Festival international de jazz/International Jazz Festival, **Montréal**: June-July. This is a big city party. If you're in Montréal while it's running you can't escape it, so why not enjoy? The event features some very big talent, but lots of interesting lesser performers can also be heard. There is much street action here—an élan that is unique. Toll Free: **1 (800) 367•7777**; Internet: **http://www.montrealjazzfest.com**

Festival international de Lanaudière, **Joliette**: June-August. This is an outstanding classical music festival in a beautiful setting. The Montréal Symphony is usually featured with a wide array of talented soloists from just about everywhere. Extensive programs. Toll Free: **1 (800) 561•4343**; Fax: **(450) 759•4343**; Internet: **http://www.lanaudiere.org**

Just for Laughs Comedy Festival/ Juste pour rire, **Montréal**: July. This is the largest comedy festival in the world, with some 300 to 400 shows, mostly in venues in Montréal's wonderful Old Port area. Catch live performances by the greatest comics in the world.

Phone: **(514) 873•2015**; Toll Free: **1 (800) 363•7777**; **(514) 845•2322** (tickets); Internet: **http://www.hahaha.com**

Montréal World Film Festival: August-September. Insofar as the visible talent goes, this is our most Europeanized film festival. The festival usually draws big stars from France. A huge variety of films from all over the world is screened—an omni-gathering rather than a selective bunch, numbering often as many as 400 films. Phone: **(514) 848•3883**.

Kellogg's Québec Winter Carnival/ Carnaval du Québec, **Québec City**: January-February. Winter events and celebrations—the Mardi Gras of the North. Phone: **(418) 626•3716**; Fax: **(418) 626•7252**; Internet: **http://www.carnival.qc.ca**

SASKATCHEWAN

Saskatoon International Fringe Theatre Festival: May. Phone: **(306) 664•2239**; Internet: **http://interspin.com/fringe**

YUKON TERRITORY

Yukon International Storytelling Festival, **Whitehorse**: July. This festival promotes the oral tradition of storytelling, not only in Northern culture, but in cultures from around the world—from Australia to Zimbabwe. Phone: **(867) 633•7550**; Fax: **(867) 633•3883**; Internet: **http://www.yukonweb.com/special/storytelling**

Major Cultural Festivals Coast to Coast in Canada

ALBERTA

Tourist Information: **1 (800) 661 • 8888**

- *Banff/Lake Louise Winter Festival*:
January-February.
Phone: **(403) 762 • 8421**
- *Dreamspeakers International First Nations Cultural Gathering, Edmonton*:
May-June.
Phone: **(780) 471 • 1199**
- *Annual Alberta Cowboy Poetry Association Gathering, Pincher Creek*:
June.
Phone: **(403) 627 • 5855**
- *Calgary Folk Music Festival*:
July.
Phone: **(403) 233 • 0904**;
Internet: **http://www.calgaryfolkfest.com**
- *Calgary International Jazz Festival*:
Late June-early July.
Phone: **(780) 432 • 7166**;
Internet: **http://www.discovercalgary.com/jazzcalgary/jazzfestival.htm**
- *The Works: A Visual Arts Celebration, Edmonton*:
June-July.
Phone: **(781) 426 • 2122**
- *Jazz City Festival, Edmonton*:
June-July.
Phone: **(780) 432 • 7166**
- *Banff Festival of the Arts*:
June-August.
Phone: **(403) 762 • 6300**
- *Edmonton International Street Performers Festival*:
July.
Phone: **(780) 425 • 5162**

- *Klondike Days, Edmonton*:
July.
Internet: **http://www.northlands.com**
- *Edmonton Folk Music Festival*:
Mid-August.
Phone: **(780) 429 • 1899**
- *PanCanadian WordFest, Calgary*:
October.
Alberta's very own authors' festival.
Phone: **(403) 263 • 7443**
- *Banff Mountain Book Festival*:
Late October-early November.
Phone: **(403) 762 • 6369**
- *Banff Festival of Mountain Films*:
November.
Phone: **(403) 762 • 6125**
- *Esther Honens International Piano Competition, Calgary*:
November.
Phone: **(403) 299 • 0130**;
Internet: **http://www.honens.com**

BRITISH COLUMBIA

Tourist Information: **1 (800) 435 • 5622**

- *Annual TerrifVic Dixieland Jazz Party, Victoria*:
April.
Phone: **(250) 953 • 2011**
- *Vancouver International Children's Festival*:
May-June.
Phone: **(604) 708 • 5655**
- *International Jazz Festival, Vancouver*:
June-July.
Phone: **(604) 872 • 5200**

- *Dancing on the Edge Festival, Vancouver*:
 July.
 Avant-garde dance from around the world.
 Phone: **(604) 689 • 0926**
- *Bard on the Beach, Vancouver*:
 June-September.
 Shakespeare with a view.
 Phone: **(604) 737 • 0625**;
 Internet: **http://www.faximum.com/bard**
- *Annual Festival of the Arts, Ganges, Saltspring Island*:
 July.
 Phone: **(250) 537 • 5252**
- *Harrison Festival of the Arts, Harrison Hot Springs*:
 July.
 Phone: **(604) 796 • 3425**;
 Internet: **http://www.echoisland.com/harrfest**
- *Benson & Hedges Symphony of Fire International Fireworks Competition, Vancouver*:
 Late July-early August.
 Phone: **(604) 688 • 1992**
- *Vancouver Chamber Music Festival*:
 July-August.
 Phone: **(604) 602 • 0363**
- *Nanaimo Festival*:
 July-August.
 Summer theatre on Vancouver Island.
 Tourist Information: **1 (800) 663 • 6000**
- *Theatre Under the Stars, Vancouver*:
 July-August.
 Broadway in the great outdoors.
- *Vancouver International Comedy Festival*:
 July.
 Headquartered on Granville Island, this laugh fest usually features more than 100 free performances and at least two dozen ticketed events. Many of the comics strut their stuff around town at various clubs.
 Phone: **(604) 683 • 0883**;
 Internet: **http://www.comedyfest.com**

- *Pacific National Exhibition, Vancouver*:
 Late August-early September.
 Phone: **(604) 253 • 2311**;
 Internet: **http://www.pne.bc.ca/index.html**
- *Whistler Jazz and Blues Festival*:
 September.
 Phone: **(604) 664 • 5625**
- *Vancouver International Film Festival*:
 October.
 Phone: **(604) 685 • 0260**
- *Vancouver International Writers and Readers Festival*:
 October.
 Phone: **(604) 681 • 6330**;
 Internet: **http://www.writersfest.bc.ca**

MANITOBA

Tourist Information: **1 (800) 665 • 0040**

- *Northern Manitoba Trappers Festival, The Pas*:
 Mid-February.
 A five-day celebration of the traditional North, including famous dogsled and snowshoe races.
- *Winnipeg International Children's Festival*:
 June.
 Phone: **(204) 958 • 4730**;
 Internet: **http://www.childrenfestival.mb.ca**
- *Winnipeg Jazz Festival*:
 June.
 Phone: **(204) 989 • 4656**;
 Internet: **http://www.jazzwinnipeg.com**
- *Red River Exhibition, Winnipeg*:
 June-July.
 Phone: **(204) 772 • 9464**;
 Internet: **http://www.redriverex.com**
- *Winnipeg Fringe Theatre Festival*:
 July.
 Phone: **(204) 956 • 1340**;
 Internet: **http://www.uwinnipeg.ca/academic/as/theatre/thefringe.htm**

- *Countryfest, Dauphin*:
 July-August.
 Toll Free: **1 (800) 361 • 7300**;
 Phone: **(204) 622 • 3700**;
 Internet: **http://www.grslink.com/icefest**
- *Folklorama, Canada's Cultural Celebration, Winnipeg*:
 August.
 Phone: **(204) 982 • 6210**;
 Internet: **http://www.folklorama.ca**

NEW BRUNSWICK

Tourist Information: **1 (800) 320 • 3988**

- *International Festival of Baroque Music, Lamèque*:
 July.
 Toll Free: **1 (800) 320 • 2276**;
 Internet: **http://www.intellis.net/FestivalBaroqueLameque**
- *New Brunswick Summer Music Festival, Fredericton*:
 August.
 Phone: **(506) 453 • 4697**;
 Internet: **http://www.unb.ca/finearts/music/camp/index.html**
- *Festival by the Sea, Saint John*:
 August.
 Phone: **(506) 632 • 0086**
- *Harvest Jazz and Blues Festival, Fredericton*:
 September.
 Phone: **(506) 454 • 2583**;
 Toll Free: **1 (888) 622 • 5837**;
 Internet: **http://www.harvestjazzblues.nb.ca**

NEWFOUNDLAND

Tourist Information: **1 (800) 563 • 6363**

- *Grand Bank Winter Carnival*:
 March.
 Phone: **(709) 832 • 2617**

- *New Dance Festival, St. John's*:
 June.
 Phone: **(709) 753 • 4531**
- *Festival Émile Benoît, Mainland*:
 July.
 French folk festival.
 Phone: **(709) 642 • 5254**
- *Stephenville Theatre Festival*:
 July-August.
 Summer theatre.
 Phone: **(709) 643 • 4982**
 Internet: **http://www.stf.nf.ca**
- *Brimstone Head Folk Festival, Fogo Island*:
 August.
 Phone: **(709) 266 • 2403**
- *Summer in the Bight Theatre Festival, Trinity*:
 July-September.
 Phone: **(709) 738 • 3256**
- *St. John's International Women's Film and Video Festival*:
 October.
 Phone: **(709) 754 • 3141**;
 Internet: **http://www.mediatouch.com/film**

NORTHWEST TERRITORIES

Tourist Information: **1 (800) 668 • 2746**

- *Sunrise Festival, Inuvik*:
 January.
 Phone: **(867) 777 • 2607**
- *Caribou Carnival, Yellowknife*:
 March.
 Phone: **(867) 873 • 4262**
- *Inuvik International Bonspiel*:
 March.
 Phone: **(867) 777 • 2273**
- *Beaver Tail Jamboree, Fort Simpson*:
 March.
 Phone: **(867) 695 • 3300**
- *Beluga Jamboree, Tuktoyaktuk*:
 April.
 Phone: **(867) 977 • 2286**

- *Midnight Madness, Inuvik*:
 June.
 Phone: **(867) 777 • 2607**
- *Folk on the Rocks Music Festival,*
 Yellowknife:
 July.
 Phone: **(867) 920 • 7806**;
 Internet: **http://www.folkontherocks.com**
- *The Great Northern Arts Festival, Inuvik*:
 July.
 Phone: **(867) 777 • 4321**
- *Delta Daze, Inuvik*:
 October.
 Phone: **(867) 777 • 2924**
- *Far North Film Festival, Yellowknife*:
 November.
 Phone: **(867) 873 • 4262**

NOVA SCOTIA

Tourist Information: **1 (800) 565 • 0000**

- *Antigonish Highland Games*:
 Mid-July.
 Highland dances, contests, sports and
 piping.
 Phone: **(902) 863 • 4275**;
 Internet: **http://www.grassroots.ns.ca/**
 ~highland
- *Maritime Fiddle Festival, Dartmouth*:
 July.
 Phone: **(902) 434 • 5466**;
 Fax: **(902) 434 • 4190**;
 Internet: **http://Fox.nstn.ca:80/**
 ~whebby/
- *Shakespeare by the Sea, Halifax*:
 July-August.
 Phone: **(902) 422 • 0295**;
 Toll Free: **1 (888) 759 • 1516**;
 Internet: **http://shakespeare.ns.**
 sympatico.ca
- *Halifax International Buskers, Halifax*:
 August.
 Phone: **(902) 429 • 3910**;
 Internet: **http://buskers.ns.sympatico.ca**

- *Word On the Street, Halifax*:
 September.
 Phone: **(902) 423 • 7399**
- *Atlantic Film Festival, Halifax*:
 September.
 Phone: **(902) 422 • 3456**
 Internet: **http://www.atlanticfilm.com**
- *Oktoberfest in Lunenburg*:
 September.
 Phone: **(902) 634 • 8100**;
 Fax: **(902) 634 • 3656**;
 Internet: **http://www.ncsl.com/**
 lunenburg/oktoberfest.html

ONTARIO

Tourist information: **1 (800) 668 • 2746**

- *Canadian Tulip Festival, Ottawa-Hull*:
 Mid-May.
 The exile of the Dutch Royal Family to
 Ottawa during the Second World War and
 a subsequent gift of tulip bulbs inspired
 this festival, which also includes the
 National Capital Marathon.
 Phone: **(613) 567 • 5757**;
 Internet: **http://www.tulipfestival.ca**
- *Children's Festival de la Jeunesse, Ottawa*:
 June.
 (613) 728 • 5863;
- *Mariposa Folk Festival, Toronto*:
 June.
 Canada's premier folk music festival.
 Phone: **(416) 588 • 3655**
- *Pride in the Capital, Toronto*:
 July.
 Gay and Lesbian Pride Week.
 Phone: **(613) 236 • 4460**
 Internet: **http://www.gaycanada.com/**
 ottawa-pride
- *Festival of the Sound, Parry Sound*:
 July-August.
 Classical music played by various
 chamber groups and soloists in a
 beautiful setting.

Phone: **(705) 746•2410;**
Internet: **http://www.festivalofthe sound.on.ca**

- *Festival of Friends, Hamilton*:
August.
A laid-back folk festival in the heart of the city.
Phone: **(905) 525•6644**.

- *Canadian National Exhibition, Toronto*:
August-September.
The venerable fair on Lake Ontario, like many of its cousin fairs around the country, seems poised on the brink of extinction every year, but on it goes.

PRINCE EDWARD ISLAND

Tourist Information: **1 (800) 734•7529**

- *Charlottetown Winter Carnival*:
February.
Phone: **(902) 892•5708**

- *Lucy Maud Montgomery Festival, Cavendish*:
August.
Phone: **(902) 963•2149;**
Internet: **http://town-cavendish.pe.ca/ lucymaudfestival**

- *Festival of the Arts, Charlottetown*:
September.
Phone: **(902) 368•4410;**
Internet: **http://www.peisland.com/arts/ festival.htm**

QUÉBEC

Tourist Information: **1 (800) 363•7777**

- *Benson & Hedges Symphony of Fire International Fireworks Competition, Montréal*:
June.
An international fireworks competition.
Phone: **(514) 873•2015;**

Toll Free: **1 (800) 363•7777;**
Internet: **http://www.bonjour-quebec.com**

- *International Children's Folklore Festival, Beauport*:
June-July.
Traditional dance and music festival.
Phone: **(514) 873•2015;**
Toll Free: **1 (800) 363•7777;**
Internet: **http://www.bonjour-quebec.com**

- *Orford Festival, Magog-Orford*:
July-August.
Classical, chamber and orchestral music festival.
Phone: **(514) 873•2015;**
Toll Free: **1 (800) 363•7777;**
Internet: **http://www.bonjour-quebec.com**

- *du Maurier Summer Festival, Québec City*:
July.
One of the largest stage and street performance events in North America.
Phone: **(418) 692•4540;**
Fax: **(418) 692•4384;**
Internet: **http://www.festival-ete-quebec.qc.ca**

- *Mondial des cultures, Drummondville*:
July.
Phone: **(514) 873•2015;**
Toll Free: **1 (800) 363•7777;**
Internet: **http://www.festivalfolklore.qc.ca**

- *Festival international du blues de Tremblant, Mont-Tremblant*:
July-August.
Phone: **(514) 873•2015;**
Toll Free: **1 (800) 363•7777;**
Internet: **http://www.bonjour-quebec.com**

- *Les Francofolies de Montréal*:
July-August.
Phone: **(514) 873•2015;**
Toll Free: **1 (800) 363•7777;**
Internet: **http://www.francofolies.com**

- *Festival des arts, Saint-Sauveur-des-Monts*:
July-August.
Phone: **(514) 873•2015;**
Toll Free: **1 (800) 363•7777;**
Internet: **http://www.bonjour-quebec.com**

- *Festival international de la poésie, Trois-Rivières*:
October.
Phone: **(819) 379 • 9813**;
Fax: **(819) 376 • 0774**;
Internet: **http://www.aiqnet.com/fiptr**
- *Festival du cinéma international, Rouyn-Noranda*:
October-November.
Phone: **(819) 762 • 6212**;
Fax: **(819) 762 • 6762**;
Internet: **http://www1.telebec.qc.ca/fciat**

SASKATCHEWAN

Tourist Information: **1 (877) 237 • 2273**

- *Flicks – Saskatchewan International Children's Film Festival, Saskatoon*:
March.
Phone: **(306) 956 • 3456**
- *Yorkton Short Film and Video Festival*:
May.
Phone: **(306) 782 • 7077**
- *Northern Saskatchewan International Children's Festival, Saskatoon*:
June.
Phone: **(306) 934 • 3378**
- *Regina International Children's Festival*:
June.
Phone: **(306) 352 • 7655**
- *Regina Folk Festival*:
August.
Phone: **(306) 757 • 7684**
- *Mosaic – A Global Village, Regina*:
June.
Phone: **(306) 757 • 5990**

- *Saskatchewan Jazz Festival, Saskatoon*:
June-July.
Phone: **(306) 652 • 1421**;
Internet: **http://www.saskjazz.com**
- *Shakespeare on the Saskatchewan, Saskatoon*:
July-August.
Phone: **(306) 652 • 9100**
- *Folkfest, Saskatoon*:
August.
Phone: **(306) 931 • 0100**

YUKON TERRITORY

Tourist Information: **1 (800) 429 • 8566**

- *Frostbite Music Festival, Whitehorse*:
February.
Phone: **(867) 688 • 4921**;
Internet: **http://www.frostbite.net**
- *Yukon Quest, Whitehorse*:
February.
Internet: **http://www.yukonquest.yk.ca**
- *International Gold Show, Dawson City*:
May.
Internet: **http://www.dawsongoldshow.com**
- *Dawson City Music Festival*:
July.
Internet: **http://www.dcmf.com**
- *Discovery Days, Dawson City*:
August.
Phone: **(867) 993 • 1996**;
Internet: **http://www.klondike.com/gold**

10
Conclusion:
The Arts in the 21st Century

ONE of Paul Gauguin's greatest paintings, his so-called "spiritual testament," bears the title: *Where Have We Come From? What Are We? Where Are We Going?* When artists—overtly or implicitly—pose such questions, they answer mostly in powerful symbols; they extend their writing, music or painting to the boundaries of communicability and touch the realm of prophecy. Mundane projections, statistics and down-to-earth observations are not required in such cases. Critics and commentators, by contrast, are expected to speak a different language. No visionary flights here, thank you! Clarification and specificity are of the essence. And yet every trajectory drawn from the past into the future is ultimately the expression of a personal vision—in today's jargon, someone's "take" on a whole set of complex phenomena. What follows, then, is one observer's sense of where we have come from and where we are going—the deepest question of all (What are we?) I leave to the philosophers and the artists.

As we enter the new millennium, it is possible to identify some trends in the arts that have become visible during the last few decades of the 20th century. I have alluded to most of these in the course of this book, and while not all of them are unique to Canada, they are worth summarizing here insofar as they offer clues to future developments in this country.

The first trend encompasses the movement of Canadian cultural creation away from the intensively self-conscious nationalism and localism of the 1960s and 1970s to a much more sophisticated and cosmopolitan conception of production. This has resulted in art with a much wider range of themes and has complicated the marketing process and made it more challenging. Although our artists continue to draw on grassroots Canadian experience, the spectrum is different: Billy Bishop has had to make room for *The English Patient*; Stompin' Tom for Sarah McLachlan. Riel has ridden into a sunset where *The Golden Ass of Apuleius* grazes; our films have been going

down the road in the direction of *The Red Violin* and *Le confessional*. In the visual arts, Les Automatistes are retrospectively celebrated and newspaper critics have even begun to apologize for the Group of Seven.

In today's Canada, the old-fashioned polite exchange between the would-be novelist and the caring editor has given way to high-powered wheeling and dealing between well-heeled literary agents and publishing firms that are often outposts of the transnational corporations. Newspapers run features on the sexual or sartorial preferences of writers, whose capacity to look good on television is an increasingly important factor in the marketing of their work. On the other hand, Canadian writers are accepted abroad as never before and compete with the best in the world for international prizes. Television programs, miniseries and rock videos produced in Canada are seen around the world; our pop music sells more platinum than Northern Ontario's Inco Ltd. does nickel, and our films are, for better or worse, finally looking like Academy Award contenders. Meanwhile our museums and galleries have jumped on the "big show" bandwagon, attracting visitors by displaying the good old nostalgic images produced by the likes of Auguste Renoir and Claude Monet, while presenting much else—including Canadian art—by means of electronic gadgetry and Web site interactions. After a hiatus of some years due to lack of funding, some of our major orchestras and dance companies are touring once more, showing off Canadian art in foreign countries, where it is increasingly welcomed. On all fronts, thanks largely to its growing confidence and maturity, Canadian art has ceased to be identified with self-conscious nationalism or localism.

This new cosmopolitanism, although it has not necessarily produced better art, has meant—to paraphrase concepts made familiar by Margaret Atwood—that we have not only survived but also surfaced in a world that is increasingly open to Canadian themes and perspectives of all kinds, and in which Canadian artists find themselves surprisingly at home.

The new international visibility of Canadian art means many things to many people. To the artists, it is challenging and exciting. To the federal mandarins, it is a justification of many decades of arts funding and a chance to give a sharper definition to our global economic ambitions. To Canadian nationalists, it is further proof of the validity of our art, but dangerous insofar as it may tempt us to sacrifice our unique identity in order to appeal to the international marketeers.

Another significant change in our cultural scene is the increasing unwillingness of our cultural critics and apparatchiks to uphold the old established cultural hierarchies. Traditional notions espousing the unique beauty of the arts, art as

visionary experience or as secular religion, art as pure aesthetic experience, the idea of a dialogue in time with the great art of the past—such notions seemed to be in decline at the end of the century. The new focus was on the community relevance of the arts, their power to give voice to the inarticulate and to affect political and social change, as well to give a face to Canada abroad. Yet, while the worst era of political correctness in the arts seemed to be over, the emphasis on relevance sometimes threatened to overshadow the powerful traditional notion that the arts could transform the individual and offer a vision that transcended gender, race and class.

As I pointed out in my book *The Presumption of Culture* (Raincoast, 1996): "We know from experience that some art has the power to lift us out of our narrow selves and to show us a world of beauty or an inner logic of life that we defy at our peril. To obscure this unique power of art by blatant manifestos and sour prohibitions is to blindfold humanity in order to make it virtuous." In the light of this, even a wily old creator-mandarin such as the former Canada Council director, Roch Carrier, seemed to strike a very dubious note when he lamented in a 1998 article that "subsidized art has been mainly elitist" and suggested that "government funding be used to establish programs aimed at popular audiences." While it would be foolish to forget the often creative blending of elite and popular art that has marked this century, in which many members of the public—more sensible than the critical gurus—manage to enjoy all kinds of art and every ingenious combination without worrying about invidious distinctions, Roch Carrier's argument seems to overlook the fact that really popular art already has a huge base of economic support and that so-called elite art has an often-demonstrated power to touch all of humanity.

Many would argue that increasing the access to great and difficult art is the perennial duty of a democracy, without succumbing to the myth that what is popular in today's world actually arises from the people, or that it deserves to be given special support. Unfortunately, in contemporary society many consumers end up liking what they are told to like by their peers or by advertisers, and because of inadequate education or limited arts experience are unable to make searching aesthetic judgements of their own. Far from turning its attention to promoting what is already popular, many have argued that public funding on all levels in Canada should be directed toward the education of the young in the traditionally difficult but vastly rewarding "elite" arts. Here, whatever training and experience are required, and however much such commitments seem to disregard what is popular, the lifetime investment must pay off in the deeper understanding of the classic works of literature,

painting and music that constitute that wonderful, but in recent decades much-maligned, entity called Western Civilization.

One way of popularizing elite culture without dumbing it down exists in what I have called the "festivalizing" of the arts, one of the main trends in Canadian culture at the turn of the century. During the past few decades, presenters have discovered that performances are often more marketable when they are clustered together, when a unifying theme or blanket concept links a series of individual works. The general isolation and loneliness of modern life, and the isolating nature of interaction with computers in particular, seem to have amplified the long-standing human need to be part of a meaningful happening, an occasion that takes place in a particular environment and creates an overall mood. Such celebratory, secular gatherings give the audience a sense of belonging. They also soften the commitment to any one event and create, on the economic level, both the convenience and the value-for-money sense of the superstore. Festivals extend the power of the single-night arts performance; they multiply it and spread it over a longer period of time. Yet, because the festival time is special and ultimately limited in extent, a great intensity of experience becomes possible. In this context, very different kinds of art can be presented together, much to the delight of creators, presenters and audience.

Another trend I have called attention to in this book is the changing role of the various levels of government in relation to the arts. Since about 1951, when the Massey-Lévesque Commission submitted its comprehensive report on government and the arts, the federal branch has assumed a large responsibility for arts funding across the country. This funding has flowed to artists and institutions through the Canada Council (since 1957), or has been directed to the various cultural operating bodies, such as the CBC or the National Film Board. In general this system has been well received, its principles challenged only by advocates of extreme laissez-faire capitalism, who believe that the arts should not be funded at public expense. The picture is more complicated than it first appears, however, since federal funding from the beginning has been only one source of arts funding. The provinces and the municipalities also contribute, and their shares of the total have fluctuated in relation to the federal portion over the decades.

Contrary to what some might assume, it was the Trudeau administration—mostly very generous toward the arts—that actually began to put the brakes on cultural spending. This occurred in the early 1980s following the OPEC oil crisis and the downturn of Canada's economy. Then, the Mulroney government's advocacy of decentralization and increasing pride in regional achievements worked to encourage

the provinces to take a more active role in funding the arts. Estimates of how much the provinces spend in relation to federal sources depend upon what one designates as culture (most provinces have defined this rather broadly) and whether one counts the federal allotments to the Canada Council only, or includes the enormous amounts budgeted for the CBC. By 1983 – 84, if one excludes CBC funding and accepts a broad definition of culture, the provinces together spent more on culture than did the federal government. Provincial funding, however, by no means continued to grow at the same rate through the 1980s and 1990s and the contributions of individual provinces varied widely as to percentages spent on culture in relation to their total budgets. (Québec was generally among the more generous contributors and British Columbia among the least—although, to be fair, we have to note that Québec culture itself is richly subsidized by the federal government.) The cutbacks that created a virtual crisis in Canadian culture in the mid-1990s, however, occurred at all levels. By 1997, Statistics Canada reported eight straight years of reduction in total government spending on culture. Only municipal governments had increased their contributions slightly.

It is safe to say, therefore, that by the last few decades of the century the federal government had begun to cut back on what had seemed previously to be an almost unlimited commitment to funding the arts and had shifted its role to one of facilitating the survival of the arts within the economic and social realities of the new Canada, as well as on the international scene. Under the quite active leadership of Heritage Minister Sheila Copps, Canada staked out its territory vis-à-vis the international culture market in the form of a series of actions, such as the 1998 Ottawa conference of 22 countries, called by Copps to find ways to stop the spread of the world "monoculture" and to insist that an individual culture is part of every nation's identity, and not a mere commodity. Such gestures (as well as similar notice-serving on the Hollywood film industry) seemed to be designed to prove that Canada was prepared to take action to survive as a unique cultural entity. Since some of these proposals and suggestions were greeted with sharply negative responses abroad as well as internally, they also had the effect of making clear to the extreme nationalists in the Canadian arts community just where the limitations of an aggressive policy might lie, what price Canada would pay for an over-militant culture policy.

One of the most striking of the federal government's recent cultural initiatives, Canada's attempt to protect its magazine industry, could hardly be described as over-militant. This involved the drafting of Bill C-55, which, as the official summary has it, "creates an offence for a foreign periodical publisher to supply advertising services directed at the Canadian market to Canadian advertisers." The issue surfaced in 1993

when the American magazine *Sports Illustrated* succeeded in subverting the long-standing Canadian law against split-runs, which are "Canadian" editions of American magazines, with a great deal of Canadian-targeted advertising but very little Canadian content. A battle ensued between Canada and the United States, and in 1997 the Appellate Body of the World Trade Organization struck down key elements of the Canadian policy. Bill C-55, Canada's response to this defeat, caused further controversy. It was denounced in Canada by conservative commentators and in the United States, where the Clinton administration actually threatened trade reprisals if the bill were made law. In 1999, the Canadian government compromised and agreed to allow split-run magazines into Canada if they limited themselves to an 18 percent content of Canadian ads. Canadian publishers such as *Maclean's*, *Chatelaine*, *Toronto Life* and others had argued that anything higher than 10 percent might well mean the death of the domestic magazine industry. If such a result threatens, then the federal government will probably have to introduce some alternative protection, possibly in the form of compensatory subsidies or tax benefits for our magazines, measures that, to say the least, would arouse no enthusiasm in the United States.

It will be interesting to see if in the new century, under successive heritage ministers, this country continues to press the issue of Canadian identity, and whether this will ever actually be carried to the test of an international showdown. Such an event, if it happens, would certainly mark a watershed for some of the cultural issues discussed here and might well polarize Canadians on matters that have tended to remain in the background of our politics and so to remain unresolved.

Even as it was opting for a higher international profile for cultural issues, the federal government was quietly readjusting its internal commitments. To employ the Canada Council buzzwords, "audience development," "aboriginal arts," "cultural diversity," "festivals and international events" have all become priorities for government support. While the Canada Council's procedures for evaluating both organizations and the work of individual artists were constantly being fine-tuned, the fundamental issues remained: could such evaluation work at all? Could it really be fair? Did the system work as well as the official gospel had it? Some even questioned whether individual artists should receive grants at all.

Meanwhile, Canadian artists and many of our local arts groups—small presses, theatre, musical performers, ballet and small opera companies and the like—seem to have become less concerned about what government can do for them and much more determinedly innovative at marketing their own creations. As the new century dawns, one seldom hears the "the world owes me a living" kind of line from Canadian

artists; partially because, like many other Canadians, they have grown cynical about what politicians will really do for them and why. But that is not the only reason. It is also because our artists have made many innovative contacts in the communities in which they live and work. They have seen how much better they are at reading their own needs than are bureaucrats at a distance. It is not that our artists have given up on public funding, or that they are so naïve as to imagine that they can do without it altogether. It is simply that they have, in many cases, found a new strength in rootedness. They are less confident about the reliability of impersonal funding sources at a distance, more confident about their own perceptions of what they need and what they can do. Here, one would think, is a golden chance for the various Canadian governments to start up new programs or to strengthen old ones—I refer to training programs that help give performing artists better skills in marketing their products, and that teach them how to improve the handling of their own finances.

As I have noted, over the past several decades Canada's largest beneficiary of the federal cultural budget, the CBC, especially CBC Television, has been undergoing many changes. In 1999, Robert Rabinovitch was appointed president of the corporation. Few envied him the task, still undone after many decades, of finding a truly creative role for CBC Television in a world where public tastes had changed and where the new media were transforming the very nature of broadcasting. As the century ended, the CBC—like another major cultural operating body, the National Arts Centre—was clearly in transition. Many of our central cultural institutions had also gone through a decade of trial and had come to see that while their survival might be implicitly guaranteed, they could no longer assume carte blanche support from public funding. Increasingly, it was pointed out that the more viable of our arts institutions could indeed survive without much public funding, the catch being that services would greatly decline and the direct cost to the public would increase across the board. In response to this, our large cultural presenters, as I have noted, turned more and more to private-sector sponsorship of major individual events (concerts, exhibitions and the like), events that the corporate sponsors regarded as suitably prestigious and popular. This, on the whole, meant more elitism in the form of glitzy and exclusive openings at which senior arts administrators and politicians could rub shoulders with corporate Canada, but it also meant some exciting shows and performances that might otherwise never have happened, or that would have virtually bankrupted the presenters.

All of this was part of a seldom articulated but quite clearly visible "second phase" of the development of arts and culture in Canada. The first phase, from the creation

of the Canada Council in 1957, until the cutbacks in cultural funding initiated by the Trudeau administration in the early 1980s, saw almost unlimited commitment to the idea of across-the-board public support of the arts. The second phase, which will certainly continue well into the next century, is marked by a much more selective commitment. Public arts funding now comes with many strings attached; its recipients are expected to exercise real fiscal responsibility and to establish their relevance to the community, as well as to maintain quality of production. Private support, as noted, is encouraged more and more, although there have been few imaginative programs (such as arts vouchers, arts lotteries, tax discounts on tickets) and, above all, no attempt to articulate and proclaim a national Canadian arts policy, as Sweden, for example, had done in 1974.

On the level of symbolism at least—although it may mean much more than symbolism—the appointment of former broadcaster Adrienne Clarkson as Governor General of Canada in 1999 seemed an omen of creative changes on the arts scene in Canada in the new century. Clarkson, who heads the board of the Canadian Museum of Civilization and was formerly Ontario's agent general in France, understands the arts scene well. Her inaugural was marked by the same aura of artistic and cultural sophistication that surrounded the arrival of President John F. Kennedy in Washington in 1961. With Sheila Copps as heritage minister and Adrienne Clarkson as governor general, Canadian culture has two exceptionally strong voices at the heart of government, an important factor given culture's low priority among both politicians and much of the public during the past decade in Canada.

CBC Television / Fred Phipps

Former broadcaster Adrienne Clarkson has always held a special interest in the arts in this country. Her appointment as Governor General of Canada in 1999 seemed an omen of creative changes on the arts scene in this country.

Where have we come from? Where are we going?

During the period from 1997 to 1999, the House of Commons Heritage Committee conducted a cross-country inquiry, interviewing artists and preparing the way for an expected overhaul of Canadian cultural policy. At this writing the federal government's response has just been tabled and it appears to indicate that strong

support is in the offing in order to ensure that Canadian culture survives to be enjoyed by the widest possible number of Canadians. Increased funding is expected to stimulate the production of new Canadian works in theatre, film, music, video and the new media. Arts training schools are also expected to benefit, and the presentation of some of our major cultural resources on the Internet seems to be slated for support. All of this bodes very well for Canadian culture in the new century.

Human creativity is miraculous, and fortunately unstoppable. Whatever the resolution of the large issues facing Canadian culture in the future, it is clear that this country, for the size of its population, is now one of the liveliest arts venues in the world. There are coast-to-coast attractions in almost every field. An astonishing array of high art and first-class popular entertainment may be enjoyed in the larger cities, while grassroots creativity with a uniquely Canadian flavour is prevalent everywhere you turn. In this book, I have tried to help the reader get in touch with some of this excitement, to indicate how it developed out of Canada's past and to hint at possible future trajectories. In the end, though, the arts have more to do with pleasure than with speculation and analysis. And if the information collected here enables the reader to enjoy what Canada's artists have produced, to expand horizons and to appreciate the new with the old, then this book will have served its main purpose.

Appendices

Bibliography

Atwood, M., (1972). *Survival*. Toronto, ON: Anansi.

Audley, P., (1983). *Canada's Cultural Industries: Broadcasting, Publishing, Records and Film*. Toronto, ON: Lorimer.

Bell, J., (1992). *Guardians of the North: The National Superhero in Canadian Comic Book Art*. Ottawa, ON: National Archives.

Berton, P., (1986). *Vimy*. Toronto, ON: McClelland and Stewart.

———. (1982). *Why We Act Like Canadians*. Toronto, ON: McClelland and Stewart.

———. (1977). *The Dionne Years*. Toronto, ON: McClelland and Stewart.

———. (1975). *Hollywood's Canada*. Toronto. ON: McClelland and Stewart.

———. (1971). *The Last Spike*. Toronto, ON: McClelland and Stewart.

———. (1970). *The National Dream*. Toronto, ON: McClelland and Stewart.

———. (1963). *The Comfortable Pew*. Toronto, ON: McClelland and Stewart.

Bissonette, L., (1987). *Le passion du présent*. Montréal, QC: Borealis.

Brown, J.J., (1967). *Ideas in Exile: A History of Canadian Inventors*. Toronto, ON: McClelland and Stewart.

Bryce, G., (1900). *The Remarkable History of the Hudson's Bay Company*. Toronto, ON: W. Briggs.

Burnett, D., (1990). *Masterpieces of Art from the National Gallery of Canada*. Edmonton, AB: Hurtig.

Burnett, D., and Schiff, M., (1983). *Contemporary Canadian Art*. Edmonton, AB: Hurtig.

Canada Council (1995). *The Canada Council: A Design for the Future*. Ottawa, ON: Government of Canada.

Canadian Conference of the Arts (1998). *Final Report of the Working Group on Cultural Policy for the 21st Century*. Ottawa, ON: Canadian Conference of the Arts.

Chapais, T., (1919 – 34). *Cours d'histoire du Canada, 8 vols*. Québec City, QC: Garneau.

Creighton, D., (1937). *The Commercial Empire of the St. Lawrence*. Toronto, ON: Ryerson.

———. (1944). *Dominion of the North*. Toronto, ON: Macmillan.

———. (1952 – 55). *John A. Macdonald, 2 vols*. Toronto, ON: Macmillan.

———. (1971). *Story of Canada*. London, UK: Faber.

CBC Radioworks (1993). *Culture and the Marketplace*. CBC Radio, *Ideas*. Toronto, ON: CBC Radioworks.

Cummings, M.C., and Katz, R.S., eds. (1987). *The Patron State: Government and the Arts in Europe, North America and Japan*. Toronto, ON: Oxford University Press.

De Kerckhove, D., (1995). *The Skin of Culture: Investigating the New Electronic Reality*. Toronto, ON: Somerville.

Emberley, P.C., ed. (1990). *By Loving Our Own: George Grant and the Legacy Lament for a Nation*. Ottawa, ON: Carleton University Press.

Fetherling, D., ed. (1987). *Documents in Canadian Art.* Peterborough, ON: Broadview.

French, S., (1979). *Philosophers Look at Canadian Confederation.* Montréal, QC: Canadian Philosophical Association.

Frye, N., (1971). *The Bush Garden: Essays on the Canadian Imagination.* Toronto, ON: Anansi.

———. (1972). *Diversions on a Ground.* Toronto, ON: Anansi.

Fulford, R., (1977). *Introduction to the Arts in Canada.* Toronto, ON: Copp Clark.

———. (1968). *This Was Expo.* Toronto. ON: McClelland and Stewart.

Garneau, F. X., (1845). *Histoire du Canada, 1913 – 20.* Paris, FR: Oleon.

Government of Canada (1957). *Report of the Royal Commission on National Development in the Arts, Letters and Sciences, 1949-51.* Ottawa, ON: Department of Supply and Services.

Government of Canada (1979). *Evolution of the Canadian Broadcasting System: Objectives and Realities, 1928 -68.* David Ellis, ed., Ottawa, ON: Department of Supply and Services.

Grant, G., (1965). *Lament for a Nation.* Toronto, ON: McClelland and Stewart.

———. (1969). *Technology and Empire.* Toronto, ON: Anansi.

Gray, J., (1994). *Lost in North America: The Imaginary Canadian in the American Dream.* Vancouver, BC: Talon.

Groulx, L., (1960). *Histoire du Canada français depuis la découverte.* Montréal, QC: Fides.

Gwyn, R., (1995). *Nationalism Without Walls.* Toronto, ON: McClelland and Stewart.

Hannon, L. F., ed. (1960). *Maclean's Canada: Portrait of a Country.* Toronto, ON: McClelland and Stewart.

Harper, J. R., (1996). *Painting in Canada: A History.* Toronto, ON: University of Toronto Press.

Hearne, S., (1911). *A Journey from Prince of Wales' Fort, in Hudson's Bay, to the Northern Ocean, 1795.* Toronto, ON: Champlain Society.

Helwig, D., ed. (1980). *Love and Money: The Politics of Culture.* Ottawa, ON: Oberon.

Reader's Digest Association (1978). *Heritage of Canada.* Montreal, QC: Reader's Digest Association.

Henighan, T., (1997). *Ideas of North: A Guide to Canadian Arts and Culture.* Vancouver, BC: Raincoast.

———. (1996). *The Presumption of Culture: Structure, Strategy, and Survival in the Canadian Cultural Landscape.* Vancouver, BC: Raincoast.

Jenness, D., (1932). *The Indians of Canada.* Ottawa, ON: National Museum of Man.

———. (1928). *The People of the Twilight.* Chicago. IL: Chicago University Press.

Kroker, A., (1985). *Technology and the Canadian Mind: Innis, McLuhan, Grant.* Montréal, QC: New World Perspective.

Litt, P., (1992). *The Muses, the Masses, and the Massey Commission.* Toronto, ON: University of Toronto Press.

Marcotte, G., (1962). *Une littérature qui se fait: Essais critiques sur la littérature canadienne français.* Montréal, QC: Éditions HMH.

McIntosh, R.D., et al. (1993). *The State of the Art: Arts Literacy in Canada.* Victoria, BC: Beach Holme.

McLuhan, M., (1967). *Understanding Media: The Extensions of Man.* New York, NY: Signet.

Metcalf, J., (1994). *Freedom from Culture: Selected Essays, 1982 – 92.* Toronto, ON: ECW Press.

Moodie, S., (1994). *Roughing It in The Bush.* New Canadian Library 31. Toronto, ON: McClelland and Stewart.

Morton, D., (1994). *A Short History of Canada.* Toronto, ON: McClelland and Stewart.

Mowat, F., (1967). *Canada North*. Boston, MA: Little, Brown.

———. (1965). *West Viking*. Toronto, ON: McClelland and Stewart.

National Gallery of Canada, (1967). *Terre des hommes/Man and his World*. Exhibition Catalogue. Ottawa, ON: National Gallery of Canada.

Newman, P. C., (1988). *Sometimes a Great Nation*. Toronto, ON: McClelland and Stewart.

———. (1985). *Company of Adventurers*. Toronto, ON: McClelland and Stewart.

———. (1981). *The Canadian Establishment*. Toronto, ON: McClelland and Stewart.

———. (1963). *Renegade in Power: The Diefenbaker Years*. Toronto, ON: McClelland and Stewart.

Ostry, B., (1978). *The Cultural Connection*. Toronto, ON: McClelland and Stewart.

Ouellet, F., (1991). *Economy, Class and Nation in Québec*. Toronto, ON: Copp Clark.

———. (1966). *Histoire économique et sociale du Québec, 1760 – 1850*. Montréal. QC: Fides.

Page, T., ed. (1984). *The Glenn Gould Reader*. Toronto, ON: Lester.

Peat, F. D., (1994). *Lighting the Seventh Fire: The Spiritual Ways of Healing and Science of the Native American*. New York, NY: Birch Lane.

Pevere, G., and Dymond, G., (1996). *Mondo Canuck: A Canadian Pop Culture Odyssey*. Scarborough, ON: Prentice Hall.

Porter, J., (1965). *The Vertical Mosaic*. Toronto, ON: University of Toronto Press.

Powe, B.W., (1984). *A Climate Charged*. Toronto, ON: Mosiac.

———. (1993). *A Tremendous Canada of Light*. Toronto, ON: Coach House.

Resnick, P., (1994). *Thinking English Canada*. Toronto, ON: Stoddart.

Ross, M., ed. (1958). *The Arts in Canada: A Stock-Taking at Mid-Century*. Toronto, ON: Macmillan.

Saul, J. R., (1995). *The Unconscious Civilization*. Concord, Ontario, ON: Anansi.

———. (1997). *Reflections of a Siamese Twin: Canada at the End of the Century*. Toronto, ON: Viking.

Schafer, R. M., (1977). *The Tuning of the World*. New York, NY: Knopf.

Schwanen, D., (1997). *A Matter of Choice: Toward a More Creative Canadian Policy on Culture*. Ottawa, ON: C. D. Howe Institute, No. 91.

Staines, D., (1977). *The Canadian Imagination: Dimensions of a Literary Culture*. Cambridge, MA: Harvard University Press.

Stefansson, V., (1921). *The Friendly Arctic*. New York, NY: Macmillan.

Swain, R., ed. (1994). *Hidden Values: Contemporary Canadian Art in Corporate Collections*. Vancouver, BC: Douglas and McIntyre.

Taylor, C., (1982). *Radical Tories: The Conservative Tradition in Canada*. Montréal, QC: McGill-Queen's University Press.

Vallieres, P., (1986) *Nègres blancs d'Amériques*. Montréal, QC: Parti Pris.

Wolfe, M., (1985). *The TV Wasteland and the Canadian Oasis*. Toronto, ON: Lorimer.

Woodcock, G., (1988). *A Social History of Canada*. Markham, ON: Viking.

———. (1985). *Strange Bedfellows: The State and the Arts in Canada*. Vancouver, BC: Douglas and McIntyre.

———. (1970). *Canada and the Canadians*. Toronto, ON: Macmillan.

Wyman, M., (1989). *Dance Canada: An Illustrated History*. Vancouver, BC: Douglas and McIntyre.

References

Aldighieri, A. M., ed. (1996). *Canadian Almanac and Directory*. Toronto, ON: Copp, Clark.

Beattie, E., (1977). *Handbook of Canadian Film*. Toronto, ON: Peter Martin.

Benson, E., and Conolly, L.W., eds. (1989). *The Oxford Companion to Canadian Theatre*. Toronto, ON: Oxford University Press.

Bidd, D.W., ed. (1991). *The NFB Film Guide: The Productions of the National Film Board of Canada From 1939 to 1989*. Montréal, QC: National Film Board of Canada.

Brown, G.W., ed. (1966 – 94). *Dictionary of Canadian Biography/Dictionnaire biographique du Canada, 13 vols.* Toronto, ON: University of Toronto Press.

Cine-Communications (1996). *Film Canada Yearbook: The Indispensable Directory of the Canadian Film Industry*. Toronto, ON: Cine-Communications.

Colombo, J. R., ed. (1997). *The Canadian Global Almanac*. Toronto, ON: Macmillan.

————. ed. (1991). *The Dictionary of Canadian Quotations*. Don Mills, ON: Stoddart.

————. ed. (1984). *Canadian Literary Landmarks*. Willowdale, ON: Hounslow.

————. ed. (1978). *Colombo's Book of Canada*. Edmonton, AB: Hurtig.

————. ed. (1976). *Colombo's Canadian References*. Toronto, ON: Oxford University Press.

Coulombe, M., and Marcel, J., eds. (1991). *Le dictionnaire du cinéma québecois*. Montréal, QC: Éditions du Boréa.

Hamilton, R.M., and Shields, D., eds. (1979). *The Dictionary of Canadian Quotations and Phrases*. Toronto, ON: McClelland and Stewart.

Hart, T., and Simpson, L., eds. (1996). *Who's Who of Canadian Women, 6th edition*. Toronto, ON: Trans-Canada Press.

Kallmann, H., Poitvin, G., and Winters, K., eds. (1981). *Encyclopedia of Music in Canada*. Toronto, ON: University of Toronto Press.

Lemire, M., ed. (1981). *Dictionnaire des oeuvres littéraires du Québec, 6 vols*. Montréal, QC: Fides.

Lumley, E., ed. (1996). *Canadian Who's Who*. Toronto, ON: University of Toronto Press.

MacDonald, C.S. (1967). *A Dictionary of Canadian Artists, 7 vols*. Ottawa, ON: Canadian Paperbacks.

Marsh, J.H., ed. (1988). *The Canadian Encyclopedia*. Edmonton, AB: Hurtig.

Reference Division, McPherson Library, University of Victoria, BC. (1971 – 72). *Creative Canada: A Biographical Dictionary of Twentieth-Century Creative and Performing Artists, 2 vols*. Toronto, ON: University of Toronto Press.

Reid, A., and Dupré, L., eds. (1989). *Who's Who in Canadian Film and Television/Qui est qui au cinéma et à la télévision au Canada*. Toronto, ON: Academy of Canadian Cinema and Television.

Ripley, G., and Mercer, A., eds. (1992). *Who's Who in Canadian Literature, 1992-93*. Toronto, ON: Reference Press.

Story, N., ed. (1983). *The Oxford Companion to Canadian History and Literature*. Toronto, ON: Oxford University Press.

Toye, W., ed. (1983). *The Oxford Companion to Canadian Literature*. Toronto, ON: Oxford University Press.

Turner, D.J., ed. (1987). *Canadian Feature Film Index, 1913-1985*. Ottawa, ON: Public Archives Canada, National Film, Television and Sound Archives.

Wallace, W.S., ed. (1970). *The Macmillan Dictionary of Canadian Biography, 4th edition*. Toronto, ON: Macmillan.

A Selection of Useful Canadian Arts and Culture Web Sites

EVERY arts organization in Canada seems to have a Web site, so the best way to check things out is simply to run a Web search for what you are seeking. There are also sites for many individuals—famous writers, singers, theatre people—and sites for almost all the major arts and entertainment facilities. Some sites pay great attention to layout and aesthetics, which is pleasing (although it often slows up your search), while others have pages of hard information but few frills. Individual provinces and major cities also have arts sites that you can access by starting with the general information site for the province or city in question. Obviously, the public art galleries and museums have sites, and these are usually excellent, although each site focuses on different things. The government sites are loaded with information but are usually dull—so what else is new? Below I list a selection of general sites that I have bookmarked for my own purposes; I'm sure you will find these helpful.

General Sites

• http://www.infoculture.cbc.ca
CBC arts coverage. A tremendously useful site. The stories are brief but informative and deal, on an almost daily basis, with almost everything that happens in Canadian arts and culture, while total (and free!) access to a plethora of past stories makes this an incomparable source for double-checking basic information.

• http://www.cs.cmu.edu/unofficial/Canadiana
Carnegie Mellon University runs this absolutely essential site. Covers all aspects of Canadian culture, including education, government and arts and culture.

• http://www.statcan.ca/english/pgdb/people/culture.htm
The official Statistics Canada site with many culture statistics. Also available in French, of course.

• http://www.canadacouncil.ca
Press releases and other information from the Canada Council for the Arts.

• http://www.pch.gc.ca
The Heritage Ministry's site.

• http://www.daryl.chin.gc.ca
The Canadian Heritage Information network. Useful.

• http://www.crtc.gc.ca
The CRTC site. Very useful for accurate information on rulings and press releases.

• http://www.globeandmail.ca/hubs/search.html
Quite useful, but, just because the *Globe* is so central and informative, it would be nice to have free access to their archives. Hint to the site editors: The *New York Times* site might be a useful model.

• http://www.ffa.ucalgary.ca/cnet
The Canadian culture net. A good site, with useful links.

- **http://www.festivalseeker.com**
 Lots of information here on Canadian festivals of all kinds, although a few mega-festivals don't seem to be listed.

- **http://www.pdarts.com**
 At the Place des Arts site you can link to the Québec culture web, an indispensable site with links covering all the arts in that province and available in both French and English.

- **http://www.schwinger.harvard.edu/~terning**
 John Terning's page, with useful information on Canadian achievers in many fields, including many artists.

Literary Connections

- **http://www.lights.com/publishers/ca**
 Lists Canadian publishers.

- **http://www.library.utoronto.ca/canpoetry**
 The University of Toronto site that lists Canadian literary publishers of all kinds, as well as a few organizations.

- **http://www.ramsay/books.com/bookstore/authorlinks**
 Bookseller Deanna Ramsay's site has many connections to Canadian writers' sites. Excellent.

- **http://www.web.net/eac-acr**
 Canadian editors' site.

Music, Dance, Visual Arts and Theatre Sites

- **http://www.oc.ca./Links/links_js**
 Orchestras Canada site.

- **http://www.dialspace.dial.pipex.com/town/place/abn39/ra**
 "Mike's Radio World" gives a plethora of links to Web radio, including many Canadian stations.

- **http://www.emporium.turnpike.net/~dpd/NA/dp_can**
 Canada dance pages.

- **http://www.dancer.com/dance-links/modern**
 Many useful links to modern-dance companies.

- **http://www.thepoint.net/~raw/companies**
 Ballet and modern-dance companies.

- **http://www.mcsquared.com/cada/links**
 Canadian Alliance of Dance Companies and useful links.

- **http://www.stage-door.org**
 Current Ontario theatre listings.

- **http://www.odyssee.net/~pigeon/theatre**
 The theatres of Québec.

- **http://www.webhome.indirect.com/~pact/members**
 The site of the Professional Association of Canadian Theatres.

- **http://www.comlab.ox.ac.uk/archives/other/museums/galleries**
 Museums and galleries around the world, including many in Canada.

Index

Page numbers referring to photographs and captions are in italics.